Marjorie Barstow and the Alexander Technique

Amanda Cole

Marjorie Barstow and the Alexander Technique

Critical Thinking in Performing Arts Pedagogy

palgrave
macmillan

Amanda Cole
Griffith University
Brisbane, QLD, Australia

ISBN 978-981-16-5258-5 ISBN 978-981-16-5256-1 (eBook)
https://doi.org/10.1007/978-981-16-5256-1

© The Editor(s) (if applicable) and The Author(s) 2022
This work is subject to copyright. All rights are solely and exclusively licensed by the Publisher, whether the whole or part of the material is concerned, specifically the rights of translation, reprinting, reuse of illustrations, recitation, broadcasting, reproduction on microfilms or in any other physical way, and transmission or information storage and retrieval, electronic adaptation, computer software, or by similar or dissimilar methodology now known or hereafter developed.
The use of general descriptive names, registered names, trademarks, service marks, etc. in this publication does not imply, even in the absence of a specific statement, that such names are exempt from the relevant protective laws and regulations and therefore free for general use.
The publisher, the authors and the editors are safe to assume that the advice and information in this book are believed to be true and accurate at the date of publication. Neither the publisher nor the authors or the editors give a warranty, expressed or implied, with respect to the material contained herein or for any errors or omissions that may have been made. The publisher remains neutral with regard to jurisdictional claims in published maps and institutional affiliations.

This Palgrave Macmillan imprint is published by the registered company Springer Nature Singapore Pte Ltd.
The registered company address is: 152 Beach Road, #21-01/04 Gateway East, Singapore 189721, Singapore

To Tim and to Olivia

And celebrating the memory of
Owen and Marie Cole
and
Anna and Murray Mardardy

ACKNOWLEDGEMENTS

This book originated in a doctoral research project that began in the Departments of Psychology and Music at the University of Otago. Dr Tamar Murachver, Dr Alan Davison, Professor Henry Johnson and Stephen Stedman supported the data collection on Cathy Madden's teaching. Terry Fitzgerald, whose research strongly influenced my own, helped to rehouse the project at Griffith University when Tamar Murachver died, and Kay Hartwig, Christopher Klopper and Dan Bendrups helped it come to fruition. A large number of musicians, academics and students have taken part in my research, all over the world. William Conable's enthusiastic support of the proposal for this book has helped it to see the light of day.

Cathy Madden, through her remarkable teaching, was the original inspiration for my research. She has been extraordinarily generous in support of my work in countless ways and continues to inspire me with her creative, critical, and ever-evolving thinking and her propensity for play.

A great many other Alexander Technique teachers have also contributed to this project: William Conable, Sarah Barker and Robert Rickover in the form of interviews and follow-up emails; Aase Beaulieu, Catherine Kettrick, Bruce Fertman, Jeremy Chance and Alex Murray in the form of correspondence; and Paul Cook gave me access to *Direction Journal* archives.

viii ACKNOWLEDGEMENTS

This book is all the richer for the many photographs of Marjorie Barstow. These appear thanks to support of Adrian (Dee) DePutron Hilz and the meticulousness of William D. Selim, who provided the family photographs, and to the fine preparation work and generosity of Kevin Ruddell, author of the photographs of Barstow teaching in her later years.

Many librarians and archivists have facilitated my work over the years, in particular, Thelma Fisher at Otago, Josh Caster at Nebraska University, Becca Mayersohn at Walnut Hill, Ted Dimon at the Frank Pierce Jones Archive in in New York, Luke Chatterton from the STAT archives in London, Maggie Barlow at The American Society for the Alexander Technique (AmSAT), and Father Andrew Campbell at St Vincent Arch-Abbey, Latrobe, PA, where Eric McCormack's papers are housed. and Nancy Forst Williamson, Gabriel Williamson and Diana Bradley in Lincoln, Nebraska.

Countless people have sent me their work, published and unpublished, including Terry Fitzgerald, David Mills, Missy Vineyard, Alex Murray, Franis Engel, and William Conable. Jean Fischer answered many emails about historical information, photographs, and the contents of the STAT archives, and I have adopted his method of referencing biographical details of the myriad people who turn up in any book on the Alexander Technique, with the use of an asterisk.

I am grateful to you all.

A Note on People and Organisations

Following a technique used by Jean Fischer,* an asterisk after a name indicates that an introductory or explanatory note can be found in the section "Biographical Notes" at the end of the book. These notes give the reader some context about teachers of the Alexander Technique, philosophers, Barstow's students, and others who engaged in the discussion about the Alexander Technique (AT) and its pedagogy. It has not been possible – and is probably not necessary – to obtain information about all players in this story. Where a biographical or explanatory note exists the name is marked with an asterisk (*) where it first occurs. These notes are in alphabetical order.

CONTENTS

Acknowledgements	vii
Prologue	xxi
About this book and who it is for	xxi
The AT as Education	xxiii
So, what IS the Alexander Technique?	xxv
Who was Marjorie Barstow?	xxx
Structure of the Book	xxxvi
A Note on Sources	xxxvii
List of Figures	xv
List of Plates	xvii

Part I F. M. Alexander and Marjorie Barstow

1 The Problem with Alexander's Technique	3
The Evolution of the Passive Experience	4
Reinstating Education into the AT: Barstow and Dewey	12
Conclusion	14
2 Marjorie Barstow's Constellation	17
What Is a Philosophical Constellation?	17
The Constellation	19

xi

xii CONTENTS

Overview of Parallels Between Barstow and Dewey 42
Summary 43

Part II Dewey's Principles in Barstow's Teaching

3 Making Ideas Clear 47
The Essence of the AT 50
The Essential Process of the AT 53

4 Reconstruction: Barstow's Reconstruction of Alexander's Principles and Terms 83
PART A: Identifying Alexander's Principles 84
PART B: Reconstructing Alexander's Terms and Methods 86
Term 1: Primary Control 90
Term 2: Inhibition 96
Term 3: Direction and Directions 107
Term 4: Positions of Mechanical Advantage (and other Procedures) 115
Term 5: Sensory Re-education 138
PART C: Philosophical Pragmatism in Action – The Parallel 'Reconstructions' by Dewey and Barstow 144
CONCLUSION: The Reconstructed Alexander Technique 146

5 Desire, Application and Art 149
The Question of Desire in Alexander Studies 152
Ends-In-View Versus End-Gaining 158
The Application Approach 161
The Problem with Inhibition-as-Stopping and Non-Application 164
Lighting the Spark for Performers 166
Conclusion 168

6 Democracy and the Social Context 171
The Beginnings of Barstow's Group Teaching 172
Dewey, Community and Communication 174
Barstow, Community and Communication 176
Criticism of Barstow's Teaching 179
Response to Criticisms 181
Barstow's Community 183
Group Teaching and the Alexander Technique 185
Coordinating Benefit 1: Observation and Thinking 186

CONTENTS xiii

Coordinating Benefit 2: Constructive Thinking &
Communicating 194
Coordinating Benefit 3: Democracy, Independence
and the Social Context 199
Summary 203

Part III Integration

7 The Art and Integration of Teaching and Training 207
Creating the Conditions for Learning (CCL) 208
Teaching by Example and Implicit Learning 210
Meeting and Accepting 214
Training Teachers 220

Conclusion 235

Notes 241

Biographical Notes 285

Appendix: The Alexanders and the Alexander Technique 305

References 309

Index 321

LIST OF FIGURES

Fig. 2.1	Barstow's constellation	20
Fig. 2.2	Constellation timeline	20
Fig. 2.3	Timeline of Philosophers of Pragmatism	21

LIST OF PLATES

From the Barstow Family Archives: Courtesy of William D. Selim

1922. Marjorie Barstow with Porta Mansfield Dancers, California	62
1902–1903. Marjorie Barstow and Frances Foote Barstow	63
1903. Marjorie Barstow and Frances Foote Barstow	63
1920s. Marjorie Barstow, Dan dePutron, and John dePutron	64
No date. Marjorie Barstow	64
1926. Marjorie Barstow and Frances Barstow	65
1932. Marjorie Barstow, United Kingdom	65
1939. Marjorie Barstow with Frances Foote Barstow and William Townsend Barstow	66
1939. Marjorie Barstow with Helen Barstow DePutron	66
1947. Marjorie Barstow in Lincoln, NE	67
1960. Marjorie Barstow in Denton, NE	67
1960. Marjorie Barstow Christmas Card	68
1961. Marjorie Barstow with Bob Selim	68
1966. Marjorie Barstow with Quarter Horse, "War Bond Leo"	69
1974. Marjorie Barstow in Denton, NE (Seated)	69
1974. Marjorie Barstow in Denton, NE (Feeding horses)	70
1977. Marjorie Barstow in Denton, NE (On horseback)	70
1940. F. M. Alexander	71

From the Barstow Institute and Doane College, Nebraska

1940. A. R. Alexander	71

xvii

xviii LIST OF PLATES

From the University of Nebraska Archives-Lincoln Libraries

1918. Alpha Phi, University of Nebraska	72
1919. Sophomores, University of Nebraska	73
1919. Women's Athletic Association Executive Board, University of Nebraska	74
1919 Women's Self Governing Association, University of Nebraska	74
1920. Student Council, University of Nebraska	75
1922. Women's Athletic Association, University of Nebraska	75

Marjorie Barstow teaching: Courtesy of Kevin Ruddell 1989–1990

With unnamed child	76
With Stacy Gehman	76
With David Mills	77
With Catherine Madden	77
With Ronald Phillips	78
With Catherine Kettrick	78
With Randel Wagner	79
With Rupert Oysler	79
With Kevin Ruddell	80
With unidentified student	80
With Rupert Oysler	81
With Heather Kroll	81
With Geoff Johnson	82
With Serge Clavien	82

Prologue

About this book and who it is for

What do the Alexander Technique, Critical Thinking, Performing Arts Pedagogy and John Dewey have to do with each other?

The Alexander Technique (AT) has had a mixed reputation amongst performers.[1] There is also considerable confusion about its aims, principles and value. Is it a relaxation technique? Is it psycho- or physical therapy? Is it postural re-education? Does it cure performance anxiety? This confusion is partly due to the contradictions its founder, F.M. Alexander,* left behind, and the resulting schisms within the Alexander community that continue today.

The contradictions in AT teaching stem largely from the fact that the steps Alexander took on his own process of discovery about behaviour, and which led to the development of the Alexander Technique, were different from the steps he taught to others when passing on his "technique." This creates uncertainty for those who wish to follow in Alexander's footsteps or benefit from what he discovered about coordination and co-operation with human nature. The vast majority of early Alexander teachers chose to follow the practices he told them they should follow when teaching his technique. These included exercises such as helping students in and out of a chair, "lying down work" or "semi-supine:" (done on a table and also referred to as "table work") and procedures such

xix

as "monkey" and "hands on the back of the chair." These are discussed further in Chapter 4.

Marjorie Barstow was one of the few who chose instead to teach students how to focus on the principle he discovered, that of a central coordination. She taught this by teaching the observation steps and the thinking process that Alexander himself had followed in order to change his own behaviour in responding to stimuli. It is for this reason I have given this book the subtitle: "Critical Thinking in Performing Arts Pedagogy." While the Alexander Technique is not exclusively for performing artists, my interest in it has always been from the point of view of a performing artist and teacher, or "teaching artist." Further, it is the usefulness of the AT *for performers* for which Marjorie Barstow became particularly well known in her lifetime.

Barstow made the distinction between Alexander's "discovery" on one hand, and his "technique" on the other, calling Alexander's teaching methods his "technique" and the steps of his experimental process and the discoveries he made along the way his "discovery," and pointing out the inconsistency between the two. This book is essentially about the ways in which Barstow separated Alexander's discovery from his technique, sticking steadfastly to his principles: (his discovery) and reinventing its pedagogy (his technique). Her pedagogy was aligned with the thinking of John Dewey, one of the greatest philosophers on education, who was also a great supporter and critic of Alexander's work. To highlight the significance of Barstow's thinking, I show how her teaching shows parallels with Dewey's philosophy, known as critical pragmatism or instrumentalism.

Who is this book for?

First and foremost, this book is for performers who are interested in the AT. As a performer myself, I wish there had been a book about Marjorie Barstow when I began to learn the technique. I enjoyed lessons and found the technique helpful but bewildering. This book is therefore also for anyone who has tried to learn the Alexander technique and been confused or nonplussed or unimpressed, but who senses there might still be something valuable in it. It is for anyone who has reached a certain level of expertise and skill in a particular area and wonders why increased effort and commitment do not necessarily translate into further improvement.

Musicians and actors are usually the people I meet who have heard of the Alexander technique. This may be because it is still taught in some

tertiary music and drama programs. It is perhaps here, however, that the widest range of experiences of the technique exists. It was a singing teacher who initially recommended the technique to me. Soon after I commenced lessons, another singing teacher told me that the AT had "nothing whatever to do with singing." Voice pedagogue Patsy Rodenburg, in her introduction to Kelly McEvenue's book on the AT, points out that McEvenue "does her work when and how she can without devaluing the Alexander Technique but aware that she can't be precious about it when a company's demands on an actor are so complex."[2] McEvenue studied extensively with Marjorie Barstow.[3] Rodenburg's implication is that some approaches to the AT are precious and give rise to the negative impressions, like those described by Jane Heirich* (see page xx). This book is an invitation to performers to consider Barstow's approach to the AT, even if they have experienced the AT before and found it difficult to perceive its applicability or relevance to practising or performing.

THE AT AS EDUCATION

According to John Dewey,* the Alexander Technique bears the same relation to education that education itself bears to all other human activities. "It contains," in Dewey's judgment, "the promise and potentiality of the new direction that is needed in all education."[4] This quote is bandied around in support of the technique. And yet, little thought has been given to how Dewey's philosophy – significantly, a philosophy of education *and* of scientific process and discovery – might improve the teaching of Alexander's work. Given that Dewey's and Alexander's work overlapped in so many ways and Dewey is recognized as one of the greatest thinkers in education in the past century, it makes sense to examine how the teaching of the AT would look with Dewey's ideas applied to it. This, as I argue, is what Marjorie Barstow's pedagogy looks like. With a Deweyan emphasis, the educational aspect of the AT is brought to the fore, and Dewey's claim for the technique is fulfilled.

Dewey's promise to education appears to have been forgotten by those who pass on the AT as if it were a remedy, a therapy, or a treatment. Alexander made significant observations about behaviour and movement but his thinking about teaching appears to have been limited. He did not appear to be especially concerned with improving his communication or evaluating or reflecting on the efficacy of his teaching. In realigning Barstow and her "school" with Dewey and his philosophical pragmatism,

xxii PROLOGUE

I hope that her teaching may be recognized as a pedagogical "force to be reckoned with."[5] I aim to show that in her alignment with some of the most advanced educational ideas of her day (and today) she actually *saved* the AT from obscurity, or, worse, irrelevance, amongst performers.

There have been several studies in the past couple of decades that examined the role and efficacy of the AT in a number of medical conditions. In these studies the technique is regarded, necessarily, as a kind of adjunct therapy. Broadly speaking, too, the Alexander Technique is usually classified as being concerned with physical or mental health.[6] It is variously understood to be a form of complementary medicine for anxiety reduction, an aid to posture, or a method of releasing unwanted tension. Even when evaluating its usefulness for performance, researchers tend to focus only on its impact on performance anxiety[7] or in preventing or alleviating injury.[8] As a performer and performing arts teacher myself, I am principally interested in the role the AT plays in enhancing performance, coordination, and technical, musical and artistic skill, and that is the focus of this book. That is, the *educative* role of the AT. The usefulness of the AT for musicians has been shown in several studies.[9] The AT has been introduced into performance academies and colleges around the world. But there is also some dissatisfaction with – and mistrust of – the technique, as evidenced by Heirich's observation that voice teachers are put off when students return from AT lessons as "devitalised robotic wimps."[10] Further evidence that the perceived value of the AT for performers may be waning is the fact that in 2010 the Royal Academy of Dramatic Art (RADA) in London retrenched three full-time Alexander teachers.[11] This change may reflect differences in teaching practice. When the AT is taught as a kind of therapy, it gives the impression that the student can passively receive a treatment. It is less likely to appeal to performers as a vital part of their practice and more likely to appear as an adjunct remedy for injury or anxiety. Differentiating the teaching of the AT – or even naming the different approaches, which may be more sensible – requires, amongst other things, clarifying and defining one's approach to the technique as either education or physical/medical treatment.[12] This book is about the Alexander technique as education and as a practice that can enhance one's coordination and performance. Alexander was certainly interested in the health benefits of his technique. But, as Richard (Buzz) Gummere* observed in the 1980s, the increasing focus on the problems of the body rather than on Alexander's whole psychophysical and moral concept, including heightened creativity and

PROLOGUE xxiii

a new consciousness, "could subtly distract our profession away from his larger mission, the elevation of the human race."[13] When scrupulous attention is also given to the manner in which it is taught, as Dewey hoped it would be,[14] it becomes a means of demonstrating and furthering good pedagogy, or, education about education. Such attention also aligns with Alexander's own emphasis on what he called the "means whereby."

A more nuanced appraisal of the Alexander Technique appears to be overdue. But, within the Alexander community, differentiating between approaches is often called factionalism and tends to be viewed with suspicion or disdain. There is an overwhelming commitment to reduce difference and boil everything down to one cohesive whole. By contrast, the need identified in this book to recognize and even name different approaches is seen as a sign that the Alexander Technique has reached a point of maturity, just like other significant fields of practice or inquiry. In studies that set out to show the technique's usefulness, there is no description of how the technique is taught, or what teaching approach is taken,[15] which, as I hope this book will show, is a crucial aspect of its quality and value.

So, what IS the Alexander Technique?

Because this book is about Marjorie Barstow, this first description of Alexander's work is in her words. It is a transcription of part of an interview she gave in 1986 at the Stony Brook Alexander Congress in which the interviewer points out Barstow's skill in demystifying the technique. Barstow's response is a succinct description of the Alexander Technique. The Appendix gives a brief outline of Alexander's work and the genesis of the Alexander Technique.

> *Interviewer:* Well, I think that you've done a great deal to help, what I will say, demystify the technique for a lot of people and make it as clear and as simple as possible, given that it is difficult. How would you talk about what Alexander called "direction"?
>
> *Marjorie Barstow:* Oh, direction, what he meant by it is… Well, I'll just talk about helping a person. I first ask them to take a look at themselves. Now what does that mean? It just means, I can sit here and I can look at myself. I can just tilt myself and I can see what I'm doing. I can *feel* if my legs are stiff. I can find out, notice if I'm in a little bit of a slump, why don't I go down here? Now this is the way most everybody sits

(slumped). There's no harm in it if we don't overdo it. But when I do this I'm putting a heavy downward pressure on my whole body. You can see that, can't you?

All right, now that pressure has put a lot of excess tension through my whole neck, which affects my voice. It has dropped my chest so I'm robbing myself of the space that my lungs need to work efficiently. And I have a lot of heavy pressure down here in my hips and this drop-down really is wasted... it's burning up energy. So that's what I help people see.

Then, when you want to stop this, instead of just sitting up straight, as most people would do, that simply transfers this heavy pressure to a thing like this (throws shoulders back and looks stiff and over-tall), see, and I say to them, "How long do you stay there?" And they laugh and say, "Nah... "

So, this is the thing Alexander discovered and then he said, "There must be some way that I can move to release this pressure" and he finally discovered that this back-and-down pull of his head was the beginning of the slump and the pressure.

So then I can help the person learn how to just redirect that energy. And the minute I start moving my head very easily, I'm changing the relationship of the poise of my head to my body. And I've lost what I didn't want. That's all there is to it. It's too simple, isn't it?

The second description of the Alexander Technique is again in Barstow's words, this time as a transcription of a class she gave in 1986 at the Stony Brook Congress. This provides an example of an Alexander class as well as an experience of Barstow's teaching, including her sense of humour.

> *Barstow:* It's great to see you here this morning and I think this is a wonderful occasion for everybody. And I don't know what I'm supposed to be doing, but I'm here and you're here, so we'd better get busy and do something, don't you think? All right, let's talk about Alexander's discoveries. He really discovered something. And I'm sure you all know that he discovered something. And I think it is such a little delicate something that people call it difficult. Now I don't quite believe that. I believe it's very little and it's delicate, but I think we're the things that are difficult. Why do you look so sober over there? (laughter) You wouldn't think that you were difficult, I wouldn't think that I was difficult, but I have discovered that I'm the difficult thing; not what Alexander discovered. It is so simple that I have taken a long time to comprehend it. So, what did his discoveries have to offer? A very unique

approach to the study of movement. And he says in his writings that it's perhaps the first time that this approach has been in existence for the human being. Now that's a pretty big statement. But as I continue teaching, I am beginning to really agree with him. Yes, and I think that's wonderful. So what did his discoveries offer us?

First of all, they help us learn how to look at the quality of our own coordination as it is today. And he says, if you want to improve in movement, in your daily activities, in your professional performances, if you really are sure that you need some improvement because you aren't quite happy with the results of your activities, then if we are all as smart as we *think* we are, we will do that. so he even tells us how to start it. He first says, "Take a look at yourself." So that's the first thing we're going to do this lovely morning.

I'm going to ask each of you to take a look at yourself, notice how you're sitting and how you feel. Now why are you so sober about that? (laughter) Haven't you ever thought of it in that way? So, how do you look at yourself? Well, if I want to look at myself, I just tilt down and look at it. Now can you all do that? Can you see what you're doing? Can you see, all right, now look around the room and see what you notice about everybody else. What kind of things do you see as you're sitting? Now I see everybody has their own little way of sitting, and that's great, because we're all individuals, are we not? OK. So, what are the things you see? Does anybody want to say what they see, either about themselves or about somebody else? But don't tell who you're talking about! (laughter) Because you don't like to have people tell you this and that. So who is brave enough to say what they think about themselves or what they see some others doing? (CUT)

Participant: Different ways people have their feet.

Barstow: Yes, everybody doing something a little different with their feet. Well, they can, they're their feet, aren't they?

Participant: (CUT)... How much we overdo. How much we tense, how much we squeeze when we're sitting down.

Barstow: All right, now, so what have we found out? That everybody has their own little habits the way they sit this morning, and I'm sure if you sit this way this morning, there'll be other times you'll sit this way, other times you'll sit a different way. Isn't that right? So, sitting is a flexible thing, isn't it? Only what do we do with our sitting? Do we take away any of the flexibility of our sitting while we're sitting?

Participant: Yes, we do...

Barstow: I think we do. So if I do this thing, what did you see me do?

Participant: Slump.

Barstow: Now, what does this do for me? Nothing... but make me burn up a lot of energy. Or *some* energy–I don't know how much. But what ...(CUT) I'm here and I'm going up here.. So if I'm going to keep the stiffness, why don't I stay here? (laughter) This is just logical reasoning. Ain't it pretty logical reasoning? All right. Now, this is where Alexander discovered something.

When we want to get rid of excess tension, which is stiffness, what do we do? Move into another place and keep the stiffness in a different direction? No. He says, what you can do and I can do and he did, and he said everybody can do it if I can do it, I have to move what part of my body first? I have to move my head, it's going to act as a lead, and as my head moves *very delicately* in an upward direction, so that my body follows it, then what have I lost?

Oh, come on, what have I lost? I've lost the downward pressure. What was the result of my losing the downward pressure? That I lost the excess tension through my neck, which affects my voice. I've allowed my body to lengthen so there's the space inside of me that my lungs need to have my respiratory mechanism being effective. And I've taken a great deal of pressure off of my joints: my hip joints, knee joints and ankle joints. Now, .. (CUT)..

Who had their hand up first? (laughter) Everybody put their hand up...Y'all had your hands up first! I happened to see this lady, so while she's right here, now what I'm going to do.... I'm going to be able to look at it myself and see what happens. So when I start to help you a little bit with my hands, be sure you don't say to yourself, "Here she comes, I'd better sit up straight." Because if you sit up straight, what will you be doing? You'll be pushing yourself up and there's no chance in getting together a delicate habit when you do that. So, if my hands come here, they're going to suggest a very delicate... Keep your eyes open! You can't go to sleep while I'm in this room. But when I leave this room, if you want to go to sleep and snore, that's just great! So, *you* have something *you* have to do. I'm not going to do it all. You have to decide that you're going to follow my hands just a tiny bit, now are your eyes open?

Participant: Yes.

Barstow: All right, now, what do my hands feel like when I put them there?

Participant: They were encouraging me to release.. and to go up

Barstow: All right, but I think you can talk a little bit.. so that everybody can hear.

Participant: They were encouraging me to release.. and to go up.

Barstow: So now you have to do the movement. I don't think you're quite letting me.

Participant: All of a sudden I feel very tense! (laughter)

Barstow: (Laughing) Well, you put your hand up. You asked for it, you put your hand up (with a smile).. Now you tell me what you're thinking right now. What are you saying to yourself?

Participant: I'm saying to myself to release my lower back and to release my neck.

Barstow: You release your *neck* in order for the freedom to *come into your lower back*. Now, are you sure you've got that straight?

Participant: Yes. (Smiles)

(CUT)

Barstow: I think you had your hand up, didn't you, Judith? (Judith Leibowitz, who suffered the lifelong debilitating effects of polio and has great trouble balancing and walking in this video. See People and Organisations).

Leibowitz I always have my hand up! (all laugh)

(Barstow, laughing and turning around to the camera, then turns back and is in front of Leibowitz, puts her hands just under Leibowitz's ears with her little finger touching the jaw and throat and her thumb up towards the roof, so fingers 3 and 4 are giving the information). All right, now, here's just a tiny little ease, that's just a speck pushy. Did that seem a bit pushy to you?

Leibowitz: Yes.

Barstow: Well now,

Leibowitz: I have to stop doing.

Barstow: No, that's negative. Let's don't talk negatively. If you just say, 'Well this is, gee, I don't know what she's doing, but why don't I follow her and find out?' This is where you can experiment just a little bit. I want to move it just a tiny bit like that. Now does that do anything?

Leibowitz: Oh yes, that changed the whole poise of my head..

Barstow: Yes, now that's pretty simple, isn't it? OK ... So what's the fuss? Who else wants help, anybody? Oh, you want help! Wait a minute, now. Stay right where you are. Don't you get ready to move. Because this is where you're going to find ... Now, what are you going to think about when I help you?

Now that she has introduced the Alexander Technique, I will introduce Marjorie Barstow herself.

xxviii PROLOGUE

WHO WAS MARJORIE BARSTOW?

A delightfully gracious and funny woman of indeterminate age
—Nancy Forst Williamson[16]

Marjorie Louise Barstow was the youngest of four children[17] born in Ord, Nebraska,[18] to William Townsend Barstow and Frances Foote Barstow. She was born in 1899 on 25 August. Soon after, the family moved from the tiny rural town of Ord to the big city of Lincoln and her father built what would become a successful grain company, W.T. Barstow Grain Company, that Marjorie would eventually run.[19] They also built the majestic house that Marjorie still lived in during the late 1980s. The Barstows were a prominent family in Lincoln[20] and were able to send their daughters to boarding school for their final schooling. Marjorie spent two years at Walnut Hill High School in Natick, Massachusetts. She described this as 'a finishing school' near where her mother had grown up.[21] The school still exists and appears to have always been a progressive institution, describing itself as offering, at its inception in 1893, "a well-rounded and robust education to prepare young women for the demands of both college and a rapidly changing world."[22] Now co-educational, it describes itself as "the only arts high school in New England, a leader in arts education, and a space where young people can grow into their best selves."[23] Barstow recalls it as a "very strict school." "We had no social gatherings hardly at all," she said. "We went there to study, get our work done … It was great. It was a real education."[24]

After school in Massachusetts, Barstow returned to Lincoln to attend the University of Nebraska (NU) in 1918. The NU yearbooks, *The Cornhusker,* show the early signs of her inclination for progressivism and reform. These were evident in her activities in athletics, equal suffrage, women's self-government, and her sorority, Alpha Phi, as I will describe.

Barstow's faculty is listed as "Arts and Sciences." Barstow described herself as having "sort of majored in physical education," but thought that she had finished her degree with "more credits in English."[25] "I did a lot in the athletic department," she recalled years later. She also remembered that they "worked hard," having to earn their own funds for the Women's Athletic Association (WAA).[26] Women had only been allowed to compete in the Olympic games since 1900, and in 1920 they were still not included in athletics events. This latter change would come in the summer Olympics of 1928. Barstow was a keen and able athlete

as well as a dancer. She was the president of the WAA in her final year (1921), having been a member throughout her studies at NU and an executive board member in 1919. In March 1920 she was NU's official delegate at the convention of the Central Section of the WAA in Columbus, Missouri.[27] She excelled in the university track meets, winning places and several prizes in dancing. She came first in both the 1919 and 1920 "Annual Minor Sports contest" when she "interpreted the difficult dance 'Bacnanal' (sic[28]) with excellent technique and spirit."[29]

Barstow and her two sisters were members of the Alpha Phi sorority. One of the first three Greek-letter organisations for women, formed in 1872 (and the NU chapter in 1906),[30] Alpha Phi was well known for its progressivism. Several of the ten founders of the original society had prominent careers in education and/or publishing and were active in women's issues. Alpha Phi began at the University of Syracuse, near where Frances Foote had grown up. One of the founding members of the Alpha Phi at Syracuse was Martha Foote. The Footes are a significant family in New England and New York State, and further research may reveal a connection with Frances Foote (Marjorie Barstow's mother). Going to college at all made the three Barstow girls progressive. Only 7.6% of the female population in the USA attended college in 1920, though this is ten times what it had been in 1870 and three times what it had been in 1900.[31] The Barstow's choice of sorority was another sign of their liberal views. But while Marj's siblings (Adrian, Helen and Frances) tend to appear in the yearbooks only as members of a sorority or fraternity, with the exception of Helen, who was also a director of the Equal Suffrage League,[32] Marjorie made a large number of appearances as a forward-thinking woman.

In 1919 Marjorie Barstow held the post of treasurer for Women's Self-Government Association, or WSGA.[33] The purpose of the WSGA was "to uphold the rights and welfare of the women in the University."[34] WSGA was "the one University organization to which all women of the University belong."[35] In 1920 (the year American women were given the right to vote) it was composed of more than 1000 women students and run by a council of nine, of which Barstow was one.[36] In 1921 she was one of seven board members, by whom "house rules are made for all women students."[37] In addition to these posts, she also helped to organise the "All University Party" in 1920,[38] and in 1921 she was the chairman of the committee for the Class Play[39] and a member of the *Cornhusker* editorial staff for the Girls' Athletics,[40] represented her colleagues on

the Student Council,[41] and belonged to the "Valkyries," Senior-Junior Organization.[42] Barstow seems to have taken on quite a load in her final year, which was interrupted by the violent and sudden death of her only brother, Adrian, in January 1921.[43] In later interviews she tends not to refer to this time, and there are few details about how she spent her time in the first few years after graduation.

In the 1924 *Cornhusker* the Valkyries listed Barstow as an alumna of their society as a "leading dancer."[44] As the Valkyries' reference to Barstow suggests, Barstow continued to dance after completing her university degree. She also taught dancing in the ballroom at the Lindell Hotel (once Lincoln's premier hotel),[45] on the corner of 13th and M Streets (demolished in 1968 and now the site of the Cornhusker Marriott). The NU *Cornhusker* describes her as having directed the dance "All in a Garden Fair" for the second annual *Fête Dansante*, "in collaboration with a recital of Miss Barstow's pupils," in 1923.[46] Barstow had learned to dance as a child: ballroom dancing, ballet and what she herself described as "modern dance." Later, when people would ask her what kind of modern dancing she did, she would say, "I can't explain it to you 'cause the thing I'm talking about you've never even seen ... those were the days of Isadora Duncan and the Balanchines ... and those people and their dancing were very different ... Freedom, flexibility, poise, grace. And you just don't see that anywhere nowadays."[47] One summer in New York, Barstow studied with some of Isadora Duncan's protégées (six German girls Duncan had trained at her first school in Grünewald, and whom she later adopted) who were carrying on Duncan's work in New York and Paris.[48] Anna Duncan began teaching at Carnegie Hall in 1926, so Barstow's trip was probably some time after this.[49]

Marjorie Barstow's dance teacher went to England one summer and worked with Alexander.[50] She brought back one of his books, which Barstow read. After reading Alexander's book, she decided to go to England to find out more about his work and how it could help her dancing. In November 1926 she travelled with her sister Frances to London where they both had daily lessons with F.M. and A.R. Alexander* for six months. On returning to Lincoln, Marjorie opened her dance studio again for a couple of years. Together the two sisters made another trip to England at the end of May 1929 for eight weeks, during which they may also have visited the Alexanders. Marjory Barlow* describes Barstow[51] as having had "years of work" before starting training. "She and her sister used to come over from the States and work with FM,"

she reported.[52] Shortly after the Barstows' second trip to London, F.M. Alexander decided to commence his formal training school. In February 1931 Barstow returned, on her own, to England. She trained with the Alexanders for the next three years, returning home only once for Christmas in the first year.

Barstow says that what drew her to the technique was partly her interest in dance, but that she knew many students "in all phases of the performing arts" and had noticed one common characteristic in all of them: "The quality of their performance did not seem to improve beyond a certain level considering the many hours they spent practising."[53] Clearly, she was originally interested in the technique from the point of view of performing and, in particular, the way people *moved*, which she often highlighted in her description of the technique. For example, she said: "For people who are interested in movement, Alexander's work can be of great value to them."[54] She had also noticed in her dance teaching that students who came to her with "fairly good coordination [not too much excess pressure on their bodies]" were always the best dancers, and this gave her "a bit of insight."[55]

Barstow was the first graduate of Alexander's course in London, completing her training in December 1933. After the three years that F.M. had prescribed for his first training course, he decided to prolong the course by another year. He had spent much of the third year rehearsing and directing the trainees in a play for a performance at the Old Vic, and Barstow was not convinced of the value of staying for a fourth year. F.M. awarded her the first of his teaching certificates.

After her training, A.R. Alexander (F.M.'s brother) invited Barstow to be his teaching assistant in Boston and New York. From about 1934 to about 1942 Marjorie Barstow worked in Boston and New York as A.R.'s teaching assistant. They spent winters in Boston, and A.R. travelled to New York on weekends. Barstow would either go to New York with him or stay and teach his Saturday students in Boston. In summer A.R. would return to England and Barstow would return to Lincoln.[56] It was through A.R. that she met Frank Pierce Jones,* who had recently completed his Alexander teaching qualification. When A.R. Alexander left Boston in 1945 he did not mean it to be permanent. He had gone to England just for the summer but was not permitted to return due to health reasons. By the time A.R. died, in 1947, Barstow and Frank Jones had begun a steady stream of correspondence based principally on questions of the Alexander Technique and its pedagogy. Jones had received

xxxii PROLOGUE

his teaching certificate from A.R. in 1944, having completed his training with F.M. and A.R. during the war in the program that started at Stow, moved to Boston and ended in Swarthmore and Media, Pennsylvania.[57] Jones was a professor of classics at Brown University (his dissertation was on Greek participles). He was an unlikely candidate for the role of scientific researcher, which he ultimately became at Dewey's urging and with Barstow's support. It had also been with Dewey's encouragement that Jones had decided to train with the Alexanders in the 1940s. His correspondence with Barstow shows that she mentored and supported him in many ways for many years.

Barstow inherited the family home in Lincoln and, it seems, the family farm and business, when her father died (at the age of 90) in 1948. Barstow says that her teaching practice "developed by itself." Despite the extra calls on her time as an entrepreneur, farmer and quarter horse trainer, she appears to have continued to teach, experiment and question Alexander's pedagogy. Walter Carrington's diary of 1946 mentions Barstow as having been writing to Alexander, "claiming to have made wonderful new discoveries."[58] F.M., it seems, would "have nothing to do with them,"[59] and Carrington describes her as having "gone clean off the rails."[60] In reality her experiments and observations were systematic and scrupulously recorded. In her letters to Jones she frequently mentions photos and movies she has taken of her students, as well as notes about her teaching. These appear to be lost, but it is to be hoped that future researchers may unearth some of these.

After teaching the Alexander Technique for many years, Barstow became increasingly critical of the way the technique was taught and teachers were trained in England. She made a distinction between his "discovery" on one hand – that of a "primary control" – and his teaching on the other – what she called his "technique" (or the AT). "The way he teaches people about the primary control is his technique," she wrote to Jones in 1948. "I am not convinced that his way of teaching shows scientific value ... I may be overstressing the two – discovery and technique – but everything seems to convince me more and more that they need separation."[61] Jones seemed to be of the same opinion, writing to Dewey in 1947, "One thing that has alarmed me about the work is the view that the teaching technique has been perfected."[62]

Her teaching increasingly attracted the interest of performing artists. In a 1962 letter to Jones, she writes of a professional cellist, Professor of Music at the University of Illinois in Urbana. "He says I have been

the most helpful cello teacher he has ever been to, and we had a good laugh."[63] In the same letter she also describes working with "a dramatic student" who said Barstow had "shown her how to do all of the things that her teacher had been trying to get her to do" and whose voice afterwards "came rolling out and the sound even surprised her." Barstow also mentions a violinist who "stood like a cork screw while playing" and whose eyes she opened "to a few things," with the result that "she and her teacher were delighted." In the same letter she mentions a series of lectures she had done in "the phys ed department," presumably at NU, though she does not specify. These examples all show that even in the early 1960s she was teaching widely and at a high level and that her reputation was growing long before her career is commonly thought to have taken off.[64] William Conable notes that in 1964 her teaching was more like traditional English teaching."[65] At that time, Conable says, Barstow's approach "was to take the student as far as they could go in half an hour and send them away." She would take him well beyond where he could follow or understand, himself, and he was "a mass of aches and pains afterwards." By the early 1970s, however, in Conable's estimation, she had become "the person who knew what we needed to know."[66]

Despite her background and interest in performing arts, Barstow was not snobbish or elitist in her choice of students, and was far more democratic than this, as the following excerpt from an interview at the Stony Brook Congress shows:

> *Interviewer:* One of the areas in which you have created a great impression in *this* country is in the teaching of performers. The teaching of musicians, actors, dancers, seems to have been a great love for you and something you've done a great deal of. Your background includes dance, doesn't it?
>
> *Marjorie Barstow:* Yes.
>
> *Interviewer:* And do you have a particular fondness for performing artists to work with?
>
> *Marjorie Barstow:* No, not really. I enjoy working with just anybody. It doesn't make any difference. The man who uses a hammer and saw, or whatever act... activity. See, because it's just helping people to really live a little more comfortably. When they know that some of their problems of heavy pressure and so forth, they're putting that on themselves without realising it. and if they want to make a change, they have to realise what they are doing. Otherwise how do they know what will be

xxxiv PROLOGUE

of value to them? And so this is very basic to everything that anybody does.

Marjorie Barstow taught until shortly before her death at the age of 95 in 1995. During the last two decades of her teaching, she attracted thousands of students to her workshops, both at home in Lincoln, Nebraska, and around the world. Her unique approach to teaching Alexander's discoveries became a phenomenon in the Alexander community.

STRUCTURE OF THE BOOK

All the aspects of Barstow's pedagogy are inter-related, and so, while there will inevitably be some repetition, the focus of the chapters changes. The remaining two chapters of this introductory part focus on what I call "the problem with Alexander's Technique" (Chapter 1) and "Barstow's constellation" (Chapter 2). The "problem" with Alexander's Technique stems from the inconsistencies between what Barstow called Alexander's discovery and Alexander's technique. Barstow's constellation is the network/web of people with whom she came into contact over several decades, and with whose ideas her own were remarkably aligned. In Chapter 2, I also give a brief outline of philosophical pragmatism and how Dewey fits into the history of American philosophy, discussing the extent to which the work of F.M. and A.R. Alexander aligned with this school of thought.

Part 2, Dewey's Principles in Barstow's teaching, is divided into four chapters. Chapter 3 is about Making Ideas Clear, one of the principal tenets of philosophical pragmatism. Chapter 4 describes Barstow's Reconstruction of Alexander's terms and teaching and is divided into five sections, each of which describes a problematic aspect of Alexander's language, technique or pedagogy and how Barstow resolved the problem in her own teaching. In Chapter 5, I look more closely at the elements of desire, will and interest and why they are necessary when learning, practising and teaching the AT, especially when it is applied to artistic practice. Chapter 6 focusses on democracy and the social context. Here I address Barstow's group teaching and consider how observation skills, awareness, communication and community were brought together by her emphasis on the social context.

Part 3, The Art and Integration of Teaching and Training, addresses other essential elements of Barstow's teaching and describes how she

saw the teaching and learning of the Alexander Technique as part of a continuum and an on-going process, rather than the two separate entities Alexander defined. Alexander called someone who was learning the AT a "pupil," while someone learning to teach the AT was called a "student." Barstow rejected this duality and integrated her teaching and training on a number of different levels.

A NOTE ON SOURCES

When Frank Pierce Jones died, Marjorie Barstow wrote to Helen Jones, Frank's wife, expressing her difficulty accepting Frank's illness and death, and offering "help of any kind." "I have for so many years looked forward to my spring visit with both of you and a chat with him, his writings, and the future of the Alexander Technique. Our ideas were always so much alike on this. Now I must recognise that I am carrying on alone in this direction ... He had talked to me about leaving all of his papers and works to Tufts. He had also asked if I had any objections to my letters to him going there with his papers. My reply was that I would like to go over the letters before that was done."[67] After going through the letters, Barstow remarked: "I notice that we both expressed our personal opinions about other Alexander teachers very freely. I am not sure whether or not such personal opinions should be placed in files, as Tufts, or any other public places."[68] Despite this, and perhaps after discussing with Marjorie the value of the letters to future Alexander studies, Helen did follow her husband's wishes and deposit Barstow's letters amongst her husband's other papers with Tufts. The Jones-Barstow correspondence has been kept faithfully by Ted Dimon of the Dimon Institute (New York) since it was bequeathed to him by Helen Jones, Frank's wife, some time after Frank's death. She gave it to Dimon on the understanding that the letters would not be copied, feeling that the many discussions about teachers still living might be hurtful if the letters were freely circulated, yet also recognising that the letters were important as historical documents. It is my aim to use these letters to reveal Barstow's teaching during those decades for which there is little other evidence of the details of her activities and thinking. Jones died in 1976. Most other people mentioned in the correspondence have also passed on. Those who are still living I have not mentioned by name, if the reference to them is less than complimentary. I hope that my use of the letters will be recognised as ethical and respectful of the wishes of those who wrote them.

xxxvi PROLOGUE

What is also revealed, which I could ascertain in no other way during my doctoral studies, is what Barstow was doing between 1940 and 1970. The correspondence between Barstow and Jones shows that, contrary to a story told by Tommy Thompson,* Barstow began teaching groups in the 1940s. Thomson's story also suggests that Barstow's success came on the coattails of Jones. Nothing could be further from the truth. She independently built her own teaching practice across the country, while also acting for many years as a kind of mentor for Jones, reading his articles and commenting (in response to his request for feedback), discussing the pros and cons of various research projects, research questions and research setups, answering his questions on teaching and giving advice about how to word advertising and promotional material for the AT. As Robert Rickover* pointed out, Barstow was unprepossessing in stature, which frequently caused people to underestimate her.[69] As an older woman, she was easily dismissed as just "someone's grandmother," and Lincolnites who knew her in contexts other than AT had trouble imagining what she could possibly have to teach and why educated and accomplished professional people would flock to her from all over the world. It is partly in an attempt to correct this prejudice that I offer this book. The example above is just one of many I have collected in my research and I want to bring to light, to the best of my ability, the magnificence and uniqueness of this pioneering and pragmatic Nebraskan woman that was Marjorie Barstow.

When completing my PhD, the source I most relied on for information about Barstow (apart from my long contact with Cathy Madden and, later, interviews with Sarah Barker,* William Conable* and Robert Rickover) was the birthday offering to Barstow on her 90th birthday – a collection of essays and reflections by a large number of her students edited by Barbara Conable.* Because this book represents what, in German-speaking cultures, is a long-standing tradition to honour an esteemed colleague, I refer to it in brief by the German name, *Festschrift,* meaning celebratory publication. Conable, the editor, also describes it as such in her introduction.[70] Its full title is *Marjorie Barstow: Her Teaching and Training. A 90th Birthday Offering,*[71] and the students whose contributions I quote from are: Meade Andrews,* Sarah Barker,* Saura Bartner,* Jan Baty,* Aase Beaulieu,* Arro Beaulieu,* Jane Bick,* Diana Bradley,* Jeremy Chance,* Barbara Conable, William Conable,* Shirlee Dodge,* Bruce Fertman,* Martha Fertman,* Marguerite Fishman,* Lena Frederick,* Michael Frederick,* Stacy Gehman,* Richard Gummere, James Kandik,* Heather Kroll,* Cathy Madden,* Kelly Mernaugh,*

David Mills,* Frank Ottiwell,* Alice Pryor,* Robert Rickover, Jean-Louis Rodrigue,* Kevin Ruddell,* Peter Trimmer,* Eileen Troberman,* Lucy Venable,* Donald Weed,* Nancy Forst Williamson* and John Wynhausen.*

Finally, the fact that I was able to write a thesis about Barstow is yet another tribute to the clarity and skill of her teaching (and of course the eloquence of her students). Using almost entirely secondary sources (ie: reports by those who had studied with her, and my own experience of Madden's teaching) I was able to come up with the idea of a philosophical constellation around, and including, Barstow, which supported her pedagogy. It was quite thrilling, then, to find in her correspondence with Jones over a period of thirty years, all the connections I had surmised, as well as first-hand evidence of her ideas and their alignment with the educational philosophy of Dewey.

Amanda Cole

PART I

F. M. Alexander and Marjorie Barstow

CHAPTER 1

The Problem with Alexander's Technique

As mentioned in the prologue, The Alexander Technique (AT) has had a mixed reputation amongst performers. Alexander teachers must decide whether to guide students towards a slower path of discovery similar Alexander's, or to teach students in the way Alexander taught – which might *seem* like a shortcut to better coordination. The two paths are vastly different, as I shall show. Their co-existence has led to a teaching dilemma for all who seek to teach the technique. Can students learn the same process of discovery, reasoning and awareness that Alexander outlined in his third book, *The Use of the Self*,[1] or do they benefit more from Alexander's pedagogy which makes use of the passive experience, where the technique is bestowed upon them?

In this chapter, I will examine the major difference between these two approaches, that is, teaching students to discover "from within," using constructive and independent thinking as a guide, *versus* "treating" students to an experience "from without," using phrases and procedures prescribed by Alexander. With the possible exception of F.M.'s brother, Albert Redden, (A.R.), Marjorie Barstow was the first teacher to raise this difference as a teaching dilemma and to change her teaching accordingly. Since there is no documentation revealing exactly how A.R. taught or what he thought about this contradiction in AT teaching,[2] and since Barstow does not give A.R. credit for guiding her thinking about this matter in particular, it is probably safe to assume that this contradiction

© The Author(s), under exclusive license to Springer Nature Singapore Pte Ltd. 2022
A. Cole, *Marjorie Barstow and the Alexander Technique*, https://doi.org/10.1007/978-981-16-5256-1_1

3

was discovered by Barstow herself. It is my contention that Barstow must also be given credit for helping to resolve it.

In subsequent chapters, I will elaborate on some other differences between the two divergent paths, many of which stem from this central issue. As will become clear, the differences revolve predominantly around questions of critical thinking versus sensations as a guide to action and practice. They develop further from the application of critical thinking to the pedagogy of the Alexander Technique, which I will outline in these later chapters.

THE EVOLUTION OF THE PASSIVE EXPERIENCE

It seems to me, in a short course as you will be offering in Portland... there is one main thing you will accomplish, or attempt to accomplish – that is, show those interested that F.M.'s discovery has a practical, valuable side and can be most helpful to those who are willing to take the trouble to do a little individual thinking. It will start them on improvement for themselves, but will not give them anything to pass on to others. Later their own improvement may reflect in their occupation, whatever it may be.

—Marjorie Barstow, 1947[3]

In 1947, in the letter to Frank Pierce Jones quoted above, Barstow reveals her concern that the common practice and teaching of the AT was becoming something esoteric, obscure and irrelevant, a practice that passively and unquestioningly followed a set of teaching guidelines, a one-size fits all, with no requirement for creativity or original thinking.[4] Alexander's own process of discovery was about *thinking, observing and reasoning out* a new "means whereby" to a desired end or outcome. The means whereby that he developed was one that by-passed, and therefore overcame, the habitual psychophysical interferences that consistently led to his losing his voice on stage. When Alexander did not consciously think through the new pattern of behaviour he had devised for himself, and relied on habitual responses to desires, wishes or other stimuli, he described himself as "end-gaining." End-gaining means trying to gain the end without due attention to the means whereby that end might be reached. The end might be success, or applause from the audience, or whatever motivated and drove him to speak and recite well. After a great deal of experimentation, Alexander understood that he could never

1 THE PROBLEM WITH ALEXANDER'S TECHNIQUE 5

entirely rely on his senses to carry out the new pattern of thought and movement he had discovered (of interrupting his habitual pattern of throwing his head backward before he spoke), because – he thought – his senses were unreliable. What he meant by this was that his *habit* was so entrenched that it proved impossible for him to be able to overcome it by simply relying on sensations of what *felt* "right." It is easy to understand this point about habit in terms of "ingrained" or "hard-wired" feelings associated with actions we perform so frequently that they have become almost unconscious. The patterns of movement to which we are habituated feel "right" because we are used to them, rather than because they are the most efficient or effective movements to undertake in a given situation. And it was precisely what was *habitual* that he was trying to change. Alexander had come to *feel* it normal to throw his head back when reciting, although he was mostly unconscious of this habit and so it was impossible to change through trying to *feel* right or normal. One of the chief tenets of Alexander's writing was that our use should be governed by reason rather than by our senses. Alexander also maintained that once you were "right," you would no longer *care* whether you were "right." That is, you would no longer be relying on your senses to test out whether you were following the new, more effective means-whereby, so committed would you be to the process of thinking it through and following it step by step.

Yet it seems that Alexander dropped the requirement for reason and thinking when it came to teaching others about his technique. He seems to have found it a frustrating business teaching pupils the process of thinking constructively, of reasoning out a new "means whereby," and of relying on reasoning processes more than senses to change their patterns of movement and behaviour. Or did he think others were simply incapable of doing what he had managed to accomplish himself? Was the work of teaching the process simply too hard and slow, and, impatient to show pupils the value of his discovery, he began to prefer to do it *for* them? Lulie Westfeldt* recounts a story from the first London training course, which certainly suggests this. "Shortly after I had realized Alexander's ineptness with words," she recalls, "he came into the classroom one morning and said exultingly, 'I can get it now in spite of them'." He went on to explain that his hands were now "sufficiently skilled" to get the new head-neck-back pattern going without the pupil's help. She recalls that he spoke as if a great burden had been lifted from him, as if he were "freed from the frustrating struggle of trying to get the pupil to understand

6 A. COLE

him." Westfeldt concluded from this that "while he seemed to feel morally responsible for changing a pupil's condition, he did not feel responsible for communicating with the pupil or for giving him understanding."[5] This story is corroborated by Marjory Barlow, who explains it by saying that Alexander was "such a magician in the end because his hands were so skilful" and justifies it by saying that "he wasn't recommending that to us" but was "very excited to find he just put his hands on and away the pupil went – no problem."[6]

These accounts by Westfeldt and Barlow provide one of the greatest clues to the confusion that bedevils Alexander Technique pedagogy. In Westfeldt's account, Alexander reveals his decision to *take away* from the pupil the responsibility for change, to omit (and even forbid) any discussion about process, and act against his belief in rational thinking. That is, Alexander taught as if the sensory experience was "the god."[7] In the moment described by Westfeldt, Alexander seems to contradict the most fundamental principle and tenet of the technique – that we must give up relying on our senses and trust our reasoning process to act in a new and conscious way. He seems to assume that the Alexander Technique, *for others*, is a passive sensory experience, while, *for him*, it is an act of conscious reasoning. Barlow confirms the contradiction, saying, "That's not my idea of teaching, and it's not what makes the long-term changes in people. I would expect it to breed an over-reliance on the hands in the teacher, and an over-reliance on the teacher in the pupil. My job [as I learned it from him and as I saw him do it himself] is to teach people how to work on themselves."[8] Similarly, the ubiquitous use by Alexander teachers of the verb "to work *on*" (rather than "to work *with*") a student confirms this strange insistence by Alexander that the student is passive and should *receive* the AT rather than practise it. Carrington used this term in 1946, which seems to have come directly from Alexander but is contradictory to his insistence on rational thinking and conscious guidance.[9]

Paradoxically, Alexander was at this very time also writing his third book, *The Use of the Self (UOS)*, responding to a challenge from the American philosopher, John Dewey. While Dewey failed to get Alexander to cooperate with a scientific investigation into the AT, Alexander did finally consent to write a detailed account of the self-observations and experiments that had led to the discovery and formulation of his technique. This became, in 1932, the first section of *UOS*. The chapter is an exemplar of all the major steps that, according to Dewey, are characteristic of a

1 THE PROBLEM WITH ALEXANDER'S TECHNIQUE 7

scientific inquiry. The scientific process Alexander had applied in eliciting changes in his own behaviour was one of the things Dewey particularly admired about Alexander's work. Alexander describes in this chapter his revelation about reasoning and senses in this way:

> I now saw that if I was ever to succeed in making the changes in use I desired, I must subject the processes directing my use to a new experience, the experience, that is, of being dominated by reasoning instead of by feeling, particularly at the critical moment when the giving of directions merged into 'doing' for the gaining of the end I had decided upon. This meant that I must be prepared to carry on with any procedure I had reasoned out as best for my purpose, even though that procedure might feel wrong. In other words, *my trust in my reasoning processes to bring me safely to my 'end'* must be a genuine trust, not a half-trust needing the assurance of feeling right as well [emphasis added].[10]

At some point, however, Alexander seems to have decided that this process of reasoning was simply too hard, or too slow, for his students to grasp. By not teaching them this process, choosing for his pupils instead a shortcut to the *feeling* that *might* accompany change, without teaching them how to implement the change on their own, he abdicated responsibility for teaching others what may have been his greatest discovery – that is, that we can change our behaviour through a process of observation, awareness and conscious decision making. But Alexander now de-emphasized what he himself had learned to trust (namely, thinking), and emphasised what he himself had learned to mistrust (reliance on sensation). Westfeldt even recalls Alexander's discouragement of her questions – and therefore her thinking – during the London training course. She claims that Alexander did not even answer her questions in class and that questions themselves were viewed "as symptoms of poor use."[11]

Westfeldt gives further evidence of Alexander's encouragement of the passivity of the pupil, noting that during his second prolonged American residency (due to World War II) many old pupils did not return to him for lessons. A number of them told her that it "boiled down to going to him for very expensive lessons and then there was nothing they could do about it themselves." As Westfeldt saw it, "they lost the benefits of his work more rapidly than if they did nothing,"[12] by which, perhaps, she meant that they were more confused about good use, and in a worse psychophysical state (trying desperately to reproduce the feelings they had experienced in lessons), than if they had had no lessons at

8 A. COLE

all. Her story bears out the central importance of clear thinking and self-observation in bringing about good coordination. And it was precisely this aspect of his work on coordination – clear thinking and a dependence on reasoning – that constituted the process that Alexander relied on for his own coordination and, curiously, that he neglected to teach those who came to him for lessons.

Other first-hand witnesses to Alexander's teaching confirm Westfeldt's reports of his increasing reliance on giving his pupils a passive (or purely physical) experience – that is, a sensation – of good use while he either worked in silence or chatted about unrelated matters. These reports support the claim that in his lessons Alexander did not ask his pupils to engage with him and learn, that he did not emphasize *thinking* as a part of the Alexander Technique, and that he taught either in silence or accompanied by unrelated chatter. One pupil, Ludovici,* was almost entirely put off at first by Alexander's "showmanship," which he described as "incessant inconsequential patter interrupted by irrelevant declamations of Byron and Shakespeare."[13] Erika Whittaker,* who trained at the same time as Barstow and Westfeldt, recalls that "F.M. did not talk much when he was teaching."[14] Another pupil (from the American school in Stow, another product of Alexander's WWII US residency) recalls, "while he moved around, he talked and entertained us. He talked about American food and American products [both of which he considered inferior] and he told jokes. His lessons were punctuated with an occasional 'There you are,' which was a sign of approval."[15] Judith Leibowitz,* who studied with him in the 1950s, said, "It's not that he was a great teacher; he'd talk about everything under the sun except the Alexander Technique but he gave me that marvellous experience."[16]

Barstow's view was that this kind of teaching was "the only type of teaching that has ever come from [Alexander's] famous and much talked-of 'technique'."[17] In a letter to Jones, she recalls her early lessons with Alexander as being "a pull, a push and a punch,[1] all of which was supposed to be wonderful because at the same time I repeated special words." In brackets she added, "I'm not trying to be funny, but it does sound rather amusing to read this."[18]

[1] Barstow never spoke in this way of either of the Alexander brothers in public, and her interviews later in life suggest that she had only praise for them. She even said that they did *not* pull or push people around (Stony Brook Congress Interview, 1986).

1 THE PROBLEM WITH ALEXANDER'S TECHNIQUE 9

By contrast, people tended to point to the constructive methods of F.M. Alexander's brother, Albert Redden (A.R.). Marjory Barlow, for example, emphasised how crucial A.R.'s teaching was to the trainees "because he was so insistent on 'thinking'."[19] Dewey, too, is reported to have told Jones that in many respects he got more from his lessons with A.R. than from the lessons he had from F.M.[20] As further evidence of the dearth of critical thinking in F.M.'s London training program I quote a letter from Barstow to Jones. Referring to a report from a trainee teacher at Ashley Place in London, Barstow wrote to Jones that she did not know who was giving the trainees "lots of most useful criticism," as the writer of the report claimed. "There is only one person in the early days who knew how to do that," continued Barstow, "and when he did it he always got into trouble for doing it. Am sure I am safe in saying there is no one there now who has developed the ability to do it. F.M. never did it, from a teaching point of view, and he is not going to start in at his good old age to reform his ways of teaching."[21] A.R. is probably the one person to whom Barstow refers. The letter was written in 1947, the year that A.R. died. A.R. had migrated to the US in 1934 because of a number of complaints made by trainees in London to F.M. in 1934 that A.R. "was not teaching the work."[22] It seems that when A.R. migrated to the US, the vital component of the Alexander Technique went with him – that of individual thinking. Ashley Place's loss was Barstow's gain. Barstow ultimately spent more time teaching alongside A.R. (from 1934 to 1942 in Boston and New York) than she had ever done with F.M.

As Westfeldt, Ludovici and Jones suggest, if Alexander taught increasingly in silence or while engaging in small talk, then the focus was *not* on getting students to think through the process in a way that was individual and specific to them, or on guiding their practice of observation, *even though* that practice is what Alexander himself had employed to change his own manner of use. Jeremy Chance describes lessons in this mode, noting the contradiction: "I did not really have to think about much at all," he recalls, "and I could still experience the wonderful changes. I developed the notion, collected from my reading, that the process of learning the technique for the present-day pupil is the direct opposite of the process used by Alexander in discovering it." That is, Chance observes, Alexander had developed an experience of good coordination from a true conscious understanding of it, while later generations of teachers – and their pupils – were to develop a conscious understanding of coordination from a solid experience of it.[23] After encountering Barstow,

10 A. COLE

however, Chance's teaching completely changed, because, as he recognized, she had developed a new way of teaching the AT that removed the confusion created by the mismatch between Alexander's method and pedagogy. Chance quickly saw that she was in the business of *educating* performers, of teaching them to be aware and self-reliant, and to think and act independently. She was not interested in pupils who wished to be fixed or treated.

From his first training in England in the 1970s, obviously influenced by F.M.'s teaching style and not A.R.'s, Chance picked up the habit of spending much of the lesson in silence or engaging in small talk. After explaining the basic concepts of the technique to students, he would look off into space, put his hands on them, and "desperately try to give them a glorious, unforgettable experience." He was sure that the experience "was the god."[24] His later training with Barstow made him aware that this kind of teaching had set his pupils off in that direction which he had heard many outsiders observe of Alexandrians, namely that some of us look "held and stiff."[25] Barstow found, from observing the effects of her own and others' teaching in this style, that such stiffness came from teaching which emphasized a passive experience. This kind of teaching often caused students to try to feel out, or recreate the feeling of, the results on their own. By contrast, Barstow believed that the way forward was to teach students to repeat the same steps of thinking, that is, those of the scientific process, rather than trying to reproduce the feeling of good use.

This is not to say that there is no place at all for giving students a passive experience of good use. Sometimes it is important to convince a performer of the value of learning a different approach by providing the shortcut. In appraising the work of a Feldenkrais practitioner, Dame Judi Dench says, for example: "It's quite the miracle. I barely felt Mark [Lacey] move me it was so gentle, and yet when I stood up I was moving and breathing twice as easily as when I lay down. I don't know what he did but it is perfectly brilliant."[26] Obviously, Dench is now convinced of the value of Lacey's work, and the passive experience has served its purpose. It is what happens next and long-term that is crucial.

If all lessons after this initial "ride" continue to give passive experiences without explanation, then Lacey's work qualifies as therapy rather than education. Barstow was quite caustic about people who wanted her to "fix" them. She was in the business of education, not therapy, and believed that performers benefit most when they learn to *think* critically

about how they move.[27] While they are not *averse* to the occasional "quick fix" (as Dench seems to be describing above), most artists *want* to be in charge of their minds and bodies and to understand – and be conscious of – their own growth and education as artists. For Barstow, educating performers meant teaching them to think, observe and move differently, rather than encouraging them to do nothing, or to "inhibit", as Alexander prescribed, and allow the teacher to do things for them. She believed – already in 1948 – that it was time for "younger people to take the initiative and go along with F.M.'s discovery as they see fit," and find something more constructive than Alexander's teaching methods.[28] "Somewhere in *Universal Constant*," wrote Barstow to Jones in another letter, "he calls it 'a technique of inhibition.' That seems a perfect definition of it, but I am more interested in constructive activity than 'learning how to stop.' It makes more sense to me."[29]

But many teachers have followed Alexander's example and some to the point of rejecting altogether the idea of the AT as education. One teacher, for example, describes his practice as "hands-on work," adding that he doesn't really consider it giving "lessons."[30] Barstow was scathing of this approach, frequently criticising the teaching that went on at Ashley Place[31] both in F.M.'s latter years and after his death, but acknowledging that at the time of her training, she liked it: "I went through the regime at Ashley Place and know it all too well. At that time I thought it was wonderful because changing conditions in me did make me feel good. But it has taken me many years to learn that that was not constructive thinking, that was not real progress."[32]

Barstow had more faith than Alexander and his Ashley Place followers in the ability of performers to take responsibility for their own learning and to think for themselves. Like Dewey, she rejected the "billiard ball" paradigm of education which sees learners as "passive, purely receptive, 'blank tablet' students, waiting to receive the proper impression from the instructor who is activity to their passivity."[33] There are a number of educational thinkers – both before and after Dewey – who rejected this kind of educational philosophy. Jane Addams,* for instance, whose ideas influenced Dewey, observed that "such scepticism regarding the possibilities of human nature ... results in equipping even the youngest children with the tools of reading and writing, but gives them no real participation in the industrial and social life with which they come in contact."[34] Dewey's ideas on this subject led to what is now widely referred in education circles as Constructivist Learning Theory, the basic idea of which is

that learning is an active, constructive process. Other proponents of this theory were Piaget, Bruner and Vygotsky. Much later, in the 1970s, Paulo Freire referred to the older teaching philosophy as the "banking concept of education," in which "knowledge is seen as a gift bestowed by those who consider themselves knowledgeable upon those whom they consider to know nothing."[35] By espousing the constructivist theory of learning, Marjorie Barstow was a pioneering educator and a long way ahead of her own teacher.

In true "billiard-ball" style, or the banking model of education, Alexander believed that his job was to imprint upon the student "the proper impression" of good use. The experience came, then, from outside the student. AT teachers who talk about working *on* people, rather than *with* people or rather than *teaching* people, reinforce this passivity of the student.[36] Alexander believed that the student would only learn proper use if he/she refused to do anything at all in response to a stimulus (i.e. "inhibited") and allowed the teacher to move him/her.

Barstow rejected the billiard ball and banking models of education. She wanted to empower her students through process, something which happens from within, and which is guided by conscious thought and awareness. She wanted both student and teacher to be active in the learning and teaching process. Barstow believed that no one yet knew how to teach the Alexander work.[37] By this she meant that the teacher must be always looking for better ways of teaching it. That is, the teacher must always be learning.

REINSTATING EDUCATION INTO THE AT: BARSTOW AND DEWEY

The American pragmatic philosopher John Dewey strongly advocated the benefits to education of the Alexander Technique, and Alexander himself called it education. But it was Barstow who took the educational aspects of the Alexander Technique to a new, "Deweyan" level. Barstow recognized that Alexander's lack of attention to pedagogy was creating an Alexander Technique that was more akin to therapy – or perhaps miseducation – than education.

In creating a new Alexander pedagogy, Barstow showed herself to be strikingly in alignment with the educational ideas of Dewey. Barstow

understood that experiences can be educative, mis-educative or non-educative, as Dewey described in *Democracy and Education* and *Experience and Education*. Barstow saw Alexander's teaching as falling under the latter two categories, miseducation and non-education. She believed that taking students "faster than their constructive thinking can follow what we are doing with our hands" gave students "wrong impressions."[38] Barstow did not exclude herself from having taught in this way. In response to a letter from Jones, who had enclosed a letter from Dewey, Barstow writes: "he [Dewey] touches on one point that I have been battling with all summer and that is – the pupil trying to keep the impression of lightness that he receives in lessons. I have much more to learn on that but up to date have come to several conclusions. First of all it is a wrong impression given to the pupil by bad teaching. I am just as guilty of that as anyone else."[39] Barstow might be forgiven for her bad teaching, however, having identified it as such and having set about changing the way she taught.

Like Dewey, Barstow saw the need for educators to aim for experiences that are more than immediately enjoyable (as opposed to simply giving students a "ride," a passive experience, or an impression of lightness), so that they promote the desire for further experiences. Barstow and Dewey both believed that educational experiences must have both continuity and interaction, which meant that the student's thinking must be constantly checked, both for continuity outside of lessons, and for interaction between teacher and pupil. As I have shown, verbal interaction *about* the technique was something Alexander did not simply neglect but actively discouraged, as Westfeldt's account suggests.

For Dewey and Barstow, educative experiences had to include reflection on the part of the student and lead to more knowledge, entertainment of ideas and better organisation of these ideas. They both firmly believed that a teacher's suggestion must be the *starting point only* of education, with the potential for growth and for the contribution from individual and group, and with learners seeing their role as active rather than passive. This contrasts strongly with Chance's description of the sensory experience – an experience "given" to the student by the teacher – being "the god." This view is also in stark opposition to impressions of other trainees, such as Alma Frank,* who saw Alexander as a kind of messiah, to be followed, obeyed and imitated verbatim. Barstow commented on this to Jones: "Why should she compare his teaching to that of Jesus? I see no connection whatever, unless she has become like

14 A. COLE

some at 16,[40] who believe he can do no wrong and everything he does and says is so."[41]

Finally, Barstow also recognized, as did Dewey, that past solutions to past problems do not necessarily solve present problems for every individual. Barstow could not, therefore, simply imitate Alexander's style of teaching without question. Like Dewey, she saw that difference must be acknowledged both amongst students and amongst teachers, and this in turn will necessitate that different styles of teaching and solutions to problems emerge. "My teaching has a touch of the Western breezes," she wrote to Jones in 1966, "which the English will never know and certainly not understand."[42]

Conclusion

In this chapter I have discussed how Alexander's teaching practice did not match the processes from which his technique was derived. I examined the teaching dilemma faced by AT teachers: whether to follow Alexander's example of independent self-awareness and discovery (and teach this in an independent and creative way) or to follow his example of teaching. This question must also be answered by performers who wish to learn the AT. Do you want to learn a new approach to movement and become independent with it or do you want to learn to inhibit your responses to stimuli and wait for a teacher to move you?

I also suggested that Barstow's constructive approach to the Alexander technique is most effective for performers who want the greatest self-awareness possible coupled with the ability to apply the Alexander technique independently to their art. In addition, I discussed the role of critical and clear thinking in applying the Alexander Technique to the performing arts. Finally, I outlined how, in contrast to Alexander, Barstow adapted her teaching in ways that align with Dewey's philosophy and make it relevant, practical and useful to performers.

In subsequent chapters I will revisit the confluence between Dewey's philosophy and Barstow's teaching, while looking more closely at Barstow's emphasis on process in several different ways. The first is to examine more closely her emphasis on thinking, and exactly how she changed the emphasis of her teaching from Alexander's procedures to teaching his process of discovery and awareness. I will examine closely how her teaching paradigm prioritises thinking rather than feeling, and

movement rather than procedures. Later chapters will include a discussion on Barstow's reconstruction of Alexander's language, her insistence on context and application, and her emphasis on community and communication. In order to provide a historical, social and philosophical context for these discussions, however, I first outline in the next chapter what I call Barstow's constellation.

CHAPTER 2

Marjorie Barstow's Constellation

In the last chapter I discussed a major problem with Alexander's technique, examining differences between the way Alexander taught, giving students a passive experience of the changes his work can bring, and the way Barstow taught, which placed a greater emphasis on education. As I explained, Barstow's work also aligned with John Dewey's ideas about the greater potential for the AT. In this chapter I situate Barstow in a philosophical constellation, giving the wider context of her thinking. In particular, I explain how her work was influenced by F.M. and A.R. Alexander and Irene Tasker and was aligned with the thinking of John Dewey and Frank Pierce Jones. The linking theme for this discussion is that of philosophical pragmatism, the principal features of which I also outline here.

WHAT IS A PHILOSOPHICAL CONSTELLATION?

In order to connect the work of Barstow, Jones and Dewey, I borrow an approach from philosophy, called constellation research. The idea of a philosophical constellation comes from the work of Dieter Henrich (1927–) in the context of German philosophy to connect seemingly disparate strands of thought around a common set of problems and issues. Henrich called it *Konstellationsforschung* (constellation research). His aim was to offer a wider understanding of a period than was possible by

© The Author(s), under exclusive license to Springer Nature
Singapore Pte Ltd. 2022
A. Cole, *Marjorie Barstow and the Alexander Technique*,
https://doi.org/10.1007/978-981-16-5256-1_2

17

surveying the life and works of a single philosopher. In order, for example, to understand Kant and Hegel and the period in which they lived and worked, he saw that it was necessary to recover, reconstruct and analyse the whole *Denkraum*, the "intellectual and conceptual space and force field, its problem situations and its developmental logic and potential."[1] In other words, a *Denkraum* is an environment within which ideas are developed and carried forward in conversation. As Freundlieb says, "the history of philosophy can only give us an insight into a period if it is aware of the developmental potential of a *Denkraum*."[2] The work of an individual cannot be adequately understood unless it is analysed within the context of the larger *Denkraum*. That individual's work is always in some ways a response to the problems and the semantic and logical potential that is made possible (as well as being constrained) by the force field.[3] Mulsow and Stamm describe this kind of research as having "reconstructed philosophical developments in a detail that is unparalleled. By creating these reconstructions between great figures and systems, *Konstellationsforschung* seeks out missing links in a forensic manner, that is, hidden pathways and mutual influences at the intersection of large systems and formations.[4]

The "*Denkraum*" I examine in this book is that of the Alexander Technique and its teaching from the 1920s to the 1970s, in the centre of which I place Marjorie Barstow. Like Mulsow and Stamm, I seek out missing links, hidden pathways and mutual influences in describing and analysing her work, investigating it in the context of philosophical pragmatism and education philosophy, and *as* performing arts education.

Barstow's detractors have argued that she neither taught the Alexander Technique nor trained teachers. This was because her teaching and teacher-training methods varied from Alexander's teaching style. Barstow has also often been underestimated, and the importance and depth of her thinking about the technique and its pedagogy overlooked. One American AT teacher exclaimed incredulously, in response to the premise of my research, that "Marj was no philosopher!" It is these views of Barstow that I challenge in my presentation of her work. Such opinions assume a limited and even tendentious approach to interpreting Alexander's legacy, as well as a limited idea of what philosophy is and, indeed, what American philosopher John Dewey thought it should be. I examine Barstow's work in relation to the "pragmatic" turn in philosophy observable in the thought of Dewey, who involved himself directly with the Alexander

Technique and its founder. One of the keystones of philosophical pragmatism is the emphasis on critical thinking, something at which Barstow excelled. This was just one of the many aspects of philosophical pragmatism that Barstow embraced, as I will show. Drawing on several sources, including her decades-long correspondence with Frank Pierce Jones, I consider Barstow, Jones, Dewey and F.M. Alexander for the first time as educationalists, practitioners and thinkers who are linked by a common concern with the pragmatic ends of philosophy.

I show that Barstow's interpretation of the Alexander Technique *evolved* from the philosophy and methods of the originator of the Alexander Technique and that this evolution is entirely in keeping with the originator's stated aims, even if the teaching methods may look different on the surface. Alexander's work itself shows many aspects of pragmatism. It is these that Barstow particularly emphasized. I also highlight how Barstow's pedagogy aligns with many aspects of Dewey's philosophy and in fact influenced Jones, who was also aligned with Dewey on the questions of education and the Alexander Technique.

THE CONSTELLATION

I have created a timeline of Marjorie Barstow's constellation, as well as a diagram (Figs. 2.1 and 2.2), as a graphic organisation of the complexity of the interactions, both direct and indirect, of six people. Around Barstow, whom I have placed in the centre, are F.M. and A.R. Alexander, John Dewey, Irene Tasker* and Frank Pierce Jones. In the constellation diagram (Fig. 2.1) it can be seen that Barstow has the largest number of direct influences. I do not suggest that this is comprehensive or the only way of viewing the Alexander-education-philosophy *Denkraum* or pattern of influences. Other ways to depict it would be to put Jones or Dewey or Alexander at the centre. They might also include other teachers and thinkers. But since my aim is to show the links between Dewey and Barstow in the area of the Alexander Technique and education, it is necessarily selective, while still accurate.

Following is my attempt to describe in a linear narrative the constellation and its web of non-linear philosophically pragmatic interconnections.

20 A. COLE

Fig. 2.1 Barstow's constellation

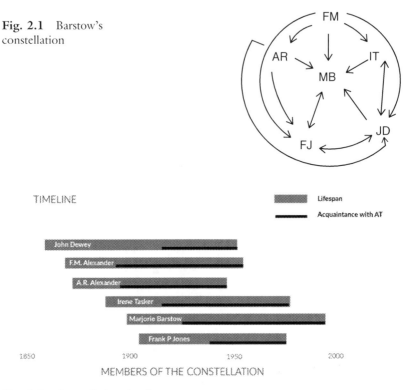

Fig. 2.2 Constellation timeline

F. M. Alexander 1869–1955

F. M. Alexander made his major discoveries about behaviour, movement, habits and thinking in his early twenties, the early 1890s. His process as recorded in *The Use of Self (UOS)* shows him closely following the steps of the scientific process. This is described in detail in Chapter 3. There were several aspects of philosophical pragmatism in his work, but the greatest was his application of the scientific process to solving his problem. He evolved his technique in Australia and England at almost exactly the same time that philosophical pragmatism was emerging in the US. Before examining Alexander's pragmatism (see the heading Alexander's Pragmatism, below), I will give a brief outline of philosophical pragmatism and Dewey's role in its evolution.

Philosophical Pragmatism, John Dewey (1859–1952) and the Alexander Technique

Pragmatism was a school of thought that emerged primarily from the writings of Dewey and two other American thinkers, Charles Sanders Peirce,* natural scientist and philosopher, and William James,* psychologist and philosopher. "Pragmatic" in the philosophical sense does not mean simply "convenient" or "practical" as it does in everyday language, but rather "tested by consequences rather than antecedents."[5] Foucault, Derrida and Rorty are included in the timeline (Fig. 2.2) because of the connection between deconstructionism and pragmatism. Dewey was "already a deconstructionist of sorts in the 1920s, says Boisvert," long before "deconstructionism" became "the latest European fashion to influence American intellectuals" in the 1980s.[6] Rorty also puts pragmatists far ahead of his contemporaries. "On my view," he wrote in the 1970s, "James and Dewey were not only waiting at the end of the dialectical road which analytical philosophy travelled, but are waiting at the end of the road which, for example, Foucault and Derrida are currently travelling"[7] (See pragmatist timeline, Fig. 2.3).

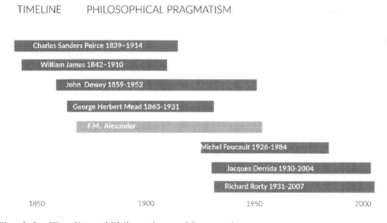

Fig. 2.3 Timeline of Philosophers of Pragmatism

Pragmatism was the first philosophical "school" to emerge in North America. It was also, as Rescher observes, the first original contribution to an intellectual tradition that was dominated initially by theology

and later by British empiricism and German idealism.[8] The characteristic idea of philosophical pragmatism is that efficacy in practical application – the question of "what works out most effectively" – somehow provides a standard for the determination of truth in the case of statements, rightness in the case of actions, and value in the case of appraisals.[9] Pragmatism emerged in the North American context, but the pragmatists were deeply influenced by European philosophers, especially Kant and Hegel. Pragmatism's roots lie, therefore, in the Western philosophical tradition. One major departure from this tradition, however, was the belief that in one way or another philosophy should take into account the methods and insights of modern science, since those too are developed from consequences in the broadest sense.

There are a number of ideas common to pragmatists. First, they rejected Cartesian thought and the separation of mind and body (and here is just one of the main reasons Dewey was drawn to the work of Alexander). Second, pragmatists took a functional view of thought, which means that thinking was not to be done for its own sake, but in order to deal with the problems of human experience. Thought should always be closely interwoven with action. Third, knowledge was seen as fallible and provisional, meaning that we can never be completely certain about our knowledge. This is because we can never be certain that the patterns of action that we have developed in the past will be appropriate for the problems we will encounter in the future. The plasticity of the world was recognized by pragmatists and they saw the universe as being forever "in the making." It follows from this point that thinking, too, is incapable of absolute fixity or absolute certainty. That is, pragmatism states that thinking is merely representative. It follows, further, that particular conclusions of inquiry must be regarded as provisional, hence incapable of yielding stability and continuity over time.

Pragmatists also prized the intellectual method, meaning that they stressed the processes of critical thinking and scientific method in philosophy, and wished to prioritise method and procedure over doctrine. But science was not immune to their deconstruction, and their new way of approaching science was with a view to social improvement. They stressed the experimental conception of science based on the centrality of the hypothetico-deductive method of scientific procedure.

I focus on John Dewey over other pragmatists because of his direct connection with the Alexander Technique. Dewey was one of America's most important public thinkers from the turn of the twentieth century

to World War II and was perhaps the last American philosopher to have had a major impact on society.[10] I will briefly outline some of Dewey's prominent views below.

Dewey made a point of reconstructing philosophy so that it would deal with the "problems of men" (the name of a book Dewey published in 1946)[11] and would not be abstract, or exclusively for philosophers. Along with this, he stressed the importance of action to knowledge, which meant that knowledge had to be experimented with and applied to daily life before being accepted. Dewey's views – and his interest in all people, not just philosophers – meant that he was necessarily interested in the nature of education and how it could be improved in practice. He saw growth as the goal of education, and his views on education and democracy were inextricably linked. The cultivation of intelligence under conditions of freedom is "at once, for Dewey, the fundamental imperative of democracy and the main task of education."[12] For Dewey, democracy was a way of life, and he believed that all enquiry should be carried out in a social context; not in an ivory tower.

All of these features of Dewey's philosophy are also features of Barstow's pedagogy, even if it is not immediately obvious how they might transfer from philosophy to pedagogy. I will explain this in ensuing chapters. I draw links between Dewey's reconstruction of philosophy and Barstow's reconstruction of Alexander-Technique pedagogy (Chapter 4). Barstow's reconstruction, with its emphasis on application, is also related to Dewey's emphasis on action in knowledge (see Chapter 5). Dewey's interest in the practical improvement of education is mirrored in Barstow's practical improvement of how to teach the Alexander Technique, especially to performers, and her emphasis on independence and self-sufficiency echoes Dewey's belief in growth as the goal of education (Parts II and III). Chapter 3 introduces Barstow's critical thinking under the banner of Making Ideas Clear and Chapter 6 focusses on the democratic aspects and social context of Barstow's teaching and classes, in line with Dewey's views about the social context of enquiry and democracy and education.

Dewey studied intermittently with F.M. Alexander from 1916 to the mid 1930s, and then with A.R. Alexander from 1935 to 1941. He and his family also studied with Irene Tasker. At the end of his life, after both A.R. and F.M. had left the US, Dewey also had lessons from Frank Pierce Jones.[13] Dewey allowed his personal experience of Alexander's work to influence his ideas. He found in Alexander's discoveries what Frank Pierce

Jones describes as "a kind of laboratory demonstration of principles that he had arrived at by reasoning."[14] Of the concepts Alexander described, those that had theoretical validity for Dewey were "the aesthetic quality of all experience, the unity of conscious and unconscious, the continuity between self and environment, the operational significance of inhibition, and the indivisibility of time and space."[15] Jones notes, however, that it was "the concrete, sensory evidence" that lessons in the Alexander Technique supplied which gave those concepts "a solid grounding in experience."[16] Dewey was also certain that he owed his longevity, health and well-being to his lessons in the technique. But he also had reservations about Alexander and his work, as he expressed to Frank Jones.[17] He disagreed with Alexander's choice of the *word* for inhibition. He even "undertook a long railway journey specially to warn [Alexander] about it,[18] concerned that the word "inhibition" would cause confusion in the climate of psychoanalytic opinion.[19] Dewey was also extremely disappointed in Alexander's refusal to cooperate with the research project into the technique, for which Dewey had secured funding. Relations between the two were strained from then on.[20] Alexander's lack of cooperation appeared to Dewey to fly in the face of his (Alexander's) willingness to apply the scientific method to his technique.

Proponents of the Alexander Technique often cite Dewey's support for Alexander's work and the influence of Alexander's work on Dewey's thought.[21] Eric McCormack* wrote a doctoral thesis on the connections between the works of Dewey and Alexander.[22] He concluded that "what you find in John Dewey after he met Alexander, you also find in John Dewey before he met him," and suggested that Alexander's principal contribution to Dewey's work was in helping him tie certain ideas together, rather than offering anything completely new.

There has been little interest in Dewey's influence on Alexander. McCormack is one of the few who attempted to clarify the extent of this. He had the benefit of being able to contact many of Alexander's contemporaries, including Margaret Naumburg,* Wilfred Barlow* and Frank Jones, who confirmed that Alexander paid little attention to anyone's ideas but his own. Specifically, Jones suggested that Alexander learned little from Dewey.[23] Equally scarce is any discussion in the literature about the importance of Dewey's ideas for *interpreting* the Alexander Technique or about the application of Dewey's ideas on education to *teaching* the technique. The impact of Dewey on the practice and teaching of the

Alexander Technique is therefore largely unexplored and is my focus in creating this constellation with Dewey, Jones and Barstow.

Having explained Dewey's connection with the Alexander Technique and outlined how the pragmatic turn was developing in the field of philosophy, I will now return to Alexander and his pragmatism and the possible influence that the pragmatists had on his work.

In his second book, *Constructive Conscious Control of the Individual (CCC)*, published in 1923, Alexander acknowledges the help Dewey gave him with his writing.[24] This indicates Alexander's willingness to accept input from Dewey. This is a direction of influence that is not widely recognized. Dewey's name is more often used to give credence to the AT, and he is described merely as an advocate for, or beneficiary of, Alexander's work, rather than an eminent scholar who helped Alexander. Given the confluence of many of their ideas, Alexander's regard for Dewey and Dewey's superior ability to communicate ideas, it is curious that the Alexander community turns so infrequently to Dewey's writing for guidance in teaching and thinking about the technique.

In this section I have situated John Dewey in the fields of philosophy (and pragmatism in particular), education and the Alexander Technique. I now return to the discussion of Alexander himself as a pragmatist.

Alexander's Pragmatism

The Nature of Alexander's Work and Connection with Philosophy
In his doctoral dissertation Terry Fitzgerald makes the link between pragmatism and Alexander, suggesting that Alexander himself was a critical pragmatist, pointing to his questioning of traditions, habits and beliefs: "Alexander, the 'revolutionary and heretic', was enough of a critical pragmatist to continuously question the process he was engaged in."[25] Fitzgerald's research focuses on teacher training and he argues for a continued pragmatic approach to this aspect of the technique.

In *CCC*, there are glimpses of Alexander's own philosophy in some of his few references to other thinkers. He dismisses Myers, for example, for his inductive reasoning and a priori method and warns that Trine's "New Thought" movement is "becoming rigid and involved in dogma, losing sight of its principle."[26] Here Alexander writes as a philosophical pragmatist. He highlights the importance of considering the mental and physical as "entirely interdependent" and, in his opinion, "even more closely knit than is implied by such a phrase."[27] Several sources

indicate that Alexander does seem to have been aware of the American philosophical school of pragmatism and acknowledges his interest in James's philosophy.[28] Horace Kallen claims that "Alexander got his idea" by reading James, then "seemed to have forgotten about James and used the formula 'ideomotor attitude,'" which he had picked up from James's *Psychology*.[29] Maisel claims that Alexander "ardently applauded what James said about 'ideo-motor function' – that is, the dynamics of conscious attitude and image in giving shape and direction to posture, and movement to the muscles of the body. As early as 1908...he was using James's concept and term in his writing."[30] As already mentioned, Dewey validated the pragmatism of Alexander's work to the extent that it gave him "a kind of laboratory demonstration of principles that he had arrived at by reasoning," amongst other things the unity of conscious and unconscious, the continuity between self and environment, the operational significance of inhibition (although Dewey had reservations about this word), and the indivisibility of time and space.[31]

Scientific Method

Dewey repeatedly pointed out that Alexander's work was scientific in regard to process. In his introduction to Alexander's book *CCC*, Dewey claimed that he would stake himself upon the fact that Alexander had applied "to our ideas and beliefs about ourselves and about our acts exactly the same method of experimentation and of production of new sensory observations, as tests and means of developing thought, that have been the source of all progress in the physical sciences."[32] Dewey defines "scientific" as using "a principle at work in effecting definite and verifiable consequences," describing Alexander's teaching as "scientific in the strictest sense of the word" and Alexander's "plan" as satisfying "the most exacting demands of scientific method."[33] In his introduction to Alexander's *UOS*, he says that personally, he "cannot speak with too much admiration – in the original sense of wonder as well as the sense of respect – of the persistence and thoroughness" with which Alexander's experiments were carried out.[34]

With respect purely to method, that is, his process of questioning, observing, experimenting and revising his original ideas, Alexander can be said to be a Peircean kind of pragmatist. Charles Peirce limited his philosophy to that of scientific and so-called "objective" methods, while Dewey, expanding the psychological but individualistic interests of James, included social, communal and political processes, such as education,

democracy and art. While Alexander's interests ran to such issues as well, and are frequently discussed in his books, his *method* was at its most critically pragmatic when he made his discoveries about "use" and functioning.

Upon Dewey's urging, Alexander consented "to write a detailed account of the self-observations and experiments that had led up to the discovery and perfection of his technique."[35] This account became the first chapter of *UOS* in 1932, and is entitled "The evolution of a technique." It is this series of steps and Alexander's final conclusion – that use determines functioning – which can be demonstrated so anyone who wishes can *know* it. According to Dewey, it is upon this point that the genuinely scientific character of Alexander's teaching rests. While Alexander told the story of how he went about solving his vocal problems, he did not himself analyse his *scientific approach*. He broke down his ultimate plan for coordinated use and functioning, and went into great detail about the development, pitfalls, successes and changes of tack along the way, but he did not set out or review his investigative process. Significantly, it was Dewey who made this link to the scientific process and to pragmatism.

Approach to Teaching and Training

Even after he began teaching his technique, Alexander continued to apply a process that could be considered critically pragmatic. He started with a problem and an idea that is based on observation, and then devised an experiment to test the idea. He gathered information about the idea through experimentation, and then revised the ideas about the source of his difficulties. Alexander continued to do this throughout his life, whether in relation to his own use, his teaching, or training teachers. He claims, in a letter to Barstow in 1950, that in recent years, they had "gone far ahead" at Ashley Place.[36] Initially the experimentation pertained only to his own use. When he began teaching the work, he experimented again. Maisel claims that both Alexander brothers taught by verbal instruction alone when they began teaching in London. He describes the two brothers as being at opposite ends of the studio "shouting their disparate and desperate instructions at [their] victims,"[37] but this may be inaccurate. Marjory Barlow says that Alexander was definitely using his hands already when teaching in Australia before his departure for London.[38] According to Frank Pierce Jones, F.M. said that "in 1914 he was just beginning to find a new way of using his hands in teaching."[39] This was

28 A. COLE

ten years after F.M. had arrived in England and only four years after A.R. had followed. Finally, in regard to his method of training teachers, Alexander's neglect of his trainees may have been a deliberate attempt to force them to learn by apprenticeship, that is, by experimenting with and on one another, with only a little input from the Alexander brothers each day. On the other hand, it may have simply been a lack of forethought or preparation, or even the sign of some ambivalence about training others to teach his work.

There are descriptions of the first training course by several of the students. Consistently reported are: the lack of rules and regulations; Alexander's lack of organization, planning and structure; a necessity for independence, self-reliance and working with the other students; a sense of adventure; and an emphasis on observation, principle and experimenting. Erika Whittaker recalls Barstow, George Trevelyan* and herself as "the very first three, on the very first day."[40] "We all sat on the table swinging our legs, saying, 'Where is F.M.? What are we going to do?' F.M. took us into the other room and we had a chair each. And he said, 'I have never done this before. It's the first time for all of us. Let's see what happens.'[41] No rules and regulations. No time table. Nothing. There never was. Never."[42] While the complete lack of a plan is not so consistent with scientific method and critical pragmatism, Alexander did show certain qualities that could be recognized as critically pragmatic. These included his openness to seeing what happened (which approach could also be described as non-goal-directed research), his trust that the students could contribute to and take responsibility for their own learning, and his acknowledgement of being at the beginning of a learning process himself. Barstow was one of the few who expressed great satisfaction about the first training course,[43] and it seems that she later adopted many of Alexander's strategies of training people. Although Westfeldt lamented the lack of support, she did acknowledge that it forced them to become independent. Marjory Barlow (Alexander's niece) comments that "an awful lot of experimentation went on because we were pretty clueless."[44] So the spirit of the first training course certainly encouraged and developed the critical pragmatism of its students, whether Alexander intended this or not.

Limitations
While Alexander certainly exhibited some aspects of critical pragmatism, there were also significant limitations and aspects of his attitude to his

work that put him at odds with philosophers like Dewey. Terry Fitzgerald suggests that Dewey did not see Alexander as a pragmatist, quoting a letter from Dewey to Randolph Bourne: "Mr Alexander's book [the second edition (1918) of *Man's Supreme Inheritance (MSI)*, to which Dewey wrote the introduction] is not concerned with setting forth instrumental, pragmatic or evolutionary philosophy."[45] But to judge Alexander only by his writing and not by his actions is to miss one of the major points of pragmatism. Dewey was not necessarily claiming in this letter that Alexander was not a philosophical pragmatist, but rather that his book was not a work of pragmatic philosophy. Remember that the characteristic idea of philosophical pragmatism is that efficacy in practical application – the question of "what works out most effectively" – provides a standard for the determination of truth in the case of statements, rightness in the case of actions, and value in the case of appraisals.[46] This was precisely the idea to which Alexander subscribed when developing his theory about a central control of our coordination and when applying the rigorous steps to his process of discovery about his own behaviour and movement.

In suggesting that Alexander was not truly or fully a pragmatist in the technical sense of the word, however, Fitzgerald has a point. Aspects of Alexander's attitude and work that disqualify him from the pragmatic hall of fame include: his unscientific wild claims, his reluctance to acknowledge the influence of others, his lack of cooperation in a research project for which Dewey had secured funding from the Rockefeller foundation, and his tendency to dismiss others (including scientists in general, and academics such as James and Dewey) as lesser beings needing his help, guidance and superior methods. As suggested, his tendency to neglect his trainees may have been a planned method of ensuring that they experiment and find their own way, *or* it may simply have been neglect.

Alexander was prone to making outlandish and unscientifically supported claims about the benefits of his technique. That is, he was inclined to severe bouts of unscientific subjectivism. His claim that the Alexander technique cured diseases such as tuberculosis and appendicitis is one example of such claims.[47] Another claim was, as Carrington reports in 1946 (apparently uncritically as a part of a dispassionate review of class that day) that "conscious direction could stop bleeding," and "certainly so with regard to haemorrhage of the lungs. One of the first cases that a doctor sent him [F.M. Alexander] in Australia was of this nature and it stopped in a few lessons and never recurred."[48] Carrington does

30 A. COLE

not report how it was ascertained either that the "case" had indeed been haemorrhaging, had stopped haemorrhaging or why the "case" was not in hospital (or a sanitorium for tuberculosis) but instead attending Alexander lessons at the time.

As mentioned above, Alexander refused to cooperate with the research project for which Dewey had secured funding from the Rockefeller Foundation. He also appears to have taken the phrase "ideomotor" from William James, but did not acknowledge this. In addition, when the opportunity to meet James fell through, Alexander's apparent regrets were only that he had not had the opportunity to help James, rather than that he had missed the chance of meeting one of America's greatest thinkers.

"Stupid" was a favourite epithet of Alexander's "for everyone and everything."[49] Carrington quotes Alexander as saying, for example, in answer to a query, that he had "never found any limit to the depths of human stupidity."[50] There is evidence to suggest that Alexander was a little disparaging even of Dewey and felt himself superior to the philosopher. The story Alexander tells in CCC of "a pupil of mine, an author"[51] is "surely that of Dewey," says Murray.[52] Alexander's attitude towards the pupil is more like what one might expect towards a recalcitrant child. If it is indeed Dewey, it is a questionable attitude to such a loyal and eminent supporter of Alexander's work. "In response to my inquiries," wrote Alexander recounting one lesson," the student (Dewey) "admitted that he'd been indulging in his literary work that morning from 9 until 1 without a break, in spite of my express stipulation that he must make frequent breaks. I pointed out to him that if he'd been continuing his work for four hours without a break we couldn't be surprised at the unfortunate result."[53] Alexander also described his eminent colleague in a flippant way: "'Oh, Dewey was a bad pupil, as he'll tell you himself. He had many lessons. But it saved him. He's an old boy of 89 or 90 now. When first he came to me, in 1914 or 15, he was like this' – [Alexander stooped over and shook his hands nervously]."[54] In a letter to Walter Carrington in 1943, Alexander wrote disparagingly of proposed investigations into his work "by academic gentlemen with big names but small brains and psychophysical make-ups."[55]

In discussing science, scientific method and the procedure of this work, Carrington quotes Alexander as having "agreed the following statement": "Scientists carry out a large number of experiments to establish certain specific facts and at the end of the process they vaguely perceive some

2 MARJORIE BARSTOW'S CONSTELLATION 31

general principle involved. We take a principle and apply it. This supplies to its own operational verification in process but also leads to the establishment of certain specific facts in course of the process."[56] It seems that no one was game to challenge Alexander on the method by which he deduced or established his "facts."

Alexander never granted anyone permission to train teachers (and I discuss this further below, under the heading "Frank Pierce Jones"). He also continually vetoed the formation of a professional society for Alexander teachers. The degree of his mistrust of and lack of confidence in current and future AT teachers is further evidence of his unwillingness to consider others as equals or as part of a community of investigators, as a true philsophical pragmatist would.

Barstow, Jones and Dewey voiced their estimation of the limitations of Alexander's pragmatism in writing, even if they did not use those precise words. These are outlined in the following paragraphs.

In 1947, Barstow wrote to Jones that it would always be a puzzle to her why "F.M. and A.R. allowed so much stiffness to develop in their pupils and never seemed too troubled about it. F.M. much less so than A.R." She points to their tendency, as described, to refuse input from, or any exchange of ideas with, others, something that was so central to Dewey's philosophy. "It must have been partly due to the fact that they isolated themselves so from the rest of the world. As I look back they did live in a little world of their own always doing exactly as they wished, and those who disagreed were pushed out. Always being the center of praise and never being jolted out of it does do strange things to people. It is easy to get used to certain things and accept them, many times it is the easiest way out. Even so it all is a curious situation."[57] In 1950, after writing to F.M. in support of Frank Jones, she seems to have been exasperated with F.M.'s response and saw it as a major limitation – and even defect – of his work. As already quoted, she wrote to Jones, "Being so upset by all of the 'vandals' you would think he would be delighted to know of one or two people who were getting on, but no, not dear old F.M. It just ain't in his blood and he has not been willing to cultivate it, even though his technique is supposed to do that.[58]

Jones, in a letter to Dewey, earlier that same year (1947), had expressed his alarm about "the view that the teaching technique has been perfected." He offers the counter view that the "whole thing is in an experimental stage" and that he expects his own teaching will always remain so. He expresses his wish to Dewey for even a "very modest grant"

32 A. COLE

to be able to "do the kind of work that would help establish F.M.'s principle on a firmer basis" and his concern, if he did not secure this quickly, about the "great danger of the whole thing degenerating into a cult" as Dewey's "English correspondent" had suggested.[59] A pragmatist himself, Jones aimed to make some ideas clear in his writing but found this particularly difficult due to the *lack* of clarity of the Alexanders. "My chief problem in writing my last article," he wrote to Dewey, "has been to clarify some of my fundamental ideas about F.M.'s work. Neither F.M.'s books nor his explanations in lessons gave me all that I needed. A.R. was more helpful but both of them left me somewhat bewildered and I have been forced to work the thing out for myself. In that task I found your phrase 'thinking in activity' more useful than anything else."[60] Jones, then, turned to Dewey for clarification of Alexander's concepts, rejecting F.M.'s words "inhibition" and "orders," both of which he considered "misleading."

In a letter Dewey wrote to Jones, he described himself as being "practically stymied" in his attempt to secure funding for a scientific investigation into the AT. He described Alexander's violent reaction to his work being investigated and Alexander's extreme aversion to any study Dewey had had a hand in helping to organise. "Alexander turned it down hard, so hard that [the director of the Macy Foundation] stopped going to Alexander" for lessons. Dewey also saw Alexander's aversion to the United States as extreme. "If he hadn't been so down on this country – or so devoted to England – and had stayed here, he might have reached someone with money and influence as he has, apparently, got someone to finance his school in England where he also has the backing of influential medical men." Despite Alexander's rejection of Dewey's help, Dewey still agreed with Jones "about the importance of the Alexander method and what it accomplishes – having living proof in myself at 87 – and in the importance of scientific investigation."[61]

In summary, Alexander certainly showed some aspects of pragmatism in his work, and yet he was the most limited pragmatist of the constellation, not least because of his refusal to *share* the process of inquiry with his intellectual equals (and superiors). He demonstrated this limitation many times throughout his life. Perhaps this resistance was driven by his conviction of his own superiority and unwillingness to acknowledge the value and influence of other thinkers, observers and practitioners, or perhaps simply by a lack of confidence that what he had discovered

2 MARJORIE BARSTOW'S CONSTELLATION 33

was robust enough to withstand scientific scrutiny, deconstruction and reconstruction.

A. R. Alexander (1873–1947) and His Pragmatism

> *Be patient, stick to principle, and it will all open up like a great cauliflower*
> —A. R. Alexander[62]

There were two aspects of A.R. Alexander's formation as a teacher that differed greatly from his his brother's. They were his haphazard training, which was interspersed with travel, war and fortune seeking, and a number of serious injuries and illnesses. In this section I will briefly outline major events in A.R.'s life that pertain to the Alexander Technique, highlighting his pragmatism and reports of his fine teaching, and reminding the reader of his interaction with other members of the constellation.

Biographical Sketch

At the age of sixteen, as his brother was settling in Melbourne, in 1889, A.R. Alexander went to Kalgoorlie to seek his fortune in gold. He returned to Tasmania unsuccessful and recovering from typhoid.[63] This left him with badly impaired vision for the rest of his life.[64] A few years later (in 1896),[65] he moved to Melbourne to help F.M. teach. When F.M. left Melbourne in 1900 for Sydney, he left A.R. in charge of his Melbourne practice. Still restless, however, and keen to travel the world, A.R. took off soon after, in 1901, to fight in the Boer War. He declared himself a "stockman," making no mention of his teaching.[66] A.R. again narrowly avoided death and permanent injury, returning to Melbourne just over a year later in April 1902. Amy Alexander* had continued the Melbourne teaching practice, making regular visits to Sydney to keep up with F.M.'s developing teaching methods,[67] and A.R. soon joined her on these.[68] In January 1903 A.R. opened his own school of physical culture in which he and Amy taught their brother's methods supplemented by the Delsarte System of Expression (after François Delsarte whose method influenced acting, declamation and dance) and the Sandow system (after the German pioneering bodybuilder, Eugen Sandow, born Friedrich Müller). By early 1904, their advertisements had phased out all references to the latter two systems and focussed entirely on their brother's work.

F.M. left Australia for London in 1904, sending instructions to his siblings at weekly intervals, which included a recommendation that A.R. study anatomy and physiology.[69] This marks another significant difference in A.R.'s training and expertise – there is no evidence that F.M. ever acquired this scientific knowledge, whereas his brother complied with the advice and hired a private tutor. By the time he left Melbourne in 1910 A.R. Alexander was a respected teacher in his own right.[70]

In 1917[71] or early 1918[72] A.R. Alexander suffered a severe spinal injury while horse riding and was told by doctors that he would never walk again. Contrary to their predictions, he recovered to the point of being able to walk with a cane and occasionally without it. After several decades teaching in both England and the U.S., including eight years working with Marjorie Barstow assisting him, and several years running the US teacher-training program, through which Frank Jones was qualified to teach, A.R. had a stroke in 1944. When he next attempted to return from England after his annual summer trip he was denied entry due to ill health. He died in England in 1947.

Physical Necessity and Pragmatism

Events in A.R.'s life made it necessary for him to learn and apply the Alexander Technique in ways that differed from the ways F.M. created and applied it. First, he learned the technique from observing his brother teach, rather than through self-observation. During his convalescence in 1918 he had an intense period in London during which he put the technique to the test: he eventually did learn to walk again, at first with two canes, and later with one. Barstow claims that around his home he did not need the cane at all.[73] The main effect on his teaching was that he now taught sitting down instead of standing. This intense period of convalescence gave him experience in applying the technique to *movement*, which F.M. did not have until decades later when he overcame some of the paralysing effects of a stroke.

Perhaps because A.R. had to keep applying the technique on a daily basis *just to get by*, his thinking about practising it and teaching became clearer than that of his brother. Once he had solved his vocal problems, F.M. gave up the professional goal that had driven him to his discoveries, and he no longer had the physical and psychological need to overcome a physical handicap.

Teaching

By many accounts A.R. Alexander was one of the greatest Alexander teachers of his time. The Alexanders' niece, Marjory Barlow, for example, described him as one of the greatest teachers.[74] "F.M. was the genius who discovered the work," said Barstow, "but A.R. was the teacher who knew how to teach."[75] She draws attention to the keenness of his observations, which were "very sharp."[76] Jones described A.R. as having "more understanding of the problems involved in learning" because he was not the discoverer but had to be taught the technique.[77] He contrasts F.M., and his lack of communication in teaching, with A.R., who "was always stopping a pupil and telling him he was 'feeling, not thinking,' by which he meant that the pupil had become either stiff or heavy and was not responding to the direction of his hands. It was very easy in a lesson to let your mind wander and be unaware of what was going on, but A.R. never let you get away with this for very long."[78] Dewey told Jones that in many respects he got more from his lessons with A.R. than from those with the older brother.[79] According to Jones, A.R. made little use of the "procedures" except for demonstration purposes. His emphasis was on thinking, and "the instant [a pupil] stopped thinking... it would be detected at once."[80] Marjory Barlow concurs, saying that A.R. was "very tough – very kind, but very tough on the thinking side... He was very meticulous about that."[81] Finally, A.R. was also the teacher in whom F.M. Alexander showed the greatest confidence (even after arranging for him to leave the UK training course and the country). He was the only teacher F.M. ever allowed to train other teachers. A.R. alone signed Jones's teaching certificate.[82] Weed claims that although F.M. expressed reservations about all of the teachers who remained in London, "he never lost faith or trust in A.R. and his work."[83]

To summarise, it seems that A.R. Alexander emphasized different aspects of the AT and taught quite differently from his brother. I suggest, in fact, that A.R. was the first to *accentuate* the pragmatic aspects of the AT and to highlight these in his teaching. A.R. had close connections with Dewey, Jones and Barstow. He taught Dewey in the years between 1934 and 1942, he worked closely with Barstow during these same years, and he was principally in charge of Jones's training. Dewey, Jones and Barstow all shared A.R.'s propensity for experimentation and his emphasis on the importance of critical thinking as a fundamental part of the technique. William Conable suggests the same. In an interview with me, Conable said that his view was that the people for whom A.R. was an important

influence "were the most flexible, interesting, exploratory and imaginative Alexander teachers of that first generation." In this group of teachers he includes Frank Jones, Marjorie Barstow and Buzz (Richard) Gummere. "I think it's true," he said, "but if you ask Marj, and I did ask her something like that, she was quite indignant and said 'Mr [F.M.] Alexander was the one.' That may be the case, but I'll stick by what I say... many of the ones who were closest to Alexander...I want to say this carefully...were *influenced* by his personality." Contrary to what she told Conable, Barstow confirmed in a letter to Jones that there was after all some basis to the hypothesis. In 1970 she wrote to him: "Am sure [that] what you say about awareness is very true with all the teachers. The lack of this creates a great problem in teaching. A.R. taught me many things that F.M. did not bother about but this was due to the different personalities of the two men."

In this section I have looked at A.R. Alexander's pragmatism and compared it with that of F.M., suggesting that some of Barstow's approach may have developed under the influence of A.R.. Even before Barstow's long working relationship with A.R., however, there was another influence on her thinking about – and practice of – the Alexander Technique and its teaching, which may have encouraged her independent take on the work – the influence of Irene Tasker.

Irene Tasker (1887–1977)

Irene Tasker is important in the constellation because of her influence on Marjorie Barstow and because she studied with both Alexander and Dewey. She began lessons with Alexander in 1913 and became his assistant in 1917 in London. Before this, Tasker had had significant academic and educational training. After completing a Master of Arts at Cambridge University, she studied early childhood education with Maria Montessori in Rome. In 1918 she met the Deweys and travelled with them from Chicago to California for one of Dewey's lecture tours. Dewey was writing *Human Nature and Conduct* at the time, and Tasker discussed both this work and Alexander's work with him at length. She taught the Alexander Technique to several members of Dewey's family[84] and in 1924 her tutelage of a young boy in London evolved into her running Alexander's "Little School" (teaching AT to children). Barstow frequently assisted Tasker in the Little School during her own training and later acknowledged the influence that Tasker's application work had had on

her: "Observing the children made me see how valuable our whole coordination is in relation to any of our activities."[85] In 1953 Tasker was the only teacher Barstow recommended to a student who was travelling to England for the summer,[86] and in the 1980s she wrote to Erika Whittaker saying that she thought Irene Tasker had been of more value than they could realise at the time they were in training: "Now I appreciate what she did for me more and more."[87]

Marjorie Barstow (1899–1995)

Briefly recapping the important landmarks of Barstow's AT journey, I will highlight her connections with other members of the constellation. In November 1926 Marjorie Barstow and her sister Frances had daily lessons with F.M. and A.R. Alexander for six months. In May 1929 they made another trip. At this point Marjorie would have been 29 and her sister four years older. The two sisters again travelled together, arriving in Southampton on 1 June. They departed Liverpool eight weeks later on 26 July, arriving in Quebec on 2 August 1929. Whether this was for another course of Alexander lessons is not clear, but since Marjory Barlow recalls that Barstow had had "years of work" before starting training, and that "she and her sister used to come over from the States and work with FM,"[88] it was likely to have been another Alexander study trip. Barstow trained with the Alexanders for the next three years, during which time she was greatly influenced by Irene Tasker, especially during their work together in the Little School.[89] This was one indirect connection with the ideas of Dewey. Prior to this Barstow *may* have come across Dewey's ideas through her arts degree at the University of Nebraska, at which she worked for four years, from 1919 to 1922.[90] Since Dewey was already at that time regarded as one of America's most important public thinkers,[91] and we know that Barstow read widely,[92] it is highly likely that Barstow had come into contact with his ideas before she went to England, even if his work had not filtered through directly to the fields of physical education and English, which were her main study areas.[93]

Even if Barstow was not yet *au fait* with Dewey's ideas when she reached England in the 1930s for her training, she would certainly have been aware of his interaction with Alexander, since Alexander discussed this frequently and read excerpts aloud during training from the book Dewey had inspired him to write.[94] After her training, she worked for eight years with A.R. Alexander, from about 1934 to 1942.[95] It seems,

38 A. COLE

then, that Barstow spent more time as an apprentice to A.R. than she did learning directly from his brother, F.M. It is at this time that John Dewey took lessons from A.R.: between 1935 and 1941. Dewey told Frank Jones "that in many respects he got more from them than from the lessons he had from F.M."[96] and Barstow confirms that she met Dewey at this time. She later wished she had taken the opportunity to discuss the Alexander Technique with Dewey. Many years later, in an interview, she recalled:

> He had lessons for quite a few years with F.M., and then when A.R. came to Boston to teach he continued to study. I used to see him when he came in for his lessons, but I never sat down and chatted with him. I don't think I understood the whole procedure well enough at that time to do so [after more than ten years of study and experience of the Alexander Technique]. I can think of a lot of things now that I'd like to ask him and talk to him about. Dewey was the one who termed the constructive thinking, 'thinking in activity.'[97]

Barstow's correspondence with Frank Jones, from 1946 to 1975, reveals further connections with Dewey. First, she made many financial contributions to Jones's research projects, several of which he planned with Dewey's assistance. Jones wrote to Barstow about his research projects. Some were merely proposals and did not come to fruition, while others were fully carried out. Together they discussed the pros and cons of various approaches to researching the "primary control" mechanism, as well as any problems they might encounter with particular conditions posed by a proposal, a funding body, or groups of subjects (such as doctors, university departments or students). In Jones's letters Barstow learned Dewey's thoughts on various aspects of the Alexander Technique and Alexander's language. Jones also told her about Dewey's input into the research projects she and Jones had discussed and about Alexander's resistance to these. Barstow would reply, seconding Dewey's thoughts and suggesting further ideas of her own. Barstow also indicated that she had read Dewey's *Art as Experience* closely during her time in Boston. It was published in 1934 and she worked with A.R. Alexander in Boston and New York from 1934 to 1942. "I read 'Art as Experience' while in Boston," she wrote to Jones in 1948, "and liked many things in it, also remember reading parts of it to A.R. Those were the early days when he was a splendid teacher and we discussed many things about teaching."[98]

One of the chief things Barstow had in common with both Dewey and Frank Pierce Jones was her interest in scientific research and her recognition for the need for it in the field of the Alexander Technique. One of Dewey's greatest compliments to Alexander was that Alexander had applied the scientific process in discovering what he called "the primary control." This process was also one of the aspects of Alexander's work that Barstow most prized. She wished to continue the process in pursuit of improving both the understanding and the teaching of the AT: "My interest in the work," she wrote to Jones in 1946, "is not to sit and give lessons year after year as the Alexanders have done, but to develop the work on an educational basis so it can be recognized and accepted as a *true* new field of science and education." She recognized that to accomplish this would require an experimental research project of some kind, "and that is what I have been working toward these last few years. My progress has been slow because first I had to learn by myself the practical meaning of the primary control and all it connotes. Second I had to find a way to pass such information on in as simplified a form as I realized I had acquired it. Working individually and also with groups gave me a variety of experiences."[99]

Frank Pierce Jones (1905–1979)

Jones was the first of only a handful of people who graduated from the U.S. Alexander teacher training course. He began his training in 1941, during the war, while F.M. was still at the Whitney Homestead in Stow, Massachusetts. At this point, Jones was the only member of the training course. He went on to become one of the first researchers into the mechanism of what Alexander called the "primary control." A professor of classics at Brown University (his dissertation was on Greek participles), he was an unlikely candidate for the role of scientific researcher, which he ultimately became at Dewey's urging. It had also been at Dewey's urging that Jones began the training course.

Jones's certificate was signed in 1944 by A.R., as F.M. had returned to England by this time. Jones remained in contact with F.M., although it seems, from the Jones-Barstow correspondence, that despite Barstow's advocacy for Jones in letters she wrote to Alexander, Alexander refused to anoint him as any kind of authority on the technique on the American continent. There are many letters back and forth between Barstow and Jones, in which Jones relates that Alexander was tardy with responses and

40 A. COLE

feedback on his writing, or in which Barstow tells Jones of her letters insisting that Jones is the obvious choice as a representative in the U.S. In 1950 she wrote to Jones about her latest correspondence with Alexander:

> I had told him what a fine teacher you were becoming, that he could always be proud of whatever you would say or do with the work, that the great distance made it impossible for those who would like to go study with him...[100] But he brushes all of these aside. Being so upset by all of the 'vandals' you would think he would be delighted to know of one or two people who were getting on, but no, not dear old F.M. It just ain't in his blood and he has not been willing to cultivate it, even though his technique is supposed to do that.[101]

On the previous page, Barstow had told Jones what she had written to Alexander, and how Alexander had responded:

> Must tell you about my correspondence with F.M. At Xmas time I sent him a card and added a note about my going to Media, you being there and suggested he should make you his representative in this country. That it would be beneficial to both him and his technique. I did not expect a reply but one came and it was a scream, just like he always writes, side tracking every question I asked. I quote from his letter, 'It is most kind of you to send me your impressions of the doings of the people you met in the work. Unfortunately the reports I have received from time to time are most disappointing. I wish I could name someone as you suggest, but how could I do that without seeing for myself where they stand as teachers. You see we have gone far ahead in recent years. In reply to your query I have not given my approval to anyone in the matter of training teachers'."[102]

Alexander's resistance to acknowledging Jones as any kind of expert must have been difficult to understand and accept for both Barstow and Jones, especially since Alexander had frequently used Jones's publications for his own advertising. In 1941, for example, he had printed two thousand copies of a review by Jones of *The Universal Constant* and *Man's Supreme Inheritance* and another two thousand copies of an article Jones had written for *School and Society* comparing the work of Dewey and Alexander.[103] While Jones later found what he had written to be naïve, both Dewey and Alexander approved of it at the time.[104]

In 1950, the year Barstow had made the suggestion to Alexander about Jones being his American representative, Alexander turned 81. It is hard to imagine what he was hoping for the future of his technique, either in the UK or the US. He had not formally approved any teacher trainers anywhere. Despite this, many were not only teaching without adequate training, but also training teachers (most notably those at Media, far from Alexander's radius of control). Of the teachers Alexander had certified as teachers (but, importantly, not teacher *trainers*), Walter Carrington and Marjory Barlow had assisted him in his training course for years, and Barstow had assisted A.R. as a teacher for years. A number of others had also assisted F.M. in training, such as Margaret Goldie* and Evelyn Webb. But it seems that no one was ever officially appointed by Alexander as a teacher *trainer*.[105] Marjory and Wilfred Barlow began their training course in 1950, which was the first training course for Alexander teachers after F.M. Alexander's own. Others followed. Jones and Barstow discussed the parameters of a training course that they planned, but this never came to fruition and they both trained teachers only unofficially, and recommending each other's work as a complement to their own.

It could be said that Jones was the conduit between Barstow and Dewey. While Barstow read Dewey, at least *Art as Experience* and Dewey's introductions to Alexander's books, and probably much more than this, it was Jones who had discussions – in person and by letter – with Dewey about some of Alexander's observations and principles. Barstow saw Jones's superior understanding of the technique, writing in 1948, "I think you have a better fundamental understanding of F.M.'s discovery than the others and what you need is experts in other fields to help you show something."

In a chapter on a book about mentorship,[106] I discussed the fact that Barstow not only mentored Jones in many ways, which included input into the design of his scientific studies, but also made financial contributions towards these studies. In that chapter, I argued that the extent, depth and breadth of this mentorship was astonishing, but perhaps not as astonishing as that fact that it remains such a well kept secret. This mentorship matured into something else over time, something which resembled more of a mastermind of two experienced equals than a mentor–mentee relationship. This is suggested by their decades of correspondence during which they shared many confidences about the direction of the technique in England and the United States. When Jones

42 A. COLE

could not make it to Nebraska one year with his family, Barstow offered to drive to Omaha to meet his train on his way to Oregon so that she could "discuss this whole idea of setting up an investigation" with him: "I liked what you told me of Dewey's remarks and suggestions and I certainly agree with you about psychologists."[107] They also made a trip to England and Denmark (and possibly elsewhere) together,[108] taught in each other's courses and had a life-long friendship which included Jones's wife and children as well. After Jones's death, Barstow wrote to his wife, Helen, describing what his loss would mean to her: "I have for so many years looked forward to my spring visit with both of you and a chat with him, his writings, and the future of the Alexander Technique. Our ideas were always so much alike on this. Now I must recognise that I am carrying on alone in this direction."[109]

Overview of Parallels Between Barstow and Dewey

As I described in the previous chapter, Barstow and Dewey shared many ideas about education and educative experiences. The first thing they agreed on was the role of the teacher – that is, as guide and co-worker, rather than instructor as in the billiard-ball or banking models of education. When it came to educative experiences, Barstow and Dewey were both aware of the danger of unquestioned teaching methods leading to mis-educative or non-educative experiences. Both were mindful that educative experiences should be more than *immediately* enjoyable, should provide continuity and interaction, and should include reflection and input from individuals and/or the group. Questioning and altering one's teaching methods and adjusting for differences in students was essential for successful educators, both Dewey and Barstow believed.

Dismissing both traditional and progressive education as too extreme, Dewey advocated what he called "experiential education." Traditional education, he said, consisted of bodies of information, skills, developed standards, and rules of conduct that worked historically, and encouraged an attitude of docility, receptivity, and obedience.[110] In some ways, Alexander's teaching legacy resembles this model. Progressive education, on the other hand, according to Dewey, offered significant philosophical improvements, such as growth and expression of individuality, free activity and learning through experience. But he believed that it suffered from excessive individualism and from being unconstrained by the educator.[111] Dewey proposed a new philosophy of experience and applied this to

education. Experience-based education, he said, must provide learners with quality experiences that will result in *growth* and *creativity* in their *subsequent* experiences. Dewey called this the continuity of experience.[112] This is what Barstow was doing by focusing on process and encouraging the independent learning and experimentation of her students, while also constraining and guiding her students to keep thinking, moving and experimenting. Contrary to the billiard ball approach, this experiential method of teaching also accords with Dewey's commitment to "democracy as a way of life." Dewey believed in the wisdom of the common man, just as Barstow believed in the wisdom of her students. She encouraged their independence because she believed that everyone had the capacity to learn and discover the Alexander Technique on their own. Compared with Alexander, who had a very dim view of human nature and its capabilities, this was a radical belief indeed. "Stupid" was a favourite epithet of Alexander's "for everyone and everything."[113] The degree of his mistrust of and lack of confidence in current and future AT teachers is also reflected in his veto of the formation of a professional society in his lifetime.

Summary

Having introduced the outline of the constellation, of philosophical pragmatism and the various levels of pragmatism of the Alexanders, Tasker, Barstow and Jones, I will continue in subsequent chapters to develop its various aspects and relevance to the teaching of the AT to performers. The following part of the book is devoted to drawing parallels between Dewey's pragmatism and Barstow's pragmatism. It is divided into four chapters, covering four broad areas of pragmatic philosophy in education: making ideas clear, deconstruction and reconstruction (philosophy and the Alexander Technique), desire and interest, and democracy and the social context.

PART II

Dewey's Principles in Barstow's Teaching

CHAPTER 3

Making Ideas Clear

How and why Barstow clarified the essence, process and principles of the Alexander Technique

> *It is now time to formulate the method of attaining to a more perfect clearness of thought, such as we see and admire in the thinkers of our own time...*
> —Charles Sanders Peirce[1]

In the last chapter I discussed the "philosophical constellation" of which Marjorie Barstow was a part, when it came to thinking about and teaching the Alexander Technique. In this chapter I examine in detail some of the ideas that Barstow refined, clarified and/or simplified in the interests of making things clear for her students. This practice became more important to her as she gained more experience of practising and teaching the Alexander Technique *and* as she saw the development of other teachers and their students whose interpretation of the work alarmed her. She began to realise that, as a student and in her early years of teaching, she too had misunderstood certain of Alexander's concepts, despite having learned them from Alexander himself (who was certain of his ability to convey accurate meaning with his hands, despite any shortcomings of the terms he used[2]). She had had to work certain things out for herself.[3] She wanted her students to have a better experience of learning the technique than she herself had had and she wanted to speak as clearly and simply as she could in order to facilitate and accelerate her students' learning. Some teachers clutter a student's mind with many or unclear instructions. In some cases this is unintentional and indicates a lack of skill, while in other cases it is a deliberate attempt to overload students and distract them from

© The Author(s), under exclusive license to Springer Nature Singapore Pte Ltd. 2022
A. Cole, *Marjorie Barstow and the Alexander Technique*,
https://doi.org/10.1007/978-981-16-5256-1_3

47

48 A. COLE

themselves.[4] Barstow had no patience either with such carelessness on one hand or with such tricks on the other. Her commitment was to the ideal of making her ideas clear and simple to her students so that they could begin to teach themselves and continue the process on their own.

Barstow's attempts to make the Alexander Technique as clear and simple as possible were part of her belief that people can learn this work independently. She would constantly reiterate how simple the work really was, saying things such as, "It's so simple. It's just too simple for us. Our little brains can't understand simplicity,"[5] and "That little bit of nothing,"[1] which is "shockingly simple" to do.[6] While it may not be good pedagogy to reiterate how simple it is when a student does not understand, it does remind people not to assume that they will never succeed, that they must rely on a teacher to get it, or that it is elusive. It reminds students that it is within reach of everyone, or that they may be trying too hard or complicating the work unnecessarily, and it is also democratic. That is, it rejects the notion that the teacher is far above or beyond the students, or that Alexander himself was superhuman or in a class of his own, far above the rest of us. To balance this, Barstow frequently contrasted the technique's simplicity with its exactingness. Comments such as "There now, isn't that simple? It's so easy!" might be followed by "It is the most demanding discipline that I know of."[7] What was indisputably good pedagogy, however, and what helped create the conditions for learning were her clarity of thought, her ability to make the Alexander work seem – and actually be – simple and achievable, and her patience and ability to allow degrees of misconception by new students to ensure this perception of simplicity: "Marj seems to allow a lot of misconception held by a new student but this is to keep the process simple."[8] She did not want students to get weighed down by detail. "Marj is a demon for simplicity," writes William Conable, quoting her as saying things like, "I only know about two things: whole heads and whole bodies."[9] He counters this by explaining that Barstow in fact had a keenly analytical mind and knew about "whole rafts of details" but was "reluctant to get involved in talking about them." When she worked with someone she would constantly emphasize the whole.[10]

[1] This seems in contrast to her belief about inhibition as stopping and trying to do "nothing," as we shall see in the following chapter, but what I believe her to mean by "nothing" here is that the coordinating movement is very small and simple.

Similarly, Barstow did not allow students to weigh her down with complaints about the past or projected problems in the future: "In her gentle but firm manner she would show them how easily they could make a change right now."[11] Gehman describes her clear, simple way of teaching as distilling "the practical essence of everything I was learning about the technique."[12] This simplicity reflected Barstow's clarity of thought, as Bradley describes: "Some of the best lessons I've had from Marj are when she's directed my thinking without the use of her hands. Her clarity of thinking and intention are so powerful that she can guide my thinking, which allows me to make a change so that the use of her hands becomes superfluous."[13]

Pragmatic philosophers and writers on pragmatic philosophy, such as Cherryholmes, Menand and Dewey, are particularly skilled in making ideas intelligible to the non-philosopher. This skill was important to pragmatists, as illustrated by Peirce's article, "How to Make Our Ideas Clear," whence comes the quote that opens this chapter.[14] Cherryholmes describes pragmatism as a discourse that attempts to bridge where we are now with where we might end up. Because of the uncertainty of the future, he notes, "the temptation is to look backward. Pragmatism resists this siren's song by accepting the challenge to look ahead."[15] Menand links the rise of pragmatism with the American Civil War. He highlights the pragmatists' belief that ideas should never become ideologies that can lead to the terrible outcomes of war. "Holmes, James, Peirce, and Dewey," he says, "helped to free thought from thralldom to official ideologies, of the church or the state or even the academy."[16] In his article, "The Development of American Pragmatism," Dewey highlights the important pragmatist idea of the universe being "in the making": "This taking into consideration of the future takes us to the conception of a universe whose evolution is not finished, of a universe which is still, in James' term, 'in the making,' 'in the process of becoming,' of a universe up to a certain point still plastic."[17]

In the same way as the philosophers, Barstow accepted the challenge to look ahead, using Alexander's ideas when they helped her learn, practise and teach the technique, and using new terms when they helped students learn. Making ideas clear was of paramount importance to philosophical pragmatists, as it was to Barstow. In this chapter, as a way of clarifying Barstow's approach to teaching the Alexander Technique and what was important to her, I will outline what drew her to the technique

50 A. COLE

and what most interested her about it. This is what I call Barstow's "ideals" and they help to explain both her take on the Alexander Technique and her dissatisfaction with Alexander's teaching. From there I examine the process that she focused on in her teaching and, in the following chapter (Chapter 4), how she reconstructed terms, ideas and practices that aligned with what she most prized in the Alexander Technique.

The Essence of the AT

It was the extraordinary quality of Alexander's movement and voice that motivated Marjorie Barstow to go and study with him in London.[18] Whatever had caused Alexander to achieve this was, for Barstow, the essence of the Alexander Technique. Whatever got in the way of getting this quality of functioning, Barstow believed, should no longer be part of AT teaching. It was for this reason that she made changes to the teaching of the AT. In this section I will outline what I see as Barstow's ideals in the AT: enhanced coordination, improved well-being and health, its educative value, the expansion of freedom, wholeness (as opposed to parts), and its applicability and relevance to any activity in life. Every change, reframing or re-interpretation Barstow made to Alexander's terms, principles and concepts was made in the pursuit of these ideals. That is not to say that she made changes that invited or encouraged end-gaining of those ideals, but rather by seeing Alexander's "means-whereby" *as a draft* only – a draft that was fit for revision.

From Barstow's original motivation, to learn how Alexander had achieved his extraordinary quality of movement and voice, we can deduce that Barstow valued the heightened coordination and fine motor control that the AT brought to an applied skill, especially an artform, since she herself was a dancer and Alexander was an actor. In her dance practice, she says, she (and her students) had always worked for "freedom and ease and flexibility."[19] She also described the AT as working for "freedom in motion."[20] In an undated letter to Jones, she wrote: "As I have acquired improved coordination my experiences allow me to think of it in terms of the most remarkable form of conscious awareness and control which allows me to work at any activity with the greatest ease, freedom and efficiency."[21] Of her own use before she started having lessons with Alexander in the 1920s, she recalled (almost sixty years later): "It wasn't too bad, but I was a little stiff.... My legs were heavy ... because of an excessive tension that had developed in my body through my dancing...

I had a tension through my neck and a bit of a high chest, but I danced and got along all right."[22]

Barstow was also interested in the AT as a means to improved health through education, and she supported Jones's numerous attempts to work with health professionals to set up a scientific research project into the technique. This does not mean that she saw the AT as a kind of therapy or treatment of any kind, but, like Dewey, she saw the AT as facilitating a broad range of human endeavour through its educative, *not its therapeutic*, power. Dewey emphasised the importance of the technique for education, claiming that it provided the conditions for the central direction of all special educational processes: "It bears the same relation to education that education itself bears to all other human activities... It contains in my judgment the promise and potentiality of the new direction that is needed in all education."[23] Aligned with this view of the AT was Barstow's insistence on thinking rather than feeling, as was described in Chapter 2 and will be explored further in this chapter. Her insistence on clear communication is discussed in Chapter 6 (Democracy and the Social Context).

Freedom of motion was not the only freedom Barstow wished to expand. She also wished, as Dewey advocated in the work of teachers, to give guidance "to the exercise of the pupils' intelligence" as an aid to freedom since, as he said, "Freedom resides in the operations of intelligent observation and judgment by which a purpose is developed."[24] Gummere observes Barstow's own personal expansion of freedom from the 1940s to the 1980s, noting that it might astonish those who knew her recently to hear that back then "she was generous and affable but a little staid – or covered." Every time he met her since, she struck him "as more free than before."[25] As Garrison says, paraphrasing Dewey, expanding freedom is as much a creative aesthetic adventure as it is a moral duty. Madden's current philosophy, which comes from Barstow's relentless commitment to constructive thinking, is "to teach from the perspective of *yes*." The following is a transcription of part of a lesson with Madden on Debussy's *Chansons de Bilitis*.

> Singer: Also what I find out by doing actions and gestures... I find out all sorts of different things that I want to do with the music... ideas that I've never had before. I mean, I've never thought of ... you know when he takes his hoe, with the iron of his hoe, he breaks the ice, I have never thought of that as him bringing [the

Naïades] back to life. I'd never thought of that until I sat down, as [the satyr] asked me to do, on the side of their tombstone... and looked, and so I did that, and then I saw and realised...

Madden: There's just so much 'no' in your instruction that it turned everything off. Not everything, because there's a lot there, but some important stuff, and you're not the only one. You're out there as a vanguard, saying, 'Excuse me, we need a lot more yes in what we do!'[26]

Another aspect of the AT that Barstow prized was its emphasis on wholeness. She observed that those educated in traditional fields such as medicine and academia were not trained to "see the condition of an individual as a whole, neither do they know how to judge it as a whole, nor watch progress as a whole."[27] She also observed that many Alexander teachers have not fully grasped the idea that the whole body should be involved. "He is doing what all of the others do," she wrote to Jones of an up-and-coming Carrington-trained teacher, after giving him a lesson – "getting his head well out of his shoulders, the upper part of his body follows then a break about waist line and his hips and legs are stiff and heavy."[28] Similarly, William Conable says that while the *idea* for body mapping came from Barstow's teaching, Barstow herself was suspicious of such details.[29] She did not want students to become focussed on parts and details of anatomy, as she saw so many performers doing. She would say, "I only know about two things: whole heads and whole bodies."[30]

Finally, Barstow valued the immediate relevance and applicability of the AT to daily life. She did not want her students to practise the technique as an exercise separate from real and meaningful activity. In order to do this, her students had to become independent of their teacher, and so independence was also something Barstow emphasized and encouraged in her teaching of the AT. As quoted in Chapter 1, in a letter to Jones in 1947 she impressed upon him the importance of showing the students "that F.M.'s discovery has a practical, valuable side and can be most helpful to those who are willing to take the trouble to do a little individual thinking."[31]

These are the things Barstow most valued in the AT and wanted her students to benefit from. In order to teach these optimally, she examined carefully how Alexander had brought them about in himself, attending to his process of discovery rather than his teaching methods. Robert Rickover highlights the fact that Barstow's focus on process was not the

predominant way of teaching. He was half-way through a training course in England when he met Barstow. He completed the English training course and immediately moved to Lincoln to continue working with her. "Marj's approach," he said, "was one which emphasized the *process* underlying the Technique… This of course was the procedure Alexander himself used to solve his voice problem, and it is one that puts a lot of responsibility on the student right from the start. It was not what I was used to, although it certainly made a lot of sense to me.[32]

In the following section I will describe what Barstow saw as the essential process of the Alexander Technique.

THE ESSENTIAL PROCESS OF THE AT

The process for Barstow was the series of steps Alexander took in discovering how to change the way he organised himself to speak. The steps were as follows, presented clearly in the first chapter of Alexander's *Use of the Self,* which Barstow made sure her students understood and knew intimately. Note that the names of the steps I use here are those that Cathy Madden has given them. While these steps were inherent in Barstow's teaching, it was Madden who articulated them in this way. In her book, *How to Teach the Alexander Technique,* Madden describes how she came to recognize that these steps mirrored the steps Alexander took in his own process of discovery. The steps are:

1. **Wanting** (Intention and desire). Alexander had a passionate desire to overcome his vocal problems (which consisted of losing his voice while giving solo 'recitals').
2. **Recognizing**. Alexander recognized that he was approaching the act of reciting in such a way that was causing him to lose his voice. He also recognized the need to change his approach if he was to continue in his chosen career.
3. **Deciding** (choice). He decided to study closely the steps he took to produce sound.
4. **Gathering information**. He gathered information (by observing himself) about how he was using himself in this activity. Alexander called this analysing "the conditions of use present."
5. **Creating a plan** for the activity. He created a new plan that helped him avoid throwing his head back as he began to speak.

54 A. COLE

6. **Deciding again**. Alexander realised that at the point of making sound, it was vital for him to renew the choice to make sound, and to have, as a truly available option, the choice of not acting at all or of doing something else altogether. When he did not give himself this option, he would tend to revert to the old habit.
7. **Thinking, asking, directing**. Alexander recognized that he could no longer rely on his habitual plan for speaking, as that involved the interference of throwing back his head. Instead of "speaking," he had to think through the new plan, asking and directing in a new way.
8. **Experimenting/acting**. After the previous seven steps, Alexander began to speak (or, remaining free to choose at every point, did something different from what he had planned).

In Barstow's classes, students would follow these steps (although, as described above, it was Madden in her own teaching who later named them thus). Barstow included the steps in her lessons in the following ways: Before they came to their first class or workshop, she would insist that students have at least one interest *other* than the AT, that is, a **want** (see Fertman's story, Chapter 5, "Desire"). Then, in order to have a "turn," or mini-lesson in the group, students would have to have a strong enough desire to ask for a turn and speak clearly about the activity to which they wanted to apply the Alexander Technique. In structuring classes in this way, Barstow assumed the next two steps, recognizing and deciding. Attendance in class and volunteering for a turn, both of which were entirely voluntary, showed that students **recognized** the desire or need to improve their coordination and that they had **decided** to use the AT to do so. Barstow's emphasis on observing and communicating helped students **gather information** and awareness about themselves and about optimal coordination (step 5). A **new plan**, which may or may not include the use of Barstow's hands in the teaching process, was then formulated for the activity, which included asking for a change between head and spine (ie: using the AT, or what Alexander called the "primary control"). If the turn continued further (and often it would not, if she judged that the student needed time to assimilate the information gathered), the student would be given the chance to **decide to continue** in the new plan (step 6) by **thinking** it through, **asking** for the change and **directing** him/herself to continue in the discipline of the new plan. Finally the student could **act** or **experiment** and return to a previous step

in the process. Barstow might stop the turn at any stage, if she thought the student needed time to reflect. Or, as Madden describes, "If I got stuck in some way, she'd say, 'Why don't you think about that for a while?'"[33]

In 1951 Barstow wrote to Jones with a list of what she was requiring of her pupils in their lessons. They had been discussing setting up a training course together. She sent Jones this list thinking that it "may help as a starter for setting up standards."[34] The list is a useful indicator of her emphasis on what she saw as the process in 1951.

1. Pupil's **observation** of his own coordination (What he is doing as he is carrying on his own daily activities).
2. Pupil's **observation** of the coordination of people he sees every day.
3. An **understanding** of the poise of the head and its effect upon his general posture.
4. **Knowledge** of controlling the poise of his head and the effects upon his general posture.
5. The **ability** to control the poise of his head and general coordination and carry this control into daily activities.[2]

Note that the first two points in the list involve observation. Through observation comes awareness. Barstow noticed both students and teachers who were missing the vital aspect of awareness. She observed that Alexander's pupils "had not developed the keen sense of awareness that he had,"[35] and thought that "his great mistake in teaching all through the years has been that he has not had the interest to teach something about awareness first of all."[36] In 1970, she named Raymond Dart* as an example of a student who had missed the importance of this. Dart was a South African who developed some exercises based on Alexander's work. "Dart missed the point of awareness as Alexander knew it," she wrote to Jones,[37] and "does not give the technique directly any credit for bringing the idea of awareness to his attention."[38] She criticizes Dart for giving the reader the impression "that it is simple and can be a do-it-yourself performance" because of the way he "toots his own horn too much about what he does or has done to become aware of his postural

[2] By 1971, she had added to this list for trainee teachers the requirement that they "know considerable about the use of hands and be able to talk about the technique in a sensible and logical fashion" (Barstow Correspondence, Letter to Jones, 2 July, 1971).

habits."[39] She and Jones also observed a lack of awareness in several teachers.[40] "Am sure what you say about awareness is very true with all the teachers," Barstow wrote to Jones in 1970.[41] "The lack of this creates a great problem in teaching. When I knew Pat (Macdonald)* he was no better but that was many years ago and whether he has changed in this respect I do not know." She then noted that Pat had spent a winter with A.R. Alexander and is perhaps suggesting that this was the point at which he may have learned about awareness, as she did from A.R. "Remember he spent one winter with A.R. in Boston when I was there. A.R. taught me many things that F.M. did not bother about."[42] In the same letter she refers to Carrington's lack of awareness of his own self-satisfaction. Barstow believed that "these people" would never change because they had "never learned to *see,* in the broadest sense of the word."[43] She instances two summers in Michigan, during which Carrington "and his English group stayed in their little corner and showed no interest at all in what we had to offer." "This happened both years," she wrote, "and it was much more set the second year."[3,44] By contrast, Barstow's students report on her endless refining and questioning of teaching methods, including her own, and her constant changes and evolutions in the way she taught and the words she used as a result of her observations. In Robert Rickover's words: "She is a person who truly lives the Technique; and she has never assumed that she has arrived at a complete understanding of it and that there is nowhere else for her to go."[45]

[3] In 1970 Carrington's newsletter nevertheless claimed that, while "the principles of the work remain constant, we need the stimulus of new ideas and experimental procedures" (Cited in Barstow Correspondence, 19 March, 1970). The way Barstow describes Carrington in Michigan, of staying in their little corner fits more with his exclamation in 1946 that Barstow had gone "clean off the rails," because she had provided new ideas and experimental procedures (Carrington, *TTR,* 26). She had also been questioning assumptions in the teaching of the Alexander Technique so that they did not become dogma, something that F.M. Alexander had proudly proclaimed to have done with his masters at school, but from which others were well advised to refrain when the dogma came from the master (Alexander) himself. Carrington describes Alexander at school: "He used to argue with the masters and dispute every statement that was held up for his belief. If they then referred him to a book he would ask how the writer of the book new it to be true" (p. 24). Years later, Carrington's observation of Barstow at the first "National Music Camp" in Michigan was that she quickly had a queue of people waiting for her and "ended up by taking about twelve lessons a day" (*Centre News,* September, 1966). Perhaps there was more than a little envy of Barstow's popularity as a teacher.

Standards 3 to 5 in Barstow's list are based on the primary control: first, understanding it and its effects, then knowing how to control it and, finally, controlling it and one's general coordination in any activity of daily life. In summary, then, based on her list of standards, Barstow wanted to emphasize, first, awareness through observation and, second, mastery of the primary control and its application.

Importantly, while Barstow's classes and mini-lessons would include the steps and process of Alexander's experiments, the shape, form and format of her classes and students' turns was not set or formulaic. As a performer herself, Barstow incorporated creativity and unpredictability into her classes and there was no set form, particularly since each turn was influenced by the choices made by the student in the spotlight at that time. Diana Bradley points out how Barstow's eschewing of the "form" of Alexander teaching necessarily led to an emphasis on process. Barstow's style did not encourage – or even allow – any kind of passivity, imitation or laziness. It required initiative and creativity, experimentation and practical application. Bradley's description suggests that Barstow's teaching was an invitation to pragmatists *and* creatives. "Because Marj doesn't utilize any set ways of putting her hands on or use any set routines in working with people, there's an endless fascination in learning from her. Since there is no particular form to hold on to, what comes through are the basic principles of the technique." Bradley highlights, too, Barstow's emphasis on individual differentiation, or what Alexander called "Variations of the Teacher's Art". As she learned from Barstow, "each teacher must make the work his or her own by continual experimentation and practical application of the principles. Then and only then will he or she have something to offer of value to others."[46]

In a lesson description by Arro Beaulieu, a pianist who studied with Barstow in the 1970s, Barstow's focus on the points of the process is clear. "She begins a lesson by emphasizing our ability to notice something, however fragmentary, about our own use at that moment" (observation). "She asks us to describe, however imperfectly, what we notice." Beaulieu explains that a student's choice of words and manner of speaking told Barstow about his or her thinking at that moment. In addition, they told her about the extent of the student's observation. Beaulieu then describes Barstow's responsiveness to what she hears and sees. She formulates her verbal directions and at the same time uses her hands "not to manipulate a change for us, but to suggest a direction that we may follow to make a constructive change in our use,"[47] thus eliciting the extent of the

58 A. COLE

student's understanding and knowledge of, and ability in, the Alexander Technique (points 3, 4 and 5 in her list above). Beaulieu describes this focus on process as Barstow's departures from the main body of teaching practice: "improvements *in form* rather than changes of any essential nature."[48]

Cathy Madden, who moved to Nebraska to study with Barstow for many years, describes Barstow's lessons as the "Living Room Étude."[49] The Living Room Étude was a series of "delicate, insistent challenges" from Barstow (in Barstow's living room, where she taught) that required "a robust, resilient skill set"[50] and from which Madden learned how to teach. Madden gives her own description of the process of Barstow's lessons, gathered in response to Barstow's request that students write down their impressions in workshops. This was a list of seven major aspects of teaching and learning the AT. They are: "I want to teach," responsibility and confidence, relationship/communication, *minking* and *thoving*,[4] *omniservation*,[5] constructive thinking, and rediscovery of *The Use of the Self*. Madden notes that she imagines that Barstow "would enjoy knowing that these are the seeds" enabling her to recreate her own process as her understanding and experience of them deepens. Barstow "insisted that we each teach in our own way."[51] In Madden's own classes, she regularly reminds students of Alexander's steps and asks students to identify them during "turns."

When Process is not Front and Centre

In 1965 Barstow wrote to Jones about Carrington and the new society that Alexander had steadfastly refused to create. He had also refused to cooperate with the teachers who, seeing the importance of a society both to the longevity of the technique and to their own livelihood after Alexander's death, tried to create it with his blessing. Despite this, after Alexander's death, the society was formed and Barstow wrote: "Perhaps Walter [Carrington] is right in joining the Society of teachers of AT. In this way, he knows what is going on and what they are doing. I doubt if any of them will ever come to an understanding of what the teaching

[4] Madden's terms expressing the integration of thinking and moving, described in more detail under "Inhibition" (Chapter 4).

[5] A term Madden invented to describe observing with *all* of one's senses.

ought to be. I think they are all too busy trying to copy exactly what F.M. did rather than take the principles of his discovery and work with them."[52]

What did she mean by this? If I describe my own experience of AT lessons in the 1990s, I can probably give an idea of what she was getting at. My first teachers helped me enormously at first, and I was a convert of the AT. But as I continued, I became increasingly confused and unclear about what I was learning and what they wanted me to do (or *not* do, as the case may be). I was completely confused about the process and the principles. In fact, if you had asked me, I wouldn't have even said there *was* a process, but rather an ad hoc collection of things to say to yourself to act more freely, some of which worked some of the time, but most of which lost their power a day or two after the lesson and made me entirely dependent on my teachers' hands. One of the things I learned to ask for was certainly a change *somewhere* in my neck (and a "noddable quality") but I did not understand this to have priority over other instructions about knees, pelvis, back, arms or other body parts. Nor did I understand that it was the head/spine change that should lead and help to organise the rest of me. This was teaching that Barstow would probably have described as having been organised by Alexander's form and format rather than by his principles.[6] In fact, my favourite parts of lessons were when my teachers would depart from Alexander's forms and draw on their own personal and artistic experience and intuition. They were good teachers in the sense that educator Parker Palmer describes: "Good teaching comes from the identity and integrity of the teacher... In every class I teach," he says, "my ability to connect with my students, and to connect them with the subject, depends less on the methods I use than on the degree to which I know and trust my selfhood – and am willing

[6] Kathryn Miranda has transcribed some of Judith Leibowitz's lessons, and the spiel sounds very much like my own early lessons: "Now I'm going to take this leg. You're thinking knee forward. The movement is from the back of the knee and these are the actual muscles that start the movement. The leg is pulling away from the torso and the torso is pulling away from the leg. That's your thought which is knee forward, neck free, head forward and out, torso lengthening and widening, knee forward. That's the same movement when you walk, bend, sit or climb stairs. What you haven't done is pull down on your skull, which is a shortening of the neck. This is a lot to remember, I know. We're covering an awful lot of material" (Leibowitz and Miranda, *Dare to be Wrong*, 41). Barstow, by contrast, made it her business to speak simply and focus on the primary control (head-spine relationship) first and foremost, what she called Alexander's discovery.

60 A. COLE

to make it available and vulnerable in the service of learning."[53] Despite my enormous respect for them as teachers, though, their own *Alexander training* had been unclear, and while some of it was helpful and other parts intriguing, its inherent lack of clarity was passed on to me.

So, if Alexander and his protégés were not paying attention to process, what is it that they were copying, as Barstow describes? First, as I mentioned, they were getting stuck on "inhibiting" *as stopping* Many of these teachers were also the ones who criticized Barstow for not teaching "inhibition," but, as I will show, she did teach inhibition, just in a more active and proactive way. Second, their focus in lessons was on Alexander's procedures (such as "semi-supine," "monkey," and "hands on the back of the chair").[7] By contrast, they called Barstow's method of teaching "The Application Approach." I will discuss here and in Chapter 6 the problem Barstow saw with the procedures and the reason for her emphasis on application instead. The third way that many teachers have lost their focus on process is, as we saw in chapter 2, by putting too much emphasis on the physical sensations they attempt to give their students, rather than teaching them how to think constructively through a new plan.

Barstow believed that many teachers trained by Alexander grabbed on to some kind of "form" in confusion and desperation. "I think they have all gone off on wild tangents," she wrote to Jones in 1968, "because they do not understand really what they are teaching and therefore must grab on to something else to keep up interest."[54]

To summarise, the series of steps Alexander laid out in his book as a description of his process of discovery and behaviour change was the process Barstow wanted her students to follow and *reason out* for themselves. In teaching them to do so, she had to prioritise thinking and moving in ways that had become quite unusual in Alexander lessons in England, as I described in Chapter 2. It involved an application of the AT at every point of the lesson, and meticulous attention to observation, as well as teaching students this kind of attention.

[7] The procedures that Raymond Dart came up with after encountering the Alexander Technique are another example of *form* that distracts away from the process of the AT. They have somehow found their way into Alexander lore, providing exactly what Barstow describes: something to "grab on to" (Barstow, Correspondence, Letter to Jones, 8 October 1968).

In the following chapter I describe some of the forms and concepts that teachers were holding on to but which, according to Barstow, were actually leading them away from the true purpose of the Alexander Technique. Under each subheading I describe the problems with that particular form or idea and how Barstow updated, reinterpreted or replaced it in order to stay true to what she saw as the essence of Alexander's discovery. I call this "Barstow's Reconstruction of the Alexander Technique" and liken it to Dewey's Reconstruction of Philosophy.

From the Barstow family archives: Courtesy of William D. Selim

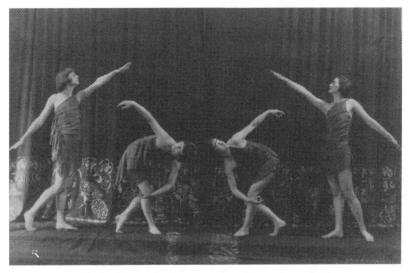

1922. Marjorie Barstow with Porta Mansfield Dancers in California. Courtesy of William D. Selim.

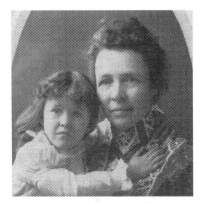

1902–1903. Marjorie Barstow and her mother, Frances Barstow. Courtesy of William D. Selim.

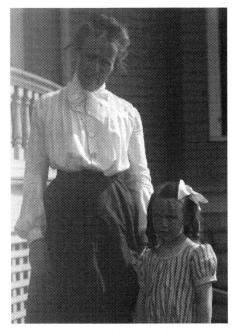

1903. Marjorie Barstow and her mother, Frances Barstow, outside their house in Lincoln. Courtesy of William D. Selim.

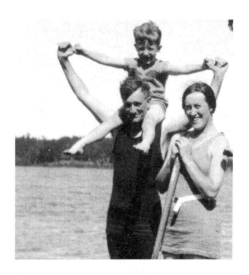

1920s. Marjorie Barstow with her brother-in-law, Daniel DePutron. The child is assumed to be John DePutron, Barstow's nephew. On vacation in Wisconsin. Courtesy of William D. Selim.

No date Marjorie Barstow

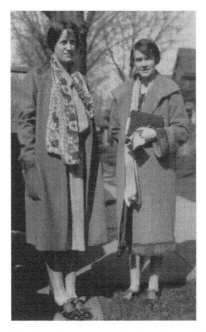

1926. Marjorie Barstow with her sister, Frances Barstow, in Lincoln, Courtesy of William D. Selim.

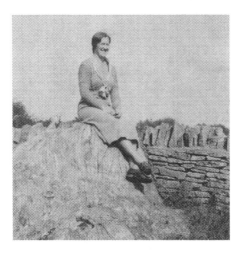

1932. Marjorie Barstow in the United Kingdom on holiday during the Alexander training course. Courtesy of William D. Selim.

1939. Marjorie Barstow, with her parents, Frances Foote Barstow and William T. Townsend Barstow Courtesy of William D. Selim.

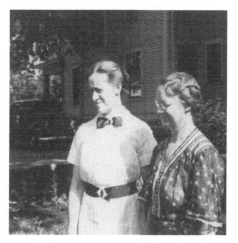

1939. Marjorie Barstow, with her sister, Helen (Barstow) DePutron. Courtesy of William D. Selim.

1947. Marjorie Barstow at home in Lincoln. Courtesy of William D. Selim.

1960. Marjorie Barstow on her horse ranch in Denton, Nebraska, near Lincoln. Courtesy of William D. Selim.

1960. Maroriej Barstow at her home in Lincoln. From a family Christmas card. Courtesy of William D. Selim.

1961. Marjorie Barstow holding her nephew, Bob Selim, in Lincoln at a family Christmas gathering. Courtesy of William D. Selim.

3 MAKING IDEAS CLEAR 69

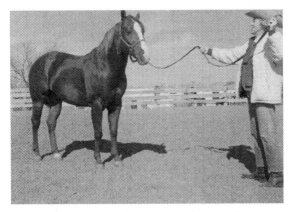

1966. Marjorie Barstow on her ranch in Denton with her champion quarter horse, "War Bond Leo." Courtesy of William D. Selim.

1974. Marjorie Barstow on her ranch in Denton. Photographer William D. Selim. Courtesy of William D. Selim.

1974. Marjorie Barstow at work on her ranch. Photographer William D. Selim. Courtesy of William D. Selim.

1977. Marjorie Barstow on horseback at her ranch. Courtesy of William D. Selim.

3 MAKING IDEAS CLEAR 71

1940. F.M. Alexander. Photographer Marjorie
Barstow. Courtesy of William D. Selim.

1940. A.R. Alexander, Boston, at the time Barstow was
working with him. Photographer presumed Marjorie Barstow.
Courtesy of the Barstow Institute and Doane College, Nebraska.

From the University of Nebraska Archives-Lincoln Libraries

The following six photographs are courtesy of the University Archives and Special Collections, University of Nebraska-Lincoln Libraries.

1918. Members of the Alpha Phi, University of Nebraska. Marjorie Barstow top row, 3rd from right.

3 MAKING IDEAS CLEAR 73

1919. List of Sophomores. University of Nebraska.

Women's Athletic Association

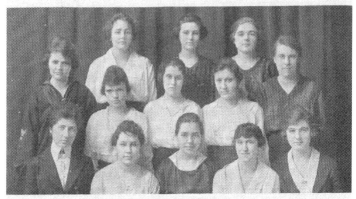

1919. Women's Athletic Association Executive Board, University of Nebraska. Marjorie Barstow front row, 2nd from right.

W. S. G. A.

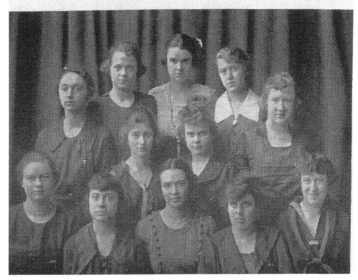

1919 Women's Self Governing Association (WSGA), University of Nebraska. Marjorie Barstow front row, far right.

3 MAKING IDEAS CLEAR 75

1920 Student Council, University of
Nebraska. Marjorie Barstow second row, 2nd from left.

1922. Women's Athletic Association, University of
Nebraska. Marjorie Barstow front row, 3rd from right.

Marjorie Barstow teaching:
Courtesy of Kevin Ruddell

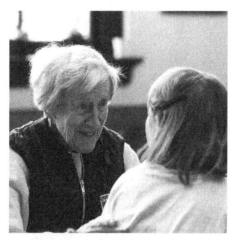

1989. Marjorie Barstow with unnamed child. Seattle. Photograph by Kevin Ruddell. Reprinted with permission.

1989. Marjorie Barstow with Stacy Gehman. Seattle. Photograph by Kevin Ruddell. Reprinted with permission.

3 MAKING IDEAS CLEAR 77

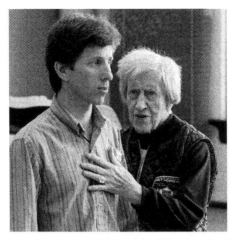

1989. Marjorie Barstow with David Mills. Seattle. Photograph by Kevin Ruddell. Reprinted with permission.

1989. Marjorie Barstow with Catherine Madden. Seattle. Photograph by Kevin Ruddell. Reprinted with permission.

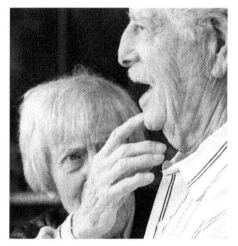

1989. Marjorie Barstow with Ronald Phillips (deceased). Seattle. Photograph by Kevin Ruddell. Reprinted with permission.

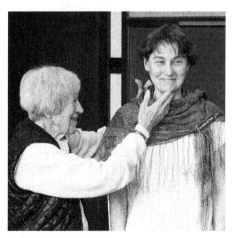

1989. Marjorie Barstow with Catherine Kettrick. Seattle. Photograph by Kevin Ruddell. Reprinted with permission.

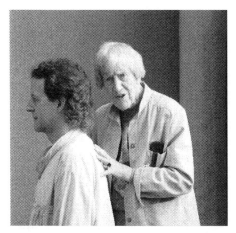

1989. Marjorie Barstow with Randel Wagner (deceased).
Seattle. Photograph by Kevin Ruddell. Reprinted with permission.

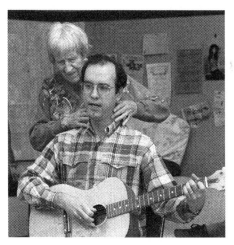

1989. Marjorie Barstow with Rupert Oysler. Seattle .
Photograph by Kevin Ruddell. Reprinted with permission.

1983–1984. Marjorie Barstow with Kevin Ruddell. Lincoln Winter Workshop Courtesy of Kevin Ruddell. Reprinted with permission.

1990. Marjorie Barstow. Seattle. Photograph by Kevin Ruddell. Reprinted with permission.

3 MAKING IDEAS CLEAR 81

1990. Marjorie Barstow with Rupert Oysler. Seattle. Photograph by Kevin Ruddell. Reprinted with permission.

1990. Marjorie Barstow with Heather Kroll. Seattle. Photograph by Kevin Ruddell. Reprinted with permission.

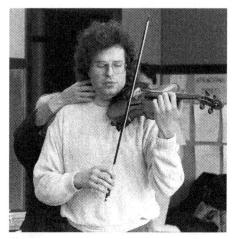

1990. Marjorie Barstow with Geoff Johnson. Seattle. Photograph by Kevin Ruddell. Reprinted with permission.

1990. Marjorie Barstow with Serge Clavien. Seattle. Photograph by Kevin Ruddell. Reprinted with permission.

CHAPTER 4

Reconstruction: Barstow's Reconstruction of Alexander's Principles and Terms

Like so many people who know but one language, they believed in a one-to-one relation between the word and the thing.

—Frank Pierce Jones[1]

During the month of June, 1982, when I first started working intensively with Marjorie Barstow in Nebraska, I had the following dream: I was visiting her in her house on South 20th Street and she offered to clean out my ears. The dream turned out to be prophetic. Because that summer, she told me what I really needed to know.

—Meade Andrews[2]

In this chapter I discuss and clarify some of the principles – terms, concepts, teaching methods – of Alexander's technique and how Barstow deconstructed and reconstructed them. I examine Alexander's stilted prose and language and show how Jones, Dewey and Barstow all had strong ideas about Alexander's choice of words. I show how Barstow came up with her own, constantly evolving, ways of expressing and explaining the Alexander Technique. I discuss why Barstow's approach to the AT is relevant for us today. Addressing Alexander's Principles and Terms, I cover: (1) Primary Control; (2) Inhibition; (3) Directions; (4) Procedures & Positions of Mechanical Advantage; (5) Sensory Re-education. As the pragmatists – especially Dewey – found, in order to Make Ideas Clear, sometimes it is necessary first to deconstruct and

© The Author(s), under exclusive license to Springer Nature
Singapore Pte Ltd. 2022
A. Cole, *Marjorie Barstow and the Alexander Technique,*
https://doi.org/10.1007/978-981-16-5256-1_4

83

84 A. COLE

then to reconstruct. Dewey deconstructed and reconstructed philosophy in order to make philosophy pertinent to the "Problems of Men."[1] Barstow deconstructed Alexander's terms and reconstructed them in order to make the Alexander Technique pertinent to her students, especially athletes and performers. In the first part of this chapter I will outline Alexander's principles. In Part B of the chapter is a discussion about his terms and methods, while Part C is an attempt to draw parallels between Dewey's reconstruction of philosophy and Barstow's reconstruction of Alexander's Technique.

PART A: IDENTIFYING ALEXANDER'S PRINCIPLES

In his *Companion to the Alexander Technique*, Fischer points to the fact that there is no single comprehensive or agreed upon list of principles that make up the Alexander Technique. He notes that in *Constructive Conscious Control of the Individual* (*CCC*), Alexander himself mentions the word "principle" 156 times but does not state what the princples are, merely making references along the lines of the "means-whereby principle" without stating in a single sentence what that principle is. Alexander rectifies this in *The Use of the Self* (*UOS*) by providing a definition.[3] Fischer quotes a wide range of sources, including STAT,* the Society of Teachers of the Alexander Technique (in the UK), all of which offer a different number (from 1 to 12) of principles that define the technique.[4] The list of ten core principles provided by STAT is the most comprehensive and clear of the collection presented by Fischer. I quote it in its entirety here:

1. The psychophysical unity of the individual.
2. Inhibition and direction as the basis of change.
3. The central role of the primary control.
4. The trap of subconscious (instinctive) guidance.
5. Development of conscious guidance and control.
6. Manner of use as a constant affecting quality of functioning.
7. Replacing end gaining with attention to means whereby.
8. The relationship of parts to the whole.
9. Restoring reliable sensory appreciation.

[1] John Dewey, *Problems of Men*. New York: Philosophical Library, 1946.

4 RECONSTRUCTION: BARSTOW'S RECONSTRUCTION ... 85

10. Addressing fixed conceptions.

Through the analysis of Marjorie Barstow's teaching in this chapter, I intend to show which of these principles she integrated into her entire approach, and which ones she needed to modify in order to make the technique internally consistent with what she thought it was about. Every change and innovation Barstow made to her teaching was based on the first principle, the psychophysical unity of the individual. An example of this is the way she connected thinking and moving in her teaching. As far as 2 and 3 are concerned (inhibition, direction and primary control), Barstow taught these three concepts in her own well considered interpretation of these words. Principles 4 and 5 (subconscious versus conscious guidance) were the reason she changed the degree to which she allowed students to rely on her to move them. All Barstow's lessons revolved around principle 6, the manner of use as a constant affecting quality of functioning and this was one of the rationales for what became known as her "application approach." Principle 7 is illustrated by the scrupulous and unrelenting way Barstow trained people to teach, while her insistence on talking to people's whole self rather than constituent parts is borne out in her reservations about the idea of Body Mapping (principle 7). Principle 9, as I discuss below (under "Sensory Re-education") is something Barstow did *not* teach, and, as I will also show, her decision to stop teaching the Classical Procedures was based on her adherence to Principle 10, addressing fixed conceptions and undoing what she called "set fixtures" (Principle 10).

Barstow could also be said to have included recognizing the principle of "the force of habit" (from Patrick Macdonald's list, 1963).[5] Pedro de Alcantara includes "action" in his list of principles (which consists of: the use of the self, the primary control, sensory awareness and conception, inhibition, direction and action).[6] His listing of "action" as a principle was noteworthy, and appeared at first glance to align with the perspective of Barstow and Jones, who saw the refinement of action (or movement) as a principle – or even a requirement – of the Alexander Technique. But upon closer inspection it seems that Alcantara uses "action" merely as a heading under which to explain "ends and means," "giving up trying," "giving up judging," "hesitation and eagerness," and "timing.' So it seems, after all, that action and movement are a vital feature and focus only in the Barstow/Jones approach. Having established what Alexander's principles were, at least according to a kind of consensus, I now

86 A. COLE

move to Part B of the chapter in order to discuss Barstow's reconstruction of Alexander's terms and methods, as a way of committing to his principles.

PART B: RECONSTRUCTING ALEXANDER'S TERMS AND METHODS

Jones observed of both F.M. Alexander and A.R. Alexander that "like so many people who know but one language, they believed in a one-to-one relation between the word and the thing ... They were confident that the words they used to describe what they did were the best that could be found. If a pupil did not understand, they repeated the explanation verbatim."[7] In a letter to Dewey, Jones writes that neither F.M.'s books nor his explanations in lessons gave him all that he needed. "A.R. was more helpful," he wrote, "but both of them left me somewhat bewildered and I have been forced to work the thing out for myself. In that task I found your phrase 'thinking in activity' more useful than anything else."[8] Jones notes that Dewey's phrase is a unified concept and more suited to describe the AT experience than "inhibition" and "orders," both of which he found misleading. He was also "bothered" by "mechanism" and "primary control," as was Barstow.[9] She wrote several times to Jones that she could not get interested in a mechanical model,[10] and that mechanism/mechanical was commonly used for inanimate things, while in this situation we are dealing with living matter.[11] Dewey, in his response to Jones, agrees that "mechanism" suggests something too mechanical. Similarly, Madden reports that clarity of communication was one of the lessons Barstow would always teach while also teaching coordination. She saw them as connected. "We needed to be able to say in words what we observed and heard ... In this practice, I learned to ... describe what I saw accurately and nonjudgmentally."[12] Part of Barstow's adjustments to Alexander's words and her renaming of concepts was in an attempt to help her students learn this lesson.

For years I argued that all Barstow was omitting when she changed her teaching technique was what she saw as Alexander's confusing choice of words and expressions. As I will explain in my discussion of the term "inhibition" she did change more than this, *or* she could be said to have preferred one of the several definitions used by Alexander in his books and

teaching over others. Either way, however, it would have been unpragmatic to have continued to teach the content and the method in a way that did not reflect her own findings from years of teaching.

Despite any changes Barstow made, she was still intent on extracting the meaning of Alexander's discoveries, words and phrases, and refining their form to reflect their import more accurately. Superficial appraisals of her teaching led to assumptions about her teaching. It is often said, for example, that Barstow didn't teach Alexander's key concepts. "Alexander students who have had experience with other teachers are sometimes surprised," Diana Bradley says, "because Marj doesn't use the words inhibition and primary control."[13] But, if they took a little time, they would "come to know through experience," as Bradley says, that all she was teaching was inhibition and primary control. "Regardless of level of understanding," insists Bradley, "all students are learning the same things – observation of self and others, inhibition/direction and the ability to carry their constructive thinking/movement into the performance of any activity, including teaching."[14]

James Kandik explains how Barstow's reconstruction of language reflects her attention to process, even quoting Alexander himself to support her changes. "Marjorie's choice of language in explaining the Technique demonstrates her adherence to principle. Alexander believed that any expansion of an idea necessitates either the revision of a definition or the employment of a new word or phrase altogether. The ways in which Marjorie speaks of this work stem directly from her expansion of the work," he wrote, observing that she used words "to give her students practical information that they may immediately use."[15]

F.M. Alexander's writing is notorious for being long-winded and difficult to read. Michael Holt describes all of Alexander's books (with the exception of *UOS*) as "obscure and difficult to understand" and sometimes defying comprehension.[16] This is "not because of the content, most of it quite straightforward, but because of the broken-backed prose style." Holt wonders why Alexander didn't pocket his pride and consult two of his most distinguished pupils, Aldous Huxley and Bernard Shaw on the gentle art of writing readable prose. Alexander's unwillingness to rely on others' ideas or expertise has been discussed in Chapter 2. He does, however, acknowledge the difficulty he encountered in writing *CCC* and his considerable need for assistance, expressing his gratitude to Professor John Dewey for the invaluable suggestions he made after reading the manuscript.[17]

88 A. COLE

Alexander's way of speaking, too, came under attack for being not very specific and prone to exaggeration, full of "broad generalizations and startling statements."[18] Westfeldt relates a conversation she had with him where she questioned his meaning. After discussing it throughout the morning, he finally agreed with her that he had meant what she had said. She also gradually came to realise that she was not alone in being unable to understand Alexander's meanings and described him as a man "whose inability to explain verbally what he meant was keeping his pupils from learning the first rudiments of his work."[19] "Colleagues in the training course, as well as private pupils who had had a great deal of work, were going around in a fog, not knowing how to carry on the work by themselves and doing some quite wrong things."[20] Marjory *Barlow* tacitly confirms this observation of Westfeldt's, claiming that it was Patrick Macdonald – not Alexander – who set her straight on the exact meaning of "head forward and up" and at which joint the movement occurs.[21]

Alexander himself admitted *in writing* to the shortcomings of "certain phrases employed in the teaching technique."[22] He stressed that his phrases call for comment, "seeing that they do not always adequately express my meaning and that, furthermore, they cannot be defended as being demonstrably accurate."[23] Alexander also explained that "expanding ideas demand new words which will adequately express the original as well as the new thought involved".[24] He also stressed that because of the inadequacy and inaccuracy of the phrases, they only serve their purpose when a teacher is present to demonstrate them, by means of manipulation of the pupil. Note that this acknowledgement by Alexander is in contrast to Jones's recollections of the teaching situation, in which the Alexanders admitted of no room for improvement in verbal expression or use of words. Perhaps this specification (of the necessity of a teacher present) explains the contradiction between Jones's reports and Alexander's written acknowledgement. Examples of phrases employed in Alexander's teaching technique include: "lengthening the spine," "relax the neck," "head forward and up," "widen the back."[25]

Erika Whittaker's recollection of Alexander aligns more with his own claims about language than those of Jones. She notes Alexander's reticence to be tied down to a judgment: "We may have wanted to tie him down yes or no to a matter which he saw as being in the process of change, and he refused to commit himself, especially if we asked him how we were getting on, were we progressing? So 'he didn't say yes and he didn't say no' – we had to put up with that."[26] Whittaker's description

of Alexander underscores and reinforces the point that his ideas and findings were, as he said, expanding – not static or fixed. That is, he was inviting future generations to improve on his terms. Barstow took up this challenge. But Alexander did not seem to approve. Recall that when Barstow wrote to tell him of her new directions and thoughts, she heard nothing back. "His silence is more of a tell-tale of his attitude than if he had written," she wrote to Jones in 1947, reminding him that F.M. had never *really* been interested in people who do any original thinking in relation to his work. "And as he has heard directly from me [that] that is what I am doing, there seems little hope," she wrote. "He is not keen about progress in his own work and that's why we must work alone." She encouraged Jones not to let Alexander's attitude to her disturb him.[27]

Despite Alexander's disapproval, students frequently remark on the clarity of Barstow's reconstruction, particularly those who attended other training courses before encountering Barstow's approach. Meade Andrews, for example, observes that "in her use of language" Barstow had "distilled the essence of Alexander's principles" and offered "the most straightforward verbal approach to problem solving."[28] Dewey believed that people are "culpable in acquiescing to avoidable evils whenever, evading the possibilities of intelligent reconstruction, they swim along with the inertia of old ways or follow the momentary promptings of whim."[29] Barstow neither swam along with Alexander's language nor followed the momentary promptings of her whim. In order to emphasise the process behind the technique she constantly invented new ways to talk about it, dropping ways that she observed had become less useful. "I'll use a word until it's no longer useful," she would say, "then I'll find a new one."[30] By observing her students, she tested the effects of the words as she used them and decided accordingly about their usefulness. In contrast to Alexander, who in Holt's opinion "hid his unique light under a bushel of impenetrable verbiage, thus concealing his 'gold brick',"[31] Barstow dispensed "with a lot of the verbal freight of traditional Alexander teaching, both Alexander's own and that developed by other teachers."[32] "If you ask about the neck," for example, "she'll say, 'The only way to free the neck is by moving the head'."[33] Conable makes the point that for Barstow, Alexander's discoveries *were not words*: "She is willing to change her language radically in order to communicate the fruits of her experience and understanding, and to abandon explanations that she finds leading to operational confusion" [emphasis in the original].[34]

90 A. COLE

"Beyond words is our intimate experience," writes Aase Beaulieu in a poem about her experience of Barstow's teaching.[35] And yet words were particularly important to Barstow. Cathy Madden says that Barstow's stress on the importance of words taught her to look closely at how she used and responded to words herself: "I learned the value of choosing what I wanted to say, watching what I did while I said it, and observing what happened as my student responded to my words and began an activity."[36] An example of Barstow's considered use of language in teaching was that she asked questions in preference to giving orders. Rather than telling a student to move her head, she might ask: "What would happen if I moved your head in an upward direction?"[2] "Questions like that are more helpful than orders," she believed.[37] According to Williamson, Barstow became reluctant to continue using Alexander's words when she realised that pupils tended to have a pre-conceived idea about what they meant and would attach a faulty meaning and action to the "buzzwords," such as primary control, directing, and inhibition.[38]

Many things that Alexander said and did seem to have led to some confusion in the Alexander world, as we have already seen in previous chapters. There are a number of terms, ideas and practices inherited from Alexander that Barstow saw the need to clarify or reconstruct in service of the ideals and creating conditions for learning. In the following section I examine some of these. They are: primary control, inhibition, directions, procedures and sensory re-education.

TERM 1: PRIMARY CONTROL

What Alexander meant by it

Barstow believed that the "primary control" was Alexander's principal discovery. By "primary control" Alexander meant the dynamic relationship of the head to the rest of the body, which, he believed, organizes our movement and alertness. Alexander defines it as a control that "depends upon a certain use of the head and neck in relation to the rest of the body." It "governs the working of all the mechanisms and so renders the control of the complex human organism comparatively simple."[39] In *UOS* (published in 1932) "primary control" came to replace the term

[2] This entry in Barker's diary was made in 1973. Later Barstow would probably have replaced "I" with "you," giving the responsibility for movement to the student.

"position of mechanical advantage," which latter disappears from Alexander's writings after 1923. As Jones recalls, "Though he continued to put pupils into positions, I never heard him use the terms 'position' or 'posture,' and he advised me in 1946 to avoid the word 'posture' in writing about the technique."[40] Although Alexander had described the relationship between head and spine as being of primary importance (in *CCC*), Jones says that Alexander's idea about the primary control did not crystallize until some of his medical friends called his attention to the work of Rudolph Magnus on posture who had showed the same principle in other vertebrates.[41]

Jean Fischer discusses the evolution of the term in *Articles and Lectures*.[42] He notes that in *Man's Supreme Inheritance*, (*MSI*, Alexander's first book), Alexander used the term "true primary movement: to describe the movement that precedes other movements and which therefore provides the controlling factor in influencing subsequent movements. Fischer sees this term as the precursor of the term "primary control." In *MSI* Alexander referred to "primary movement" and "primary inhibition." In *CCC*, these terms had been joined by "primary direction." He also distinguished between "true primary movement" (what Barstow later called "use" and Madden called the "coordinating movement") and "primary movement" (as being the initial movement after the coordinating movement). It was not until *UOS* that Alexander used the term "primary control," providing the description given above, "a primary control of the use of the self, which governs the working of all the mechanisms."[43] In a letter in 1951, Alexander adds to this description: "A control that is primary in thought and action to all other forms of control."[44]

Problems with the term "Primary Control"

As already mentioned, Jones saw limitations in both the Alexander brothers' use of language. In deciphering meanings offered by F.M. and A.R., Jones claims to have been forced to "work the thing out" for himself, finding Dewey's phrase "thinking in activity" more useful than anything else."[45] Jones was "bothered" by the terms "mechanism" and "primary control,"[46] as was Barstow. Barstow wrote several times to Jones that she could not get interested in a mechanical model[47] and that the words "mechanism" and "mechanical" were commonly used for inanimate things, while in this situation we are dealing with living matter.[48] Dewey, in his response to Jones, agrees that "mechanism" suggests something too

92 A. COLE

mechanical. Westfeldt observed that the term "primary control" is not a happy one, "as it is ambiguous and lends itself to misunderstanding."[49] I will discuss her solution immediately below (under the heading, "What others came up with instead").

What others came up with instead

Westfeldt's solution was to replace the term with "HN&B (head, neck, and back) pattern." Fischer observes that "although the head, neck and back relationship is not specifically mentioned as being the primary movement, Alexander could hardly be referring to anything else" when he writes about primary movement.[50] Head-neck-back is a widely used concept and term in the Alexander world, and there are several things that make it little – if any – better than "primary control." First, it sounds static and can imply that there is an ideal position to be attained. Second, the term "neck" is anatomically vague, as is the term "back." These are extremely broad lay terms, pertain more to the visual than to movement, and they do not accurately describe muscle groups or any other single category of anatomy (such as bones, joints, ligaments, etc.). Third, focussing on the back is misleading, especially since the weight-bearing part of the spine is the *front* of the vertebrae. The weight-bearing part of the spine does not consist of the vertebral processes that we can *see* and therefore tend to *think of* as the location of the spine. The bulk of the spine is closer to the *centre* of the torso than it is to the *back* (whatever it is we mean anatomically by "the back" – probably the superficial layers only). This focus on the "back" is therefore inaccurate and incomplete body mapping if our intention is to involve the whole torso and spine. Barstow noted this in 1947 when commenting on a letter Frank had forwarded from "Alison"[3] at Ashley Place.[51] Barstow was dismayed at Alison's descriptions of "sensations of those important antagonistic pulls," and described them as "wrong impressions." "Certainly," she concluded, writing to Jones, "I do not like the idea he [F.M.] is emphasizing of the back. Lulie talked about it a lot too."[52]

Another common way of describing the primary control is that "the head leads and the body follows." This can also be confusing, as it is oversimplified. I have heard Alexander trainees expounding that the head

[3] Alison Grant-Morris.*

4 RECONSTRUCTION: BARSTOW'S RECONSTRUCTION ... 93

should always lead in any activity, which is misleading. What is actually meant, but often not explained, is that the head leads the primary (or coordinating) movement, but it is not necessarily the first thing one should move in order to carry out the activity.

Barstow gives us her understanding of the primary control in her correspondence with Jones. In an undated letter, she describes it as "a force of energy working in such a manner as to give consciously controlled motion to all activity. This force of energy results in improved relationship of parts to parts affecting the whole." In 1946, amongst the comments for which Jones had asked Barstow on his paper, she wrote that she agreed that the primary control was a mechanism, but disagreed with his assertion that it was "the means by which thought is translated into action." To clarify, she wrote, "Thought brings about action and the combination of the two result in the improved functioning called the primary control."[53]

A year later, Barstow wrote another definition of primary control to Jones: "I think 'primary control' is the natural relationship of head to spinal column but our acquired habits have interfered with that activity."[54] A couple of weeks later she wrote again, saying that pupils can't understand the primary control until they get how to observe their coordination in activity and make continual changes and adjustment *in activity*. By doing this, she said, "I can continue to improve my coordination and, as I do so, and acquire an improved manner of use, I am conserving quantities of energy therefore get less tired and gain more efficient functioning of all kinds." Until they have this, she believed, "they do not know the real significance of primary control." "Years ago," she observed, "I talked a lot about primary control, but it was parrot talk. It has taken me a long time to see the difference. Now that I see it I dislike more than ever the word 'stop' and would not use it under any circumstance."[55] I discuss the words "stop" and "inhibition" under the heading "Inhibition" below.

In another letter, in 1949, Barstow again criticises those who "cling to the technique," by which she means focusing on freeing single parts of the body rather than the "lead of the head," (thus revealing her primary interest in the primary control). "'Letting of the knees go' is of little importance, as is 'whole back going back.' Don't you see how they are all quibbling over specifics? If there is ease and freedom of movement by the lead of the head, [then] the back, knees and what you will, fit in and do what they should."[56]

94 A. COLE

Barstow clarified that there is a distinction between the head leading in the primary control and the head leading in an activity. She called these two separate movements "use" and "extension" respectively: "When you ease up it is a very subtle movement. You only go a tiny bit. This is the difference between extension and use."[57]

The way I learned this distinction was through Madden's clear explanation between extension and use. Understanding it made me realise that after ten years of lessons in the Walter Carrington paradigm I had never fully understood the concept of primary control or even the phrase "head forward and up." I had also never understood that there was such a distinction. Madden's clarity on this was a revelation for me, similar to the Conables' sudden realisation in 1972 that they had come across the person (Barstow) who knew what they needed to learn. When I later questioned Madden about the genesis of her own explanation, she said that she could not remember exactly how Barstow articulated it, but that the distinction was certainly inherent in her teaching. Since we have no record of exactly how Barstow articulated it, other than the brief allusion above by Barker, I offer Madden's way of describing the difference. Barstow does not seem to have articulated it in her correspondence with Jones. Note that Madden continues the reconstruction of language, employing her words, which are clearer still, "coordinating movement" and "activity movement." They also remind the student of the Barstowian emphasis on movement.

Coordinating Movement (Barstow's "Use")

Madden uses the term "coordinating movement" to describe the primary control. She describes it by asking people to do the following exercise. "If you put one finger up to represent your body ... and use the other hand to create a very large head for the body ... you can make a very approximate model of a head and spine. Take your little person for a walk. Now, if you press the fist down into the finger, as if trying to compact or shorten the finger, and take your finger for another walk, you'll notice the reduced flexibility, range of movement, ease and comfort and the increased amount of effort required for just a small amount of movement in the finger. Now if you do the reverse, hold on to the end of the finger with the fist, and pull the finger as if trying to lengthen it, take the finger for a walk you can see how that moves and feels. Finally, allow the fist to rest – without pushing or pulling – at the end of the finger. Observe

the quality and quantity of movement now possible in your finger. It is towards this ideal balance between head and spine that the coordinating movement takes us before, and as, we engage in the activity movement. We ask to "coordinate" so that a change may occur in the relationship between head and spine. This necessarily involves movement, no matter how small, and all of me follows. Madden's short-hand for this process is "head moves, so that all of me can follow." Her use of the verb "to coordinate" here means: "To ask for [or to will] the optimal relationship between your head and spine in movement – cooperating with our design. If you have been interfering with the head/spine relationship, then "to coordinate" is about restoring design. If you are preparing for a task you care about and not particularly disturbing your coordination, asking "to coordinate" is a request to your whole self to work optimally."[58]

Activity Movement (Barstow's "Extension")

The activity movement is made up of the specific tasks necessary to do something. While the coordinating movement is the same for all activities, that is, head moves and all of me follows, the activity movement is specific to each activity. In walking, the activity movement does begin with the head moving first. If the activity is to lift something, however, then the activity movement will probably begin with some part of the arm instead. But the activity movement should be preceded by the coordinating movement. Madden includes both the coordinating movement and the activity movement in her plan for any activity: "Head moves, so that all of me can follow *so that I can* sing this phrase," for example.

Madden's terms take us back to Alexander's original term, that is, the term he used *before* he changed it to "primary control": the "primary movement." When he realised the central importance of this particular movement in our overall coordination, he changed it to "primary control." If he had retained the first term, the idea of movement might even have remained central to the Alexander Technique, thus mitigating its esoteric image and making it something more mainstream, with obvious relevance to performers.

TERM 2: INHIBITION

Somewhere in Universal Constant he calls it 'a technique of inhibition'. That seems a perfect definition of it, but I am more interested in constructive activity than 'learning how to stop.' It makes more sense to me.
—Marjorie Barstow[59,60]

Alexander's Meaning and Barstow's Interpretation

Alexander used the term "inhibition" in a variety of ways in his writings and it is this that may be the source of at least part of the confusion and controversy that surrounds this term. One of the problems with Alexander's version of pragmatism was that he tended to continue to use terms, while changing their meaning as the years went on and as he published new books. In *MSI*, his first book (1910), Alexander explained that to "inhibit" meant to prevent the subconscious habit from happening so that new ways of doing can occur in their place.[61] In *CCC*, his second book (1923), he offered: "This... really means that in the application of my technique the process of inhibition – that is, *the act of refusing to respond* to the primary desire to gain an 'end' – *becomes the act of responding* (volitionary act) to the conscious reasoned desire to employ the *means whereby* that 'end' may be gained" [emphasis in the original].[62]

In *UOS*, his third book (1932), however, Alexander describes the need to "inhibit the misdirection associated with the wrong habitual use of my head and neck" when the stimulus came to him to use his voice. That is, he says, "I should be stopping off at its source *my unsatisfactory reaction to the idea of reciting*, which expressed itself in pulling back the head, depressing the larynx, and sucking in breath" [emphasis added].[63] On page 41 he points out that the old instinctive direction (which he is trying to inhibit) is "associated with untrustworthy feeling." Perhaps Alexander is also saying here that what he intended to inhibit was *his reliance on feelings* when learning to follow a new plan for a familiar activity.

On page 40 Alexander also says: "To change my habitual use and dominate my instinctive direction, it would be necessary for me to make the experience of receiving the stimulus to speak and of refusing to do anything immediately in response." Here Alexander prescribes a period of nothing (other than giving directions and *not* following them) in response

to a stimulus. Alexandrians who subscribe to "stopping" or doing "nothing" in response to a stimulus can point to this as the source of their process. Alexander is very clear here that, at this stage of his experimenting, in order to replace one kind of response with another, he had to practise thinking it through without actually doing it, because his old way of responding was too strong for him to overcome directly.

Alexander did confine his work *for a while*, then, to giving himself the directions instead of actually trying to "do" them or to relate them to the "end" of speaking, and he did spend successive days, weeks and months practising this. For many, this is still the main work of the Alexander Technique. But Alexander *also* says that he ultimately returned to applying the new "means whereby" to the purpose of speaking, and therefore that the new plan eventually *took the place* of the old plan. That is, his practice of inhibition alone was a temporary phase, and one which taught him that he had to continue to use the primary control throughout the activity, referring to this process as "all together, one after the other": a combined activity and, crucially, that he had to maintain the possibility that he might choose to proceed with a different action or not to proceed with any action at all. He explains that the process is an example of what professor John Dewey has called "thinking in activity," "and anyone who carries it out faithfully while trying to gain an end will find that he is acquiring a new experience in what he calls 'thinking'."[64] Was it possible, then, to bypass the temporary stage of doing nothing in response to a stimulus (if, indeed, doing "nothing" is even possible)? This is what Barstow ultimately taught her students after she began to see that this "nothing" stage was counterproductive.

Barstow saw that the trend in teaching the Alexander Technique was to spend increasing amounts of time on the temporary phase, apparently in the attempt to master directions in isolation and without application. She believed that this was making both teachers and students stiff, and that it was not possible to *do* "nothing" in response to a stimuli. What people were beginning to fill the space with was tightening. She also saw that this trend was not helping people in their daily lives and was taking away their agency and independence. Instead, she trained people meticulously to observe when they were falling back into old patterns of movement and thinking and also to preserve the element of choice in everything they did. Her take on "inhibition" was, instead of replacing the old pattern with holding or muscle tension (which they appeared to be doing in an

98 A. COLE

attempt to do nothing), to approach an activity with the new plan but maintain the meticulous attention to what they were doing and thinking.

In her interpretation of the concept of "inhibition," Barstow reflects the early writings of Dewey. In an essay entitled "Ethical principles underlying education," Dewey writes: "I am aware of the importance attaching to inhibition, but mere inhibition is valueless ... To say that inhibition is higher than power of direction, morally, is like saying that death is worth more than life, negation worth more than affirmation, sacrifice worth more than service.

In his last book, *The Universal Constant in Living (UCL)*, Alexander uses "inhibition" in a number of contexts. He refers to: inhibiting one's "impulsive, 'subconscious' reaction to a given stimulus, and to hold it inhibited while initiating a conscious direction, guidance, and control of the use of himself that was previously unfamiliar;"[65] inhibiting one's "habitual reactions;"[66] inhibiting one's "tendency to be 'carried away' by his desire to gain his 'end,' before he has set in motion conscious impulses in the laying down of new lines of communication in the use of self [his instrument];"[67] and inhibiting the habitual (automatic) reaction to the stimuli of daily living.[68] These uses all indicate that Alexander only intended inhibition to refer to our habitual end-gaining patterns. But his earlier work (in *UOS*, as described above) and his references to stopping and non-doing invite confusion. "They must learn HOW to stop this 'doing,'" he says,[69] referring here only to the "doing" that is responsible for the wrong manner of use they are anxious to change which might be better described as "going out of coordination," and which, taken out of context, can sound like an invitation *never* to do. Indeed, I learned from several Alexander teachers that singing and making music in many different ways should be done without "doing." As Madden clarifies, there *is* work to be done. It is simply a matter of making that work as efficient as possible. As my *Heldentenor* singing teacher used to say, "I need to see a high note cost you something." And while all good singing doesn't need to appear to cost the singer something or appear to be hard work, being calm and relaxed throughout every piece makes for a fairly boring performance. As a performer, Barstow understood that elite performance is not about *not doing*, but rather about maximizing the efficiency and ease of the work required.

To return to the discussion of Alexander's meaning of "inhibition," in *UCL* he also says: "In selecting the necessary practical procedures for

changing the manner of use, non-doing is not only of the greatest practical value, but also essential to their purpose."[70] Taken out of context, or without the inclusion of Alexander's parentheses, this comment sounds like Alexander is again prescribing non-doing as an approach to life. In parentheses Alexander explains "non-doing" as: "in the primary sense of preventing themselves from doing those things which lead to a repetition of their wrong habitual manner of use."[71] Alexander's final chapter in this book is called "Knowing how to stop," which again simply refers to the *replacement* of what is undesirable with what is desirable. He does use the word "stop" twenty times throughout the book, however, which is what Barstow objected to in her letter to Jones.

In summary, Barstow was perfectly aligned with what Alexander himself had described in his first and second books as inhibiting. That is, rather than stopping, Barstow used the new constructive plan directly to *replace* the old habitual one. From the survey of Alexander's works it is clear that he made extensive use of the words "inhibit," "stop" and "non-doing." Barstow recognized the problem and confusion that these words caused for students learning the Alexander Technique. The problems arose when students tried to "inhibit" without awareness, or tried literally to do nothing. Their attempts to do so, and the confusion arising from their inability to do so, led to increasing degrees of stiffness. Barstow clarified what she meant by "inhibition" and then stopped referring to it by that name. She continued to teach the practice of inhibition consistently but without Alexander's interim stage of inhibiting without application to movement, because she saw that it was making people *stop* and get stiff. In the following discussion, I will reiterate what Barstow came to see as the problem with teaching inhibition in the way Alexander proposed in *UOS*.

Awareness, Continuity and Application

Dewey and Jones discussed inhibition by correspondence,[72] Jones saying that "inhibition itself has value only within a frame of reference which has a qualitative character. In other words, the disturbance and lack of harmony have to be perceived before inhibition can be applied." Barstow suggested the same thing, writing to Jones that Alexander had created a problem by teaching inhibition without teaching students the importance of awareness first. Without this, she suggests, students do not know exactly what it is they are supposed to be inhibiting:

In my early teaching I used it as it had been taught to me as inhibition, but I soon realised it was not getting the kind of results I wanted so gave it up, but had not thought of it as an artificial device. To F.M. in his experimental work perhaps it was not that, but it certainly became so as he used it in teaching. Of course his pupils had not developed the keen sense of awareness that he had. And I think his great mistake in teaching all through the years has been that he has not had the interest to teach something about awareness first of all.[73]

The cardinal error, Jones believed, lay "in thinking of inhibition as a thing apart, as something that can be practiced and perfected outside of what educators call "real-life" situations." This echoes both what Dewey wrote (above) and what Barstow often said. Jones stressed the importance of awareness and the power to inhibit increasing "side by side" and reinforcing each other, "thus bringing about a greater and greater harmony among the parts of the self." He also pointed out the importance, as Barstow did, of inhibition being something that does *not* cause "a break in the continuity of experience, but rather a change in the direction of growth" [emphasis added].[74] Yet because of this continuity that Barstow insisted upon, she was criticised for not teaching inhibition and therefore for not teaching the Alexander Technique. Actually, what Barstow and Jones removed was the *stopping*, rather than the inhibition of an unconscious habit.

With her emphasis on continuity and application, Barstow also removed the *necessity* for full understanding and awareness of one's habitual patterns before being able to change. In fact, as she showed, by the success her students had in applying – early – the AT to any number of activities, a focus on the old plan (in order to inhibit it) could be counterproductive. As Madden observes, the old plan is, paradoxically, the one that tends to prevail when you focus on it in order *not* to do it. Madden often illustrates with the invitation to her students, "*Don't think of a pink elephant.*" Barstow used to say: "Inhibition is *all* that I teach. If you're doing or thinking something else, then you're not thinking the thing you don't want to be thinking."[75] In other words, as Heather Kroll put it, "by seeing to it that I continue to carry out the decision to allow my head to move and my body to follow, my habitual response has no opportunity to get started."[76] A practical example given by another of Barstow's students, Lucy Venable, is that of overcoming a problem with an injured knee. Venable had been trying to organise her approach to

curbs so that the "good" leg was always ready. She applied what she had learned from Barstow, noting that with her approach, there was no need for a micro-analysis of her old plan: it was simply by-passed: "Obviously I had been 'preparing' for this activity, but once the preparation (whatever it was) was eliminated, I had no problem. Thus I did not consciously inhibit the old way, *I never even knew what it was*. I simply substituted this new activity of moving up" [emphasis added].[77]

Inhibition and the Impossibility of Nothing

Arro Beaulieu, one of Barstow's students, identifies the problem with Alexander's earlier definition (from *MSI*) of "inhibition" as a complete refusal to act. As he says, it is impossible to do nothing, and he warns of the dangers of trying to do such an impossible task as being in "neutral" with regard to ourselves. As he observed, "we cannot do nothing; we must always do something," even if that something is just thinking and breathing and allowing our balance to change with inhalation and exhalation. Beaulieu explains that Alexander's refusal "to do anything immediately in response" to the stimulus to speak (the classic definition of inhibition) "referred only to his habitual pattern of response, not to any and all activity." "Non-doing," Beaulieu believed, as he had been taught and shown by Barstow, "means not employing habitual use, and nothing more." Complete inhibition actually leads to a new – sometimes worse – kind of tension and holding. As he says, "if it becomes confused with an attempt to literally do nothing, then the inevitable result will be holding a position of one sort or another, since that is how our feelings will interpret such an attempt, and that holding is a *doing* readily habituated and as destructive of good use as any other 'old activity'."[78] Beaulieu refers to Alexander's earlier and more active definition of inhibition (as replacement), explaining that "this is precisely what Marjorie means when people ask her why she has not talked about inhibition." She replies, "'I haven't talked about anything else because you can't go in two directions at once'."[79]

In his philosophy of experience, Dewey goes into how we must always be doing something and cannot *not* do something.[80] Marjorie Barstow dispensed with the words "stopping," "inhibiting" and "non-doing" that are common in the AT teaching of others. Something is always required to fill the space people believe they are creating when stopping, inhibiting or not doing. That something is usually holding or "getting set," as Lena

102 A. COLE

Frederick describes it. Barstow taught her that, rather, inhibition is "a delicate movement of head and body together that doesn't allow tension to set in.[81]

In a lecture in 1934 Alexander himself gave another example of this direct replacement of an old, habitual, plan with a new, more constructive plan, which by-passes the "doing" of which he wants people to rid themselves. "Therefore we have that trouble to get rid of, too, but we do not do any exercises for it. All we say to a person is, 'Remember, when you sit down and touch the chair, simply say to yourself, "I am not going to sit down. I am just going to allow the chair to support me".' In a word, what we have to do is to learn to think in activity."[82]

In the same lecture Alexander acknowledges the problem of knowing what giving or refusing consent (to respond to the stimulus) *means*. He reiterates that the new pattern replaces the old pattern directly: "We do know that when you have refused to give consent, it simply means that you have refused to indulge in the old habit. Instead you say, 'These are the new messages I have decided to send. I am going to give these new orders and directions instead of the old ones I have always given,' and you must see that you cannot order your head back while you are sending it messages to go forward."[83]

Inhibition and Stiffness

As described above, Barstow noticed that students and teachers who attempted to "inhibit" an old behaviour pattern without applying a new plan of response to a stimulus (other than nothing) were becoming stiff. In a letter to Jones in 1947, Barstow likens the isolation of inhibition with the isolation of the Alexander brothers from the rest of the world.

> It will always be a puzzle to me why F.M. and A.R. allowed so much stiffness to develop in their pupils and never seemed too troubled about it. F.M. much less so than A.R. It must have been partly due to the fact that they isolated themselves so from the rest of the world. As I look back they did live in a little world of their own always doing exactly as they wished, and those who disagreed were pushed out. Always being the center of praise and never being jolted out of it does do strange things to people. It is easy to get used to certain things and accept them, many times it is the easiest way out. Even so it all is a curious situation.

John Wynhausen draws attention to a characteristic of Barstow and her teaching that differentiates her from other teachers – her fluidity and flexibility of approach and way of moving. He contrasts this with the stiffness he had observed in teachers of other schools. Wynhausen observed a major difference between Barstow's interpretation and the way teachers he had encountered earlier had discussed it: "Marj describes the work in terms of taking actions. You move your head, you let your body follow. The traditional view is: first you refuse to do anything, that is, you 'inhibit' your impulse to move. Small wonder so many Alexander teachers look stiff, almost paralysed, in their movements."[84]

"All Through the Activity"

In the tradition of Alexander that was followed by Patrick Macdonald, Marjory Barlow, Walter Carrington and others, pupils are asked to "do nothing" in response to a stimulus and to allow the teacher to move them. This tradition follows what Alexander wrote in *MSI* and *UOS*. In *MSI* Alexander stated that pupils are unable to perform the act correctly because they believe that there is something for them to do physically, "when as a matter of fact the very opposite is necessary": they are *"doing* what is wrong" [emphasis in the original].[85] In *UOS* he wrote about the temporary phase he had found necessary of refusing to respond to a stimulus at all. This is contrary to what he wrote in *CCC*, where he said: "This... really means that in the application of my technique the process of inhibition – that is, *the act of refusing to respond* to the primary desire to gain an 'end' – *becomes the act of responding* (volitionary act) to the conscious reasoned desire to employ the *means whereby* that 'end' may be gained" [emphasis in the original].[86]

The "do nothing" approach has led to the widespread conviction that the Alexander Technique is about "stopping and thinking." Even Dewey occasionally talked about stopping and thinking *before acting*.[87] But by 1947 – and perhaps even earlier – Barstow had already moved away from this idea of stopping in order to practise the AT. "No doubt you could do a good essay on 'stop and think,'" she wrote to Jones, "but I would substitute some other word for 'stop.' Definitely I do not like that word."[88] Barstow also taught people to remember the primacy of making a change between head and spine (ie: cooperating with the primary control) *before and as* they decided to act, thus removing the need to stop and do nothing. As Alexander himself said, in a lecture in

1934, it is "a wish, as it were," that you keep going "all through the activity."[89]

Perhaps Barstow's clarity about inhibition was one of the things about which she had written to Alexander in 1946, when he rebuffed her by not answering her letter,[90] despite the fact that it is in keeping with his own explanation in *CCC*. Certainly this new logic was already part of her teaching, as she wrote to Jones in 1947, saying: "What we do consciously, is to leave off the wrong acquired muscular activity by thinking in a right direction. All conscious directions are preventive."[91]

Dewey's Term: "Changing Direction"

In her interpretation of "inhibition," Barstow was at one with Dewey when he reported sharing her scepticism of the term. As already described, he is supposed to have made a special trip to warn Alexander about the word "inhibition."[92] In its place, he suggested "change of direction," and there is even evidence that Barstow took this term from Dewey (via Jones), as it described the way she was already thinking and doing. In 1947 she wrote to Jones, "Am pleased that you are having frequent chats with Dewey. I like his idea of 'change of direction' in place of 'stopping.' Fundamentally it really is a change of direction and that change can take place without actually stopping an activity."[93] She gave an example of how she could change her coordination while typing without stopping. "I am constantly doing this type of thing in all of my activities and by so doing over a period of years I have learned more fundamentally about manner of use and its controls than in all the concentrated study I had in earlier years."[94] This interpretation of "inhibition" as "changing direction" (even before Dewey described it as such) was fundamental in changing her teaching. "This is one feature that has so decidedly changed my teaching and continues to change it," she wrote, explaining that "anyone who makes use of this knowledge practically knows and understands F.M.'s discovery. Until they have this they do not know the real significance of primary control." But, she lamented, "it is not the type of thing students in training learn."[95] Years earlier, she said, she had "talked a lot about primary control, but it was parrot talk" and it took her "a long time to see the difference. Now that I see it I dislike more than ever the word 'stop' and would not use it under any circumstance."[96]

As for the idea of needing to stop in order to change one's approach, Barstow used the analogy of driving down the freeway and suddenly realising that you are going the wrong way. You realise you need to do a U-turn. If there is no traffic coming, you *might* make a complete stop before joining the road going the other way, but you *don't have to*.[97] "The movement in and of itself is the inhibition ... She makes the connection that inhibition is within the action."[98] Frederick explains how different this interpretation is from the rest of the Alexander world.[99] As Rickover describes, this difference is crucial for performers. "Now, I remember watching Alexander teachers unable to process that," he said. "You know, to them, it was just too much of a radical way of looking at things, but it's absolutely true. You see, if you want to go North and you find you're going South, what you have to do is change direction. And if you are an athlete or an actor in the midst of the sport or the performance, you cannot stop and say to the audience 'Well, I have to stop now, I notice myself tightening and I have to inhibit a little bit before I re-engage in the performance'." As a performer herself, Barstow understood that "what you have to be able to do is change it within the action."[100]

Barstow's approach, which recognizes the importance of movement and the continuity of experience (as Jones describes) rather than trying *not to act*, as Alexander describes in *MSI*, is also in line with the psychological research about reafference that Jones cites. Jones found a great deal of experimental evidence to show that "perceptual learning is very much more effective if the subject is allowed to make some voluntary use of his muscles during the learning process. In animal studies the term 'reafference' has been used to describe the neural excitation that follows sensory stimulation produced by voluntary movements of the animal doing the sensing."[101] Jones goes on to make the case that the principle of reafference applies in teaching the Alexander Technique: "Instead of depending passively on a teacher for whatever new experiences he obtains, the pupil becomes an active participant in the operation, taking major responsibility for what happens."[102] Jones notes that he liked this way of presenting the technique better than the way in which it was presented to him (by the Alexanders).

Jean-Louis Rodrigue shows how different Barstow's approach was from that of the "Ashley Place School" when it came to this question of the responsibility of the student. Rodrigue had learned in his ACAT* training to "do nothing" and was already a teacher when he encountered Barstow. He highlights the difference in the two schools of thought on

inhibition, explaining how Barstow changed his understanding from the more common interpretation of stopping: "I truly thought that I had *to do nothing*, I had to inhibit, just think the directions, trust implicitly my teachers and let them move me." Indeed, Rodrigue's interpretation is correct if we are to adhere to the interim stage Alexander describes in *UOS*. But Barstow, in practising and teaching the work for over a decade had begun to see problems with spending too much time in this interim stage. By contrast, recounts Rodrigue, "Marj was asking me to *actively think* of the change I wanted to bring about," and be *completely responsible for that change*.[103]

Cathy Madden also tells an anecdote that highlights the importance of the dynamism of Barstow's approach. She noticed, from her very first lessons, the immediacy and integrated nature of the way Barstow taught the Alexander Technique. She often tells the story of how this aspect of the AT (as Barstow taught it) was one of the things that drew her to the work. Barstow had come to teach a workshop at Washington University in St Louis, where Madden was a graduate student and had just finished playing Cordelia in *King Lear* opposite an internationally experienced actor as Lear. She asked Barstow to help her with one the monologues. "In the play, when I began this monologue, I moved my hand toward Carnovsky, who as Lear was sleeping in front of me."[104] She had always wanted her hand to move toward his face in a way that carried "all of Cordelia's love with it." "And I could never quite get my hand to do what I wanted – no matter what I said to myself, it looked stiff. As Marjorie Barstow helped me to use the Alexander Technique to speak the monologue, my hand did what I had always wanted it to do … Suddenly my voice was responding to my ideas about the text and its expression. "Suddenly I realised that some of the words meant something more, something different than what I had thought." And, in a paradoxical end to this story, Madden says she was so overwhelmed that she could not continue. Being unable to continue due to the power of an extraordinary learning moment, however, is different from having to stop in order to practise the Alexander Technique.

At the root of the assumption that one must separate out the inhibition plan from the new constructive plan of action may be a tendency to separate thinking from moving altogether. As a way of emphasizing the wholeness inherent in Barstow's teaching, Cathy Madden coined the words *minking* and *thoving*, to overcome the pattern one student had of separating thought and movement so strongly "that saying either word

became unproductive."[105] The switching of the initial sounds of the words *moving* and *thinking* serves to integrate even further the two acts of thinking and moving, reiterating that *noticing* something about your own movement and *changing* it do not have to be two separate acts. "Marj often remarked," observes Madden, "that if you are looking at your hands and see that you stiffen, you could use this information to make a new choice." No stopping is required, no inhibition, and no separation.

I discuss Barstow's emphasis on movement further under the section Practice Idea 1, Procedures and Positions of Mechanical Advantage.

In summary, it does seem that Barstow dropped something that other teachers (including Alexander) find essential: the interim stage Alexander believed it necessary to move through in order to master the Alexander Technique. Other teachers have criticised Barstow for "not teaching inhibition." Her omission of this "nothing step" seems to be what they mean, because for them, this step is a defining feature of the technique. From Barstow's perspective, other teachers fell into a trap of thinking that the Alexander Technique was about *never doing anything* in response to a stimulus, and never moving on from this stage to act with energy and volition. The fact that she omitted what others saw as a vital step in the technique may also have made them think that her standards were loose. But nothing could be further from the truth. Madden describes in detail Barstow's meticulous and conscientious attention to helping her students forward into constructive thought and movement, catching them when they were falling into their old patterns. "Many times," reports Madden, "my lesson in teaching ended before I even started to move or talk to my student ... Many, many months of the same questions: 'What do you notice about yourself?' 'What do you notice about your student?'."[106] Some of her turns lasted less than a minute before she would hear, again, "Why don't you think about that for a while?" Madden reckons that about nine months passed before she got close enough to her student to use her hands as part of the teaching process.[107] Perhaps if Alexander had had a Marjorie Barstow watching him through his changes, he too could have dispensed with the "nothing step" and gone straight to replacing an old plan with a new.

TERM 3: DIRECTION AND DIRECTIONS

What Alexander Meant by "Direction" and "Directions"

Alexander used the term "direction" in three ways. I will discuss each of these uses in turn.

108 A. COLE

1. **Direction (noun, with respect to motion)**: Alexander seems to have used the word "direction" to stop students and pupils trying to find positions: "There is no such thing as a right position, but there is such thing as a right direction."[108] This is typically cryptic Alexander-speak. Barstow made things clearer by insisting that the Alexander Technique was about movement.

2. **Direction (noun, from the verb "to direct," as in projecting messages)**: The action or function of consciously directing one's use.

> When I employ the words 'direction' and 'directed' with 'use' in such phrases as 'direction of my use' and 'I directed the use,' etc., I wish to indicate the process involved in projecting messages from the brain to the mechanisms and in conducting the energy necessary to the use of these mechanisms.[109]

3. **Directions (noun, as in an order or command)**: These are the actual messages used in the process described above in (2). "Directions" are what Alexander called "certain phrases employed in the teaching technique."[110] Alexander also called these "orders,"" or "preventive orders" – "a projected wish *without any attempt on the pupil's part to carry it out successfully.*"[111] For example: "The pupil is then asked to give the following preventive orders. In the way of correct direction and guidance, he is asked to order the neck to relax, to order the head forward and up to lengthen the spine."[112] Alexander's orders are described below. Before discussing them in *CCC*, he points out that the phrases he uses "call for comment, seeing that they do not always adequately express my meaning and that, furthermore, they cannot be defended as being demonstrably accurate."[113]

Examples of Alexander's directions are as follows:
"Relax the neck:" Alexander believed that this was the first thing that had to happen for full coordination. He also recognized the futility of trying to relax any body part by direct means.[114]
"Head forward and up:" Alexander calls this phrase inadequate, confusing and dangerous, "unless the teacher first demonstrates his meaning by giving to the pupil, *by means of manipulation*, the exact experiences involved."[115]

"Lengthen the spine:" Alexander found that by modifying the curve in the spine, the spine tends to lengthen.[116] Note that this is supposed to *follow as a result of* the first two orders, which allow this third to happen.

"Widen the back:" "What really occurs is that there is brought about a very marked change in the position of the bony structures of the thorax... also a permanent enlargement of the thoracic cavity, with a striking increase in thoracic mobility and the minimum muscle tension of the whole of the mechanisms involved."[117]

The "orders," or "directions," are what Barstow referred to as the "special words" she had to repeat as she was given "a pull, a push and a punch" in her early lessons.[118] What she meant was, as Maisel describes, that "though helpful in the first stages of learning the technique, they become, in time, more and more ritualistic – a string of played-out inhibitory 'Hail Mary's' gone over by rote – and tend to lose their effectiveness."[119]

Discussion

In an attempt to clarify what Alexander's discoveries were really about, Barstow rarely used the "orders," such as "neck to be free," "head to go forward and up," "back to lengthen and widen."[120] She disliked both their form and their content. She saw these phrases as part of a "technique" that obscured Alexander's main discovery, that of the primacy of the head-spine relationship in our whole-person coordination. Voicing her doubts about Ashley Place and what would happen after F.M. was gone, Barstow wrote in a letter to Jones in 1949, already quoted in part above:

> Perhaps Charlie and Eric have a fair set up, and may, in time, develop something worthwhile. I am dubious at the moment, for they cling to their technique. 'Letting of the knees go' is of little importance as is 'whole back going back.' Don't you see how they are all quibbling over specifics? If there is ease and freedom of movement by the lead of the head, the back, knees and what you will fit in and do what they should.[121]

First, it should be noted that Barstow preferred questions to orders. This can be seen in Madden's detailed descriptions of lessons in Barstow's living room, which consisted of Barstow directing a student's attention principally by questions.[122] Second, she found the content of Alexander's

110 A. COLE

orders limited and limiting, focussing on parts rather than the whole and drawing pupils' attention from the main game, which she saw as asking for a change in the head-spine relationship, going ahead with the new plan for your chosen activity, and paying attention to what you were actually doing in response to this plan. She wanted her students' attention to be far broader than the handful of directions Alexander had provided. Two discussions of these phrases follow, "head forward and up" and "back to lengthen and widen." Perhaps, too, Barstow had been influenced by A.R. Alexander in the years she taught with him in Boston and New York. He had his own view of the directions or orders. A.R. believed that they were "an aid to thinking but not a substitute for it."[123] He had observed that it was possible to "give orders" without thinking, thus echoing (or perhaps influencing) Barstow's joke about "repeating special words"[124] and also her reference to her own "parrot talk" about the primary control.[125] A.R. had also noted that there were occasions (when talking, for example) when you had to be able to think without giving orders. He voiced these objections to Jones, who "had the feeling that [A.R.] would have given up the concept altogether if it had not been stated so explicitly in the books."[126]

Example 1: "Head Forward and Up"

> *Most people do have lots of trouble over the word 'forward.' I did for about 10 years or more until I began to do a little reasoning for myself – when I learned some new things about it I began to have a new conception and discovered for all those years I was mistaken. Was that entirely my fault or partly due to the fact that my teachers did not see to it that I had a clear understanding?*[127]
> —Marjorie Barstow

In the letter quoted directly above, Barstow points out the limitations of Alexander's proviso that, in order for it to be understood, the instruction "Head forward and up" be preceded by teacher demonstration, that is, that the teacher must give a pupil "the exact experiences involved" *by means of manipulation,*" [emphasis in original].[128] Despite years of repeated demonstrations via manipulation from the master himself and from the master's brother, Barstow admits to having been mistaken about the meaning of this instruction until doing some reasoning of her own.

4 RECONSTRUCTION: BARSTOW'S RECONSTRUCTION ... 111

While many use the phrase "head forward and up" to define the primary control, or the central direction of the Alexander Technique, Barstow expressed – and acted on – her reservations about both directions "forward" and "up." In the case of "forward," she made sure her students understood what was meant, and in the case of "up," she ceased using the word all together.

Referring to the distinction Barstow made between extension and use, or coordinating movement and activity movement, Conable explains that Barstow viewed the clarity of this concept "as an important distinguishing characteristic of her teaching." Because the activity movement may require – especially for dancers – the head moving backwards and down, it was necessary to clarify that the forward and up movement of the head only consistently described the coordinating movement. Conable continues: "Marj has an extraordinarily lucid understanding of the meaning of 'head forward' ... She draws a clear distinction between the forward rotation of the head at the atlanto-occipital joint and the head's path in space or relative to the body, which may well be *back* as well as up. I have seen a great deal of confusion on this point from even some very senior teachers."[129]

Sarah Barker quotes Barstow as still using the phrase "to move the head up" in 1973. Madden recalls that it was some time in the 1980s that Barstow stopped using the word "up."[130] This decision shows Barstow's unflagging commitment to observation, reflection, critical thinking and action. The change was perhaps due to Barstow's observation of training schools, where trainees were becoming stuck, stiff, or overextended in this direction, just as in the exercise that describes the coordinating movement, above (under the heading "Primary Control"), when the finger is over-stretched and over-straightened. If a student replaces a pulling down with a poking forward, then the direction of change needs to be towards general movement and potential to move freely rather than in just one direction. Insisting on the same direction lesson after lesson, year after year, may explain the stiffness resulting from Alexander lessons previously described.

The direction of "head forward and up" can hamper singers, who need freedom at the atlanto-occipital joint (the joint between head and spine) at all times and need to be able to tilt their heads back slightly for high notes, as Doscher describes.[131] Doscher describes Caruso as singing high notes with his arms down, head back and jaw open, standing in an absolutely straight line.[132] Cecilia Bartoli is another example of an

112 A. COLE

extraordinarily co-ordinated singer who makes full use of this movement of the head. When the forward and up direction is taken to an extreme, which it can be in some Alexander studios, singing teachers are justified in claiming that the technique is not helpful for singers. Alexander teachers' hands can get in the way of the freedom of movement at this joint. I have had some Alexander experiences in which I could not access my head voice at all because extension at this joint was being prevented by the hands of the Alexander teacher. Working with Madden (who studied with Barstow) enabled me to access more of my voice more consistently than any other teacher of either voice or AT.

Example 2: "The Back to Lengthen and Widen"

> *Certainly, I do not like the idea [FM] is emphasizing of the back. Lulie talked about it a lot too.*
> —Marjorie Barstow[133]

> *Marj didn't use the word 'widen' much—it would appear periodically for a specific purpose in some of the early years, and then disappeared.*
> —Cathy Madden[134]

Alexander acknowledges that this order rivals the "head forward and up" instruction in its shortcomings, "when considered as a phrase for the conveyance of an idea which we expect a pupil to construe correctly, unless it is given by a teacher who is capable of demonstrating what he means by readjusting the pupil's organism so that the conditions desired may be brought about."[135] As for the instruction "head forward and up," however, Alexander appears to have had no mechanism for testing whether a student had correctly understood his meaning as conveyed by his manipulation, which, as we have seen, Barstow described as "a push, a pull and a punch." Perhaps the real problem with Alexander's Technique was that, having worked his coordination out for himself, he was: (a) unable to tell whether his communication of it to others really conveyed what he wanted it to convey; and, (b) unaware of the effects (or limitations) of learning the technique through someone else's words and manipulation. Barstow had the advantage of having experienced Alexander's teaching *and* of noticing, without investment in the technique (it not bearing her name), that the coordination of her own students was not improving to the extent she wished when she used his methods. She also

had the advantage of being able to compare Alexander's own movement, coordination and voice production (what had drawn her to the technique) with that of her students. Other teachers who trained with the Alexanders also had this advantage but perhaps lacked Barstow's insistence on observation and the questioning of tradition just for tradition's sake.

Alexander specifies that things such as the back lengthening and widening happen *as a result of* the coordinating movement: The pupil is asked to order his neck to relax and his head to go forward and up, "*in order to* secure the necessary lengthening" [emphasis added].[136] But he also taught the lengthening and widening as directions in themselves. In Alexander training schools there is continued talk of lengthening and widening the back as if it were a real possibility of direct and voluntary action and sometimes as if this is the mainstay of the AT. What Alexander was describing was more likely to have been a sensation of expansion that came about indirectly as a result of other things he was doing (such as ceasing to put downward pressure on the torso and spine). Going directly for the expansion (ie: lengthening and widening), however, can create stiffness, particularly since, as Weed points out, it is impossible to shorten (that is, use) muscles and lengthen them at the same time. He calls the attempt to do so "the definition of tension."[137] If a muscle is required for an activity, then we cannot lengthen it simultaneously. I suggest that this is why Barstow stopped using the words "lengthen" and "widen," given her attention to process, her desire to separate cause from effect and her reluctance to ask students to create sensations.

As she suggested in the letter quoted above, Barstow was distressed by the focus on the back. She began to use the word "torso" rather than "back," as in "the head can only continue moving 'forward and up' when the torso moves with it." This takes the excessive focus off the back.[138] As I described above (under the heading Primary Control), the weight-bearing part of the spine is in the centre of the torso, rather than in the back, and referring to "torso" rather than "back" fits with this anatomical truth.

Such details of anatomical accuracy that set Barstow's teaching apart were what led William Conable to develop his idea of "Body Mapping." These details have been extraordinarily helpful in my own learning of the technique and singing, and were introduced to me by Cathy Madden. William Conable says that the *idea* for body mapping came from this aspect of Barstow's teaching.

Anatomical and physiological knowledge, which A.R. acquired, but F.M. seems *not* to have acquired, may be a significant factor in the evolution of Body Mapping. When I asked William Conable about what he meant by "getting the idea of body mapping" from Barstow, he said that while he couldn't be very specific at this remove (in 2021, some five to six decades later), he clearly remembers her making statements in the form of: "Oh, you think X [some issue of what is really the body map], but really Y [a more accurately mapped version]."[139] He says that he had been exploring the general idea for some time in his teaching in the early 1970s or even earlier, but that the penny really dropped for him in the incident he describes in *How to Learn the Alexander Technique*.[140] "At that point it exploded in my mind," he said.[141]

The incident he describes in the book is as follows:

> Some years ago a colleague asked me to observe a violin student who was having difficulty bending her bow arm at the elbow. Nothing the student or the teacher could think of was effective in helping her to solve this problem. Watching her play, I asked myself what I would have to think in order to move that way.[142]

Conable proposed the possible cause of the student's inability to move at the joint – a detail about the precise location of the elbow joint hinge mechanism – and offered her a more accurate idea. "She immediately proceeded to play with a freely moving elbow."[143] This incident, from which the popular phenomenon of Body Mapping came, was first described by William Conable in 1991 at the AT Congress in Eisenberg, Switzerland.

While Conable says that the *idea* for Body Mapping came from this aspect of Barstow's teaching, he says that Barstow herself was suspicious of such details. She did not want students to become focussed on parts and details of anatomy, as she saw so many performers doing. She would say, "I only know about two things: whole heads and whole bodies."[144] He explains:

> Marj generally distrusted the idea of Body Mapping, even though I was at pains to explain it to her as carefully as I could and to insist that it was just a somewhat systematic development of one aspect of the AT. Her doubts about it, with which I heartily concur, stemmed, I believe, from a concern that it would lead to a piecemeal approach to Alexander's discoveries, trying to construct the whole from the pieces in a way that would

interfere and indeed preclude an understanding of Alexander's fundamental discoveries about how the mind and body function as a whole. This has indeed happened with at least some practitioners.[145]

This concludes the discussion about Alexander's use of the words "direction" and "directions." The following discussion focusses on the fourth aspect of Alexander's technique that Barstow reconstructed: Alexander's procedures, including Positions of Mechanical Advantage. I call this section "Term 4: Positions of Mechanical Advantage, which she subtitled "Set Fixtures." But this section also addresses the method of teaching with a focus on procedures and the major shift Barstow made away from this approach.

Term 4: Positions of Mechanical Advantage (and other Procedures)

The fourth term that I will analyse is "Positions of Mechanical Advantage." This discussion covers not just the term, but also the method of teaching that encompasses such a term, which I call teaching with procedures. The structuring of AT lessons around Alexander's "procedures," or "positions of mechanical advantage," was another way that Barstow saw other teachers prioritising form over process. In her commitment to process rather than form, Barstow preferred to structure her lessons around observation, constructive thinking and application to a free range of real-life activities that students cared about.

Alexander abhorred the idea of exercises to be practised and wrote copiously about their evils. He also taught that there was no such thing as one stereotyped correct position for each and every pupil.[146] Part I, Chapter 2 of *MSI* (his first book) is devoted to the dangers of exercises, or what was then called "physical culture." He avoided the term "posture" in relation to his work because of its etymological and semantic association with "position." And yet, paradoxically, one of the major features of his teaching were a set of procedures that aimed to achieve "positions of mechanical advantage" (POMAs). The procedures include Monkey, Hands on the Back of the Chair, Lying Down Work, and Whispered "Ah." Other teachers invented their own "procedures," such as Macdonald's "Elevator," Dart's "Spiral" and Judith Leibowitz's "Arabesque."[147] Today these exercises are carried on by many teachers as if they are the hallmarks of the Alexander Technique, more or less confirming Moshe

116 A. COLE

Feldenkrais's* description of the disintegration of the AT after Alexander's death into a set of manipulations of the body.[148] As far as can be ascertained from reports of Alexander's teaching, this repertoire of exercises was combined with a very limited number of activities that more closely resembled those from everyday life, such as walking, and getting in and out of a chair.

Throughout the many decades of her correspondence with Jones, Barstow increasingly made the distinction between what she called Alexander's "technique" and Alexander's "discovery." This was one of her pioneering observations. By technique she meant his teaching language (such as the directions), his reliance on his procedures (and the tendency to reduce activities to getting in and out of a chair) and the insistence that students remain passive, do nothing in response to a stimulus or desire to move, and allow the teacher to move them, thus, apparently, "re-educating their senses." "It seems to me," Barstow wrote to Jones in 1947, in response to – and in order to counter – this development, "in a short course as you will be offering in Portland ... there is one main thing you will accomplish, or attempt to accomplish – that is, show those interested that F.M's discovery has a practical, valuable side and can be most helpful to those who are willing to take the trouble to do a little individual thinking."[149]

In 1948, Barstow wrote, "Don't let her [Alma's] type of teaching depress you for that is the only type of teaching that has ever come from the famous and much talked-of 'technique'." It was in describing her early lessons, which would have been replete with Alexander's procedures that Barstow's description, "a pull, a push and a punch," came about. Barstow recalled finding the feeling of changing conditions "wonderful" but recognized later that the feelings and experiences that came from practising the procedures was not constructive thinking. As we have seen, she still acknowledged Alexander's "remarkable discovery – the discovery of a law of nature" but this, she believed, was "smothered under a much talked-of, over-rated 'technique' which is not standing up under the test of time."[150]

A little later that year, in April 1948, Barstow and Jones were still discussing the teaching at Ashley Place, Barstow writing that she believed F.M.'s technique was "a hindrance" to the "research problem." "When we talk of his discovery we are on a fundamental principle," she wrote; "when speaking of his technique, we are not."[151] In July, this discussion was around Ethel Webb's* fear of change and her rejection of

anything not written in "F.M. style." Barstow believed that it was time for "younger people to take the initiative and go along with F.M.'s discovery as they see fit," and find something more constructive than Alexander's teaching methods.[152] Here she was expressing her wish for Alexander teachers to teach the *process* rather than any set *form* teachers had dreamed up.

Barstow raised the question of what to teach in the Alexander Technique simply by starting to change what she emphasized. Judging by her letters to Jones and by the writings of her students, it was also something she discussed frequently with her students. In the 1980s supporters and students of Barstow's method, such as David Mills and Don Weed, began to ask of her detractors whether they were teaching what Alexander did for himself – that is, the scientific process as applied to human movement – or whether they were simply imitating the ways Alexander had taught others. As Mills observes in his doctoral dissertation, Alexander's discoveries and the method of teaching it are two different entities.[153] Don Weed summarises the debate between those who teach the "procedures" and those who teach the process, observing that we must decide whether we are trying to trademark a particular set of protocols for teaching (employing Mr Alexander's "work") or trying to identify a group of principles, discoveries, and ideas whose applications are as flexible as the ideas themselves.[154]

As indicated earlier, Moshé Feldenkrais, who knew F.M. Alexander and was the founder of another mind-body-function method, lamented what the Alexander Technique had become after Alexander's death.[155] In Feldenkrais's view, the Alexander Technique had lost much of the brilliance and potential of the creator's thought as a standardized practice was developed. Feldenkrais expressed the concern that after his own death his work, too, would become a set of manipulations of the body rather than a functional approach to human learning based on a way of thinking. In 1913 Dewey had described such a phenomenon as "a tendency unfortunately attendant upon the spread of every definitely formulated system." He was describing what he feared would happen to the methods of Maria Montessori – that teachers would "reduce them to isolated mechanical exercises."[156]

Just as Feldenkrais observed, Alexander's procedures have become a kind of jargon and defining feature of the technique in conservative Alexander circles and in the wider public, without carrying a great deal of meaning. John Wynhausen says that before encountering Barstow, he

"had practically equated Alexander work with lying down on a table" with books under his head.[157] This kind of equation is not unusual. A music graduate from a New Zealand university said of her dance and movement class, "Oh yes, we learned about the Alexander Technique: something about getting in and out of chairs."[158] Similarly, at the slightest mention of the AT, a senior music researcher[159] would begin moving his head around strangely as if trying to reach the ceiling or trying to find some elusive position or sensation. Needless to say these two musicians had not been introduced to the technique by a teacher trained in the Barstow style. The impression left on these two musicians from introductory studies appears to have given no hint of the AT's potential to maximize the efficiency of the performer's instrument or increase physical and vocal flexibility and range "while also facilitating the manifestation of thought into embodied action, increasing spontaneity and creative choice," as Cathy Madden describes the AT.[160] Alexander himself complained that, rather than seeing that his technique was simply about "inhibiting a particular reaction to a given stimulus," people would "see it as getting in and out of a chair the right way."[161] "It is nothing of the kind," he said. Yet he continued to perpetuate this impression through his teaching methods.

Michael Frederick says that Barstow described many AT teachers as "getting locked in procedures."[162] By contrast, she felt that the Alexander Technique was a living thing, and therefore the way it needed to be taught was also a living thing. Frederick believes that she "stayed away from those more traditional procedures just because she wanted to put an emphasis on that ability to explore other ways, to experiment." It was not that she refused to include the procedures in her teaching. In line with Dewey's philosophy of starting with the student (the seed of constructivist learning theory, still one of the major accepted learning theories in education today), Barstow worked from and with students' wishes and interests. If Frederick wanted to practise the procedures, and sometimes he did, having trained first with the Carringtons in England, Barstow would work with him in those activities in the same way as she would work with a violinist playing the violin. "I think fundamentally she sees that there's no difference," he concludes. "It's just that she doesn't want her students to get stuck in form." Somewhat contradicting the premise that "she sees no difference," Frederick then concedes that one of the traps he found in doing things like monkey and hands on back of a chair, is that one "gets a little linear in the way the body operates." And as

Barstow taught him, the body doesn't operate linearly. "She really nails me on that," he says. "I've become much more flexible and less moving into a specific form when I teach."[163]

Bruce Fertman tells how his first lesson with Barstow upset his preconceived ideas about the Alexander Technique. This was after he had been studying it for three years and had joined a training program. After reading Alexander's writings and some of Jones's articles, he felt that he was still "off track." "I was sitting, literally, on the edge of my chair," he says, "feet on the ground, legs uncrossed, perfectly symmetrical, back straight, palms up, 'directing' a mile a minute, doing my Alexander best. Marj came over, steady, unhurried, and placed the tip of her index finger ever so lightly upon my rigid chest and said 'Sit back. Why don't you just take a good old slump?' I did what she asked as best I could, having not slumped in years."[164] The way he describes his "Alexander best" can be a result of teaching that is, as Frederick described, stuck in form and linear, or as Martha Fertman put it, "replete with orders and positions of mechanical advantage,"[165] and the idea that there are right positions for us to be in, which encourages a lack of movement and experimentation.

Having introduced the general question of teaching with set procedures, I will now examine Alexander's rationale for his procedures and describe the most common ones in detail. Jean Fischer lists the "Classical Procedures" as: Chair work, Going up on the toes, Hands on the back of the Chair, Lunge, Monkey (a position of mechanical advantage), Squatting, Table work, Walking, wall work and whispered "Ah." I was introduced to many of these in my early Alexander lessons. In my lessons with Madden all of these – except for walking, which can be categorised better anyway as an activity of daily life than a procedure – fell away and I was invited to go directly to whatever activity meant the most to me, which was usually singing.

Alexander's Rationale of the Procedures

It seems that what Alexander was trying to achieve with his positions of mechanical advantage was what others had been trying to achieve through relaxation exercises. Whereas what others achieved was "collapse," Alexander argued: "Relaxation really means due tension of the parts of the muscular system intended by nature to be constantly more or less tensed, together with the relaxation of those parts intended by nature

120 A. COLE

to be more or less relaxed, a condition which is readily secured in practice by adopting what I have called in my other writings the position of mechanical advantage."[166]

Alexander describes the position of mechanical advantage, which "may or may not be a normal position," as "the position which gives the teacher the opportunity to bring about quickly with his own hands a co-ordinated condition in the subject. Such coordination gives to the pupil an experience of the proper use of a part or parts."[167] He claims that it is "by the repetition of such experiences" that the pupil is enabled "to reproduce the sensation and to employ the same guiding principles in everyday life."[168]

Here is the principal reason Barstow stopped using the procedures: This approach tended to encourage students to try to reproduce, on their own, the sensation they had experienced in their lessons. Alexander had been very clear that we should not rely on our senses because the senses are unreliable, particularly so, he thought, before students had learned the Alexander Technique (see also the discussion of Sensory Re-Education, under Term 5, below). Alexander acknowledges that such positions "would ordinarily be considered an abnormal position" but insists that the mental and physical guiding principles that are apparently established "enable the pupil after a short time to repeat the coordination with the same perfection in a normal position."[169] Such experiences from my own early Alexander lessons *never* translated into normal positions, I was never able to reproduce the sensations on my own, I never experienced "perfection" on my own, and my understanding about the mechanisms and processes Alexander technique was poor.

It should also be noted that Alexander claimed that by his "system of obtaining the position of '*mechanical advantage*,' a perfect system of natural internal massage is rendered possible, such as never before has been attained by orthodox methods, a system which is extraordinarily beneficial in breaking up toxic accumulation; thus avoiding the evils which arise from autointoxication."[170] Alexander also maintained that "any case of incipient appendicitis may be treated successfully by these methods"[171] and that "the real cause of the development of such diseases" as "cancer, appendicitis, bronchitis, tuberculosis, etc." was the "mental and physical limitations and imperfections of men and women" and "the erroneous preconceived ideas of the persons immediately concerned."[172] It is to be hoped that no AT practitioner subscribes any longer to such beliefs, but the procedures do continue to be taught in the name of Alexander.

Despite what Alexander believed, about avoiding the terms "posture" and "position," his descriptions of the "positions of mechanical advantage" strongly suggest that he believed that there *were* particular positions in which one breathed or otherwise functioned "to advantage." He articulates the way in which his technique provides these positions so that breathing exercises may be done in a way that will not cause emphysema.[173] "If the fundamental principles of my method are observed," he claims, "the conditions [that cause emphysema] cannot be present during the practice of the exercises, and, therefore, emphysema not only cannot be produced, but is even likely to be remedied when previously existing."[174] In the same article he claims that "a mechanical advantage is essential to the proper expansion of the thorax for the intake of air."[175]

Further evidence of Alexander's confusion about what he really means, and where he really stands (pardon the pun) on the issue of "right positions" can be found in a 1909 pamphlet.[176] Here he contradicts himself on a single page, saying first that the process is "really a *re-education of the kinaesthetic systems associated with correct bodily postures and respiration.*" Two paragraphs later he emphasizes that "there can be no such thing as a "correct standing position" for each and every person. The question is not one of correct position, but of correct coordination."[177]

Fischer also observes Alexander's inconsistency, but describes what he calls "apparent differences" as "differences of emphasis, not of essence." He explains that they "testify to the dual nature of the situation: a mechanically advantageous position facilitates a release in exactly the same way as a certain release facilitates and supports a position." Fischer concedes that the term "position of the mechanical advantage" is misleading, but that this is only due to *our* familiar associations with the words and our *unfamiliarity* with Alexander's experiences and concepts.[178] Fischer does not elaborate on what our familiar associations with the term might be. Alexander, too, stressed that the term was not satisfactory: "The position thus secured is one of a number which I employ and which for want of a better name I refer to as a position of 'mechanical advantage'."[179]

Rather than working (as Barstow and Dewey did) to clarify his terms and concepts and how he could best teach them, Alexander built his teaching technique upon the inconsistency and contradictions. Rejecting the idea of both exercises and right positions, he invented and continued to teach a variety of exercises and positions to help pupils experience and

understand mechanical advantage. Not only that, but many of his claims about the procedures required a subscription to his beliefs and points of view. Many of his beliefs would not be accepted by anyone today, such as the aetiology of emphysema and tuberculosis. But perhaps the limitations of his beliefs are not restricted to his extravagant claims about health and pathology, but also apply to his understanding of how we learn. At the same time as Alexander was *telling* people what worked (in all manner of fields), across the Atlantic, Dewey was experimenting in his Lab School – applying the scientific process to teaching and trying to *discover* what worked in teaching and learning. It was the latter whose teaching methods Barstow's most resemble.

Following are descriptions of some of the procedures. They are either by Alexander or, where there exists no explanation by Alexander himself, by first generation teachers.

Monkey (and Lunge)

> We never told him that's what we called it. I don't think he would've been too pleased.
>
> —Erika Whittaker

Jean Fischer (editor of many of Alexander's works in high-quality and well referenced editions) describes "Monkey" as "a bending position," where the knees are forward and (often but not always) the torso is bending forward from the hips.[180] There are no extant descriptions by Alexander of "Monkey" in the sense of standing, knees and hips bending.[181] Erika Whittaker says that F.M. showed those in the training course "what is now known as "Monkey." We never told him that's what we called it. I don't think he would've been too pleased."[182] Whittaker perpetuates the confusion about exercises, claiming that Monkey "was not considered an exercise but a piece of coordination that he thought was very important for working at different levels."[183] She describes it as "a preparation" for activities such as washing up or ironing, just as "hands on the back of the chair" was "a preparation for using your hands and other levels."[184] "It was a very fine way of coordinating your head, hips, knees and hands: the totality."[185] As Barstow saw, however, it is not really a totality, as the term "coordination" requires a context, an application and an end. If not, the supposed coordination dangles abstractly without purpose and is untested. What *is* coordination if it is not applied to an action? For

affirmation and confirmation that this exercise really does "coordinate," then, we must return to relying on the belief of Alexander's dogma. It might *feel* co-ordinated (somehow, or to some unspecified purpose), but precisely *how* to take this coordination into another activity remains a mystery unexplained by Alexander. It is the very abstractness of this "piece of coordination" that renders it an exercise.

The closest and earliest thing to a description of "Monkey" given by Alexander is in a 1910 pamphlet, where he called it "Door Exercise."[186] A photograph survives of Alexander teaching "Monkey" (or the "Lunge," which Fischer describes as a "variation on Monkey") to Deborah Frank*.[187]

Jones, who trained with F.M. Alexander in the 1940s, described "Monkey" as producing a state of plastic tonus throughout the extensor system.[188] Alexander's niece Marjory Barlow goes into great detail about how "Monkey" should be done, and claims that "lots of it" should be done: "Anything to encourage those muscles to work," she says. "It's the back. You've got to get the back muscles working."[189] Patrick Macdonald concurs, "A variation I find difficult to understand is the omission by some teachers of the use of the 'position of mechanical advantage' as F.M. called it – what we call Monkey Position. It is much the easiest and shortest way to get the lower back working."[190,191]

Again, as I suggested above, if the back only learns to "work" in "Monkey," how does the back know when it is required in another activity, and to what extent and in what way? How do we transfer this "working" of the back to other activities? Of what use is the position of "Monkey" in everyday activities? What does Barlow mean precisely by "the back muscles working"? Which ones? Working how? And for what purpose? If it is just to work or stretch muscles in isolation for no reason, then this is the definition of an exercise to be practised, something that Alexander abhorred. Such random widening of the back without application to activity could encourage reliance on the *sensation* of width, something Barstow wanted to avoid. If Monkey is to "get the lower back working," then it also encourages an excess of attention on the back of our organism, when we also have a front and sides, where most of the muscles that help to balance us are to be found. Madden, who taught alongside Barstow as she made many of her changes to language, talks about torsos, rather than backs, and frequently reminds Alexander trainees that we have a front side, back side, inside, outside, right side, left side, up side and down side (and see the discussion of the back and torso

124 A. COLE

under "Direction and Directions," above). Barstow did teach "Monkey" in the early 1970s, according to the notes from Sarah Barker's journal of 1972: "Worked with 'Monkey (business) position' … Monkey stand also widens the back."[192] It had disappeared from Barstow's teaching by 1975, Madden believes.[193]

Note that there are two procedures that require the use of the chair, one very particular exercise designed by Alexander, "Hands on the back of the chair," and the other a more-or-less everyday activity of sitting down and standing up, which I shall call "Chair work." The reliance on chair and table has led to the term "Chair and Table School" to describe those who teach in Alexander's prescribed way.

Hands on the Back of the Chair
A description of this exercise appears in a 1910 publication Alexander called "Supplement to Re-Education of the Kinaesthetic Systems." He calls it here "Chair Exercise [Standing]."[194] The description is a page long, so I will point out only the salient features. The student stands behind the chair with the teacher standing behind the student in order to "manipulate to the best possible advantage." While the student rehearses or gives "the mental orders" the teacher inclines the student's body "forward and upward in the direction of the chair" and must "cause the pupil to place his hands, some distance apart, upon the back of the chair." The four fingers are kept "quite straight on one side of the back of the chair and the thumb on the other side of the back of the chair." Revealing his lack of anatomical knowledge, Alexander then says that the student must grip the back of the chair while relaxing the muscles of the arm. The fingers are controlled by the muscles in the forearm. It is not possible both to use a muscle and relax it at the same time. The directions hereafter become increasingly complicated and confusing. The student is asked to "pull the top of the chair as if endeavouring to lift it," while "allowing the right elbow to point directly towards the right and left elbow towards the left." The teacher helps the student to "support the body in the required mechanical position." In a final act of mysterious control, the teacher "will then bring about the activities of the respiratory and other processes."[195]

Barstow never mentioned this procedure in her correspondence with Jones. It is a good example of what she described as a set fixture, apart from being the antithesis of her practice of making ideas clear. Probably also because it lacked any practical application *and* did not encourage movement, Barstow excluded it from her teaching practice.

My own experience of this procedure is that it is fun and challenging and is accompanied by an unfamiliar and quite pleasant combination of stretches and pulls ("sensations of those important antagonistic pulls," as one trainee described it, but important for what and why?).[196] I recall my most overriding impression being admiration for Alexander, in trying to work out how he had come up with such a curious exercise. The problem was that I could not apply it to any other activity. I would try to reproduce the feeling when I was singing, with no success whatsoever and probably a great deal of tension from trying to do so. My lasting impression of the exercise was of failure, mystification and frustration.

Chair Work (Getting in and Out of a Chair)
In his final book *UCL* (1941) Alexander explained that in the employment of his technique the difficulty of changing habits is taken into account from the start of the lessons. "Hence," he explains, "in any attempt to help a pupil to change habitual reaction, I begin with procedures that involve only simple activities on the pupil's part, such as sitting and rising from a chair, in order to give him in the easiest way the opportunity to inhibit his habitual response when any stimulus to activity comes to him."[197]

The act of sitting down and standing up was one of Alexander's central teaching activities. Where it became an exercise, and lost relevance to daily life, is the point at which it became a repetitive act, alternating between sitting down and standing up. As mentioned, Alexander himself saw the danger of this when he described the way students saw the AT as "getting in and out of a chair the right way."[198] While claiming that it was "nothing of the kind,"[199] he continued to use this as a central teaching activity. Perhaps he meant it as a symbol for all the acts of living, which offer the student "a real and never-ending intellectual problem of constructive control."[200] Alexander observed that a student, as soon as he touches the chair, will "make certain unnecessary movements and alterations in the adjustment and general condition of the organism, involving that imperfect use of the mechanisms which he subconsciously employs in order to seat himself ["sit down"]."[201] Similarly, "when he stands up, he 'feels' the way to stand up, and repeats the same subconscious indulgence of his automatic habits," says Alexander.[202] When sitting and standing are performed with constructive conscious control, however, Alexander says that "the process involves an adequate and continuous state of increasing awareness in regard to the use of the mechanisms, so

that immediately there is a wrong use of these mechanisms, the person concerned becomes aware of it, and at once substitutes a satisfactory for the unsatisfactory use."[203]

Alexander's rationale for choosing this activity for almost everyone was that while it employed many unconscious habits and patterns of movement, it was not usually associated with a strong emotional impulse or "cultivated habits,"[204] things which make "un-learning" more difficult. The drawback of this lack of investment in the *how* of getting in and out of a chair is that it is usually accompanied by a lack of care or interest, and a lack of motivation or incentive to make any change. Walter Carrington quotes one of his students as saying, "I know what is the trouble with me, I don't really want to do this."[205] In my own lessons that involved chair work, I certainly had no interest in, or concern with, the way I sat down or stood up. My heart always sank when a teacher suggested chair work. It was an unconstructive learning experience to have to rely completely on a teacher's feedback on how I was doing. And since I couldn't tell whether I was sitting or standing in the habitual way or the new way, I never improved. It remained hit and miss. Whether or not I succeeded relied entirely on chance. What's more, I wasn't curious enough about learning how to succeed in this activity because I didn't care enough about it. My awareness did not increase, although my confusion about what was required did. I did not learn to become aware of my wrong use, as Alexander said I would. In *ten years*, this never changed. I did not learn to substitute satisfactory for unsatisfactory use in the act of sitting and standing and I never gained any independence in making changes. Indeed, if lessons had consisted only of sitting, standing and semi-supine, I would not have continued. I became increasingly frustrated and impatient during any time spent on chair work. When I sang in my lessons, however, I could *hear* immediately when a change in my use had occurred. I did learn to recognise unsatisfactory use and I did learn to make changes to my general coordination on my own. To summarise, then, the disadvantages of this activity are: lack of motivation and desire, lack of obvious feedback and clear information, the dependence on the teacher and, in my own case, a complete lack of progress in a decade. It wasn't until I met a teacher who trained with Barstow that I was encouraged to direct lessons based on my own desires and priorities, increase my independence and observe immediate changes in my coordination through clear thinking and moving (see also Chapter 5 on wishes and desire).

4 RECONSTRUCTION: BARSTOW'S RECONSTRUCTION ... 127

Marjorie Barstow did sometimes work with people getting in and out of a chair. Her earlier teaching still focussed heavily on this activity. Late in her teaching career, it seems that chair work only featured in a lesson or class if a student requested it. William Conable says that she was still using it generously in the early 1960s. Sarah Barker's journal from the 1972 summer workshop includes mention of chair work: "Began the morning by watching each other get out of chairs very slowly."[206] Her journal suggests, however, that this was just one activity among many. Moreover, even in 1972 Barstow's emphasis seemed to be on getting the students to watch one another in the process, thus training observation and analysis rather than an introverted process of self-focus and reliance on the feelings generated by the teacher's hands. Michael Frederick says that it was the main activity in the first class he attended of Barstow's, which was in 1974. "Marj Barstow came to the University of Iowa, to the music department, and I went there to check her out, as it were, and she was giving classic chair turns in front of a group of musicians and other people who were interested."[207] Robert Rickover's response to this is: "That's interesting that she was doing a sort of a traditional chair lesson at that point. By the time I first met her, which was in the winter of 1979, 1980, I think it was here in Lincoln, she wasn't really doing those kinds of lessons anymore."[208] Cathy Madden says: "I started studying in 1975 and I didn't know chair work, semi-supine or monkey existed until many years later. [Marj] did none of those."[209]

By way of overview, Don Weed observes that as the years went by, Barstow used a chair less and less often.[210] By 1988, he claims, almost everyone who was working with Marjorie at that time found it hard to believe "that we used to get in and out of chairs regularly."[211] It seems, then, that Barstow's use of the chair as a regular activity disappeared gradually but that perhaps there was also a significant shift around 1974/1975. As I describe in Chapter 5, she replaced this with activities more pertinent and pressing to the lives of her students.

Semi-Supine, or Table Work

Semi-supine was also called "table work," or "lying down work." A description of table work and its benefits are not set down anywhere by Alexander. In my own experience, the student lies face up on a table that resembles a massage table without the face hole. The knees are bent, and the head rests on a small number of paperback books. The AT teacher

moves the student's limbs gently (and sometimes not so gently), occasionally reaching under the torso and stretching out the spine. One student in 1947, Eva Webb, wrote a diary of her lessons with Irene Stewart* at Ashley Place. She describes the table as having "no give." "It was I who was supposed to 'give', and meanwhile it felt hard to my unyielding bones!"[212] Webb describes the procedure thus: "Irene Stewart showed me how to think myself on to a table and then allow my back to 'unroll' as she lowered my head to rest on a covered book. This was not, of course, to her satisfaction, and she re-arranged me where I lay, with a good deal of stretching and bending and the hope that I was doing the thinking."[213]

It is presumed that for severe end-gainers, Alexander considered it necessary to remove all traces of impulse (or temptations to "do") before they could be given an experience of satisfactory use. The fact that there is no written reference by Alexander to this practice has led to some controversy over the authenticity and value of table work. It seems, as will be shown in the following review of sources, that while he prescribed it, it did not form part of the private lessons he taught, presenting yet another of Alexander's contradictions.

There is a clip on YouTube in which Alexander's niece, Marjory Barlow, answers a question from an audience member about whether F.M. worked with people on the table.[214] The question is: "I receive from my teachers conflicting information in answer to the question 'Did F.M. work with people on the table?'" Barlow's answer is elliptical. She starts by grumbling about myths and "things that aren't true." She appears to be saying that there is a "myth" that he did not do table work. She seems to be about to say that he *did* do table work and then pauses and sidesteps away from the question at hand. She distracts attention away from this realisation by inventing new questions: whether F.M. taught trainees how to do it, whether he thought table work was important and whether he approved of it. Transcribed, her answer is as follows:

> Oh yes, yes. This is a very good question, because you know I spend my life trying to get rid of the myths about Alexander [laughter] yep [pause] things that aren't true. He certainly worked [pause] he didn't have a table in his teaching room, but his assistants used to take the people after they'd had a lesson from him, take them on the table. And in the first training course, he spent hour after hour after hour, day after day after day teaching us how to do it: exactly how to give a lying down turn. So he thought it was very important [pause]. He said that it was a wonderful

opportunity for people when they were lying down to pay attention to their orders. They didn't have to bother about keeping their equilibrium or their balance. So he thoroughly approved of it, or he wouldn't have taught us how to do it.[215]

We can only deduce from this that Alexander himself did not actually do table work. But Barlow does not seem to want to say this. She wants to underline her uncle's *belief in its importance* rather than allowing his avoidance of it to reflect poorly on table work. She does say elsewhere that if F.M. "wanted to work with somebody lying down, that was usually when he would pass them on to one of the teachers and he would come and help." In the clip transcribed above, Barlow is standing on a stage in front of a massage table draped with a white sheet. This gives the impression that the table is central to Alexander work, or is even a kind of symbol for it.

Barstow's recollection fits with Barlow's answer. She recalls that it was the assistants who did the "lying down" lessons.[216] When asked by Stillwell if table work originated with the two women, Tasker and Webb, Barstow assures her that it was F.M. Alexander's invention. She also observes that the table work seems to have gained in popularity *since* her own training. Barstow recalled that both brothers used the "chair work" throughout their teaching, and that although she noted that the "lying down" work had become very popular in the training in the 1970s, "the Alexanders, themselves," she said, "did not give many 'lying down' lessons. If they felt someone would be helped by having it, it was generally Miss Webb or Miss Tasker who gave that work. I used to get 'lying down' lessons during the first six months we were there, from Miss Webb. In the training course we worked with each other."[217]

Alexander himself may be indirectly responsible for the increase in its popularity, not by practising it himself, but by what he prescribed. One account of lessons in 1947 documents that Alexander gave a consultation and just one lesson to new students, who were then referred to his assistants with a prescription such as, "I should give her plenty of time on the table, Rene."[218] By delegating in this way he perhaps caused his trainees and assistants to value the table work more than other activities or procedures, since it was in that practice that they had the most experience.

Erika Whittaker, on the other hand, says that Alexander did not "even approve" of table work when she was training, which was from 1931 to 1934. She is perhaps one of the teachers to whom Barlow referred

130 A. COLE

obliquely above, when complaining about people who propagated myths or "things that aren't true."[219] Whittaker says that F.M. considered "lying-down turns" "too therapeutic and just a nice rest."[220] Both she and Irene Tasker confirm that Alexander referred the "lying-down turns" to Ethel Webb or Tasker herself: "He did often ask Ethel Webb to 'put down' a pupil after a lesson with him."[221] A report from a pupil at the Alexander School in Stow (Massachusetts) in 1941–1942 indicates that this was the common practice there too: "Miss Webb was the only one that I remember who gave 'lying down work'."[222] The other teachers were F.M. Alexander, A.R. Alexander, Margaret Goldie and Irene Stewart. Whittaker regrets not having enquired of Alexander how he explained the apparent contradiction. She comments that they did not do "much lying-down work in those days; in any case there was only the floor to do it on, except for a kind of trestle table in the small back room."[223] This, then, accords with Barstow's observation that table work grew in popularity after F.M.'s death.

Whatever Alexander's view of table work, its appeal to performers is probably limited. As Madden said once in class when asked about table work, "If I'm lying on a table, I want a massage!"[224] Barstow observed in 1986 that table work was incompatible with her movement-oriented approach, saying, "I don't work on the table. I think the Alexander Technique is about movement. I like to work with my pupils in their daily activities."[225] Already in 1948 she had moved away from using it in her teaching. She also confirms Marjory Barlow's story that it was Alexander's assistants who did the table work, as if it were not the main staple of the technique. In a letter to Jones, she writes: "The idea of lying on a hard surface with a book under the head is a relic of Ashley Place and too antiquated for me now. However at one time I did the same thing and I had many such lessons from E [Ethel] Webb and I [Irene] Tasker. Then I thought they were wonderful, as I have mentioned before, but there was nothing constructive about them and [they] made me entirely dependent upon the teacher."[226]

Jones observes that table work gives an impression of the Alexander Technique as relaxation therapy. He did not know the Alexanders to do table work when he was training in the 1940s: "So far as I know, the Alexander brothers never did 'lying-down-work' of this kind unless they had a pupil who was bedridden. In my observation, it gives a wrong first impression of the technique, as if it were a form of relaxation therapy."[227] In 1975, according to Madden, Barstow did not even appear to own a

table for such work. John Wynhausen also noted the absence of a table in 1979. "The first Alexander tool I had looked for at Marj's house were tables for lying down work," he says. "There weren't any."[228] In 1981, Barstow is reported as having said that another reason she did not teach with the table was because of the immediate needs of the performing artists she taught. She noted that her teaching situation was different from that of the Alexanders: "Most of their work, at the time I knew them, was dealing with middle-aged or older people. I work mostly with university students. Most of my students are active in the performing arts and business. They want something that they can make use of right now."[229]

Finally, in the same letter as quoted above, Barstow articulates another reservation she has about "lying down work," that is, the over-straightening of the spine.[230] "There are times when lying down has its advantages," she writes, "but not in that form and certainly the flattening of the back is not the thing to be stressing." She also expresses the same concern as Moshe Feldenkrais, that of Alexander's work becoming a set of meaningless exercises. "I would say Alma is carrying on some glorified kind of gymnastics as are the other teachers. That is all they know, that has been their training."[231] Showing her emphasis on critical thinking, awareness and the importance of the whole over parts, Barstow asks, "How does she know she should have 2 books under her head? What is happening with the rest of her when she is so interested in the flattening of her back?".[232]

Barstow asks again in another letter, this time in 1968, where the idea of piles of books came from. "The idea of a person's head on a pile of books is another question. Walter and his followers use it and I cannot understand where they got it, that is, several books. Ordinary observation shows that it throws the head too far forward and out of line with the normal poise of the head, while one book, which may need to be of different thickness for different people, aligns the head with the whole body."[233]

This dichotomy between table work and active work suggests the kind of split between theory and practice that Dewey was against, and the kind of mind-body split that Alexander rejected. The table work, as described by Barlow, is a kind of chance to work on theory: practising your directions without having to worry about balance, equilibrium or application to everyday life and therefore without stimulus to which to react. Activity work could be seen as the practice. Like Dewey, Barstow believed these

132 A. COLE

must be integrated, which is why she restructured the lessons to align with Dewey's description of the AT: thinking *in activity*.

Whispered "Ah"

The only studies or exercises Barstow retained from Alexander's teaching repertoire were the whispered "Ah" and walking. As Fischer explains, the 'Ah' has a long history in singing, and he quotes Crivelli's 1841 *L'Arte del Canto*, as an example.[234] Crivelli is just one of many 19th-century *bel canto* vocal pedagogues. It is probably an impossible task to find its true origin and well beyond the scope of this book, but it would have been much earlier than this judging by its use by Classical and Baroque composers in long *melismata*. What is unusual about this exercise is its "whisperedness." Fischer points to Aiken[235] and Hulbert[236] as evidence that this exercise had been part of vocal training before Alexander adopted it for his technique. In Alexander's own words, "We must resort to the whisper tone, which is rarely used in speaking, and is, therefore, little associated with cultivated bad habits. It affords, also, the most favourable opportunity for freeing an unduly depressed larynx and correcting the imperfect action of the vocal reeds, soft palate, cheeks, and tongue, and the student is more easily enabled to open the mouth correctly."[237] Barstow continued the practice of this exercise for most, if not all, of the rest of her life.[238] She appears to have considered it to have enough inherent movement that it did not threaten to become a "set fixture."

Deconstructing the Procedure Method

As explained in many of the descriptions of individual procedures, Barstow saw that consistent attention to process was missing in the procedures-oriented approach advocated by Alexander. As mentioned in Chapter 3, Barstow observed that their form offered something for students and teachers to "grab on to" in the absence of really understanding the process of the AT.[239] Further, they presented a number of problems that Alexander had either not noticed or considered, or did not care about. First as we have seen, the procedures had unclear goals and gave unclear messages to students about whether the Alexander technique was a set of abstract exercises or a practical tool for everyday life. Second, the fact that they included *positions* of mechanical advantage was a further confusing message about whether there was such a *thing* as a correct or right position (Alexander claimed that there *wasn't*, but often taught as if there *were*). Third, practising the procedures did not help students apply the Alexander technique to real activities in their lives. Fourth, if we take

Alexander's description of them, the procedures make the student entirely dependent on the teacher. Fifth, their abstract and esoteric nature make it difficult to engage students' interest. As Alexander pointed out, students were unlikely to be invested in the outcome. Without this investment in the outcome, however, why would they be interested in the means whereby they were to reach that outcome? As Carrington points out, his student did not "want to do this" (see Chapter 5 for further discussion of this). Finally, and to reiterate, the procedures are static and fixed and do not encourage natural movement. As I described under the heading "Inhibition" above, Barstow's approach to the technique was based on the premise that if we resist movement, we make ourselves stiff.

Barstow ultimately stopped teaching the procedures and giving her students passive experiences, encouraging them instead to think and move and apply the technique to their passions. The only "procedures" she retained were walking and Whispered "Ah," both of which can (and must) be done independently of the teacher. Barstow's approach thus put a greater emphasis on process. It elevated movement and desire to key concepts in the technique. This change of emphasis was of enormous importance in shifting the Alexander Technique away from its treatment-focussed bias and towards the goals of constructive education.

Before ultimately rejecting the procedure-based approach, Barstow taught for many years in Alexander's way, both as A.R. Alexander's assistant in New York and Boston and in Nebraska. In the 1940s she began to experiment, while still adhering closely to the process Alexander had outlined. "Approaching the subject in my own fashion," Barstow wrote to Jones in 1948, about teaching a new student who had come to stay with her for ten days, "even I was surprised at the response from him and the simplicity with which I was able to get him to see that by directing his thoughts to acquire ease and freedom of movement the old habitual strains through his body disappeared."[240] The new student was accompanied by his sister, whom Barstow had previously taught "in the formal Alexander method" and who had "improved noticeably," yet with the development of "that form of rigidity that is seen in all pupils under such training." Barstow commended the sister for being "a good sport" as they discussed the change in Barstow's teaching and having to break down that rigidity. "We were both pleased with what she accomplished," Barstow reports.

Barstow's "own fashion" meant three things. First, it meant generally preferring process and principles over form (such as Alexander's language

134 A. COLE

or procedures). It also meant prioritising thinking over feeling, and movement over feeling. It meant guiding her students to think constructively *at the same time* as she guided them towards an independent experience of good use, rather than giving them a passive, teacher-induced one. She became a master of subtlety and restraint in order to keep students' experiences in lessons in line with their thinking, rather than taking them past what they could do on their own. In her words, "As teachers our hands should guide the pupil rather than take the pupil somewhere and say, 'That's where you belong.' When we do that we are wrong because a pupil belongs, momentarily, only where his thinking and the guiding hands of the teacher show him, and no further." She acknowledged that this was a different approach from the Alexanders, but gave "good reasons," as Marjory Barlow said she also did when changing an aspect of the technique she had learned from her uncle.[241] "This may sound strange to you," Barstow wrote to Jones, "but am sure I can prove it to you the next time I see you. If our teaching is changed on this one point alone we will find a great difference in what our pupils learn. We have been teaching as we were taught ... In the past, as pupils, we have all expected and allowed the teacher to do too much for us."[242] This change in the status and independence of the student and the role of the teacher aligns with Dewey's educational principles. Dewey believed that the most significant learning happens when students are *guided* by teachers, rather than dictated to by teachers, and the teacher is guide, not god.[243]

As I discussed under "Inhibition," and as William Conable observed, one of Barstow's "most clear and brilliant insights" is that the Alexander Technique is about movement.[244] That this is a unique insight by Barstow suggests that other Alexander teachers of Barstow's generation were restricting their movement. Any criticism Barstow made of other teachers of the AT were about stiffness and holding fixed positions, which is why, Conable explains, "unless you really press her she doesn't spend time on anything that you could make into an exercise."[245] One of the reasons that Barstow moved her teaching away from the set procedures as laid down by F.M. Alexander was that they removed the focus of the technique away from movement and inadvertently towards "set fixtures," as she called them. In a letter to Frank Jones in 1973, Barstow writes: "Give my greetings to Walter and all the ones I know in London. I had to smile at your reference of feeling like a missionary. I think I would have the same feeling. After working with some of Walter's students I found out

4 RECONSTRUCTION: BARSTOW'S RECONSTRUCTION ... 135

that they have not learned that giving 'orders' is a procedure that turns into activity and not fixtures."[246]

Barstow's descriptions of the AT always include a reference to movement. Her introduction at the beginning of the voice-over of a filmed workshop in 1986 was such a movement-oriented definition: "The first thing that I think is very important ... [is] to help people to realise that it's a very unique [sic] and unusual approach to the study of movement."[247] In a more detailed description for an oral history project by the Nebraska Historical Society, she says that the AT "is information that is valuable for anyone who wishes to improve their efficiency in movement." She explains that "without recognizing it we put an excessive amount of tension and strain on our bodies, downward pressures. You can always see it. You know, the way everybody sits in a good old slump? It's constructive thinking to help you recognize how you mistreat yourself in movement."[248] In 1969 she taught a group of students at "the Institute."[249] "Last week we discussed balance from many angles," she wrote to Jones, "stressing the fact that it is always motion and not static, and we talk about the various activities they get in the other classes. I relate and then prove how the primary control aids in all they are doing. When they try it out in other classes they then prove it for themselves."[250] And in a discussion (by letter) with Jones about the primary control and coordination, she finished with this summary: "A most remarkable form of conscious awareness and control which allows me to work at any activity with the greatest ease, freedom and efficiency."[251]

As Conable observed above, fixed positions and stiffness were Barstow's main criticism of her students, her colleagues or their students. "She does not like to see people slouching around, but I think she probably prefers that to rigid posturing," he further explained.[252] Barstow was interested in movement for a variety of reasons and as a result of a variety of influences. She was a dancer, having studied ballroom dancing, ballet and a kind of modern dance influenced by Isadora Duncan. As Marsha Paludan explains, the Duncan style was about the exploration of movement and encouraged the freedom of movement.[253] Paludan suggests that it was precisely Barstow's interest in *freedom* of movement that prompted her to study with Alexander. With her interests in this particular kind of dance, as well as the natural and co-ordinated movement of horses, her patience must have been severely tested with the growing tendency of Alexander teachers to encourage "set fixtures."

136 A. COLE

Martha Fertman was studying the AT with Kitty Wielopolska* when she met Marjorie Barstow. Fertman had developed a reputation as a dance teacher who could help with difficulties and injuries. She says that this was because she had been learning about the Alexander Technique as if it were about "alignment."[254] On her way to her first workshop with Barstow, she was prepared for "any level of rigorousness, asceticism, or tedium," but she found instead a liveliness that was absent from her previous training. To her surprise, the workshop was overwhelmingly lively; it was full of sound, action, motion, and energy. "Even in the act of moving," Fertman noticed, "there was thinking," and an alive, inquiring, intending mind. "That this should have something to do with movement was a revelation, both from the point of view of more 'traditional' Alexander Technique, which in my experience had been replete with orders and positions of mechanical advantage, and from that of my dance training which had also had its full measure of directives and right positions."[255] Others noticed this emphasis on movement, too. Saura Bartner, also a dancer and ACAT-trained AT teacher, singled out movement as the differentiating feature of Barstow's teaching. "This is what Marjorie Barstow does differently. She encourages us to move. To think and to move and think and move."[256] Sarah Barker observed that "the ease can come as we move" and that "improvement always comes through motion."[257]

Other teachers, entirely unconnected to Barstow, have made similar discoveries. Jane Staggs, for example, had taught the AT for almost twenty-five years in what she calls the "traditional" forms when she started to notice her long-term students "gently falling apart." She began to realise that they needed to move more. Staggs decided to explore Pilates and even trained as a Pilates instructor in 2006. To her delight the Pilates work improved her coordination and in turn her use in everyday life.[258] Barstow was doing this without recourse to another discipline more than thirty years earlier. As Lena Frederick observes of Barstow's work, "I saw that working with people in activities put the Alexander work into the realm of movement, which was where my interest in it had originated."[259]

As I discussed above, under "Inhibition," the reservation Alexander teachers have towards movement probably comes from the ideas of "non-doing" and "inhibition." While this idea of "non-doing" came about to help people understand the way we habitually interfere with our natural coordination by overdoing – or ineffectively expending – the effort that is required for any given movement, an unfortunate side effect of the phrase has been that students of the technique believe that

4 RECONSTRUCTION: BARSTOW'S RECONSTRUCTION ... 137

they don't have to move or indeed must inhibit *all* movement. It also feeds into, and may even have contributed to, the idea that we should be relaxed and de-energised when we perform. Jane Heirich's comment about robotic, de-vitalised wimps is an example of this.[260] Alex Murray offers "relaxed playing" as a goal of studying the Alexander Technique.[261] Cathy Madden, who teaches in Alexander training schools around the world, noted in a keynote conference paper the widespread perception in the Alexander world that the AT is about doing less. She also noted the common perception in the performing arts world that the Alexander Technique turns you into "a wet noodle", hardly appealing to performers or performance institutions.[262] And yet, the word "relax" is hardly new to performers and athletes, the most successful of whom are often described as "relaxed." Better words would be "coordinated" and "efficient." The AT can even create *more* of the tension we are trying to lose if, in attempting not to "do," we start holding ourselves and our breath.

Cathy Madden took on Barstow's emphasis on movement in her own teaching. It is one of the things that caught my attention in my first encounter with her. I realised I was puzzled – and always had been – about what happened, when practising the AT, at what Madden refers to as "the joint between head and spine," (or the atlanto-occipital joint, the point at which Alexander described the "primary control" as existing). When I first met Madden, she called this movement "the coordinating movement." When I asked her to clarify this further, she said, "It's *movement* we want." This was really a surprise to me after ten years of AT lessons and thinking that it was only the *potential* for movement that was required,[263] and that one should *do nothing* in response to a stimulus. This began a process of *allowing* for me, which started to undo a great deal of the holding and stiffening I had previously been employing in the production of my voice, thinking that I was practising the Alexander Technique as a way of also executing singing teachers' instructions to move less. One of the greatest discoveries I made by not just *allowing* movement in my practice, rehearsals and lessons, but by *exploring* it actively, was the connection between movement and meaning. Moving revealed itself to be an extremely important part of interpreting the text and music of a song for me, something I had been blocking by trying to obey the countless messages I had received from teachers – singing and Alexander – to limit my movement instead of encouraging, investigating and experimenting with it. This process was greatly facilitated by

138 A. COLE

Madden, and she includes a description of helping me explore it in her first book.[264]

In another attempt to encourage students to move, Madden often clarifies the concept of "effort," so that she minimises any chance for students to interpret the AT as "doing less."[265] In accordance with the "non doing" I described above (under "Inhibition"), many teachers and students equate the Alexander technique with less effort.[266] Alexander himself originally used the phrase "true primary *movement*."[267] Unfortunately he later revised this expression to "primary control," which reduces the idea of movement. His decision appears to have contributed to much of the confusion about positions, inhibition and non-doing and the stiffness often observed in Alexander practitioners.

In summary, Barstow's emphasis and insistence on movement was unusual in the Alexander world of her time. It helps to explain some of the changes she made to her teaching and some of the ways she diverged from F.M. Alexander, especially her consistent attention to process. Being particularly interested in movement, she saw early on that a procedures-based teaching practice could only be of limited assistance in helping students to learn to move better. Under the next main subheading, I discuss the fifth major term that Barstow updated, "Sensory Re-eduation"

TERM 5: SENSORY RE-EDUCATION

"Sensory Re-education" is the final term I will analyse in Barstow's reconstruction of Alexander's terms and methods. As Alexander himself said, he used the positions of mechanical advantage to give students a sensation of good use, leaving the teacher in charge of movement. It was his belief that students would know how to translate this into their own activity. What he overlooked though, and what Barstow observed after many years of teaching Alexander's way, was the fatal flaw in trying to reproduce sensations. First, trying to reproduce a sensation without a process is not a reasoned – and may not even be a fully conscious – action. In *MSI*, this is what Alexander said he wanted people to learn – to replace unreasoned (or subconscious or partly conscious) actions with reasoned ones. The second, and perhaps greater flaw in his logic was that in order to reproduce sensations, they had to rely on their sensations (not their thinking), which Alexander was at great pains to reveal as *unreliable*. In the section above on inhibition, I referred to the point (in *UOS*) where Alexander also makes it clear that what he had to "inhibit" was his reliance on

what *felt* right, even after having formulated a new constructive plan (or "means whereby"), because it was what *felt* right that was misguiding him.

Frank Jones describes the effect of practising the Alexander technique as "the lightness, sensory effect," which comes about "only as the result of inhibition."[268] But describing the effect of the AT as a sensory effect can be unhelpful, as it does not allow for individual differences of perception, besides tempting people to try to reproduce feelings. As Madden describes, many students actually feel heavier and more grounded when they learn the Alexander technique, rather than lighter. I am one of these students. In my early days of performance, I would feel so light – and breathless – that I was barely there. After studying the Alexander Technique I began – with great pleasure – to feel solid. I was increasingly able to be physically and mentally present.[269] Describing the AT in sensory terms can encourage students to "end gain," by trying to feel sensations without due attention to process.

The Role of the Senses

The exact role of the senses is a source of confusion in the teaching of the Alexander Technique. The following section is my attempt to clarify this.

The senses are of course vital for our survival. In performers, many senses are highly developed for obvious reasons. These highly developed senses help performers assess the value of things (such as the AT) that are a help or a hindrance to their practice and art. But they are not the most reliable pathways to follow if we wish to create new actions, or make subtle changes to familiar actions.

In the performing arts, our senses are indispensable. They perceive stimuli for us to respond to, they provide much of the motivation for us to persevere with our art, and they allow us to appreciate the art of others. The visual and aural senses help us gauge quality and the accuracy with which we execute our attentions. For the kind of changes performers might make in applying the Alexander Technique to their art, finely tuned aural and visual senses can be enormously helpful in gauging the usefulness of the technique. A newly experienced sense of ease can also convince us of the usefulness of the AT. With precisely what sense do we sense this ease? I suggest that it is a combination of balance (which is now recognized as a sense), proprioception, kinaesthesia and perhaps even (lack of) pain, some of what I call the "self-sensing senses."[270] But it does not

140 A. COLE

follow that we can find this ease again by trying to reproduce the sensation. As Alexander said, "You can do what I *do* if you *do* what I *did.*"[271] He did not say you can do what I do if you *feel* what I feel. He explains very clearly in the first chapter of *UOS* that he did what he did by *not* relying on his senses. In fact, Marjory Barlow insists that this oft-quoted phrase of Alexander's was only half of what he always said. She had heard it from F.M. himself, and said that in the retelling the crucial ending was always left off: "...but none of you want anything mental!".[272]

And yet, it was Alexander's belief that what his technique achieved was a re-education of the senses. As we have seen, this is *not* what he trained himself to do in his own process of discovery, but rather what he decided he was doing when teaching. This contradiction and inconsistency has led to extraordinary confusion in and about the Alexander Technique.

To summarise, since no one has yet proven that re-education of senses is possible (or even necessary), and since the senses are unreliable for absolute judgement and guidance, we would be safer to focus on the re-education of thinking. It seems that Alexander's legacy (his teaching methods and his writing about the re-education of the senses) has led to the widespread belief that "the work" of teaching is to give students a passive experience of good use and to re-educate the senses largely through teaching the procedures that Alexander had invented. As discussed in Chapter One, this is in stark contrast to the process he followed himself in solving his vocal problems.

After much observation and critical appraisal of the teaching methods she had inherited from Alexander, Barstow changed the emphasis in her lessons from feeling to thinking, just as she changed the emphasis from stopping to moving. For Barstow, thinking and moving went together, as I will show below.

Thinking and Moving

I don't believe in giving lessons in silence because I want to know what my pupils are thinking.

—Marjorie Barstow[273]

There is continuous change bringing improvement. An improvement which comes by constructive thinking as a trustworthy guide.

—Marjorie Barstow[274]

4 RECONSTRUCTION: BARSTOW'S RECONSTRUCTION ... 141

Barstow was determined to get students to think for themselves creatively *while they were in action*. The way she assessed their thinking was to get them to articulate what they observed at any point in their activity. (This is what Madden describes as Step 4 of Alexander's process, gathering information). She would then interpose her questions (as described by Madden in Chapter 6) and what they were planning (what Madden calls Step 5, making a constructive plan). Barstow was meticulous in her focus on the process of thinking and moving, and in allowing students to find out the consequences of their thinking (and moving) for themselves. Writing to Jones in 1963 about William Conable, who was considering going to train in England, she said, "I do not want him to get involved in that stilted way of giving orders and looking out into open space waiting for something to happen."[275]

"When teaching," Barstow would say, "you should put the students on your level, explain what you're trying to do but not what results you want."[276] Michael Frederick describes how Barstow encouraged her students to think for themselves, saying that she had "the quality of direction that I experienced with my best English teachers, but she doles it out, as it were, when your thinking is equal to that direction."[277] That is, she would physically help students with movement only sparingly and only when she was satisfied that the feeling you might get from her hands would not distract you past the point you had reached in your thinking. Similarly, Arro Beaulieu claims that she "does not make, but only guides, the movement for us," thus highlighting the importance of thinking and initiating movement oneself.[278] "We gain an experience which includes not only a glimpse of a new sensory appreciation, enabling us to better recognize our habitual use ... but also the confidence which comes with having initiated the change in our use through our own volition and movement.[279]

In a 1981 interview, Barstow observed that the Alexanders, too, leaned increasingly in this direction over the years. "I think they did less," she says. "I think they emphasized the thinking more, that is, the value of the thinking. It seems to me they were just more and more insistent upon the thinking and the importance of that.[280] She seems to be shielding F.M. from her real thoughts here. She was, in fact, very critical of F.M. and, as both Jones and Barlow remarked, it was A.R. who put more emphasis on thinking.[281] In 1947, she wrote to Jones about F.M., saying: "You must remember he never has been interested in people who do any original thinking and as he has heard directly from me [that] that is what I am

142 A. COLE

doing – there seems little hope. His silence is more of a tell-tale of his attitude than if he had written.[282] In 1970, too, she clearly states her disapproval of F.M.'s teaching and observed that she learned more about teaching from A.R.[283]

While Barstow did have the opportunity to observe F.M. Alexander's teaching over several years (from the 1920s to 1933), it was his brother's teaching to which she had the longest and latest exposure. As already mentioned above, A.R. Alexander laid great emphasis on thinking rather than feeling. It seems that he was more consistent in this than his brother. He also used the procedures and the directions less than F.M. Alexander did, according to Jones.[284] The reports of F.M.'s teaching in silence or accompanied by an unrelated patter came more from the later years of his teaching (1940s on), which also tells against Barstow's claim that he was emphasizing thinking in the later years, and suggesting that she was referring more to A.R.

Barstow's emphasis on thinking is demonstrated in the following two descriptions of her teaching by Troberman and Fertman. Troberman describes herself in her first (pre-Barstow) lessons in San Francisco as "not catching on at all."[285] Barstow's teaching clarified what was required and even inspired her to train to become a teacher (which she did in San Francisco because Barstow had no formal training course). Troberman started to see other people change in Barstow's classes, and she thrived on the practical, constructive reasoning and the clear kinaesthetic information that Barstow provided. It seems she was not getting these in her lessons in San Francisco: "In retrospect, I realize the importance of beginning with that constructive reasoning process. In fact, as I later learned, that is where Alexander himself began."[286] She adds that while the information she was receiving from Barstow's hands was the clearest that she had experienced, it was something else that made Barstow's work so streamlined and unique: "She was teaching us how to reason out."[287] Martha Fertman describes Barstow's process-oriented approach as a revelation. Her previous experience of the Alexander Technique, she says, "had been replete with orders and positions of mechanical advantage," and her dance training had also had "its full measure of directives and right positions." To find that Barstow believed that "an alive, active, inquiring, intending mind ... should have something to do with movement" was revelatory to Fertman.[288]

To reiterate, the process referred to here is an emphasis on thinking and moving; not on teaching the student a feeling of good use or indeed

a position of mechanical advantage. Feelings, or our sensory apparatus, give us important feedback that we should not ignore, but they are not, as Alexander observed, absolutely reliable. Feelings are a *result* of process, rather than the process itself. Feelings may be different each time we follow a process, as we never start from the same place twice. Finally, feelings depend on a multiplicity of factors specific to each individual. They are therefore an inaccurate and misleading way of teaching a process.

Barstow's emphasis on thinking was intimately related to her emphasis on movement. The reason she talked to her students (rather than working in silence) was that she wanted "the student to start thinking about how their thoughts influenced the quality of their movement. And she would do that really right from the beginning of working with anybody. And that, for sure, was not part of the standard methodology of the time," as Rickover pointed out.[289] As Franis Engel suggests, "Thinking is a kind of movement that is the first phase of the action. Movement extends intent."[290] Engel made this observation after studying with Barstow, and her statement is supported by Dewey. In describing the possible benefits of teaching psychology in high schools Dewey pinpoints beautifully the movement that is thinking. "How can we make the mind, not more mature, but more receptive to ideas?" he asks. "How can we cultivate, not a higher grade of intelligence, but spontaneity of action? ...The notion that the study of psychology will aid in answering them, is because this study requires in such large measure the self-initiating, self-directing movement of mind."[291]

Alexander, in his teaching, had tried to create a shortcut by "re-educating the senses" and providing students with an experience of good use that was beyond their capacity to think and understand. Barstow was really the first teacher to identify that this method of providing shortcuts to students was counterproductive, was giving "wrong impressions" and was causing people to search out the feeling of that shortcut experience on their own, rather than follow a mental process.[292] As she told her students repeatedly, "You don't want to reproduce the feeling but the mental process."[293] Ironically, trying to reproduce feelings is a kind of end gaining – something that Alexander's technique was supposed to be avoiding.

Recall, also, Madden's linguistic integration of thinking and moving, so that these are not two separate acts: "minking" and "thoving." With this creative extrapolation of Barstow's teaching, I conclude the discussion of individual terms and methods that Barstow reconstructed. The

144 A. COLE

following section is an attempt to synthesize and compare the parallel reconstructions by Dewey and Barstow, of philosophy and Alexander's teaching respectively.

PART C: Philosophical Pragmatism in Action – The Parallel 'Reconstructions' by Dewey and Barstow

Now that we have seen some of Barstow's specific changes, their background, and the rationale for them, I revisit Dewey and philosophical pragmatism briefly, because one of my aims is to draw parallels between what Dewey did in philosophy and what Barstow did in the Alexander Technique. Now that I have described some of the details of Barstow's reconstruction of the Alexander Technique, I will provide a very short recap of the dominant themes in pragmatism to make it clear how they echo some of the changes Dewey made to philosophy and pragmatism.

In *Four Pragmatists*, Israel Scheffler postulates nine dominant themes in pragmatism, which are those given in Chapter 2. I have divided these themes into three broad categories because these categories helped me to conceptualise what pragmatism is. In the interests of making ideas clear, I present the groupings here. They are Unity, Uncertainty and Scientific Method. Within the descriptions below, I refer back to the terms, methods and principles already discussed above.

Category 1: Unity

Within the category of unity I discuss the rejection of the Cartesian split, the functional view of thought and the connection between thought and action.

First, the Cartesian split: Philosopher René Descartes (1596–1650) drew a sharp distinction between mind and body. His resulting philosophy was called dualism and greatly influenced centuries of Western thought. Alexander's acknowledgement of the connection between mind and body was one of the aspects of his work that had drawn Dewey to it. And yet, as we have seen, in expecting students to be able, in practising inhibition, to separate the giving of directions (mental) from acting on the directions (physical) without experiencing anything else in their place (such as tension or holding) was a contradiction of this principle. Barstow's interpretation of inhibition as replacement addressed this contradiction by both accepting and allowing mind and body to function as one. That

is, she understood, as the pragmatists did, that thought and action are interwoven.

Pragmatism's rejection of the Cartesian split meant a strong belief in the unity of theory and praxis. It also led to a functional view of thought, that is, that thought and philosophy are for dealing with the problems of human experience. In the same way, Barstow was adamant about the functional – practical – value of the AT and moved her teaching away from the classical Alexander procedures and into the actions and needs of her students.

Dewey's *Reconstruction of Philosophy* comes out of these two ideas – rejecting the Cartesian split and adopting a functional view of thought – just as Barstow's Reconstruction of the AT came out of the same ideas.

Inherent in this theme is the importance to pragmatists of making their ideas clear.

Category 2: Uncertainty

Under this subheading fall the ideas that knowledge is fallible, that thinking is representative only and that conclusions of inquiry are always only provisional. It is in this spirit that Barstow treated the writings and teachings of Alexander. She did not treat his word as gospel, just as she did not regard her own teaching as an endpoint or pinnacle. Like Dewey's view of the world, she saw her teaching as constantly *in the making*. The pragmatists argued that we can never be completely certain about our knowledge. This is not because of a gap between mind and matter or consciousness and reality, but rather from the fact that we can never be certain that the patterns of action that we have developed in the past will be appropriate for the problems we will encounter in the future. With this fallible view of knowledge are connected the importance of consequences rather than antecedents, the connection with future rather than past and the plasticity of the world: a universe in the making. It follows from this point that thinking, too, is incapable of absolute fixity or absolute certainty. That is, pragmatism states that thinking is merely representative. It was for this reason that Barstow made mastering observation one of her principal requirements for trainees in the Alexander Technique. If we keep observing what is happening around us and inside ourselves (ie: observing both thoughts and feelings), we stay alive to the consequences of our actions and can make new choices.

146 A. COLE

Category 3: Concerning Scientific Method

In this category belong the social and experimental conception of science, the importance of critical thinking and scientific method to philosophy, and the primacy of method and procedure over doctrine. Science was seen by the pragmatists as the effort not of an individual, but of an "ideal" community of investigators dedicated to learning from the consequences of "artful transformations of nature."[294]

I include this category here to complete the summary of pragmatism's principal ideas, even though I have not yet gone into any detail about what this meant for Barstow. In Chapter 6 (Democracy and the Social Context) I will discuss her adherence to the pragmatists' view of scientific method. It was shown principally in her insistence of observing and teaching her students to observe, but also in her financial support of Jones's scientific research projects and the many years of support she gave him to help design such projects. This was in stark contrast to Alexander's view of a scientific investigation into his discoveries to put his principles to the test.

All pragmatists argued in one way or another that philosophy should take the methods and insights of modern science into account. It is allegiance to critical methods of learning from experience that unifies the generations of scientists despite the revisions of their substantive views. Such methods, moreover, reach beyond the special sciences in their significance and relate these sciences to critical thought in the spheres of art, practice, and education. The function of the latter is to foster those habits of mind capable of sustaining *critical thinking* in all areas of life.[295] As the notion of scientific method is broadened to embrace critical thought generally, the concept of the scientific community is taken as a suggestive analogue of democratic society. According to Scheffler, if we follow the teachings of the pragmatists, we will "avoid enclosing their doctrines in a casket."[296] We will try, rather, to use the best resources of our intelligence and critical thought to make sense of our world, as they did of theirs and as, indeed, Barstow did of hers.

CONCLUSION: THE RECONSTRUCTED ALEXANDER TECHNIQUE

The temptation in so many things in life, especially today, is to take the easy road and go for surface or form, rather than do the active and deep

work of thinking, analysing and innovating. Barstow had no patience for this. In a letter of 1947, she told Jones the story of a friend of hers who wanted to work with handicapped children. "She asked one of the professors what would be the first thing to do and in a few days he came to see her bringing elaborate plans for a new building that would cost about $200,000." Barstow could have been talking about herself in this story. She goes on: "She calmly said to him, and she knew a lot about education, 'the things I think are necessary for those children to have can be learned in a simple room, with a few chairs and a table' And that was as far as the professor got with her."[297] For Barstow, however, the few chairs and a table were the activities of life her students cared about and brought to lessons, not a literal chair and table, as Alexander used. In this analogy, Alexander's orders, language and "procedures" were the expensive – and unnecessary – shiny building.

In this chapter I have reviewed Barstow's emphasis on process, which meant the foregrounding of thinking over feeling, movement over the positions of mechanical advantage, the connection of thought and activity, and a careful choice of language so as to prevent adherence to fixed or pre-conceived ideas. Barstow's answers to the various aspects of F.M. Alexander's confusing legacy put the Alexander Technique firmly in the field of education, rather than treatment, and echo Dewey's own interpretation of the technique. Barstow also supports Dewey's emphasis on education as experiential and his belief in democracy. Barstow's insistence on clarity led her to rename some of Alexander's concepts (eg: the primary control), to reframe others (eg: inhibition as replacement rather than stopping) and to stop using some of them altogether (eg: the procedures and a reliance on re-educating the senses). In the interests of making the Alexander Technique clear, meaningful and valuable to her students and adhering to her priorities of process, thinking and movement, she changed her teaching practice from one that centred on Alexander's procedures to one that welcomed any and all activities her students wished to bring.

In the following chapter I will discuss Barstow's "Application Approach" in more detail, explaining how it originates in Alexander's own story of discovery and aligns with Dewey's ideas about education.

CHAPTER 5

Desire, Application and Art

In the morning I gave John Gosse a lesson and, to my great satisfaction, he observed: 'I know what is the trouble with me, I don't really want to do this.' So, at last, he is seeing the light.

—Walter Carrington[3]

In my daily puzzling and tedious experiments with ordering, with lying, sitting, standing, with walking occasionally, and with getting in and out of a chair in an odd manner, I kept waiting for something to happen to my dancing.

—Martha Fertman[4]

In the previous chapters I showed the various ways in which Marjorie Barstow emphasised process over form. In this chapter I will show how she connected this process with desire, in what became known as "The Application Approach." This was a name applied to her teaching by others, in an attempt to differentiate it from the older style created by F.M. Alexander and upheld at Ashley Place in the 1940s by teachers such as Walter Carrington, Patrick Macdonald, Margaret Goldie, Irene Stewart and Ethel Webb. I seek to show how the element of desire is integral to Barstow's applying the Alexander Technique to a much wider range of activities than Alexander prescribed. I will define the Application Approach, examine its origins, and discuss the opposition to the approach,

© The Author(s), under exclusive license to Springer Nature Singapore Pte Ltd. 2022
A. Cole, *Marjorie Barstow and the Alexander Technique,*
https://doi.org/10.1007/978-981-16-5256-1_5

149

150 A. COLE

which comes mainly from those who trained in – and held tenaciously to – the Ashley Place paradigm, despite this vital element (desire) having been the driving force behind Alexander's original work, as we shall see.

Again I will show, by pointing out the parallels of Barstow's teaching with Dewey's philosophy, how Barstow was pedagogically ahead of her time and her teacher (F.M.). The ideas of Dewey with which Barstow shows herself in alignment are: first, his observation that interest is required for real learning to take place and that desire is required for action; second, his desire for the unity of theory and practice (in this case application of the technique to areas of practice in which students are interested; and, third, his belief in the importance of context. Specifically, Dewey points to the advances of science and philosophy in the last generations that have "brought about recognition of the direct value of actions and a freer utilization of play and occupational activities."[1] In relation to the application of a skill and the interest of the learner, Dewey says that there is no sounder point in the philosophy of progressive education "than its emphasis upon the importance of the participation of the learner in the formation of the purposes which direct his activities in the learning process, just as there is no defect in traditional education greater than its failure to secure the active cooperation of the pupil in construction of the purposes involved in his studying."[2]

Even Walter Carrington, a stalwart believer in inhibition, stopping and non-doing, recognized that desire is a vital ingredient in learning the Alexander Technique, as his diary entry (from his days teaching with Alexander at Ashley Place) at the top of this chapter shows. Even if Carrington was celebrating the fact that the student had finally understood the importance of his own will to learn the AT, Carrington himself seems to have missed a different light. That is, Carrington has understood the importance of desire, but has overlooked the fact that the *responsibility* for harnessing the student's desire lies as much with the teacher and his methods as it does with the student. In fact, Dewey goes further than this, putting the responsibility fully on educators: "The problem of educators, teachers, parents, the state," Dewey says, "is to *provide the environment* that induces educative or developing activities" [emphasis added].[5] "Where these are found," Dewey believed, "the one thing needful in education is secured."[6] He described interest as "a unified activity," which signifies a direct and personal concern, "a recognition of something at stake, something whose outcome is important for the individual."[7] Recall, too, that what Dewey most prized about

the Alexander Technique was its potential contribution towards education. A month before Gosse (Carrington's student) had "seen the light," Carrington had discussed his case with Alexander. Alexander had said that "it was very doubtful if he [Gosse] would ever learn to inhibit and, until he did so, it was hopeless to expect any improvement."[8] This fixed attitude towards the student (as the problem) and the solution (as the responsibility solely of the student) is somewhat reminiscent of the inflexible attitude towards words that Jones described in the Alexanders (see Chapter 4, Reconstruction, Alexander's principles).[9] It does not appear to carry the promise to education that Dewey had claimed. It certainly does not admit of any shortcoming of teaching methods along the lines of engaging students or emphasizing the importance of their own interest(s).

Martha Fertman, who studied with Barstow and is also quoted at the head of this chapter, highlights the importance of the "something at stake," which Dewey described, in Alexander lessons. She describes her earlier, pre-Barstow, procedure-based lessons and experiments with "ordering" without a goal as "puzzling" and "tedious". The manner of getting in and out of a chair, lying "semi-supine," standing aimlessly, and sometimes even the more dynamic exercise of walking can lack that "something at stake" for performers, as it did for Fertman. Barstow addressed this issue by requiring her students to have an interest they cared about and to which they could apply the Alexander Technique. She discouraged study of the Alexander Technique as an end in itself or as something unapplied. She also discouraged students from studying it purely with the aim of teaching it, which may be why it seemed to some that she did not train teachers. She insisted that the Alexander Technique was a *how* and not a *what*.[10]

Almost twenty years before Dewey met Alexander, he was publishing his ideas about desire, interest and effort, and the need to be conscious of both end and means "for the process of self-expression to be effective and mechanical."[11] This was in 1895. Before the century was out, in 1899, Dewey had also published what would become some of his most enduring ideas about education: in particular, the importance of recognizing the desires and interests of students in order to help them engage and learn.[12] The fact that Barstow maintained that desire was a fundamental aspect of learning and practising the Alexander Technique again points to her alignment with Dewey when it came to teaching.

The Question of Desire in Alexander Studies

Barstow's recognition of the importance of desire in both artistic practice and education led her to evolve her teaching practice increasingly away from Alexander's. That meant leaving behind his prescribed procedures (from which students found it difficult to transfer what they had learned to their art) applying the Alexander work increasingly to her students' interests, which was frequently but not exclusively in the realm of artistic practice.[13] Because of this, Barstow's pedagogy eventually became known as the "Application Approach."

The use of the term "Application Approach" appears to have come from Irene Tasker's contribution to the early development of the AT, namely, "the starting of the children's class for the application of the Technique in 1924."[14] Tasker was probably the first teacher to teach predominantly "application work." Her first work as an Alexander teacher was "mostly in 'application'," she says.[15] Tasker makes a distinction between this application work and "lessons in the technique," as if they are completely separate entities: "There was no question of my giving lessons in the Technique that summer, so I did what I could in getting them to inhibit in the sense of stopping to think out 'means' in whatever they were doing – games, riding, swimming, canoeing, acting play."[16] Tasker says that only *after* this initial teaching, in which she helped children apply the AT, did she begin her "apprenticeship" in teaching.[17] That is, she began to learn to teach after she had already been teaching the technique to children. Tasker seems to suggest that her early teaching (application work) was considered neither training nor AT teaching. This segregation seems to have come from Alexander himself, who asked Tasker to "give lessons *and* 'application work' to one of his pupils."[18] Does this mean that he saw lessons and application as mutually exclusive? Alexander's definition of lessons *did* involve application, but only to a limited and prescribed set of activities: sitting, standing, walking, lying, whispered "Ah" and the positions of mechanical advantage. All other activities were called "application work." Alexander's and Tasker's separation of "application" and "lessons" is another part of the confusing legacy of F.M. Alexander. The term "application work" or "Application Approach" (which later gained capital letters) introduces a split between theory and practice. By separating the application work and giving it its own name, the Alexander community tacitly acknowledges that the rest of the work – chiefly Alexander's procedures and directions, or anything

that is not applied – is "pure," and therefore theoretical and separated from practice. Perhaps Tasker means that she began to learn to teach *as Alexander taught* only after she had some experience in teaching it her own way. It seems that her apprenticeship consisted chiefly of "taking over various pupils after their lessons with F.M. Alexander, and doing 'inhibition work' with them lying down."[19] Curiously, Tasker seems to suggest that teaching inhibition in general activities was considered neither training nor teaching. Teaching inhibition to pupils who were lying down, on the other hand, *was* considered teaching.

Barstow did not take on Tasker's narrow definition of the Alexander Technique and was impressed enough with Tasker's application work to have made it (albeit much later) one of the defining features of her own teaching. She recognized the importance of desire in the learning process and of harnessing it by applying it to the activities students were interested in. During her training (1931–1933), Barstow helped Tasker in Alexander's "Little School" for children, acting as an apprentice and/or assistant to Tasker. Tasker may even have been Barstow's introduction to the ideas of Dewey. Tasker had studied psychological ethics with Dewey, accompanied the Deweys to Stanford University (California) for a lecture tour and taught the AT to several members of his family. Looking back, in her eighties, Barstow acknowledged the influence that Tasker's application work had had on her. "Observing the children made me see how valuable our whole coordination is in relation to any of our activities," she told an interviewer.[20] At around the same time Barstow wrote to Erika Whittaker saying that she thought Irene Tasker had been of more value than they could realise at the time they were in training. "Now I appreciate what she did for me more and more," Barstow wrote.[21] Thus, it can be seen that Barstow did not "invent" the Application Approach or its name. But her name did become associated with this approach, almost as if she *had* invented it.[22]

Dewey observed that "desires are the ultimate moving springs of action."[23] In her book with Trevor Davies, Barlow underlines the role of desire in Alexander's path to better coordination. Davies asks Barlow, Alexander's niece, "What do you think kept F.M. alight through all those years of work?" Her answer is: "Passion. All his youthful, violent energy, you see, went into his passion. That's the right word. That was what F.M. had – real, real *passion…* for Shakespeare. He wanted to be a great Shakespearean actor." She even goes so far as to say that "if he hadn't had *that* petrol in his engine, he never could have discovered this work. Never.

154　A. COLE

And that was what carried him all the way!"[24] The same passion drove his writing, according to Barlow, who says: "It was his love of language that allowed F.M. to write – his love of the Bible and Shakespeare."[25] And yet, as we saw in Chapter One (his dismissal of Westfeldt's questions and wish to discuss process), and shall see (his discouragement of students' interests and artistic practices), he did not value such a desire in his students and even actively discouraged it. Walter Carrington, in his diary of 1946, observed this paradox too, describing himself as "full of misgivings" despite his gradual improvement in class. "Have we got a chance," he asks himself, "of getting to where FM has got without imitating his experiences? And how is that to be done *without his motivation and driving force?*."[26]

Barstow's emphasis on applying the Alexander Technique to activities chosen by the student echoes Dewey's beliefs that the educational process must begin with – and build on – the interests of the child, and that the teacher should be a guide and co-worker with pupils, rather than a taskmaster assigning a fixed set of lessons and recitations.[27] Barstow recognized that in order to do what Alexander did, you need to have a desire as strong as Alexander had (as described by his niece Marjory Barlow). In a 1949 letter to Jones Barstow highlighted the importance of desire in learning or applying the AT in her comments about the design of Jones's proposed research project. "Incentive is very important," she wrote. "Whether it comes from the desire to be better or the willingness to be a guinea pig should make no difference as long as the interest is there."[28] Unlike Alexander and his followers (Carrington, for example), Barstow saw it as her role to nurture this motivation in her students. She harnessed that desire in her students by making sure they had an interest that they cared deeply enough about, which would both make them persevere and make them see that the AT was something practicable and applicable, rather than a set of exercises in isolation from real life. She emphasized the aspect of desire in practising the AT by structuring lessons around it. That is, she made it clear that desire was the first step in the learning process by requiring students to volunteer for a "turn" in class. Without the desire to improve in their areas of expertise or artistic practice, they might hesitate to take that first proactive step. They would be lacking what *Barlow* had identified as so crucial to Alexander's path: passion. As Cathy Madden sees it, this was what most differentiated Barstow's teaching from that of other Alexander teachers.[29]

5 DESIRE, APPLICATION AND ART 155

In Dewey's terms, Barstow helped students turn desire and impulse into purpose, or an "end-in-view." Dewey stresses that desire and impulse alone do not constitute purpose (or "end-in-view"). Rather, they need to be translated "into a plan and method of action based upon foresight of the consequences of acting under given observed conditions in a certain way."[30] "In an *educational* scheme, the occurrence of a desire and impulse is not the final end. It is an occasion and a demand for the formation of a plan and method of activity... The teacher's business is to see that the occasion is taken advantage of."[31] Barstow made it her business to teach people how to keep their end in view while thinking through and planning a new means whereby they could achieve it, that is, with better coordination.

Barstow helped students to access and harness their deep desire to learn and/or change. Kevin Ruddell recalls her asking him during a turn if he really wanted to change. The activity he had chosen for his turn was to make a fist. "I briefly considered the years of fruitless practice during which I had tried to improve my manner of movement," he says.[32] Just as he was deciding and saying that he really *did* want to change, Barstow began to help him move. Barstow was not in the business of playing it safe so that people could languish in their unwillingness to change or to learn. She had the skills to help them out of this if they truly wished. If they didn't want to or were not ready, she wanted them to recognize this and take responsibility for the next step themselves.

Despite the passion Alexander had for his art, which drove him to discover a better coordination, Alexander believed that such a desire was unhelpful (for those other than himself) in the learning process, tempting people too strongly into end gaining. This is why he limited his teaching activities to fairly inconsequential tasks. But in doing so, he created yet another contradiction in his work, overlooking the importance of his own desire in his own process of discovery. "You can do what I do if you do what I did," he used to say.[33] But for this to be true, all other things must be equal, including having a desire as strong as his desire to get to the bottom of his vocal trouble so that he could continue performing. "The intensity of the desire measures the strength of the efforts that will be put forth," wrote Dewey.[34] And this can cut both ways, rather than only in the negative, end-gaining, sense. That is, desire leads not only to end-gaining but also to our determination to learn a better way. Did Alexander forget about his original passion once he had made his discoveries? He did eventually give up performing, apart from brief reprisals as Hamlet

156 A. COLE

and Shylock in the two Shakespeare plays he produced with his dramatically untrained students, first in Sydney in 1901 and again in London in 1933. Carrington's report in 1946 that Alexander recited "as of old" at Margaret Goldie's housewarming party also suggests that this art was something Alexander had given up except on very special occasions.[35] Alexander's own example teaches us that committing to the Alexander Technique leads to the abandonment of one's art and makes the technique into an end in itself. He encouraged the same in his students, as I will show. He *claims*, in a lecture in 1925, that he was a "very successful" Shakespearean reciter and gave his career up because he "realized that in appearing in public one is appealing more to the herd instincts than anything else."[36] This may be simply another of Alexander's unsubstantiated claims, especially since we know that one of the things that caused him to stop reciting regularly was difficulties with his voice. Further evidence is the fact that Westfeldt describes Alexander in his 1933 Shylock performance as technically "excellent," but "neither moving nor true," and lacking "the talent required for such a role."[37]

Barstow believed in art and performance, perhaps more than Alexander did. She also wanted to work with young, passionate people to increase their vigour and passion rather than diminish it. Her critical pragmatism led her to think differently from Alexander about desire and to value it more highly, to the extent that she insisted on her students bringing specific interests to class, in contrast to Alexander. It was her interest in the arts that led Barstow to the Alexander Technique. In particular, what fascinated her was the fact that many people in the performing arts did not continue to improve the way they should for the amount of time they spent: "I was always trying to answer that question," she says, "and I could never answer because it just didn't seem logical to me."[38] When she came across the Alexander work, she thought that it may be part of the answer she was seeking about why performing artists didn't improve as much as she expected given their ongoing commitment and study. That is, the improvement in the functioning, the efficiency and even the aesthetic expression of performing artists was a major interest of hers, whereas Alexander tended to see art for the value it gave his technique. In 1950 he described the first experience of mounting the plays for his students as "a test," the result of which was "highly satisfactory" to him, for there "wasn't a hitch in the performance." He elaborates: "No stage fright, the prompter need not have been present, and the stagecraft was, in the words of the stage-manager, up to professional standard." But he

5 DESIRE, APPLICATION AND ART 157

also confesses to "the weaker parts," of which "there were many."[39] Note that Alexander measures the success of the production by the absence of hitches rather than any artistic or interpretive heights. In a lecture given in 1925, he had equally described the success of that production in terms of the absence of trouble and, it seems, as proof that one does not need dramatic training to be an actor. "I did this merely to show the theatre people who were interested in me ... that a man does not want this training, twenty-five years' training, to know how to walk across the stage. These young men and women were never taught to walk, they were taught how to use themselves, the whole psychophysical organism, satisfactorily; their sensory consciousness and sensory appreciation of the use of themselves was properly developed, and there was no need for any trouble."[40] For Alexander, it seems that there was no higher goal than this. For Barstow, it was the other way around.

These plays, despite what Alexander says about them being purely a technical test, did seem to be something that woke up his passion. It seems that his teaching changed when his students were allowed to apply it to something that *he* was (or had once been) passionate about.[41] Westfeldt, otherwise critical of his teaching, claimed that when it came to putting on the play (*The Merchant of Venice*) with his trainees, he seemed transformed. "In teaching me this role of Gobbo he was more of a *teacher* than I had ever seen him," she recalls. "He still 'showed' me rather than used words to tell me about it, but in this instance showing me was the right thing to do, and he did it to perfection... and, wonder of wonders, he actually seemed to try to get in touch with my mind in an attempt to remove whatever impediments were deadening me."[42]

Alexander's mistake, however, was to assume that all his students shared his passion for acting. This was his *own* desire misplaced. As he himself says and as Westfeldt reports, Alexander's rationale was to provide a showcase for his training course.[43] As Westfeldt reports, Alexander wanted his students on the public stage (no less a stage than the Old Vic and Sadler's Wells) not because of their acting ability, but to show how they handled themselves "from the point of view of both voice and movement." While some of the trainees, according to Westfeldt, became "stage struck," others were genuinely distressed at having to spend valuable (and expensive) training hours applied to an art for which they had neither care nor aptitude.[44] The reviewer (from the *Daily Telegraph*[45]) was perhaps equally non-plussed at Alexander's random application of his technique. Having been informed, as had the rest of the public, that

158 A. COLE

the actors did not expect to be judged on their acting ability, he wrote that he "had no comment to make."[46] Westfeldt reports that the play "sagged pretty badly," and lamented the fact that they had "attempted something that required the finest acting." "Well," she concludes, "that was unfortunate."[47]

ENDS-IN-VIEW *VERSUS* END-GAINING

While Dewey was a great supporter of Alexander's work, and their work intersected and was mutually aligned in many ways, there were also many important differences. One was that, in contrast to Alexander's idea of end-gaining, in which all thought of the desired goal must be put aside to focus on the "means whereby," Dewey makes the "end-in-view" *an important part* of thinking, action and consequence. By eschewing end gaining, many Alexander teachers, like Alexander himself, throw the baby out with the bathwater and miss the guiding and motivating influence of an end-in-view. In Barstow's pedagogy, the end-in-view is the *reason* you want to change your use, and it needs to remain front and centre, as it was for Alexander in his discoveries, to motivate students to follow through. In order to engage our whole psycho-physical selves in changing deeply ingrained habits, we need a reason to make this change, and the reason needs to be compelling. Otherwise, as in the extreme example of F.M. Alexander, who gave up performing in order to master his coordination, the Alexander Technique becomes the end-in-view, or an end in itself. The requirement to give up desire was intimately connected with Alexander's extreme practice of inhibition – that of stopping altogether. Barstow believed, as did many after her, that she had found a better and more dynamic way to improve one's coordination, one which was also more realistic and integrated with daily life.

Trying to practise the Alexander Technique without applying it turns the practice into a *what* rather than a *how*. In an article that appeared in the 1980s at the peak of the battle between the Application Approach and the "classical school," Eckhart Richter points out, in an attempt to acknowledge the criticisms of Barstow's appraoch, that Alexander's apprehension that his work "would end up as a mere adjunct to another discipline and be subsumed under it... " was "quite justified."[48] But Richter does not say what it *is*, when the technique becomes a *what* and not a *how*. It is precisely its value as a guiding principle to any and every aspect of *life* that makes it important and attractive. If the Alexander

5 DESIRE, APPLICATION AND ART 159

Technique is to have wide appeal to performers, it must not become an end in itself or relegate art to a mere adjunct of the Alexander Technique. One case in point was a pianist who participated in my doctoral research. He said that in his limited previous experience of the Alexander Technique he had never sat at the piano. "I guess what I recall about it was I never sat at the piano with Barbara Kent. You know, she worked on my posture, standing... That *was* helpful. I mean, I felt relaxed and wonderful after the session." These lessons seem to have shown (or suggested to) him that the AT is a stand-alone practice, an *extra* time commitment away from his instrument and without obvious benefit to his artistic practice. Since it was not apparent to him how this practice could help his playing, he did not persevere with the AT after his two initial lessons during the Aspen summer program.[49] Decades later, after experiencing Madden's Barstow-style teaching, he saw what he had missed.

To return to the comparison of Barstow's teaching with Dewey and his philosophical school of pragmatism, let us turn to a description of William James's intentions with that school of philosophy. Louis Menand, author of several books on the history of pragmatism, describes James as presenting pragmatism, "after all, not as a philosophy but as a *way of doing philosophy.*"[50] Similarly, Charles Peirce "described it as a *method* for making ideas clear and not as a place to look for ideas themselves."[51] "In its most basic sense," says Menand, "pragmatism is about how to think, not what we think."[52] Echoing this description of pragmatism, Madden frequently describes the Alexander Technique as "a *how*, not a *what.*" This is her own description, but one she formulated through her study with Barstow. The Application Approach emphasizes and proceeds from the idea that the Alexander Technique is a *how* rather than a *what*. It fits with Alexander's principles (as described in the previous chapter) but it also clarifies the confusing legacy of his teaching *methods* that have given the impression that the technique is a *what*: chair work, table work and positions of mechanical advantage. The description of the AT as a *how* reminds us that in studying and practising the technique, we are particularly concerned with our overall use in whatever activity we happen to be doing. The choice of activity is less important than our overall use as we do it, but applying it to activities we care about gives the AT more meaning, more value and more relevance. It also makes performing artists more likely to pursue it (as suggested by the story of the pianist above). Perhaps most importantly, it is also important to know that the AT is

160 A. COLE

something you do *while* practising or performing and is not an extra activity.

As I showed in the previous chapter, Barstow focussed on the *process* of the Alexander Technique rather than an inherited *form*. She also fused theory and praxis by applying the technique to all and any activities, in preference to working simply with a chair or table. In what Jeremy Chance calls "the classical school,"[53] the chair and table work acts as a kind of symbol for all other activities. Students are expected to transfer the knowledge (or, more accurately, the feeling memory of a passive experience) gained in chair and table work to all and sundry activities. According to Frank Pierce Jones this was a shortcoming of his training with both Alexander brothers: "Although the technique is non-end-gaining, it has to be applied in an end-gaining world. We were given no help in finding ways to bridge the gap."[54] Madden sometimes asks Alexander teachers of the "classical school" how their students learn this application to their other activities. Many teachers say that the students simply don't. As Dewey said, using symbols is better than trial and error, but still involves some degree of hit and miss. Best of all, Dewey observed, is the trial of a particular solution or response appropriate for the particular situation.[55]

Dewey believed that neglect of context was "the greatest single disaster which philosophic thinking can incur."[56] Barstow and Jones believed that the same was true of practising and teaching the Alexander Technique. Jones wrote to Dewey in 1948,[57] applying Dewey's paper on "Qualitative Thought," to "the work of the Alexanders."[58] "The cardinal error, to my mind" said Jones, "lies in thinking of inhibition as a thing apart, as something that can be practiced and perfected outside of what educators call 'real-life situations'."[59] In "Qualitative Thought," Dewey points out that "the selective determination and relation of objects in thought is controlled by reference *to a situation* – to that which is constituted by a pervasive and internally integrating quality, so that failure to acknowledge the situation leaves, in the end, the logical force of objects and their relations inexplicable."[60] When it came to education, Dewey wrote similarly about the importance of context. In an essay about the Dewey school, he wrote: "Because of the idea that human intelligence developed in connection with the needs and opportunities of action, the core of school activity was to be found in occupations, rather than in what are conventionally termed studies. Study in the sense of inquiry and its outcome in gathering and retention of information was to be an outgrowth of the pursuit of certain continuing or consecutive occupational activities."[61]

5 DESIRE, APPLICATION AND ART **161**

Barstow's conviction about the importance and centrality of context in AT education was equal to Dewey's in both philosophy and general education. As can be seen in the discussion on inhibition (Chapter 4), Barstow saw the same problem Jones described in his letter to Dewey (above) about practising inhibition as "a thing apart." Bruce Fertman recollects his first contact with Barstow, which illustrates this emphasis on context and her view that the Alexander Technique is not an end in itself. On a recommendation from Ed Maisel, who claimed that Barstow was "by far the best teacher of the Alexander Technique," Fertman immediately called her:

> She said, 'What do you do?' I said that I studied the Alexander Technique. 'Is that all? What else do you do?' I was a little taken aback, but proceeded to tell her that I was a graduate in movement education, a professional modern dancer, and a martial artist. She said something like, 'Come to my winter workshop. I think you might enjoy it.'[62]

Having looked closely at the role Barstow retained for desire in the practice and teaching of the AT, I will now examine one of the consequences this had: that her teaching became known as the Application Approach.

The Application Approach

I begin this discussion by providing a critique of the Application Approach and its many misinterpretations in order to highlight first what it is *not*. I then use this to clarify both what it *is* and how it aligns with Alexander's principles.

Walton White, in a caustic article about Barstow's teaching, complained that she did not teach the Alexander Technique, and that to say she did compromised both the technique and her own innovation. One of his chief criticisms of the "Application Approach" was that there was undue attention paid to the quality of the performance of an activity rather than to the quality of employment of the organism in any given activity. His emphasis was on the fact that the Alexander Technique concerns itself "with how well an individual employs his organism as a whole [a set of means] in any activity, not with how well he performs the activity." He believed that "The Application Approach" (that is, Barstow's teaching) focused on "performing an activity [an end]" and used "the

quality of this performance as a basis for making judgments on how well the individual is using himself as a whole."[63] I will answer White's charges with two main arguments: the first, that he grossly misjudged Barstow when he claimed that she needed to gauge the quality of the performance in order to be able to judge the coordination of her students; and the second, that he has not understood one of Alexander's fundamental principles, that is, the relationship between use and functioning.

First, it is not accurate to say that Barstow used the quality of the performance as a basis for making judgments on how well the student was using himself as a whole. Her powers of observation are well documented and her own use across a wide range of activities and daily encounters was a model for all her students. I will discuss the centrality of these in Barstow's practice in the next chapter. She certainly did not need students to bring in their activities so that she could use those as a method for assessing her students' use.

While it is true that the Alexander Technique is not to be judged by the quality of the performance of an applied activity, it is important to acknowledge that it is precisely through its impact on their performance that most performers will gauge its value, especially in early lessons. A singer's specific vocal problems, for example, can sometimes be remedied – at least in part – by an improvement in overall (whole person) use through the Alexander Technique. In addition, the student will usually need to attend to certain aspects of specific vocal technique, but the change in whole-person use can have a noticeable impact on the art-specific technique of a performer. In fact, it is often this initial impact on their art or craft that convinces performers of the value of the Alexander Technique and draws them to further study. Cathy Madden has applied the Alexander Technique to performance to such an extent that Dewey might have called it "thinking in artistic activity." Madden herself calls it "Integrative Alexander Technique for performing artists" (also part of the title of her book). She constantly gathers information – and encourages students to do the same – about the "conditions of use present" and requirements for a performance. These include a constructive and grateful attitude to adrenaline (as opposed to the usual attempt to conquer or banish it), and audiences. She also helps performers harness their global and overarching artistic desire(s) as well as helping them clarify specific intentions and desires for each performance. She trains performers to think constructively about these aspects of performance that are rarely addressed in traditional music education.[64]

In her correspondence with Jones over many decades, a repeating theme Barstow reveals is the application of her teaching to various specialised fields. Barstow mentions teaching doctors, nurses, phys-ed students, phys-ed teachers, drama students, drama teachers, musicians, a playwright, and voice teachers.[65] Musicians received more attention than any other profession in the correspondence between Barstow and Jones with respect to teaching the AT. In her personal notes to Jones, she also mentions photography, dance, dolls, horses and musical friends, showing her eclectic interests, but with a definite emphasis on the arts.

The second point against White is that he has overlooked Alexander's principle that "use" determines "functioning." By this he meant that any change in overall use will have an impact on any given activity. While it does not follow that every improvement in functioning is due to an improvement in use, an improvement in use will increasingly be manifested in the quality of the activity, and thus can give Alexander *students* important feedback about the impact of the Technique, even if their teachers do not need it. Further, the student's specialised expertise brings with it an ability to judge an impact *in that field* that may even rival the Alexander teacher's ability to judge or observe overall use. This expertise gives the Alexander teacher extra feedback and encourages students to be actively involved in their learning. This self-observation occurs in conjunction with the observation of the teacher, who is ideally observing both the use *and* the functioning and can give vital information to the student about either or both. The immediate impact upon performance is especially important to performers who cannot afford to invest years of their time and money in learning a technique that does not have an obvious or immediate benefit on their playing or performing, as was the case with the pianist described above, who had only two lessons in the AT and could not see its relevance to his playing. By contrast, Cathy Madden describes her fundamental commitment to the Alexander Technique as stemming from a pivotal learning experience she had with Barstow in which she learned the value of applying the AT to her acting. Recall the impression Barstow's teaching had on Cathy Madden as she did Cordelia's "recognition speech" in class. "As she worked with me," Madden recalled, "I saw my hand reaching out the way I had always intended it to; I heard subtlety and power in my voice and many nuances that I had planned but had never heard; my images became amazingly clear; action choices and changes were very easy, yet so full of energy and the love that fuelled all the actions; I was even making new discoveries

about the text itself." Madden even noticed that she was frightened by the changes because everything that she had always wanted to happen – and more – was happening. "After I calmed down, I realized that I had had a glimpse of what had been fascinating me all along, the power and ease of psychophysical integration."[66] Madden has made a difference to thousands of performers. Imagine if, like the pianist in my doctoral study, her first experience of the AT had put her off studying it instead of sparking her interest in its potential.

The Problem with Inhibition-as-Stopping and Non-Application

Contrast Madden's inspiring experience above with the story of Ethel Webb. Webb studied with Alexander as an apprentice long before the first training course, and is said to have given up the piano to master the Alexander Technique.[67] Ethel Webb was F.M.'s amanuensis. "She made his appointments, was his receptionist and taught," as Conable describes. He tells her story this way:

> She was a pianist. But she stopped playing because she wasn't going to play until she had really understood what Mr Alexander was teaching. And she didn't play the piano again for the rest of her life. Now, I'm sorry, but that's nuts. It's exactly the opposite of Marj's approach ... She wanted us to use what we were learning all the time."[68]

In Conable's account, Webb makes the AT into a *what*, or an end in itself. Focussing on this *what* completely obscured her passion for piano playing, a passion that had once been so strong that it had led Webb to the Alexander Technique. Erika Whittaker (Webb's niece) offers another anecdote revealing the attachment Webb had to stopping, and refraining, which is consistent with the picture Conable painted. "I was playing some Chopin," Whittaker says. "Well, I can't play Chopin of course, but I was sight-reading and pulling it all to pieces. It probably sounded awful but I was enjoying myself so much. And my aunt suddenly came in and said, 'Stop! You're making a *terrible* noise.' And I knew she'd say that. 'Stop'."[69] Whittaker is not quoting her aunt here in a critical way, rather just to show how she viewed this fundamental idea of inhibition in her application of the Alexander Technique to life. Confoundingly, she says that the things she learned from Irene Tasker and from her aunt "are all

to do with living, and stopping."[70] Barstow, by contrast, saw living as the opposite of stopping.

To give up their art in order to master something else is not what most performers want. They don't want to stop doing it in order to master another thing that may or may not help them with their art. They are drawn to the technique because of its promise to help them to do what they love doing and/or are paid to do. Michael Frederick, initiator of the first AT Congress, in New York State 1986, points out that of the five "Guest Senior Teachers" at congress, Barstow was the only one who had been a performer. He compares her love of dancing with F.M. Alexander's love of acting.[71] Alexander and Webb seem to have believed it necessary to give up their desire to play altogether, in order to master the AT. They urged their students to do the same, but to what end? Barstow says that Alexander recommended that she stop dancing during her training with him in London.[72] And while, upon her return to Nebraska after her training, she moved into AT teaching in preference to dance teaching, because "it was so fundamental,"[73] she never lost her interest in – or her belief in the importance of – art and performance and applying the AT to them, as her letters to Jones reveal. Dancing, besides, was just one of her many interests and occupations. Alongside her teaching, she cared for her father, learned to run business and various farms, lent a hand with her sister's family[74] and other such earthly tasks. Later, she said of herself: "I'm just a farmer – diggin' in the dirt."[75] Here, she was highlighting her humility and also suggesting that her observations (and the changes she had made) had simply come from the same kind of attention farmers must pay to their environment in order to succeed at farming. Comparing Barstow to Alexander, Richard Gummere described this as "the steadier attention of a farmer, sizing up everything, large or small, that needs watching," while he recalls Alexander's "responsiveness," which he manifested "with his theatrical flair." With the farmer comment, Barstow also seems to be saying that, even as a teacher of the AT, she was applying it to her life, rather than making it an end in itself. The last thing Barstow wanted would have been to recommend to performing artists that they put aside their art in order to master the Alexander Technique.

Although in the cases of Alexander and Webb, the idea of refraining from their art was probably supposed to be only a temporary phase, and designed to enhance the learning process, their example highlights the dangers of not applying the AT and the potential of fetishizing it. Such an extreme practice of inhibition led to Webb's (and Alexander's)

166 A. COLE

artistic practice grinding to a complete halt. They then encouraged others to do the same. The story Whittaker tells contains an almost violent and cruel practice of inhibition. Note that she tells how much she was enjoying herself when her aunt (Webb) said, "Stop! You're making a *terrible* noise," thus killing the joy of a young girl. In the same way Webb seems to have stopped herself from deriving any joy she had from playing the piano herself. Whittaker mentions in the same interview how her aunt had a most wonderful touch on the piano but hardly ever played when she got older (again confirming Conable's story). When she played it was wonderful, Whittaker recalls, but she hardly ever played. As Conable suggested ("That's nuts!"), this scenario does not show the Alexander Technique as a technique that can serve art or enhance the artistic process. Webb's story represents everything that Barstow opposed in Alexander's teaching.

Alexander expected that pupils should, without any assistance, apply the work to all areas of life. But this represents another contradiction in his thinking. On one hand he believed that everyone had to be spoon-fed and could not learn the technique on his or her own (evidenced by his desire to "get it for them," as discussed in Chapter 1). On the other hand, he expected students to make the transition *on their own* from chair work to every other activity in life. Barstow said that when she first began studying with Alexander, she asked him about giving up her dancing while she studied with him. His response was: "It might be [a good idea]."[76] It was perhaps Alexander, then, who encouraged Webb to stop her piano playing, too. Barstow noted long after her training, however, that to practise the concepts of "easing up" for just fifteen minutes a day and then forgetting about it was not going to help her with anything, let alone her dancing.[77] And yet it seemed that Alexander's lessons implicitly encouraged this. By contrast, as Barstow observed, "Being conscious of what you're doing with your body in all activities *will* [help]."[78] Barstow helped her students make this leap to application by including as many activities in her classes as possible, while still emphasizing the students' own role in the process.

LIGHTING THE SPARK FOR PERFORMERS

Lena Frederick, who had trained as an AT teacher in England before meeting Barstow, saw in Barstow's work how the technique really touched people when it related to something that was important to

them, for example, playing a musical instrument, dancing or teaching a class.[79] Barbara Conable called Barstow's work with performers "applying Alexander's discoveries right at the point of greatest personal relevance."[80] In the same way, Lucy Venable observes the importance of application work in helping people understand *what the technique is about*. She describes Barstow's approach as a dialogue rather than a monologue.[81] "You talk to the student to learn of his or her interests," says Venable. "You want to establish trust with the student. You find out what you can help a person with before you ever start talking about heads and bodies." As Dewey says of education, Barstow observed: "You need to relate the lesson to something the student is interested in and understands, since there is nothing you can compare the Alexander Technique to that they have ever experienced before."[82]

Another reason Barstow may have had for focussing on activities that people cared about deeply and had therefore practised, is that these activities had many "cultivated habits"[83] associated with them. Alexander had observed that cultivated habits were often harder to shift because people had paid a teacher or coach to teach them that particular habit. One of the cultivated habits that he himself struggled to overcome was that of clutching the floor with his feet as he recited.[84] Every performer will have their own repertoire of cultivated habits, both helpful and unhelpful in the performance and technique of their art. Heather Kroll reports that it was particularly in watching people meet these cultivated habits in their chosen fields that she learned "to see when someone's constructive thinking stopped." Kroll's comment draws attention to one of the ways in which application work and group teaching are mutually beneficial: the fact that combining them provides opportunities for observing others in the act of learning and changing. I will go on to look more closely at observation and group teaching in the next chapter.

In this section, I have refuted Walton White's criticisms of Barstow's Application Approach, arguing that Barstow was far beyond White's estimation of her as a teacher, especially in her ability to observe use. I also argued that he had overlooked the usefulness of application for reaching more students than just those who wish (and who can afford) to while away their time staring into space while inhibiting.[85] In this second point, Alexander's principle of use affecting functioning is constantly put to the test and borne out. White does make one valid point, which is that it may be time to recognise Barstow's contribution to education by giving her approach a different name.[86] It would be a shame, however, if this

168 A. COLE

renaming were based on a misunderstanding of Barstow's teaching and its origins, evolution and rationale, and its connection to Alexander's principles were lost in the process.

Conclusion

In this chapter the focus has been on the importance of desire in the process of learning the Alexander Technique and how that desire is harnessed in application work. While teacher training is an example of application of the AT, I discuss that in the final chapter of this book rather than here, as it ties together *all* Barstow's principles so well. In this chapter I distinguished between ends-in-view and end gaining. In trying to avoid the end gaining, Alexander seems often to have wanted to dispense with the end-in-view altogether, and did dispense with acting to concentrate on his technique, apart from starring in *The Merchant of Venice* and *Hamlet* with his first training course in London. Barstow, however, saw the importance of retaining the end-in-view (or desire and interest) for performers. Even though she herself gave up dancing, she wanted her students to have other interests, a "so that I can," or an end-in-view. Desire was an important part of the process to which Barstow adhered.

In the following chapter I consider the next of the mutually enhancing aspects of Barstow's teaching, that of group teaching. Belief in the importance of a student's desire goes hand in hand with group teaching. One enhances the other. Desire is important in any learning, and the group situation highlights its value. One of the synergistic effects of combining these aspects of teaching is that the dynamic of a group can create an overall desire that belongs to the group and can be more motivating than learning on one's own. Barstow's extended workshops enabled people to form small groups on their own, in which they continued learning independently and together, just like the students in Alexander's first training course, and in a way that foreshadowed the cooperative learning strategies of Kagan in school education today, which are contributing to great improvements in learning outcomes.[87] Furthermore, a student may need an even stronger desire to learn in front of others. Barstow believed that this desire was the first step in learning the Alexander Technique. The second step was accepting responsibility and deciding to do something about it. She made sure that students exercised these two steps every time they volunteered or asked for a turn (which they had to do if they

wanted one). Once they were standing in front of the group, ready for their turn, they were already well on the way through Alexander's steps of discovery. The combination of the Application Approach with group teaching is particularly suited to performers, as I will show.

CHAPTER 6

Democracy and the Social Context

Every time Marj helped someone, we were all touched... This kind of group experience is a powerful one and much appreciated at a time when life is increasingly insular, specialized and fragmented.

—Jan Baty[1]

In this chapter I discuss the fourth group of Dewey's principles with which Barstow's teaching aligns: democracy and the social context for learning. Under this heading I rationalise and explain first how Barstow's pioneering practice of group teaching has community and communication at its heart and is ultimately democratic in that she made the Alexander Technique more accessible, more practical and egalitarian. That is, her emphasis was on the fact that everyone can practise it in any endeavour, rather than on the requirement to put all work aside while mastering the technique. The way she ran groups also encouraged all students to learn, contribute and exchange while learning to practise and teach the technique. Second, I explain how the social context of group teaching offers what I describe as "coordinating benefits." I present these coordinating benefits under three subheadings: observation skills; constructive thinking; and democracy and independence.

To tie Barstow's ideas in to Dewey's philosophy, I offer in the first instance a paragraph on education and social intelligence, from his *Experience and Education*. This paragraph could be read as a description of the way Barstow used the group class to enhance her teaching of the

© The Author(s), under exclusive license to Springer Nature Singapore Pte Ltd. 2022
A. Cole, *Marjorie Barstow and the Alexander Technique*,
https://doi.org/10.1007/978-981-16-5256-1_6

171

172 A. COLE

Alexander Technique. It is not unreasonable to suppose that Barstow read this book, since it was published during the period of her acquaintanceship with Dewey, while she was working with A.R. Alexander. There is evidence that she read his work, and the subject matter of this book is close to her heart.[2] Dewey writes here of the role of the teacher:

> It is possible of course to abuse the office, and to force the activity of the young into channels which express the teacher's purpose rather than that of the pupils. But the way to avoid this danger is not for the adult to withdraw entirely. The way is, first, for the teacher to be intelligently aware of the capacities, needs, and past experiences of those under instruction, and, secondly, to allow the suggestion made to develop into a plan and project by means of the further suggestions contributed and organized into a whole by the members of the group. The plan, in other words, is a cooperative enterprise, not a dictation. The teacher's suggestion is not a mold for a cast-iron result but is a starting point to be developed into a plan through contributions from the experience of all engaged in the learning process. The development occurs through reciprocal give-and-take, the teacher taking but not being afraid also to give. The essential point is that the purpose grow and take shape through the process of social intelligence.[3]

First, Dewey declares the need for the teacher to be "intelligently aware of the capacities, needs, and past experiences of those under instruction." In contrast to Alexander, who tended not to give anyone much credit for anything and did not tend to understand the reasonable requirement for artists to be able to continue their artistic practice, Barstow valued the knowledge, experience and desires her students brought to class. Second, while Dewey recommends that plans be made as a cooperative enterprise rather than a dictation, contributed to by members of the group, and she took up this proposal, Barstow still guided her students, watched them closely and was rigorous with her training and standards.

THE BEGINNINGS OF BARSTOW'S GROUP TEACHING

By the late 1940s Barstow had begun to see the shortcomings of teaching individual students. "Working individually," she wrote to Jones, "as we have had to do, is slow." She noted that in forty years there had been little progress and "not one well trained, efficient person to carry on where the A. brothers stopped growing."[4] Nine years later she wrote, "One gets

6 DEMOCRACY AND THE SOCIAL CONTEXT 173

nowhere with private pupils," adding that "one" in this case included the Alexanders.[5] In that letter, she called it "the type of teaching that the Alexanders did." She was also indicating her preference, which, she said, she had "found out long ago" for teaching groups of younger people. And although she had been teaching groups since the 1940s, in 1969 she wrote: "This Institute has been a fabulous experience in teaching and now I see clearly how group teaching can be very successful. I have been handling 12–14 at a time." She added the proviso that she would not recommend it for teachers just starting out.[6] These letters indicate that Barstow had been refining her teaching of groups and receiving professional invitations to universities for a couple of decades before she really understood the true value of this kind of teaching. She was extremely experienced, therefore, by the early 1970s when, as myth has it, she fell into the practice by a quirk of fate.[7]

Bound up with Barstow's preference for group teaching was her firm belief in the importance of being able to talk simply and sensibly about the Alexander Technique. As discussed in Chapter 3, speaking simply requires clear thinking, and Westfeldt described Alexander's shortcomings in this area. Patrick Macdonald excused Alexander's lack of clarity, saying that you mustn't expect to understand. Alexander, Macdonald explains in a video, "was not good at explaining what had to happen and how it had to happen and why it had to happen." Macdonald remembers one man coming out of Alexander's room "in a rather flustered state." The man said to Macdonald, "What a wonderful man, what an extraordinary man, what a marvellous man. I can't understand a word he says!" Macdonald agrees, almost condoning Alexander's impenetrability. "And it was rather like that," he says. "People *didn't* understand a word he said. And he didn't even explain to people at all reasonably *why* they couldn't understand what he said. Because you mustn't *expect* to understand what an Alexander teacher tells you straight away."[8] Even if this is true, it does not release teachers from the responsibility to make things clear or at least easier to understand.

Rather than clarifying what *is* possible to communicate in first lessons in the AT, and finding ways to do this, Macdonald settles for the assumption that the AT is impossible to explain and clarify, not questioning it further, and deciding instead that the solution is "to make people understand *why they can't understand* and carry on from there."[9]

For Barstow this cloud of confusion and muddiness was completely unacceptable. The analysis in this chapter examines Barstow's highlighting

174 A. COLE

of community and communication and the interrelation of these concepts. I discuss the etymological connections between community and communication and refer to Dewey's observations. Again I review some of the criticism levelled at Barstow, now focussing on her group teaching, and I clarify precisely *how* she taught groups. It is my aim to identify and explain how some aspects of her pedagogy were emphasized and enhanced through this model of group teaching.

Dewey, Community and Communication

The very process of living together educates. It enlarges and enlightens experience; it stimulates and enriches imagination; it creates responsibility for accuracy and vividness of statement and thought.
—John Dewey[10]

Dewey wrote about the importance of community in education, and the impact of social intelligence on purpose. He also understood the connection between community and communication, as well as the importance of community in science. I will look at these more closely in turn.

First, Dewey firmly believed that the very process of living together educates. In *Democracy and Education,* he wrote, "It enlarges and enlightens experience; it stimulates and enriches imagination; it creates responsibility for accuracy and vividness of statement and thought."[11] He even believed that education often failed because it neglected this fundamental principle of "the school as a form of community life."[12] In *The School and Society* he argued for each school to be made "an embryonic community life, active with types of occupations that reflect the life of the larger society and permeated throughout with the spirit of art, history, and science."[13] In his work on experiential education, Dewey claimed that an educational experience is the experience between an individual and his or her environment.[14] He also saw the relationship between education and social process as affecting the role of the teacher. "When education is based upon experience and educative experience is seen to be a social process," he wrote, "the teacher loses the position of external boss or dictator but takes on that of leader of group activities."[15] He saw this guidance and the educative plan as a cooperative endeavour (as quoted above), where he stressed that where the teacher's suggestion is a starting

point to be developed into a plan "*through contributions from the experience of all engaged in the learning process*" rather than, as he said, a mould "for a cast-iron result."[16] His essential point is that the purpose should grow and take shape through the process of social intelligence."[17]

The second idea, the connection between community and communication, stems from, but is not limited to, the etymological relationship of their names. The words "community" and "communication" share a "common" root, "common" being the translation of their mutual Latin origin, *communis*. As Dewey says, though, "there is more than a verbal tie between the words common, community, and communication."[18] We live in a community in virtue of the things we have in common; and communication is the way in which we come to possess things in common. What we must have in common in order to form a community or society are "aims, beliefs, aspirations, knowledge – a common understanding – like-mindedness as the sociologists say. Such things cannot be passed physically from one to another, like bricks ... the communication which insures participation in a common understanding is one which secures similar emotional and intellectual dispositions."[19] While language is an expression of thought and a logical instrument, "it is fundamentally and primarily a social instrument. Language is the device for communication; it is the tool through which one individual comes to share the ideas and feelings of others."[20] This is why Barstow so prized clear language (as we saw in her reconstruction of Alexander's language), as a means to the end of clear communication. "When treated simply as a way of getting individual information," Dewey goes on, "or as a means of showing off what one has learned, it loses its social motive and end.[21] Dewey further observed that "the use of language to convey and acquire ideas is an extension and refinement of the principle that things gain meaning by being used in a shared experience or joint action."[22]

Dewey's belief in community extended further than education and schools. He also had a social and experimental conception of science. Dewey saw science as the effort "not of an individual, but of an 'ideal' community of investigators dedicated to learning from the consequences of artful transformations of nature."[23] Barstow cultivated this kind of community of investigators both in her classroom and in her decades-long correspondence with Jones, in which they made a concerted effort to establish and implement a research project into the principal mechanism of the AT. Having summarised Dewey's position on community and

176 A. COLE

communication, I will now look in detail at the ways Barstow's approach to teaching aligned with Dewey's philosophy.

Barstow, Community and Communication

Marj was widely known as a master communicator. At one point, some Neuro-Linguistic Programming (NLP) specialists came to a workshop particularly to watch her because they had heard how well she communicated. Although she seldom directly addressed communication (though she did ban mumbling), I know I learned osmotically from being in her teaching arena as much as I could.

—Cathy Madden[24]

Throughout this book I refer often to the 90th birthday collection of essays by Barstow's students, naming it the *Festschrift*.[25] One of the overwhelming impressions the *Festschrift* makes is the sense of community that Barstow created and that her students continued. This legacy lives on today in the organisation called ATI* (Alexander Technique International). Barstow's teaching is far from common, and yet it revolves around the ideals of community and communication, and the values her students had *in* common. Her attention to language and communication is bound up in her belief in the community she created for her teaching. This is part of the rationale for Barstow's elastic approach to Alexander's terms. She observed the effect they had on her students, both individually and as a group, and she used the group to try out her new ways of clarifying Alexander's ideas in her own words. That is, she allowed the social and educative context to change the way she taught Alexander's discoveries. While Dewey's educational precepts were written principally for the education of children, they have a marked resonance with Barstow's pedagogy for adults. Paradoxically, this is not because Barstow treated her students as children but, rather, the opposite. She gave them more responsibility for their own learning, not less.

Unlike Barstow, Alexander was not, in the words of Erika Whittaker "a 'group' person." Whittaker recalls that Alexander never felt comfortable in discussions "where everyone had a go" and that his discomfort was linked to his "intense dislike of committees and organizations."[26] His training courses *were* based on group classes. But Barstow diverged from Alexander in making group teaching a conscious and deliberate part

of her teaching to all levels of students, not just trainees. She may not have been "a group person" any more than Alexander in that she did not participate in the "great split" of the first training course, choosing to remain independent.[27] Further, her group classes were not exactly as Whittaker describes groups. Barstow remained the teacher and she was in charge. Nor was it teaching by committee. Nevertheless, she does seem to have valued the contributions, discoveries and observations made by her students more than Alexander did. She did treat her students as co-investigators in their own learning and the learning of the group as a whole.

Following this principle of treating students as co-investigators, Cathy Madden often brings a kind of Derridean deconstructive flavour to the coordinating movement (or primary control) by using a made-up word for it that has no prior meaning to anyone in the class, so that the group can construct the meaning as it learns, that is, *through experience*. This is so as to avoid "irreconcilable interpretations of interpretation simultaneously" as the pragmatist, Cherryholmes, described them.[28] Madden's practice pays heed to Alexander's comment that we can use "abracadabra" if we like, as long as it means what he meant.[29] Her approach also reflects Dewey's idea of practical intersubjectivity. As Biesta describes this, "partners in interaction create a shared, *intersubjective*, world."[30] That is, as Biesta says, they make something in common, and this is why Dewey referred to this process as *communication*. "Communication is not the simple transfer of information from one mind to another, but the practical coordination and reconstruction of individual patterns of action, which results in a shared, intersubjective world."[31] That this is intimately connected with action also reflects Barstow's alignment with Dewey's understanding of communication and education. Biesta says: "'Practical intersubjectivity' thus designates a structure of communicative relations 'that arises and takes form in the *joint* activity of human subjects to achieve ends set by their life needs'."[32] In Madden's class, the group *creates* the meaning, through action and experience, of the new word that signifies the coordinating movement. Nancy Forst Williamson also learned this approach from Barstow: "As Alexander's principles are applied, the Technique *is created anew* with each intentional contact between teacher and pupil, depending on what each is able to bring to the experience at that moment."[33]

The social context offered by group learning has another benefit for performers in that it gives them practical experience in performance,

178 A. COLE

rather than just theoretical experience, as is the case in individual lessons. Furthermore, if the teacher is able to cultivate a constructive environment for learning, as Barstow did, this mini performance experience can help to overwrite negative experiences of performance. For performers, then, group lessons are another example of connecting theory and praxis. Ed Bouchard tells how important it was for him to learn the Alexander Technique in application to performance. Having originally learned the AT in the style of Ashley Place, Bouchard found that he continued to suffer from stage fright, despite what Alexander had claimed about his training eradicating it.[34] His individual lessons did not address or alleviate what he described as his problem when performing. "At last the motor processes of my stage fright were identified," he writes of his first experiences with Barstow. "The performance setting of Marjorie's class revived my stage fright in full force," and "the group setting itself seemed to enhance my ability to respond." He observed how useful this experience was in learning to overcome his unhelpful responses to the performance situation. "It is possible that the attention of the group magnifies the awareness of the individual. One appears to notice more or be moved more easily from the habitual to new territory if the teacher creates the proper environment in the group for change to occur. Marjorie Barstow, for instance, constantly encourages people to 'take a risk' as they suddenly find themselves performing with ease what previously had been difficult."[35] Of course, there is more to learning how to be successful on stage than simply being aware of motor processes. As a theatre professional and performance coach, Cathy Madden has again taken Barstow's work further, teaching performers constructive responses to the various circumstances of performance, in which we are traditionally untrained.[36]

The social context also reminds performers of the important aspect of communication that can be easy to forget while alone in our practice rooms, or just with a teacher working on technical problems. And if our only experiences of performance are high-pressure situations or exams, the communication aspect can also be forgotten in the striving for correctness or high marks, or "wins." Having an audience present *during learning* can help performers remember the co-ordinating aspect of communication in what we do. By "coordinating aspect" I mean that communication can act as a coordinating force for whatever we are doing (including performing or teaching), making our intention clearer and therefore our movements clearer in turn. Cathy Madden observes that "the audience is one of the most neglected factors in training, rehearsal

and performance" and reminds us that communicating with them is the point of performance.[37]

Madden also describes the multi-level teaching value of this emphasis on communication. Not only is it easier for students to understand what is being taught (compared, say, to Alexander's student described by Macdonald above), but the students are learning better communication and coordination" simultaneously. Since one of the ways our students learn is by imitating the teacher, Madden explains, the emphasis on communication that she learned from Barstow ensures that she presents an improved coordination to her students.[38] In other words, Madden *communicates* an improved coordination to her students.

CRITICISM OF BARSTOW'S TEACHING

The criticisms that were levelled at Barstow and her group teaching were of two main kinds. The first kind was based on the assumption that the founder of the Alexander Technique didn't teach groups, and so it was neither "allowed" nor "authentic." Weed notes that throughout his career as a teacher, people have told him that "F.M. never taught in groups."[39] The second kind of criticism proceeded from the assumption that it was not even possible to teach the Alexander Technique in groups. Sometimes these two categories overlapped and became justifications for each other. For example, many of those who assumed that group teaching was not possible pointed to the "evidence" that Alexander himself didn't teach this way. Below I will provide some examples of complaints about and criticism of group teaching in general and Barstow's teaching in particular.

By 1978 Barstow's teaching was attracting attention internationally. Robert Rickover heard (while studying in England) that she was "an excellent teacher who usually worked with her students in a group setting." He notes that there was very little group work being done in England at the time and that, in fact, there were some teachers there who didn't think the Alexander Technique *could* be taught in groups, at least not without compromising its basic integrity. Many still thought the same thing as recently as 2015, as evidenced by the PAAT (Professional Association of Alexander Teachers)* website, which stated that during a lesson "you are *worked on* by the teacher almost continuously." The website claimed that "as the teacher works to encourage you to let go of tensions that you are creating, he/she talks to you, explaining the Technique and relating it to your particular circumstances." Categorically, it stated that

180 A. COLE

it "is not possible to *work on* two people at once" and "lessons must be geared to your specific needs and not to the more general needs of a group."[40] Note again, while referring to the work of the teacher, the use of the preposition "on" rather than "with," suggesting a therapeutic role of the Alexander Technique rather than a teaching one. The view that the AT cannot be taught in groups is consistent with the idea that it is something that is *done to* a student, rather than a process to be taught.

In 1988 an Alexander teacher, Diana Johnston, wrote a letter to the *Alexander Review*. She complained about large classes that were being held in Australia by Jeremy Chance "and others," insisting that "the teacher who teaches PRIVATELY re-educates the individual."[41] At the same time, according to Johnston, such teachers have "respect for the fact that each person is totally different, physically, mentally, instinctively and emotionally, while following closely the principles as stated and *taught* by F.M."[42]

One of the concerns by the dissenters who believe in the "impossible" argument, as this example shows, was that group teaching assumes that everyone is the same. From this position, they argue that since the Alexander Technique is about one's own use (and no one else's), it is pointless to teach it in a group. They are convinced that nothing beneficial can be learned in a group situation and that individual lessons are paramount. Alex Murray* explained his view on this. "What can be group-taught" he wrote, "is not necessarily what the individual needs."[43] To illustrate, he recounted a joke told by James Galway (flautist) about instrumental master classes, which, once again, makes a flawed comparison with a clinical, or therapeutic, situation. Galway compared group classes to a physician calling for patients in a full hall. "One comes up, he observes the problem, takes a piece of sticking plaster and puts it on the thumb of the volunteer. The audience all take their own pieces of plaster and stick them on their thumbs."[44] Murray told me this story in an email, as he was willing to answer some of my questions but unwilling to speak with me. This made communication difficult at times, as I could not always follow his point and there were several breakdowns in communication. He did make it clear, however, that he thought Frank Jones disapproved of Barstow's teaching. He wrote: "Frank and Helen Jones were initially good friends and admirers of Marj, but when they watched a late group session in Boston, they thought it a travesty of the technique."[45] When I asked for clarification of some of the details, the story became muddy, and I will outline below why it cannot be

6 DEMOCRACY AND THE SOCIAL CONTEXT 181

completely accurate. Murray had few kind or relevant words to say about Barstow, despite having been a beneficiary of her hospitality and her individual teaching. Perhaps all that can be safely said about this contribution is that *Alex Murray* disapproved of Barstow's group teaching, and his reasons were illustrated in the Galway joke.

RESPONSE TO CRITICISMS

In response to the first criticism – that Alexander did not teach in groups – Michael Frederick points out that group teaching is not such a foreign idea in the Alexander world. "Any teacher training program that I've ever seen in America, England or in Israel is a group activity," notes Frederick. "I mean, the teacher is there working with individuals, but it's also a group process."[46] Similarly, Erika Whittaker recalls that group work was an integral and regular part of the first training course. She remembers working in class "in twos and threes under F.M.'s guidance" and that he "worked on" them, whatever their part in the group.[47] And yet, the underlying belief persists that the technique cannot be taught in groups, with the possible exception of training classes, suggesting a tacit approval of group teaching in training courses but not for the wider public. There are many instances of teachers reiterating this split between teaching and training. In a collection of interviews with first generation teachers on the subject of teacher training, *Taking Time*, the tendency of the interviewees is to talk about the two teaching processes as if they are fundamentally different, and as if this difference is not only essential, but a foregone conclusion.[48] Alexander himself was responsible for this division, calling those who were simply learning the technique "pupils," and those who were training to teach "students." Barstow, on the other hand, as we will see in the following chapter, did not subscribe to this artificial separation and saw the learning and teaching of the Alexander Technique as a continuum and a lifelong process.

Even if there weren't this apparent split, there is also evidence to suggest that Alexander did teach both students and pupils in groups. That is, in addition to teaching trainees in groups, as Frederick describes above, he also taught groups of pupils who were not training. One boy gave this report to Frank Jones about his experience at the Alexander School in Stow from 1941 to 1942. "F.M., when he was there, gave group lessons," he recalled. "It seems to me that both adults and children were in the group. The pupils were seated on chairs in a circle.

182 A. COLE

Sometimes in summer we sat outside under a large horse-chestnut tree on the front lawn. F.M. would move from one pupil to another, often leaving one in an uncomfortable position and moving on to the next. I don't remember specifically that he ever abandoned anyone when they were halfway out of a chair but he might have. While he moved around, he talked and entertained us... and he told jokes."[49] This story may offer one reason why Alexander did not teach his students to teach in groups – that he thought a group class was one in which the teacher entertained the class while teaching individual students, and he had little faith in the performing abilities of his students. This would explain why, instead of teaching them about running group classes, he taught them how to do table work and other procedures.

In response to the second kind of criticism, that group teaching is either impossible or inappropriate, it should perhaps be clarified here what is meant by group teaching as exemplified by Barstow. As Frank Ottiwell pointed out, one reason there was so much controversy over her teaching may have been that there was a misinterpretation of what she did. "The fact that Marj teaches almost exclusively in groups appears to be anathema to many other Alexander teachers. I think there may be a misunderstanding... She works, as Fritz Perls described in his method of working in Gestalt therapy, *one-to-one in a group setting.*"[50]

By all accounts, there was a mixture in Barstow's classes of whole-group activities and individual turns in front of the class. There were also times when the larger group would divide into smaller groups and student-teachers would assist the small groups, or small groups of student-teachers would work with one another. Certainly, for group teaching to be effective, the teacher must have extraordinary skill. Rickover recounts that Barstow was able, for example, to help one person with her hands, another with her voice, and bring several others into the process with her eyes.[51] Alice Pryor realised, through watching Barstow work successfully with 50–70 students, that she knew she could learn as much from her teaching style as from its content, so skilfully did Barstow retain her students' attention and guide their learning through the movement process.[52] "She connects with people because she's connected with herself," says Wynhausen,[53] who notes Barstow's talent for an "easy rapport with her students." "What really categorizes her teaching," he notes, "is the lively dialogue that transpires. It is this thing that really distinguished her from the other eminent teachers who came to New York for the International Congress."[54]

A Travesty of the Technique?

As reported above, Alexander Murray claimed that Frank Jones described one of Barstow's "late classes" as a "travesty of the technique." First, Alexander Murray may well be mixing – or confusing – his own opinion of Barstow with that of Jones, as Murray said other irrelevant and disparaging things about Barstow in his correspondence with me. Second, Jones died nearly 20 years before Barstow, who continued to teach in her 90s. It is not possible for him to have attended a late class or had an opinion about her "late classes." Finally, Barstow and Jones continued to observe each other's teaching, visit each other and support and champion each other's work, right up to two weeks before he died,[55] and continued the correspondence with Helen, his wife, after this.[56]

Comparison with Master Classes

In response to the Galway story, Barstow's classes were not "master classes." They had little in common with master classes as these are generally conducted in music institutions. As Renée Fleming observes, master classes are a form of entertainment in which the "master" often chooses to entertain her audience at the expense of the students.[57] Furthermore, they are usually one-off classes. There is no follow-up and no long-term guidance. Such master classes do not create the kind of on-going, nurturing and learning environment of Barstow's group classes. Nor have most "masters" in these classes spent decades thinking about how to communicate and teach clearly so they are teaching the whole group.

BARSTOW'S COMMUNITY

There's more to education than just picking up new information. The people who came to the workshop were very fun to be with.

—John Wynhausen[58]

In an interview published in 1981, Barstow told the interviewer (Stillwell) how she began teaching group classes. Stillwell noted that Barstow was able to work with very large groups of people, "up to 87 people in a room at one time," and asks her when she made the transition to working with larger groups. First, Barstow mentions her long-standing observation that

184 A. COLE

university students are often "used to working together in performing. They're used to taking constructive criticism from their teachers; and I've always believed that if a person had something simple and logical and reasonable to present to students of that age and at that time of life, they would be interested. And I wanted to prove to myself that this could be accomplished in a group situation." A friend of Barstow's in Lincoln, who had been the first Dean of Women, had made arrangements for her to teach three classes for one semester at the University. "I had one group from the speech department," Barstow recalls, "another from psychology, and the third from home economics." She says that she saw each class once a week and was "pleasantly surprised" how quickly the students became interested. "They were seniors and would be off teaching the next year. They all wanted to continue learning more of the Technique." Barstow concludes that it was this experience that proved to her that the AT could be successfully taught in groups and she was "anxious to continue experimenting with the idea."[59]

Barstow describes the beginnings of her group classes as an experiment – something she wanted to test and prove. What might be described as a surprising result of this experiment was that as the number of people in the groups increased and the individual time with Barstow decreased, the quality of learning actually increased, as observed by both Barstow herself and William Conable.[60] Conable suggests that this inverse relationship has something to do with another phenomenon he observed in Barstow, that "she does less and less for her students and makes them do more and more for themselves."[61] He also attributes it to people only being able to learn the Alexander Technique effectively in small bites, while large spectacular changes often lead to end gaining, fixture and confusion.[62] The success of Barstow's large classes probably also says something about the commitment of those who were drawn to Barstow's teaching and the high value that they themselves placed on community. Many of her students took on Barstow's attitude toward community and the social context. "The people who came to the workshop were very fun to be with. We did things together during the free time that made the workshop that much richer an experience," recalls John Wynhausen.[63] Arro and Aase Beaulieu even got married at Barstow's house. They had planned to have the ceremony outside during the month-long summer workshop. But when rain threatened to spoil their plans Barstow offered her own house.

Barstow's students also formed their own study groups. "During the Lincoln workshops, a number of us who were teaching the technique, or studying to teach, would regularly get together after workshop hours to exchange work and ideas," says Troberman.[64] Those who lived in Lincoln also "got together about once a week, without Marj, to work with each other," says Fishman.[65] Barstow invited her student teachers to assist at her larger and more public "Community College" classes, thus reinforcing the continuity of learning and the community of those learning and training.[66]

One of the most remarkable things about Barstow was the way she seems to have invited so many of her students in to various aspects of her life. Sarah Barker suggests that at least part of the motivation for this was for the further and more complete education of her students, but it seems that the invitation into her community *for itself* was at least as important. She offered this to her students as a part of herself. "Marj worked with us daily, weekdays, for four to six hours," says Barker. "But we all saw her outside of the class when she would invite one or two of us to accompany her visiting the ranch, making a milk run, having lunch with her friends, and she made us a part of her Lincoln community. And no matter what we were doing we couldn't help but think of using the Alexander Technique under her watchful eye." Barstow would say, in her tactful way, "I've been watching you as you go along in your activities and I wonder if you might do a little more thinking about how you are using yourself."[67] This is application (in teaching the Alexander Technique) of the highest order.

Group Teaching and the Alexander Technique

There are obvious benefits of private lessons, such as having the teacher's complete attention, privacy, and having to encounter discussion only about questions that are of immediate interest to – and at the right level for – oneself. For performers, individual lessons offer the chance to work on larger amounts of repertoire with the teacher. What was unusual in the case of Barstow was that some of her students – my teacher, Cathy Madden, among them – learned the Alexander Technique solely in groups.

In analysing Barstow's teaching, I have observed that the benefits of teaching the AT in groups fall into three main groups, each of which I will now discuss in detail: Observation Skills; Constructive Thinking and

186 A. COLE

Communication; and Independence, Community and Democracy. Each major category is called a "benefit and coordinating effect" since each benefit connects with another important aspect of Barstow's pedagogy.

COORDINATING BENEFIT 1: OBSERVATION AND THINKING

It is wonderful to observe how each person uniquely reflects the more or less universal habit of 'pulling down.'

—Arro Beaulieu[68]

Barstow's emphasis on observation was so great that, for her, visual and aural observation eventually completely replaced Alexander's idea of re-educating the kinaesthetic and proprioceptive senses. "The more I teach," she wrote to Jones in 1975, "the more I realize people are so insensitive to seeing and hearing that they cannot comprehend a new experience, and their re-education at this point consists in learning how to use eyes and ears."[69] For Barstow, observation was not just visual. One student describes Barstow as helping her grow in her sensitivity to the sounds of speech as another means to find out what she was doing with herself,[70] while Cathy Madden has invented the word "omniservation," which improves upon the predominantly visual word "observation" to describe the multi-sensory practice that she learned from Barstow. As Madden describes, "Observation – omniservation – wasn't solely a visual report: sight, sound, sense of movement, or impressions of changes in communication or thought or presence were all key components" in answering the questions "What do you see?" and "What do you notice?", which Barstow continually posed. "The student having the turn might further report on elements such as thinking processes and emotional shifts," says Madden.[71]

The McGurk effect[72] and several sense studies[73] suggest that vision is our dominant sense. It has the ability to override our other senses and can actually be less reliable than other senses. Of approximately eleven million pieces of information that we receive with our five senses at any given moment, ten million of them are received through vision.[74] So it can require a conscious effort to enlist the other senses in our observations so that we can, as Madden puts it, "omniserve."

In 1947 Barstow had criticised Alexander, saying (also in a letter to Jones), that his great mistake in teaching had been that he had not taught

"something about awareness first of all."[75] Barstow was beginning to formulate her ideas and re-prioritise what should be taught and when. A few years later, in 1951, she sent Jones a list of five things she was "requiring" of her pupils in their lessons. The first was the "pupil's observation of his own coordination." What he is doing as he is carrying on his own daily activities." The second was the "pupil's observation of the coordination of people he sees every day."[76]

Learning in a group facilitates the training of observation skills. Barstow did not use mirrors in her teaching because she wanted people to watch themselves directly in activity (rather than in a mirror image) and to watch others, sometimes simultaneously. Using a mirror, Barstow realised, built the same unhelpful dependence on an external agent or instrument as Alexander's teaching. You couldn't take it with you when you walked away from lessons. But students could sometimes act as live, *communicative*, non-mirror-image feedback givers, especially because they were encouraged to practise observing while *not* experiencing a direct "turn" from the teacher and to articulate what they saw. Any feedback then had to be processed through thinking not feeling, as Kroll describes. It also encouraged students to look at others rather than at mirror images of themselves, helpful for performers, because it also trains looking outwards and communicating, whereas the mirror image of self encourages an internal dialogue with self that tends to exclude the audience (in this case the rest of the class). Kroll explains how this training helped her apply the technique to herself: "I found at first that I could see someone else's habits of movement much more easily than I could see my own. By watching other people as Marj worked with them, I learned to see how their thinking changed their coordination. Seeing this process in others helped me to understand it better so that I could apply it to myself more easily."[77] This process of learning by observing the work of others is supported by contemporary education research, such as that of Dylan Wiliam's work in the field of formative assessment. As many teachers have discovered, Wiliam observes, we are all better at spotting errors and weaknesses in the work of others than we are in our own work. Further, when we notice mistakes in the work of others, we are less likely to make the same mistakes in our own work. While his book is directed towards school teachers, Wiliam recommends this kind of practice for students at all levels of learning.[78]

Frederick notes that observation is the first part of "thinking" in the Alexander Technique. His explanation shows how group work, with its

188 A. COLE

emphasis on observation, can encourage students to think: "What I mean by thinking is, first of all, observing exactly what is going on within myself kinaesthetically. Seeing what exactly I'm doing with myself... it's really an act of attention."[79] He describes how Barstow's insistence on his carrying out that act of attention while he worked with Frank Ottiwell made him see that he was "stiffening and tightening."[80] "What are you doing?" she asked him. His act of attention, as she then helped him to put his hands on Ottiwell again was "like a lightning flash" that went through him as he experienced a clear understanding of what psychophysical re-education meant. "Prior to that," Frederick says, "Alexander work had seemed 'physical-psycho'," working from the body to change the mind, as opposed to seeing that it was your thinking that had to change.[81]

The observation skills that Barstow taught and engendered in her students can cut through the sometimes baffling detail of the technique of another discipline, or the way our habits can make these details seem baffling. Peter Trimmer describes how his training with Barstow helped him learn Aikido, for example: "In Aikido we are shown a technique and we have to perform what the instructor has done. With my ability to see, I am able to execute the demonstrated techniques as they were shown and not how my habits perceived them."[82]

Madden's skills in observation equally enable her to cut through the details of vocal technique to see right to the core of how a student has conceived of the task of singing. In 2005 she watched me in a lesson while I sang and then asked whether I used to play the flute. I did play the flute for many years. "It looks like you are trying to adjust your lips to a flute, or trying to form an embouchure that is right for the flute, but not for singing," she said. Madden happened to have a flute at hand. She observed what I did with my mouth as I played it. We then talked about the differences required for playing the flute and singing, which helped to clarify what I needed to do to sing. Previous teachers had simply become frustrated with me, demanding (sometimes to the point of shouting) that I get "it" away from my lips (whatever "it" was); to "relax" my lips or jaw, when I could not perceive anything that felt like tension; or to "speak from a forward position," another vague and impossible instruction if one doesn't already know what it means to do so. A forward position with what part of my body? Forward of where and with respect to what? If I ever asked such questions of my previous teachers I would be accused of "getting into semantics," but I was simply trying to find out what they meant and to get instructions that I could follow. Madden's observations,

coupled with her precise understanding of speech articulation and her ability to suggest changes that are comprehensible and possible, led to the beginning of significant changes in my singing. It is these kinds of extraordinary observations that make Madden's teaching remarkable.

Madden made a similarly astute observation while teaching one of my doctoral research participants in a private lesson. The participant allowed me to watch and record the lesson. Her singing was of a very high standard, but she seemed to be carrying excess tension in her arms. "You *look* like you're trying to bow," observed Madden. "Oh I *am!*" said the student, "I used to play the violin. But I didn't realise that I was still playing it!"[83] Madden helped the singer clarify the movements required to play the violin, separating them from those required to sing. This clarification was a kind of gathering of information, or analysing the "conditions of use present" (See Chapter 3) for the student so as not to make the movement of her arms *wrong*. The singer easily made the change. Madden explains this as curiosity. Rather than judging what she sees, she asks herself how that might be a perfect choice for that student. It is simply this constructive thinking process (coupled with a high level of skill and experience, of course) that often comes across as "magic," as many have described it.[84]

Having discussed the importance of observation skills and some of their applications in teaching performers, I now return to their connection with – and dependence on – group teaching.

Many of Barstow's students draw attention to the importance of observing the learning and teaching of others. The way they describe their experience of Barstow's group teaching suggests that it pulled the technique away from being an introspective and meditative process and moved it towards an interactive and social process with communication at its heart, something that Dewey would have delighted in. Bradley admits that she "never knew how important it was to observe others in the process of learning the technique" until she met Barstow,[85] who would say, "Watch yourself, watch others. What do you notice? What do you see?"[86] In this way Barstow invited her students to learn by watching the interactions that occurred between teacher and student without being the one in the hot seat. Bradley noted that she sometimes learned more about herself from watching Barstow teach than she did from having a lesson.[87] Gehman observes this, too: "Although I remember feeling in many lessons that I had made a great step forward, I feel that the real changes in my depth of understanding have come from watching Marj

190 A. COLE

teach. ... the respect, thoroughness and joy with which she approaches each student is a constant inspiration."[88]

Heather Kroll, too, stresses the link between group teaching, observation, communication and thinking, showing that group teaching helps bring observing and thinking together. As Barstow worked with one student, explains Kroll, she would "draw the attention of the group to the student's movements, to his thinking and to the relationship between them."[89] With time, Kroll's observation skills developed, and she was able to perceive progressively more subtle movements. "At first," she says, "I did not see the relationship between all those movements. Now... it is often as though I can see what someone is thinking which is causing him to move as he is. And when I "see" what a person is thinking, I have a much easier time helping him to make a change."[90]

The Sources of Barstow's Emphasis on Observation

The example of F.M. Alexander himself is testament to the importance of observation skills. In her teaching Barstow emphasised that the most important thing Alexander did was to "take a look at himself."[91] She would stress this over and over to students at all levels: that their first responsibility is to observe their own use. She used to remind her students that Alexander began his exploration "through visual perception, observation... He watched to see what he was doing incorrectly and then he experimented to see what happened."[92] But he also maintained its importance in teaching, even if this was more in teacher training than general teaching. Barstow changed this emphasis. Erika Whittaker recalls that in the first training course Alexander constantly stressed the importance of observation: "Not to judge what we saw as right or wrong but to see what people did when they talked, walked, stood, carried bags, sat in theatres and at meals, at desks and at work with hobbies."[93] "Use your observation!" Whittaker recalls him saying.[94] As Barstow said to Jones, she wished that Alexander had the interest "to teach something about awareness *first of all*,"[95] and not just for trainees in a training program.

Marjory *Barlow* also recalls that Alexander tried to train this skill of observing in the training course: "He'd sometimes get us lined up on the couch watching whoever was working. Our job was to shout out when we saw it going wrong. He was testing our observation, trying to train our eyes."[96] Barlow notes that "they don't do that much now," highlighting the uniqueness of *Barstow's* approach, but also perhaps conceding that its

emphasis on wrongness could be counterproductive. Certainly, Barstow would have not have approved of such negativity, but it seems that she did build on this practice of actively engaging students in observing. The big difference she made was not separating students (ie: those who were training to teach) from pupils (ie: those *not* training to teach).

In addition to Alexander's conscious effort to train observation skills, there may have been another aspect of his training through which his students learned to observe: his reluctance to give verbal explanations. According to Westfeldt, she and the other students in the first training course knew that they would have to take the initiative in learning Alexander's work. Since, as she says, "it was not likely F.M.'s explanations would improve, our powers of observation seemed the best thing to rely on." She points out that Alexander was, after all, *showing* them, rather than telling them. "So we began to observe carefully what F.M.'s hands were doing in a lesson and what changes occurred in a pupil." The students would then discuss and appraise these observations amongst themselves. "As a final step," she said, "they would sometimes turn to Alexander for "confirmation on doubtful points. The more we knew, the better chance we had of getting information from F.M."[97]

Barstow compared the teaching of the two brothers, saying that they "taught alike but their personalities were different, so their teaching was (pause) individual." F.M., being an actor, "was always very dynamic, a little bit of his acting creeping in. He had lots of pep and enthusiasm." She describes A.R. as being "naturally of a more quiet nature" but draws attention to the keenness of his observations, which were "very sharp."[98] A.R. clearly had different strengths from his brother. Barstow juxtaposes F.M.'s "pep and enthusiasm" with A.R.'s "more quiet nature" and keen, "very sharp" observations.[99] In this juxtaposition is the suggestion of A.R.'s superiority in observation power. In Jones's estimation, A.R. was overall a more diligent teacher, with "none of his brother's showmanship" and being, perhaps, "less skilful with his hands."[100] But A.R. was a very patient and determined communicator. Jones sometimes felt, in comparison, that F.M. "lost interest in a pupil after he had made dramatic changes and was bored with teaching him anything further."[101] Jones observes that, because A.R.'s teaching did not involve spoon-feeding, it forced him to apply the principles of the technique in order to come up with his own style.[102]

Barstow seems to have valued the skill of observation more highly than others, as she retained it as a defining feature of her teaching.

She is known for her emphasis on observation, perhaps more than any other teacher of that generation. In this emphasis, she was carrying out Alexander's step of gathering information, a crucial part of the scientific process or "the ongoing *detailed* interaction of principle and concrete observation."[103] As Barstow observed, Alexander spent days, months and years observing his own movements, and then those of others, so that he "developed within him an extraordinarily keen sense of perceiving the delicacy of movements." She recalled that in her first private lessons with both F.M. and A.R. this information was continually stressed, and that observing and perceiving movement was also a core "subject" in the training course.[104] Still, she complained to Jones that Alexander didn't make more of this aspect of the technique.[105] Perhaps she was lamenting that Alexander didn't explain or teach *how* to observe constructively, and so she taught herself and others.

Observation is fundamental to the experimental approach that Barstow employed in her practice and teaching of the Alexander Technique and which echoed both Alexander's own path of discovery and the pragmatists' emphasis on testing and the scientific process, or looking to the future rather than always to the past. Lucy Venable's notes on teaching reveal Barstow's commitment to this process. "The teacher has to be able to observe what the student is doing because that is the clue for what to do next. You do not set out with a fixed plan."[106] Richard Gummere observed how Barstow's emphasis on observation echoed Alexander's responsiveness. "I recall responsiveness as a trait of F.M. Alexander, who manifested it, with his theatrical flair. In Marjorie it seems like the steadier attention of a farmer, sizing up everything, large or small, that needs watching."[107] Barstow became known for her extraordinary powers of observation. Ottiwell, who ran a training course in San Francisco, noted Barstow's unusual capacity, even in the Alexander world. It was clear to him that one of the major components was "her skill of dispassionate observation." "Skill? Art? Talent?" he asks. "It hardly matters, because whichever it was to begin with, it has been honed by years of disciplined attention."[108]

Learning to teach from someone with such highly developed observation skills was, as Madden says, "exciting and exacting." When Madden first began to teach with Barstow, she gained even more respect for Barstow's observation skills. "I learned to see what I was doing with myself with more honesty and precision. There were times when the honesty she asked of me frightened me, but I continue to be rewarded

many times over for 'opening my eyes and really seeing what I'm doing.'."[109]

Heather Kroll attributes her own observation skills to Barstow's subtle teaching: "Just as when Alexander first looked in the mirror during his ordinary speaking and saw nothing unusual, so I, when I first 'took a look at myself' during a lesson, saw nothing unusual."[110] She points to Barstow's patient guidance with her words and hands as having gradually taught her to be able to observe her whole self during activity.[111]

Observation and Multi-Level Teaching

Observation is also connected to multi-level teaching. In group classes the level of experience can vary widely. Beginners can learn from a variety of sources – not just directly from the teacher. More advanced students get to observe how to teach beginners and can use their "turns" to teach at a range of levels under supervision. All students can observe all stages of learning and expertise. Fellow students offer valuable insights when we have a "turn." These insights often generate discussions in which much useful information is shared. For beginners who might otherwise give up in frustration and confusion, seeing others respond to the teaching can help make an early and informed decision about whether to persevere. William Conable believes that because the subtlety and unfamiliarity of the Alexander experience can seem vague at first, it can help to see other people have it. It removes the necessity for blind faith in the teacher, who stands to gain financially from telling the student that they have made a positive change in their use. If other students confirm that they see it too, they provide a more impartial feedback. Eileen Troberman, for example, put her early doubts to rest as a result of learning in a group: "Luckily, Marj worked in groups and I could see people making remarkable changes, so I figured there was hope for me, too."[112] When a teacher is given only a limited time with students, such as in a university class, the opportunity for students to see others change is invaluable.

Conversely, in groups, there is the danger of the emperor's new clothes phenomenon, in which there is a kind of peer-group pressure to talk yourself into being able to see changes that you cannot really see. Young undergraduate students, however, with no investment in the success or otherwise of Madden's class at the University of Otago (run as part of my doctoral data collection), frequently volunteered the point that it was helpful to have their classmates, whom they knew and trusted, give them

194 A. COLE

extra feedback about the changes they were making and the impact of the changes on their singing and playing. Watching a video of the class later during their interviews further confirmed for them that the observations (both by Madden and their colleagues) were accurate.

Having looked in detail at observation skills and how they are linked to thinking, I will now examine more closely the constructive thinking, language and communication skills that can be emphasised through group teaching.

COORDINATING BENEFIT 2: CONSTRUCTIVE THINKING & COMMUNICATING

The 'magic,' if you want to call it magic, is your constructive thinking.
—Marjorie Barstow[113]

Barstow's emphasis and insistence on constructive thinking and language demonstrated her total acceptance of the unity of mind and body that both Alexander and Dewey (amongst others) pointed out. That is, she saw that there was a direct link between the quality of one's thinking and one's coordination. This is encapsulated in observations such as "you always move better with a smile"[114] and practices she adopted that increasingly emphasized thinking. Barstow used the group situation, for example, to maximise the teaching of constructive thought through subtle and varied repetition. By communicating with her class using constructive language, her students could observe its impact on themselves as well as the person who was having a "turn." If they were particularly perceptive, they could also observe its impact on the group as a whole. Teaching in groups allowed Barstow to *model* the application of the Alexander Technique to communication. Communication was F.M. Alexander's original motivation for, and application of, his work and is therefore its original *raison d'être*. When learning in a group, students also learn from the teacher how to communicate to a group, an important skill for performers. In teaching group lessons in the Alexander Technique, one models one's use of self, one's vocal production and one's clarity of communication. Long-term students implicitly learn this. To be effective and constructive, then, this kind of teaching requires exacting standards of use of the whole self, voice production, communication and constructive thinking. The requirement of having to reach (or train others to reach) these standards may account

6 DEMOCRACY AND THE SOCIAL CONTEXT 195

for some of the objections to group teaching by Alexander teachers. It is also probably why, in 1969, Barstow did not recommend it for beginner teachers.[115] By the 1970s, she had adapted her teaching again so that her students learned these skills as part of the Alexander Technique.

Constructive thinking and constructive language in teaching may be best learned in groups because of the reiteration, myriad examples, discussion and social interaction they afford. In her description of what ideally takes place in lessons with an Alexander teacher, Barstow explains that the student "discovers downward pressures on the body which heretofore have not been observed." The constructive thinking begins as the student then asks, "Are these pressures beneficial or not?" "If one decides that they are not," she goes on, "the knowledge of the AT will be a guide to prevention of these pressures. In other words, the redirections of energy will release unnecessary pressures and one will sense greater freedom of movement. Through the constructive thinking one continues this process while carrying out daily activities. Constructive thinking is basic to the understanding of F.M.'s discovery because one constructively makes sense of his technique in a practical manner."[116] This description is really just the beginning of constructive thinking for Barstow, however. She took the word "constructive" to lengths and heights that are far beyond its commonly accepted meaning and practice. For example, she never focussed on what a student *had* been doing or thinking or why. She called such a focus "useless speculation about the past" and instead kept everyone "focussed on the present moment so they could constructively redirect their thoughts and energies."[117] She regarded analysing old habits as negative thinking and this analysis was, itself, "our old habits at work."[118] "How we get ourselves into this mess I don't know," she would say, "but this is a way to get out."[119]

Group classes allowed everyone to see that that they were not alone in entertaining too many negative thoughts that are both "destructive and generally stunt growth" observes Jean-Louis Rodrigue.[120] Barstow worked tirelessly with her "unfailing positiveness" to turn these thoughts around.[121] By all accounts, she could turn any situation into a constructive learning experience. "I've seen her disarm the most negative and sceptical of prospective students by her simple, direct and unpretentious manner," says Diana Bradley.[122] William Conable spoke of Barstow's absolute commitment to positive expression, and gave an example in which it was coupled with both her sense of humour and graciousness. When a young student asked if he could smoke in her house, she

196 A. COLE

replied, "Certainly. If you can take the smoke with you when you leave." As Conable explained: "She really did not want to be negative about *anything*."[123]

Once, when Barstow saw that she had created an unsatisfactory teaching situation, she rectified the situation the following day, as William Conable described to me in an interview. "The next day," he said, "she came in wearing a chartreuse baseball hat and a funny T-shirt, and a little rubber monster puppet on her finger. She was old by this time, shrunken and had osteoporosis. She stood there and hissed at us with the puppet for about five minutes. We were laughing so much it hurt. We started class and everything was fun. She realised she had created a bad situation. She took responsibility. She was saying: 'We're not going to have any more of that.' I don't think she actually thought it through, but it was intuitive. To me that says a lot about who Marj was. She would say: 'It doesn't matter why you're doing that... what matters is that you have a choice now.' She lived that." This story is not only an example of constructive action and group teaching, but also of replacing an old way of being (or simply an "off" day) with something new and, in this case, funny. In a way, she was demonstrating her own interpretation of inhibition.

Part of Barstow's reluctance to continue with the word "inhibition" stems from her absolute insistence on constructive thinking. Saura Bartner came to Barstow from ACAT-NY and so still used the word "inhibit." Barstow's insistence on positive thinking and framing did not prevent her from getting frustrated at times. Bartner's story suggests that negativity – no matter how subtle – was so prevalent that Barstow did occasionally become frustrated and even angry when it appeared. "When I said, 'I am finding it difficult and I need to inhibit, inhibit,' she said, 'Enough with that negativity.' She got quite angry for a moment. She said, 'How often do I have to tell you that you think of it once, you observe the habit once and you move – that the positive approach is more constructive thinking. Notice the habit once and let the head move up and your body come with it'."[124] This description of Barstow certainly aligns with the frustration she would sometimes express in letters to Jones about other teachers' wild tangents, negativity or bad teaching (such as what was happening at Media and also at Ashley Place). It may be that Barstow later regretted expressing these thoughts in writing and regarded them as unnecessary or negative. I do not reproduce them, therefore, as gossip, but rather to show the depth of her distress about what others were doing with the AT. Many years later she hid her uncomplimentary thoughts about

anyone, both from her students and from interviewers, thus practising what she preached at that time about negativity, even when asked for a simple comparison of one Alexander brother with another.[125]

Barstow also knew how to use a positive lesson learned, no matter how small, to reinforce the constructive thinking of the student. "It is important to stay with what is happening at the moment," she would say. "It is not helpful to call attention to what has gone wrong," (as in Alexander's classes) or "to what has happened in the past. Work until you find something that is done properly. Then leave the student to think about it."[126] For the same reason Barstow would interrupt a student's attempts to plaster over any small successes with the ubiquitous and permanent list of things still to be learned. "Early in my studies," says Baty, "I would describe an experience to Marj and immediately begin qualifying, '...but...' 'No buts!' Marj would interrupt decisively. 'No buts?' I would wail inwardly, 'But then how can I say what is still not clear?' My frustration lessened as I began to understand what Marj was doing. In her own way she was insisting I allow myself a positive experience and learn from it, instead of muddying the waters."[127]

The aim of the Alexander work is constant improvement and commitment to process, rather than a state of everlasting perfection. Current psychological research supports Barstow's belief in acknowledging small improvements rather than dismissing these in the search for that elusive state, perfection. It shows that emphasizing a sense of progress, rather than achievement and arrival, is an important motivator in learning.[128] Stanford University psychologist Carol Dweck summarises this difference as that between a growth mindset and a fixed mindset. Now mainstream, Dweck's research could be described as an extrapolation – or exemplification – of Dewey's (and the other pragmatists') emphasis on endless becoming and growing rather than on perfection, certainty or an absolute state.

The constructive thinking and communication cultivated by Barstow's group classes not only fostered this critically pragmatic emphasis on improvement rather than perfection, but also encouraged experimentation. In Marjorie Barstow's classes and education in general, it is not a matter, as in James Galway's analogy (given above, in Criticism of Group Teaching), of students being given a *treatment* and all observers trying the treatment. Whatever one's philosophy of education, it could never be said to have been about cures and treatments. When Barstow gave someone a "turn" in class, she was communicating with

198 A. COLE

the group, inviting people to observe and think, and to experiment with ideas. This is different from the analogy, which suggests that observers apply a common cure to themselves simply, passively and unquestioningly. "People observing start to experiment with the various ideas that she is suggesting," describes Bradley. "They come to understand that Marj isn't only working with the individual she is speaking to and has her hands on, but that she is working with the entire group all of the time."[129] That is, she is not instructing a single student, as Galway suggests, and nor is her teaching anything like his example of sticking a plaster on a patient's thumb.

The final example of the intersection between group classes, constructive thinking and communication shows the particular benefits that this kind of teaching has for performers. Madden was teaching groups of actors while she studied with Barstow. "Because of the changes in thinking that I was making," she says, "it was much easier for me to see how negative thinking and trying to do something right were preventing my acting students from progressing."[130] In addition to obviously negative responses such as "I can't" or other "variations on the 'I'm not good enough' theme," she began to identify it in the phrases, "I should be" and "I'll try," and nonverbally in looks of disbelief, anger and long intellectual responses. Consequently she set out to remove negativity from her own requests and comments, and to defuse negative comments that she got back.[131] Madden also learned from Barstow – in groups – the link between such negativity and poor coordination (more detail of how she learned to teach is given in the following chapter). She realised that kindness to self was also a part of constructive thinking. "One of the major things that caused me to pull down was negative, critical thinking about myself. To stay in good coordination I really did need to make what I was telling myself kind."[132] By modelling kindness to herself and her students, Madden teaches her students to do this for themselves. When she does this in group teaching, it is again an important implicit lesson for performers. Performers learn this kindness to self *in the act of* communicating with a group, which is one thing group teaching and performance have in common. Thus they are learning performance skills implicitly. In the tradition created by Barstow, Madden is constantly on the lookout for language in her teaching that might directly or indirectly imply a negative judgment. She does not say the word "stop," and she even removed the word "change" from her vocabulary when describing what students were doing (or might do), because, she said, "it implied

that what they were doing previously was wrong."[133] In her efforts to engender constructive thinking, Madden is scrupulous in avoiding any comment that makes the student feel wrong. This includes instructions or commands of any kind. As psychologist Vincent Kenny observes, conversations of command and obedience "take place within an emotional frame of negation. That is, by complying with commands to do as he otherwise would not do, the one obeying the commands both negates himself and the person commanding (by attributing to him a characteristic of 'superiority'). The one commanding also engages in this dual negation."[134] In her scrupulous kindness to self, which engenders – as she explains – good use, Madden teaches performers better coordination that then influences their performance.

The following and final section on community and communication examines the way in which group teaching honours the ideal of democracy, contributes to the independence of the student, and can foster further constructive communities.

COORDINATING BENEFIT 3: DEMOCRACY, INDEPENDENCE AND THE SOCIAL CONTEXT

The final "coordinating benefit" of teaching in groups I describe as democracy, independence and the social context. Barstow embraced three key features of Dewey's education philosophy: democracy, independence of the student and the importance of the social context. One of the major differences between Barstow and Dewey, on one hand, and Alexander on the other, was their trust in the capacity of students to learn. That is, Barstow and Dewey had an underlying respect for their students, while Alexander seems to have had an underlying disregard (as I showed in Chapter 1). This respect and trust meant that one of the tenets of Barstow's teaching was to engender her students' independence from her. In addition, it meant that she trusted that students could learn from one another and not just from their "master." Her group lessons, based on trust and respect for her students, also ensured that the social context helped to teach her students, because they were required to contribute to their own and one another's learning, while interacting and communicating with one another.

Martha Fertman's description of Barstow's teaching shows the interconnectedness of community and independence (or responsibility for one's own learning), the third major benefit of learning the Alexander

Technique in groups. "In groups," she writes, "as we observe each other make remarkable and brave changes, a self-evident conclusion is that if this change is so simple and obvious we must each be able to figure this out for ourselves. Marj's group teaching encourages, by necessity, the independence of will that fundamentally lets the technique be learned."[135] As discussed in Chapter 4, and as Barstow wrote in a letter to Jones,[136] the kind of lessons she experienced at Ashley Place, with the emphasis on "lying on a hard surface with a book under the head," had "nothing constructive about them" and makes the student "entirely dependent on the teacher." "A teacher," Barstow believed firmly, "should never force a pupil, or take him faster than his thinking can follow."[137] This point about independence relates to the discussion on thinking versus feeling in Chapter 1. In that discussion I focussed on how Barstow's emphasis on thinking was an example of following process rather than results and how this encouraged the student's independence. Here the focus is on the link between group teaching, independence, and encouraging students to take responsibility for their own learning.

Arro Beaulieu counts Barstow's insistence on her students' personal responsibility for improvement in their own use as "her most fundamental departure from the traditional way of teaching the Technique," and insists that it is "of greater consequence than changes in procedure and vocabulary."[138] As he observes, this responsibility leads to greater confidence, which "comes with having initiated the change in our use through our own volition and movement." Bruce Fertman emphasizes that watching Barstow work with others "is not a passive experience, but very demanding." Watching the teacher teach, watching how the teacher observes, and watching others learn were further activities to which Barstow encouraged the application of the AT in her classes. All participants in every class could be actively learning all the time *if they chose to be*, and this way of teaching again put a premium on the student's own responsibility and choice to pay attention and learn.[139]

In his book on formative assessment, education researcher Dylan Wiliam highlights the value of observing and evaluating other's work as a learning tool. He emphasises the importance of helping students identify both successful *and* unsuccessful examples, rather than just one or the other.[140] It can be hard for musicians who are used to individual lessons to see the value of watching others do a number of varied activities that are not obviously or immediately related to their own interests. I am one such musician who sometimes gets impatient. But the lessons I have

6 DEMOCRACY AND THE SOCIAL CONTEXT 201

learned from watching others have been some of the greatest learning moments in Cathy Madden's Barstow-inspired classes. Barstow, too, used both the successful *and* unsuccessful examples of Alexander's teaching to inform her own. That is, she saw him not as an authority beyond reproach, but as a teaching colleague, in many ways effective, and many ways not. This is another reason that I quote from her letters when she was less than complimentary about anyone: not because I want to reduce or ridicule that person, but because it shows her thought processes and critical thinking. In interviews later in her life she appears to have wished to hide such thoughts as she expressed privately to Jones, what she might have called "negativity," but they are shared here to show the evolution and rationale of her later teaching.

Psychologist Patricia Carrington offers a description of just one of the ingredients that contribute to the learning (or in this case the *changing*) process in groups, calling it "borrowing benefits."[141] When audience members or workshop participants align themselves empathically with the person in the spotlight, a large number of observers report improvement with their own issue. "When we Borrow Benefits," as she calls it, "we allow the person who is actually saying the words and doing the [work] ... to take responsibility for these actions and so we are in a sense not responsible for them, we are only followers. Consequently, when we are absorbed in the problems of another person and identifying on an energetic level with them, we seem to be not nearly as defended against insights or change in ourselves as ordinarily. In a sense, Borrowing Benefits seems to 'sneak' past our psychological barriers so that this technique can reach directly to the core of ourselves," says Carrington.[142] Further, contrary to what Alex Murray and James Galway describe in disparaging terms (the band-aid effect in music masterclasses), the benefits (such as reduction of biological markers of stress) of the group technique Carrington describes have been supported by several studies, with verifiable and repeated results.[143]

Group teaching, as Barstow practised it, meant that each student had a short individual "turn" in class rather than a prolonged period of intense learning. Between short turns students were given the chance to think about what they learned while also benefiting in various ways from the learning of others. Barstow believed that if the work was to be learned thoroughly and independently, then the learning had to take place in small chunks. "Be happy with small progress," she would say,[144] or "Okay, just do a little bit – your head's moving – go on and continue that – don't do

any more – just a tiny bit of change is enough."[145] Here, then, is another argument for group classes over individual lessons, since short individual turns, which teach small steps only, are what constitute group lessons with a Barstow-style teacher.

The idea of "small progress" connects the ideas of independence, democracy *and* constructive thinking. Independence is involved because small changes can be made more easily alone than large ones. "It is the little changes that I can follow, understand, and reproduce *myself* that last and contribute to my long-term benefit," says Conable, contrasting this with his early lessons with Barstow and another "hilarious lesson with her in which she imitated the teaching of another senior teacher."[146] In that lesson, Conable describes feeling "very much like a puppet," as she produced "an astounding effect" of "such intense lengthening and widening" that he had not ever felt before or since. Barstow stopped teaching like this because she realised, as Conable did, that he had "no possible way" of doing that for himself. The effect soon faded and left him "in a dangerous tendency to set."[147] Small steps can be difficult to recognize as progress, especially if we are expecting large steps or obvious changes. Sarah Barker quotes Barstow as saying: "This delicacy of movement is what our feelings aren't quite used to. You can't get a big feeling from a little movement."[148] According to Dewey, gradual improvement is the way to liberation, rather than large steps, or even flight: "Liberation is to be sought, not in a flight from habits, but in their improvement... The course Dewey advocates is one of continual adjustment and renewal of available habits through intelligence."[149]

Celebrating "small progress" is linked with democracy because more of us are likely to be able to make small changes on our own than large ones. If everyone is capable of making small changes, then we can all learn the Alexander Technique. It is not an elite sport or academic achievement. Small successes and changes in coordination count. Dewey's allegiance to democracy lay in his belief in the wisdom of the common man. Similarly, Barstow had an underlying belief that people can learn this work on their own, just as Alexander did. This is only possible if the steps are small. Constructive thinking is involved because we are celebrating small successes rather than focussing on what still needs to be learned. One participant in my research both noticed and articulated this about Madden's teaching too: "I felt that her approach was to take baby steps and to get you to do things that you could actually do and have a sense

of achievement... And, yes, just little bits of success... may be a way of getting you to keep going with something conceptually difficult."[150]

Barstow was able to communicate through group teaching that the responsibility to learn the work rested with the student. She constantly and consistently demonstrated this, as observed by Williamson: "At no time have I had the impression that Marj was assuming responsibility for a student's ability or lack of it."[151] Or, in Marguerite Fishman's words, "the Alexander Technique is a self-help program. And it was this approach that [Barstow] emphasized over and over."[152] Fishman found this "the most difficult and elusive thing to grasp, but ultimately the most valuable."[153] Martha Fertman concurs, claiming that "this primary responsibility of the individual to the work is its greatest rigor."[154]

SUMMARY

In this chapter I have drawn parallels between Dewey and Barstow as regards their ideas and practices pertaining to democracy in education, student independence, social context, community and communication. In particular, I looked at the ways that group teaching enhances other aspects of the AT that Barstow emphasized in her teaching, such as observation skills, constructive thinking, and responsibility for one's own learning. In the following chapter, I will outline the ways in which Barstow brought all these things together to train teachers.

PART III

Integration

CHAPTER 7

The Art and Integration of Teaching and Training

One thing, don't be too serious with them – have a bit of fun. I believe everyone has to work out his own way of teaching – after a principle has been learned there are many ways of presenting it.

—Marjorie Barstow[1]

In this chapter, I show how Barstow integrated all of the principles discussed in the previous section (making ideas clear, deconstruction and reconstruction, using desire and interest, and using democratic principles and the social context) in her teaching and teacher training. I also introduce some concepts that she introduced into her teaching that do not fit neatly into the four principles of the previous section. As I have said before, Barstow was an educator and was particularly interested in questions of teaching, more so, it seems, than Alexander himself. Broadly, the concepts that differentiated her teaching from that of both Alexander and his protégés, which I will discuss here, are: creating the conditions for learning; teaching by example and implicit learning; respect, meeting and accepting; the use of the hands in teaching; and multi-level teaching based on a learning-teaching continuum model rather than an artificial separation between learning and training to teach. Some of these are *related* to concepts I have addressed above, such as constructive thinking, but they still merit a discussion of their own.

© The Author(s), under exclusive license to Springer Nature Singapore Pte Ltd. 2022
A. Cole, *Marjorie Barstow and the Alexander Technique,*
https://doi.org/10.1007/978-981-16-5256-1_7

207

Creating the Conditions for Learning (CCL)

"Creating the conditions for learning" is a term I learned from Cathy Madden in 2011. I was teaching a singer as part of my lesson with Madden and paused to tell Madden that I noticed myself wanting to somehow transfer the knowledge on to my student in a way that Barstow might have described as "a bit pushy." Clarifying the teaching contract, Madden reminded me that my job was to create the conditions so that my student could learn. Immediately I noticed the "pushiness" fall away, and a space for my student to understand what I was telling her begin to open up. I was no longer invested in my student's success and I had stopped worrying about whether or not I was "being a good teacher." As I began to analyse Barstow's teaching for my doctoral thesis, I observed that Barstow's teaching, with all its integrated ingenuities, created the conditions for learning, which I abbreviate as CCL.

There are a number of Dewey's ideas that correlate with Barstow's practice of CCL. These are the importance he gave:

1. objective conditions for education,
2. conditions that arouse and guide curiosity,
3. educating indirectly by means of the environment and by example and
4. expanding freedom.

Highlighting again the importance of community and the social environment, Dewey discusses "objective conditions" for education. These include a wide range of things, the most important among which is "the total social set-up of the situations in which a person is engaged."[2] "Establishing conditions that will arouse and guide *curiosity*" is a requirement for "forming habits of reflective thought," wrote Dewey in his revised edition of *How We Think*.[3] He believed that "we never educate directly, but indirectly by means of the environment,"[4] and that "any environment is a chance environment so far as its educative influence is concerned unless it has been deliberately regulated with reference to its educative effect."[5] This is precisely what Madden made me see when she reminded me of my job as a teacher. I had been trying to educate directly and to make the transaction about my teaching ability rather than about the kind of environment I was creating.

Dewey's belief that "example is notoriously more potent than precept"[6] shows, once again, his belief in indirect means of educating. It also suggests that the student is responsible for his/her own learning, and that, rather than attempt a direct transfer of knowledge from self to pupil, the teacher must set up conditions that allow the student to learn. "Despite the never ending play of conscious correction and instruction, the surrounding atmosphere and spirit is in the end the chief agent in forming manners."[7] When I had dropped my secret agenda (of "being a good teacher"), I was able to demonstrate the exercise I was teaching my student and allow her to learn whatever she needed and wanted to learn from me (thus, again, returning to the idea of the independence and freedom of the student).

Finally, with respect to expanding freedom, Dewey believed that helping others is "simply an aid in setting free the powers and furthering the impulse of the one helped," rather than "a form of charity which impoverishes the recipient."[8] "Education is an awakening and move-ment of the mind. To take hold actively of any matters with which it comes in contact, to be able to deal with them in a free, honest and straight-forward manner is the condition under which the mind grows, develops."[9] Dewey scholar Jim Garrison draws attention to the connec-tion between creativity, morality and expanding someone's freedom. "Expanding freedom," he says, "is as much a creative aesthetic adven-ture as it is a moral duty... Finding means to desirable ends is a matter of inquiry, imagination, and creativity. It also requires technique."[10] Returning to the example of my lesson with my student and Madden, by focussing on my job as creating the conditions for learning, I allowed my student the freedom to understand or not, to imitate me or not, and to learn or not, without any obligation towards the teacher.

The ways that Barstow created the conditions for learning are a kind of synthesis of all that has been discussed in the previous chapters. Specifi-cally, for her, to create such conditions meant: to pay attention to process, to value and encourage students' independence and autonomy, to make her ideas clear, to look after her own coordination so that she could teach by example, to think about what she was saying "in action," to meet and accept her students, and to expand their freedom. We have looked in depth at Barstow's emphasis on process, her encouragement of students' independence and her commitment to making ideas clear. I have only touched upon her approach to teaching by example, meeting

210 A. COLE

and accepting students, and expanding freedom. This is the focus of the next section.

Teaching by Example and Implicit Learning

Jan Baty highlights how consistently Barstow taught by example. "As Marj teaches we all benefit by her example. Seemingly tireless, Marj uses her energy so evenly that after many hours of teaching she is still going strong... Since there is no unnecessary effort in her own motions, her teaching becomes transparent."[11]

Marjorie Barstow used to ask of her students, "Who's the most important person in the lesson?" Her answer is: "The teacher."[12] By this Barstow meant that if you are not "in good use" yourself, you cannot teach "good use." If you go out of coordination in order to press a point, then you make something other than yourself and your use more important. Barstow also showed that good teaching of *any* kind – not just the teaching of coordination – is best carried out when the teacher is well coordinated. She said: "We carry out our teaching better with good coordination rather than with poor coordination."[13]

Teaching by example acknowledges the phenomenon of implicit learning. Implicit learning, according to Cleeremans and Dienes, is the process through which one "becomes sensitive to certain regularities in the environment." They stipulate that it occurs when students are not trying to learn these regularities and do not necessarily know that they are learning regularities. Further, it happens in such a way that "the resulting knowledge is unconscious."[14] Learning is implicit when the learning process is unaffected by intention,[15] say Frensch and Rünger. This means that if students are in a state in which learning can easily take place, they are more likely to learn and imitate the use of their teacher. This phenomenon puts a premium on the good use of the teacher, as Barstow acknowledges in her question about the most important person in the lesson. This is why she was so demanding when it came to the process of teaching people to teach the Alexander Technique."[16]

Marjorie Barstow placed great value on the example of good use that she represented for her students. Students learned implicitly how to use themselves better simply by being around someone with excellent use and remembering to apply the AT process. Rickover relates a story of one of Barstow's health aides who noticed this effect, without having had any independent desire to learn the technique. Towards the end of her life

7 THE ART AND INTEGRATION OF TEACHING AND TRAINING 211

Barstow always had home health aides with her. If Barstow was sitting, they would just sit in a chair in the room; if she was standing they would stand behind her. "One in particular, Becky," says Rickover, "was very, very fond of Marj... After one of the classes, Becky asked me, she said 'You know, when Marj is teaching, I feel like I'm a little lighter inside myself, is that possible?'" Rickover stresses that this was a 20-year-old student who knew nothing about the Technique except the little that she had seen while working for Barstow.[17]

Many of the students who contributed to the *Festschrift*[18] draw attention to Barstow's scrupulous commitment to modelling what she was teaching. In William Conable's words, Barstow "puts a remarkable emphasis on the teacher's own use both as an exemplar and because of the understanding that what a teacher communicates most clearly is the quality of his or her own use." He contrasts this with working "on" students. "It is clear enough that it is possible to produce effects on other people; it is this approach which Marj most strongly deprecates. She says over and over, 'the most important thing is what you yourself are doing'."[19] Heather Kroll adds to this the importance of recognizing that we communicate with our whole selves. "I learned," she says, "that the skill of using my hands does not reside in my hands, but in my brain, which controls the way I use them. I learned that teaching happens when I use my whole mechanism skilfully... in order to communicate with my voice and my hands that [we] can think in a different way."[20]

Barstow was meticulous about living the Alexander Technique, not just for herself and her own benefit but for the benefit of her students. Donald Weed tells the story of sweeping leaves off the front porch at Barstow's house, which shows her meticulous and constant review of the *how* of even so mundane a task:

> Every time Marj would sweep the porch, she would try to figure out the best way to do it. The broom held to the left. The broom held to the right. Left hand low on the broom. Right hand low on the broom. One hand at the top of the broom. Both hands along the sides. Holding the top hand still and 'sweeping' the lower hand [and broom] underneath. Holding the lower hand still and leveraging the leaves forward from the top. Dragging everything forward in a single motion. Sweeping everything along next to yourself while stepping forward. Pushing the leaves in front of you from behind. Sweeping in a circle. Sweeping in a straight line. Sometimes she would actually try all of these things. Sometimes she would just talk about them. But always she would think about the best way of

212 A. COLE

doing the task. I was amazed at how inventive she could be to come up with so many different variations... And no matter how often she came up with the same answer to the best way to sweep the porch [to me, each 'best' solution she created each time we did this looked remarkably like the 'best' solutions she had created on previous days], she always went through this same process at the same level of involvement; and her part of the swept porch always looked better [and bigger] than mine.[21]

Marjorie Barstow's "Use of Self": Her Example

Did Marjorie Barstow have a head start in the realm of psychophysical coordination? As we have seen, she was above average in her physical skills, most notably in the realm of athletics and dance. Of her "use" before she undertook the Alexander work, she says: "I wasn't doing too bad a job. I knew that."[22] When it was suggested to her that her "use was probably pretty good to begin with," she replied (as quoted in Chapter 3): "It wasn't too bad, but I was a little stiff.... My legs were heavy ... because of an excessive tension that had developed in my body through my dancing... I had a tension through my neck and a bit of a high chest, but I danced and got along all right."[23] Of the dance pupils (all children) that Barstow taught before she learned the Alexander Technique, Marsha Paludan observed a great freedom of movement. Barstow replied: "They were real free. That is what we worked for. Freedom and ease and flexibility."[24] She had also made her own observations about the limited improvement made by many performers she knew despite the amount they practised, as she described in the Nebraska Oral History Project (see also Chapter 5).[25] This made her wonder about a central coordination even before she encountered the work of Alexander, suggesting her own natural ability to observe and recognize optimum movement. Barstow's use before learning the Alexander Technique was probably above average but with some room for improvement.

Frank Ottiwell believed that Barstow "probably got off to a relatively good psychophysical start." When he asked her whether she had always been well coordinated, she said, "Oh, I don't think so. But one day I decided that if I was going to do this [Alexander] I had better start doing it."[26] Shortly after meeting her Ottiwell asked one of the members of the first training course if he remembered her. His answer was: "Yes. We all thought she was the best of the lot of us at the time."[27] Michael Frederick

7 THE ART AND INTEGRATION OF TEACHING AND TRAINING 213

recounts a similar tale about Patrick Macdonald. At the first International Congress, in Stony Brook, NY, in 1986, Frederick was present at a meeting between Macdonald and Barstow. "I was standing," recalls Frederick, "when Marj and Patrick Macdonald first saw each other after about 40 years, and Patrick very clearly came up to Marj and said, 'Ah, Marj, it's so wonderful to see you,' and he looked her in the eye and said, 'You know, you were the best of all of us in those early years, you had the best hands.'[28] It is probable that both these anecdotes (rather than just the latter) refer to Patrick Macdonald, as he is the only male member of the first training course who spent any time in the US in the 1970s, where Ottiwell might have met him.[29] Marjory Barlow also remembers Barstow's hands during training: "Marjorie Barstow had wonderful hands. Some people are naturally gifted with good hands. Other people's hands are like plates of meat – no intelligence in them at all."[30]

Robert Rickover claims that Barstow learned a great deal about good movement from training horses,[31] again suggesting a learned characteristic over a natural one. But she was no average horse trainer, either. She trained quarter horses and in 1970 her horse was the world champion cutting horse.[32] It seems, as Ottiwell suggests, that Barstow did have a flair when it came to coordination, movement and observation.

Rickover met Barstow when he was already half-way through his training at the School of Alexander Studies in London in 1978. This suggests that he had a reasonable degree of experience in the different standards and qualities of "touch" of Alexander teachers and students with which to compare Barstow's. One of the special qualities of her teaching that he noticed was "her extraordinary touch."[33] Don Weed suggests that by this time (the late 1970s) Barstow's touch had been greatly refined. "Students who started in the late '70's find it hard to believe that Marjorie once used 'heavy hands' more than 'light hands'."[34]

Rodrigue describes Barstow's touch as "clear, very powerful and subtle."[35] Baty writes, poetically, that Barstow's touch could "tap the creative core of our liveliness: instead of walking, we dance; speaking becomes singing."[36] Another student of Barstow's, Kelly Mernaugh, says that in his first lesson in the Alexander Technique in 1979, he wanted to give her a compliment: "I told her that she had a nice touch with her hands. In retrospect, I see that she had a nice touch, period."[37]

On a more humorous note, William Conable tells the story of Barstow's *always* winning the watermelon-spitting competition at the end of the summer workshop, even in her eighties. He was also moved to

214 A. COLE

share the story of her sitting in a bar during the interval of a play, again surrounded by several of her students. Suddenly she picked up a piece of popcorn and, using her other hand as a bat, flipped it into her mouth.[38]

Perhaps Barstow's relatively good use, which governed the use of her hands in teaching, also had something to do with having had more experience than the other students at the time of the training course. As Marjory Barlow said, in comparison with herself, "some of them had had years of work, like Marjorie Barstow," before beginning to train.[39] In addition, Barstow was older than most of the other students, and her maturity may have given her an edge and a greater degree of independence and confidence in herself.

To conclude, Barstow was probably above average with respect to her physical prowess. But, as we have seen, she did not want to use this to give her students passive experiences of good use. Rather, she chose to use it, along with her constructive thinking and attention to process, to model good use.

MEETING AND ACCEPTING

Under this heading I discuss Barstow's skill in respecting and accepting people for who they are and meeting them at whatever stage they are at, and in whatever way they need to be met. This skill applies both to a meeting through listening and observing and to a *psychophysical* meeting with the use of hands in teaching. An interest in the personal was what Barstow appeared to share more with Dewey than with Alexander. According to Horace Kallen, Dewey "was fundamentally interested in the human being, in the individual, in people. Unlike Alexander, he also had great tolerance of people. His ability to listen was one of his most striking characteristics."[40] By contrast, judging from Walter Carrington's account, it seemed that Alexander's chief social *modus operandi* was to entertain by reciting or holding forth.[41] There are no apparent accounts of Alexander's skill at listening, or of his interest in others.

Meeting with Language, Gestures, Movement and Humour

Mernaugh outlines what I call Barstow's "meeting," describing her as "helping her students understand delicacy with less and less fuss. How? By taking the student from where the student is. She works with the student's own vocabulary, gestures, movements, and humour."[42] Such

an approach was "based on respect for the individual student's ability to make observations and actively participate in the process of learning."[43] Bradley notes that Barstow did the same with the group as a whole: "She teaches appropriately to the group that she is working with. She gives them what they need. It's simply a matter of meeting people where they are and delicately showing them how the technique can improve what they are doing."[44] Frederick and Rickover also noted Barstow's ability to perceive people's needs and attend to the individual while still teaching the group. "Part of her brilliance," noted Frederick, "was that she had this amazing adaptability to the individual. She would listen, really listen to you and watch you, [a] keen observer. And then she would figure out how to best access you so you could learn." "And if it was in a group setting," Rickover adds, "which it usually was until the very end of her life, she was very aware of what she was saying in terms of how people in the group would interpret it. Very careful with her choice of words."[45]

Cathy Madden carries on this tradition. One of her longer-term students, interviewed as part of my doctoral research, observed how rare it is for a teacher to meet students where they are and how important it is for learning. "What I do appreciate about Cathy's teaching, that you don't find many places, is that she allows you to simply be where you're at." He gives an example of being exhausted when arriving at a lesson. He describes Madden's approach as: "'OK, well you're exhausted so let's sing from that exhausted place.' There's no coercing to try to make you do something or be something that you aren't being or doing, it's taking you where you're at and going forward from there."[46]

Another participant in my research described the wisdom and effectiveness of this kind of meeting. He contrasted it with a situation where you are "lying on a wharf on your tummy and you smack the water. There's massive resistance from the water. The water doesn't get harder; it's to do with the way you approach." He then likened Madden's approach to lowering your hand "slowly and gently" into the water so that "it doesn't resist. And I try to remember that as a way of going through life, because when you try and barge, life resists. In a way, the atmosphere she creates, it works on the same principle."[47] In an interview I conducted with Madden, she described this skill. She said that she does her best "to hear and listen in the world they're in," couching her language to enhance the language of her students. The example she gave was of a

216 A. COLE

student who always answered her "in geography." By way of explanation, Madden added: "Head in the Arctic and feet in the Antarctic... so I started talking to her in geography."[48]

Meeting with Hands

For descriptions of Barstow's use of hands in teaching, I have relied on the testimony of Barstow's students (including Madden), and my experience of learning how to teach from Madden. As a second-generation example, I use data collected in the research on Madden's teaching in Dunedin, New Zealand, to illustrate the impact, impression and effects of *Madden's* hands, and offer this as a glimpse through the present into the past.

Michael Frederick notes Barstow's use of hands in teaching as being judicious and intimately connected with the student's thinking. He contrasts this with the very hands-dominant school of teaching prominent in England, where he trained with the Carringtons. Several of Barstow's students make specific reference to her use of hands in teaching. Venable explains Barstow's guiding intention: "Shape your hands to the shape of the person's body... The touch should be delicate, but clear. If you are not using yourself properly, then you will not be communicating anything with your hands."[49] Aase Beaulieu, in poetic reverence, points to the delicacy of Barstow's touch and, less directly, to the subtle intention. I have attempted to preserve the layout of the poem excerpt:

> Your touch like to that of a bird on a mountaintop—
> A gentle reminder that we move without being
> coerced.[50]

Madden Describes the Use of the Hands in Teaching

> *If you want to know about using your hands in teaching,*
> *watch how you use them all day.*
> —Marjorie Barstow[51]

In an interview with me in 2011, Madden says that she learned how to use her hands in teaching from Barstow. As she said, her guiding principle is first to allow the student to shape her hand, and then to help the student to "say 'yes' to the new idea." While using her hands to teach, she is

7 THE ART AND INTEGRATION OF TEACHING AND TRAINING 217

also constantly asking for her own coordination, so that she can ask the student to coordinate, so that the quality of her touch is imbued with this fine coordination. Madden articulated this way of using her hands while teaching me to do so. In the following excerpt from my lesson, the chair is standing in for a student:

> *Madden*: It is a wilful move; it's not a nothing. So my fingers come here and I *intend* to let them take the shape of the chair. What I'll note if I haven't before is: it *is* bypassing a reflex. Because the reflex would do this: It says, 'Oh, chair...' So I am consciously by-passing that, in order to create another skill...
>
> Now, this is something we can't ask, because Marjorie Barstow is on the other side, but what I realised at a certain point... is that this is a way, as close as we can to not interfere: to meet someone *where they are* rather than imposing an idea of where they are. So it's a meeting. As soon as I stiffen my hand first, I am more likely to create an anomaly, or to make them do something *because* my hand is there.[52]

Barstow was "very sensitive," says Madden, "to the fact that the imposition of the teacher's will upon a student is a violation of the severest nature of both the principles of the technique and the sanctity of the open relationship which allows learning to take place. She respects each person she deals with."[53] More recently, in 2018, Madden writes that she would now word the instruction above this way: "Look at your hand as you lead with your fingers to reach for the object in such a way that your hand moves along the shape of the object."[54] The new phrasing asks the student to be less passive by using more active verbs than "allow" and "let." She maintains, however, that how she learned to reach for things, and eventually for people, "fosters respect for each student. I intend to be with them, meet them where they are, and follow them as they experiment with new ideas."[55]

One of the questions I asked all research participants in Dunedin was "How did you respond to the use of Cathy Madden's hands in her teaching?" The following comments are by those who noticed and articulated the quality of Madden's touch *and* noted how it enabled them to learn or find something new for themselves or on their own: "Her touch is very light, and once again gives you that confidence that she's not trying to readjust you, but just giving you a bit of guidance," said one amateur musician.[56] An Alexander Technique teacher observed that her touch was "very inviting, not pulling or pushing me around at all...

218 A. COLE

And I felt that definitely with her hands she was doing the same thing I do, but talking maybe with a different emphasis, with head leads, body follows."[57] Two professional musicians (a singer and a cellist) described Madden's hands as creating "an awareness" that enabled their own coordination. "She manages to put the body in an awareness so that you can do what you're trying to do," said the singer, while the cellist described Madden as creating "an awareness where you then naturally adjust."[58] A professional violinist pointed out the importance of Madden's ability to put people at ease as part of her facilitation of this self-coordination: "It's like she puts her hands *near* where you're going to be and then you adjust, so I think the ability to have people completely at ease, at least for me, is very special."[59] Finally, a professional pianist waxed lyrical about the involvement of the spirit, emphasising again the facilitation of one's own power:

> I think, the only way I can describe it, somehow it's the laying on of hands and then you are visited by the spirit, but the laying on of hands hasn't changed your body and the spirit is still coming from within you... you know, it may *feel* like the light of the holy spirit visited you and now your head's on fire, but it's all released, it's *your* spirit released and alive and governing what you do, which is kind of where we all want to be, so the enabling, or the physical work she does frees your own energy.[60]

The Alexanders' Legacy: The Delicacy of Movement

To conclude the discussion of meeting students, and to complete the circle back to the Alexanders, I refer to the interview Barstow gave during the Stony Brook Congress, Here she describes the way she recalls the Alexanders delicately meeting their students, weaving observation and constructive thinking into everything they did. Note that by the 1980s, at least publicly, Barstow seems to have dropped much of her critical stance towards the Alexanders. It should be noted that her letters reflect only what she thought and felt at the time, which were probably at least partly motivated by the hurt she must have felt at F.M.'s treatment of her in the 1940s. She never had anything but praise for them in public.

> *Interviewer*: When you say that this is a whole new way of learning, that we have not even scratched the surface of yet, are there ways you would see this developing or into fields ... that haven't yet been delved into or thought of?

7 THE ART AND INTEGRATION OF TEACHING AND TRAINING 219

Marjorie Barstow: Well, the simple procedure of noticing when you wish to improve your general manner of use, and I like that expression because it's a moving expression, rather than, I could say posture, I could say coordination, I could say balance, a variety of words could be used, we haven't been trained to observe ourselves with this same quality or delicacy of movement that is a result of the technique. It's a broader field.

Interviewer: Was Alexander delicate in his approach to you all when you were learning to teach?

Marjorie Barstow: Oh yes. It's strange since I've been here I've thought about both of the Alexanders, he and his brother, they were both excellent teachers. They were different personalities, very different, but as I think back on the work I had with them, there was a delicacy and a certain quality of delicate power in their hands in the process of their teaching. And they were very, very insistent about what they called the redirection of energy. Conservation of energy through constructive thinking.

Interviewer: When you worked with the Alexanders, were they *strong* with their corrections to students? You said they were very insistent. How did they work?

Marjorie Barstow: They were insistent with a certain amount of delicacy. In other words they were not sort of pushing and shoving a person around. They were wanting the students to go, well, let me see, how shall I explain this so that I give you the impression I'd like to give you? They were insistent on the students' thinking. Thinking of what? Noticing what their hands were doing. Noticing the *suggestion* of direction that they were giving each of the students. I think that's the best way to express it.

TRAINING TEACHERS

Marj teachers are different. What makes them different?
—Participant at a residential AT workshop[61]

In this last section I will outline the evolution of Barstow's beliefs about her role in training teachers and how her training method emphasised desire and application, as well as the other features of pragmatism discussed in previous chapters, that is, making ideas clear, deconstructing and reconstructing, and the social context. It will be seen that while she did not ever run a formal training course, she certainly trained a significant number of teachers in her own way, and she certainly put a great deal of thought into how teachers are best trained.[62]

In 1916 Dewey observed the increasing need for formal or intentional teaching and learning "as societies become more complex in structure and resources." And yet, as he cautioned, "as formal teaching and training grow in extent, there is the danger of creating an undesirable split between the experience gained in more direct associations and what is acquired in school."[63] This observation of Dewey's is central to the analysis of Barstow's method of training teachers, because Barstow ultimately rejected what had become the widely accepted way of training teachers – a way that created such an undesirable split between training teachers and teaching "pupils." Instead, she turned to Alexander's original way of training teachers by apprenticeship, but added her own touch – that of the continuum between beginners and master teachers. She did not distinguish, as Alexander did, between students and pupils, and she did not train teachers separately from any of her other teaching. She saw teaching as simply another application of the technique. As mentioned, Barstow's method relied on all the principles discussed in previous chapters.

Although Barstow corresponded with Jones about a training program that they might run together, she ultimately resisted the idea of a formal training course with a set number of hours, weeks and years and a set curriculum. She preferred to teach people to become independent – both in learning the Alexander Technique and in their thinking – however long this took: "I do not teach people to teach," she said. "You must learn as much as you can about Alexander's discoveries and how to apply them. How you pass on this information is then up to you."[64] Here we see Barstow applying the principle of independence, as well as a qualitative

7 THE ART AND INTEGRATION OF TEACHING AND TRAINING 221

style of teaching, learning and certification rather than the quantitative style, with its 1600 hours.

There were many examples of fine "first generation teachers" whom Alexander had trained by the apprenticeship method, including his sister Amy Alexander, Ethel Webb, Irene Tasker, and Margaret Goldie. Frank Jones's training was conducted as a kind of apprenticeship, he being the only trainee in 1941, and the training being "conducted informally like a protracted private lesson in which one or more of F.M.'s assistants took part."[65] Despite these well known and respected teachers who had trained by apprenticeship, people claimed in the 1980s that Barstow could not be training teachers at all because she did not run a three-year training program.[66] In 1963 it was true that she did not train teachers at all. When William Conable met her and explained his desire to learn to teach, she recommended Frank Jones: "If you're going to England, go to Walter Carrington, but I'd like to see you go to Boston and study with Frank Pierce Jones."[67] At this point, then, while not training teachers herself, Barstow expressed a preference for Jones's methods. Jones did not run a formal training course and taught informally by apprenticeship. Conable was to experience a similar prejudice against less formal training methods when he later received a letter from a New York AT teacher telling him, "You can't have trained with Frank Jones, because he didn't train teachers." Barstow did begin to train teachers in the following decades, but she returned to the original training model, that of apprenticeship. Bruce Fertman confirms that Barstow took inspiration from the quality of teaching of those who had learned from F.M. Alexander "more informally, over a longer period of time. She admired these teachers, and she decided to bring about Alexander teachers based on this older, original model of training through apprenticeship."[68]

Barstow's method of teaching, as described by Diana Bradley, shows up the mismatch of formal teaching with the Alexander Technique. Bradley saw the importance of the way Barstow brought her own self and life to her teaching and doubted that such an approach could be compatible with formal teaching. She illustrates:

> I wasn't sure where the Teaching left off and where Marj began. Was there something magical about being in her presence? She has a way of putting people at absolute ease before she even begins to teach. Or had the teaching already started in the way in which she leads her life and relates to people and her environment? I was beginning to wonder whether one

could really learn what she was teaching in a formal setting. Or does the formality already set up rigidities?[69]

Principles 1 and 2: Making Ideas Clear and Reconstruction: From Specific Training Programs to Universally Applied Good Use

The principal idea Barstow made clear by eschewing the structure of modern training programs was that the Alexander Technique was an ongoing process that one must both understand and be able to apply to any activity, including teaching, rather than a checklist of teaching techniques to master. Conable highlights Barstow's primary attention to the central idea of Alexander's work: "She has often been distressed to see graduates of other training courses who have learned 'Alexander teaching techniques' but who do not in her view really understand the core of Alexander's discovery."[70] He also emphasizes that her attention to teaching the process of the Alexander Technique means that she is necessarily less interested in the conventional *form* of training teachers: "I believe that she has also been reluctant to concentrate her energies on setting up a structure, a curriculum, and a school. I don't think she is sure that is the best way to train Alexander teachers. I think that this is what she means when she says 'I do not train teachers' [because] in fact, she *does* train teachers."[71]

Barstow's insistence on thinking critically about process in preference to form meant that she was committed to the process of teaching in a qualitative way, rather than a quantitative way. Modern training schools stress that a minimum of 1600 hours over a minimum of three years be spent in full-time training.[72] Some schools, such as PAAT (a Carrington-inspired school), require a minimum of 2000 hours over four years, in addition to a prerequisite year of lessons prior to training.[73] This is regardless of what exactly is being learned and how well it is being learned. As Conable explained above, Barstow observed graduates of formal training courses who, she believed, had not understood the underlying process of Alexander's work and/or had not developed the fundamental observation skills, communication skills, analytical skills or sensitivity required to teach the work. Madden explained that training in Barstow's style "takes as long as it takes,"[74] and that for some, 1600 is not enough while others need less. Bruce Fertman remembers someone once asking Barstow how long it took to become a teacher of the Alexander Technique. She said, "I don't know. It depends on the individual. It could

take six months, six years, or it might take forever!"[75] As Marjory *Barlow* put it, "Out of a training course come a range of people, some of whom won't teach at all, some of whom will be poor teachers, some adequate, and occasionally a superb one or two."[76] Barlow simply accepted that this is "how it is," but it seems that *Barstow* was only interested in training people to become the latter, and she did not consider any of her students as qualified until they were more than adequate. In her letter of 1986 to ACAT, she lists 26 students whom she describes as "very well qualified," not only from a quantitative perspective (and she does state that they have all had over 1600 hours of personal work with her). She adds a qualitative statement, saying that she has observed their teaching "at various times and under different situations," and that they are qualified as "teachers of the Alexander Technique as developed and taught by F. M. Alexander and as described in Mr. Alexander's four books." She describes their training as "an extended apprenticeship program," many of them having moved to Lincoln, Nebraska, to study with her.[77]

Fertman recalls how she changed her description of her teacher training over the years. Occasionally, at workshops, people would ask her if she trained teachers. Fertman remembers her replying for a number of years, "No, I help people to become sensitive and what they do with their sensitivity is their own business." Later, she used to reply, "No, I don't train teachers, but many of my students have gone on to become excellent teachers."[78] As Conable says, "Teaching is not the issue for her, *use* is."[79]

Formal training courses, while possibly a necessity in a growing field, reinforce the split Dewey describes between learning in real-life situations and learning in the abstract. In particular, the formal training model, with its segregation of trainees and beginners, does not give students experience in teaching beginners. Barstow's mode of training draws less of a distinction between learning the technique in order to teach it to others and learning it for use in other activities or professions. She saw teaching as an activity not inherently different from any other activity in that "we must be able to use ourselves well in order to engage in it successfully."[80] As quoted above (in Teaching by Example), Barstow wanted her student-teachers to understand that the teacher's use is of the utmost importance "both as an exemplar and because of the understanding that what a teacher communicates most clearly is the quality of his or her own use."[81] This was the main content of her teacher training, says Conable, "from which everything else flows."[82]

224 A. COLE

Marjory Barlow, like Barstow, saw the value of the apprenticeship method and regretted that when she brought it up once or twice with STAT, there was always a "significant silence in response."[83] She points to her uncle's belief in this method, justifying his reluctance to begin a training course in the Alexander Technique: "In the best tradition of all great teachers, he preferred to teach the individual and to train people on the apprenticeship basis."[84] She notes that some of the greatest teachers learned that way and points out the limitations of a formal training course. Echoing Dewey's concerns, Barlow says of the apprenticeship method of training, "It's good because you see people working in a real situation – a training course is always somehow artificial, don't you think?"[85] Note Barlow's assumption that training courses are run in groups, while apprenticeships are individual. Barstow shook up this "set fixture," just as she had shaken up others. Her apprentices learned, along with all her students from beginner to advanced, together in groups.

Rather than the kind of "*Quest for Certainty*"[86] of a formal training course, with its set number of hours, number of years, and a certificate at the end, Barstow saw the process of becoming a teacher as a continuum. Her own training began informally when she and her sister went to London twice for intensive series of lessons. She completed the training course and then for many years worked as A. R. Alexander's assistant in Boston. As Frederick says, "It's not that you become certified and then rest on your laurels... It's not that at all – it's a living process that continues as our use changes and improves."[87] Martha Fertman describes her organic transition to teaching the AT while studying with Barstow. Her private practice as a "dance coach" gradually widened to include people of all sorts of interests and problems: "Slowly, as I grew more proficient, it became self-evident that what was most useful for most people were the principles of the Alexander Technique. Eventually, I became an Alexander teacher because that was what I taught."[88]

The apprenticeship model, because of the lack of formality and official certification, can only work if students honour the code to the extent that the trainer expects. In Barstow's code, as Conable describes it,[89] people began studying as ordinary pupils. Then, if they had interest and talent, they began to function as teachers-in-training, assisting her, working with older apprentices and being closely supervised. With the teacher's blessing, they then began to teach elsewhere, returning from time to time for help and guidance. Still later they begian to make their own contributions to the technique. There will always be those, however, who

do not honour the code, and it was some such students who damaged the reputation of Barstow and her methods in the 1970s when, "people who had been to one workshop, perhaps not even for the entire month, were going away and claiming to be Alexander teachers, to the dismay of everyone and the detriment of the reputations of both Marj and the technique."[90] In addition, Conable says that some obviously unqualified people had been importuning Barstow about certification before they were remotely ready to teach.[91] Similarly, after a three-hour introductory Alexander class in Dunedin in 2010, where Madden had come to teach, one physiotherapist wanted a certificate to put on his practice wall. This kind of expectation justifies the existence of formal training courses. And yet, people so intent on certification and end-gaining might never learn to apply Alexander's principles successfully. As Barstow said, "it might take forever."[92] Barstow's model was certainly idealistic, and it depended on the honour and maturity of her students, or a code of conduct or ethics. Such a code was not formally adopted by Barstow teachers until 1999, when they formed Alexander Technique International (ATI), the professional society established by apprenticeship-trained teachers.[93]

Principle 3: Desire

The second – and perhaps most dominant – idea of Barstow's that can be seen at work in her training model is the importance of desire. The desire to teach had to drive the student to direct his/her own learning. While teaching was just another activity to which to apply the Alexander Technique, Barstow took this activity extremely seriously. It had to start with a strong enough desire for a student to be able to stand up in class and say, "I want to work with teaching." When it came to teaching, there was "no frivolity,"[94] "no evasion," and "no equivocation."[95] She expected of her students an extraordinary degree of clear reasoning and attention to principle and to detail.[96] For someone who did not officially or formally train teachers, her training was extremely rigorous. As Eileen Troberman says:

> We also learned to pay particularly close attention to how we were using our voices – a basic in F.M.'s own learning process. And we had to be actively carrying out a delicate upward direction in ourselves during the time our hands were on, or we would be told – in no uncertain terms – to

226 A. COLE

take our hands off. I cannot imagine stricter training. At times I felt as though I was under the scrutiny of Alexander himself.[97]

In order to succeed under these stringent conditions, students' desire to teach had to be extremely clear and compelling. As Madden says, "One day, my desire to learn to teach became stronger than my fear of failure."[98] She also says that, in a large group class, "you got great practice in pursuing your desire to express what you needed and wanted. If you didn't find a way to ask, you probably didn't get a turn."[99] Madden also describes the requirement to be clear about one's wish, or desire, as the thing that most differentiated her own training with Barstow from what she still observes, and hears about, in training schools. "Marj had class at various times," Madden explains. "She unlocked her front door and whoever wanted to come appeared. We never 'had' to come. Everything was volitional."[100]

Principal 4: The Social Context

For Barstow, as we saw in Chapter 6, good teaching involved the social context, which allowed for the communication of good use (or coordination), the training of observation skills and constructive thinking, and the independence of the student. From these things students also learned to create the conditions for learning, to teach by example and to meet each other with respect and acceptance, without *willing* a change on anyone.

First, trainee teachers must learn to stay in coordination as they teach, partly so that they can communicate good use (that is, teaching by example), but also because good coordination assists in observing both self and others. As Madden describes it, "the first and most important key that we have as AT teachers in communication is our ability to use our constructive thinking to be in good use of ourselves ... With good coordination we are able to see and hear our student clearly."[101] The following description of how Barstow trained teachers is by Cathy Madden. It shows her absolute commitment to process and the extremely high standard of use and communication that she required of her students before allowing them to teach unsupervised.

> If I wished to teach, I would say to Marj in one of our group classes, 'Marj, I would like to work with teaching.' Once I had someone willing to be a student for me, I would start to rise from my chair and Marj would

7 THE ART AND INTEGRATION OF TEACHING AND TRAINING 227

> say, 'Cathy, what do you notice about yourself?' If I could describe what I noticed, which might include my thinking, my feeling, or my moving; and, if I could 'use my constructive thinking' to improve anything that needed improving, I would be encouraged to continue in the lesson I was giving. And the next question Marjorie would ask from her chair across the room is 'What do you notice about your student?' Again, if I could answer, we went on with teaching. If, however, I was unclear or negative or mumbled, or was unable to prevent interference in myself, my lesson would be over for the moment and Marj would suggest 'why don't you think about that?' It was quite a while before I made it all the way across the room to my student.[102]

As Madden explains, the order of Barstow's questions is vital. It was not until Madden could constructively work with or answer the question, "What do I notice about myself?", that she could move on to noticing anything about the student.[103] Student-teachers had to articulate what they saw and were expected to talk to the student while moving well and speaking clearly. "Since one of the ways our students learn is by imitating us," says Madden, "this process that Marj taught me ensured that I presented an improved coordination to my students."[104] Heather Kroll tells a similar story about this synthesis and virtuous circle of good teaching abilities.

> Before I could even get to the point of actually moving someone, as I would at work [as a physiotherapist], Marj in her very particular way would insist that I go back to paying attention to myself. What was I thinking about? Did I have a clear idea about what I was doing? How was I using my voice? Was I speaking in a manner which the person I was working with could easily understand? Were my instructions clear and simple? Was I engaging the thinking processes of the person I was helping or just letting him go along for the ride? By attending to all of these issues first, the physical part of the task became much easier.[105]

Stacy Gehman adds to this discussion the importance of the group setting in learning to teach everyone in the room, even while working directly with just one person: "She [Marj] really asks only one thing of me as a teacher: to be able to watch myself with every movement I make and word I say, while seeing and doing just what I need to do to help the individual with whom I'm working, and remembering that I'm teaching everyone else in the room."[106]

228 A. COLE

Under subheadings that derive from Dewey's pragmatism, I have shown how Barstow's approach to teaching and training aligns with it. I even argue that Dewey would have seen Barstow as an enlightened, pragmatic educator. In the last section of this chapter I tell the story of Barstow, official certification, and the training bodies. I argue that Barstow's approach to teacher training not only aligns with Alexander's own work but is also a fine example of critical thinking and pragmatism in action.

Multi-Level Teaching and the Continuum

Since Barstow did not separate the teaching of trainee teachers from that of performers or anyone else, she taught everyone together and in the same way. It was up to the students to ask for what they needed. Barstow taught everyone together, so trainees received constant tuition in how to teach all levels from beginners through to advanced pupils. Perhaps even more importantly, students learned many things from watching one another: how to learn, how to ask for what they needed and how Barstow responded to these needs, even when they were not articulated. Barstow was extraordinarily sensitive to, and perceptive of, students' needs: "She teaches appropriately to the group that she is working with. She gives them what they need. It's simply a matter of meeting people where they are and delicately showing them how the technique can improve what they're doing," observed Bradley.[107]

Barstow's repair of the split between teaching and training has the added benefit of teaching trainees how to teach beginners, something which might otherwise be left out of training courses. It was said of Barstow that she did not train teachers, but it could equally be argued that *all she did* was train teachers, whether people went on to teach others or whether they simply learned to teach themselves. She adopted the teaching format in which she had learned to teach the technique, that is, the group class, and applied it to all learning of the Alexander Technique.

While Alexander eventually moved from an informal apprenticeship model to a formal training course in the 1930s, there is no evidence that he valued the teaching of those taught by apprenticeship any less than those who attended a training course. In fact, if anything he seemed to value the teaching of his brother A.R. above that of anyone else, leaving his entire teaching practice in his care when he moved first to Sydney and later to London. A. R. Alexander is said to have had only

7 THE ART AND INTEGRATION OF TEACHING AND TRAINING 229

six lessons before he began teaching,[108] thus making a mockery of the time-specific requirements of training that were brought in with the first training course.

Barstow and Official Certification

Arro Beaulieu describes Barstow's refusal to certify teachers as "a fine act of inhibition," serving as a constant reminder to all in the Alexander community "to look first and foremost to themselves in that same spirit" as Alexander himself did. But, as I will show, Beaulieu is not completely accurate in saying that she refused to certify her students. When an opportunity arose in the 1980s for her students to be recognized by an official body, she was proactive in attempting to have them acknowledged and certified, but her attempt was rebuffed.

In 1986, after the First International Alexander Congress in Stony Brook, the West arm of ACAT (The American Center for the Alexander Technique, run by Frank Ottiwell) was planning to merge with the East arm of ACAT (founded by Judith Leibowitz). Ottiwell's organisation was attempting to create a way for Barstow teachers to be part of the new organisation. In the midst of negotiations ACAT-East suddenly gave ACAT-West an ultimatum to join with them at short notice and exclude the Barstow teachers.[109] Reluctantly some of the ACAT-West members joined, but Michael Frederick continued to look for ways for the Barstow teachers to be accepted by the newly merged association, established by David Gorman and named NASTAT.[110] Frederick told Barstow that if she wrote a letter to NASTAT acknowledging the people she recognized as teachers, then they would be welcome to join. She wrote the letter, explaining that each of the people named had worked with her in "what can be considered an extended apprenticeship training program." Every one of the teachers named had studied with her for "over 1600 hours," had assisted her at workshops as Alexander teachers, had been observed by her "at various times and under different situations," some having worked with her consistently since the early 1960s and moved to Lincoln, Nebraska, for various lengths of time to study with her, "some for up to six and seven years."[111] There are 26 names in the letter. She says that she considered them all "very well qualified as teachers of the Alexander Technique as developed and taught by F. M. Alexander and as described in Mr. Alexander's four books."[112] Barstow added that she fully supported the formation of NASTAT. The board

gave *Barstow* a membership and rejected her letter and her teachers.[113] Madden notes that Barstow "did tear that membership certificate up."[114] Out of the political rubble, Alexander Technique International (ATI) was born, an association that embraced those trained by Barstow and that now embraces the next generation of teachers trained by her graduates to her standards.

The letter Barstow wrote is reproduced below and also transcribed for clarity. Ironically, the teachers who set up ACAT (Leibowitz and Caplan) were less experienced and no more certified by STAT to train teachers than Barstow, but managed to create ACAT and exclude anyone trained by Barstow who had not already been certified by another training course. That is, they simply valued their own training programs more highly than Barstow's.

Dear Board of Directors, A.C.A.T., Western Region:

It has come to my attention since the International Congress this past August 1986, at Stony Brook University, that there are two misunderstandings that seem to be present in the thinking of some members of the great Alexander community.

The first is that after studying with me for only one month or so at my summer workshop in Lincoln, students are encouraged to go away and

teach the Alexander Technique. This is a complete fallacy. Students are encouraged to apply what they have learned to their daily activities, but not attempt to teach the Technique to others.

The second misunderstanding is that I have never trained Alexander teachers. Since the early 1960s there have been a number of people who have worked with me consistently in what can be considered an extended apprenticeship training program. Many of these students have moved to Lincoln, Nebraska, for various lengths of time to study with me, some for up to six and seven years. Others have trained with me at regular intervals for intensive periods over a span of many years. This apprenticeship program is as instructive as any more traditional training approach in the Alexander Technique. Every one of the students listed below has had over 1600 hours of personal work with me. Also, these students have assisted me at my workshop as Alexander teachers. At various times and under different situations, I have observed their teaching and considered that they are very well qualified as teachers of the Alexander Technique as developed and taught by F. M. Alexander and as described in Mr. Alexander's four books.

Although I am addressing this letter to the Board of Directors of A.C.A.T., Western Region, I am aware of the recent developments towards creating a national organization of teachers of the Alexander Technique (N.A.S.T.A.T.), a development which I fully support. I recommend that the teachers listed below be considered as teaching members of A.C.A.T. or of N.A.S.T.A.T., as the latter becomes a viable organization.

Janet Baty
Sarah Barker
Arro Beaulieu
Pamela Black
Mary Lou Chance
Jane Clanton
*Barbara Conable
*Bill Conable
*Bruce Fertman
Nancy Forst
Catherine Geham[115] (Madden)
Stacy Geham[116]
*Martha Hansen[117]
Catherine Kettrick
Cynthia Mauney
Kelly Mernaugh
David Mills
Mio Morales

232 A. COLE

Alice Pryor
Heather Ruddell[118]
Kevin Ruddell
Hope Shaw
Peter Trimmer
Lucy Venable
Don Weed
John Wynhausen

*Barbara and Bill Conable, and Alice Pryor, are already full teaching members of A.C.A.T., West. Bruce Fertman and Martha Hansen have recently submitted applications to join A.C.A.T., West.

I feel that it is important that I stand behind and support the above Alexander teachers who have spent many, many years studying with me. If I can be of any further assistance please let me know.

With best wishes
Marjorie L. Barstow

Vindication

As a kind of 21st-century vindication of Barstow's practice, I offer Terry Fitzgerald findings on teacher training programs. In his doctoral research in 2007, he found that the mandatory time-specific practices of AT teacher education are "not only anachronistic" but also "flawed to the extent they are devoid of qualitative assessment standards."[119] He also argues, using critical pragmatism as his methodological framework, that there is "no educational justification for maintaining the numerical protocols, although there may be administrative reasons for doing so."[120] Fitzgerald proposes a training program that is remarkably aligned with Barstow's move to a method of teaching and training teachers – one that is more flexible with respect to time and attendance and that qualifies teachers and teacher-trainers via competency rather than time spent training or teaching.[121]

Summary

In this chapter I discussed some additional aspects of Barstow's teaching, such as CCL, teaching by example, and meeting and accepting. I then described the evolution of how Barstow trained teachers and examined the ways that her teacher training integrated all the aspects of her teaching

that I covered in previous chapters, that is, making ideas clear, deconstruction and reconstruction, desire and will, and the social context. Her training method stresses the importance of a group, with a real-life mix of students of all levels, so that experience is relevant and not detached from reality, thus answering Dewey's concerns. Like any good training method in the Alexander Technique, it puts a premium on good use. What's more, her training method synthesises all the aspects of her teaching, emphasis on process, importance of desire, communication skills and community, observation skills, independence of the student, expansion of freedom and teaching by example.

Conclusion

In this work, my aim has been to examine Marjorie Barstow's interpretation of the Alexander Technique and, in particular, the way her teaching touched performing artists and influenced their practice. As part of the analysis of her work, I have drawn on the work of John Dewey and other members of the educational/philosophical constellation of which she was a part. To summarise the analysis, I gave the book the subtitle "Critical Thinking in Performing Arts Pedagogy," as critical thinking is the theme that runs through all the changes she made to Alexander's teaching methods in order to stay true to Alexander's principles. I have not yet attempted to articulate succinctly what Barstow's principles were when it came to teaching the Alexander Technique. If Alexander's principles are difficult to summarise (as discussed in Chapter 4), let us now see whether Barstow's are any easier to summarise after a full analysis of her teaching. In this book I have outlined Barstow's principles of teaching the Alexander Technique to be:

1. Make ideas clear.
2. Question, deconstruct and reconstruct evolving systems that are valuable but broken.
3. The Alexander process is Alexander's scientific process (outlined by Cathy Madden as steps).
4. "Head moves and all of me follows"[1]—the primary movement, coordinating movement, or "use" (Alexander's "primary control") is front and centre, and use affects functioning.

© The Editor(s) (if applicable) and The Author(s) 2022
A. Cole, *Marjorie Barstow and the Alexander Technique*,
https://doi.org/10.1007/978-981-16-5256-1

236 CONCLUSION

5. The process involves constructive thinking and action, rather than reproducing feelings.
6. The Alexander Technique is education not therapy.
7. The teacher respects and encourages the independence of the student.
8. The teacher starts with the interest of the student and makes AT relevant to his/her life through application.
9. The teacher must train and practise observation and awareness.
10. The psychophysical self is a whole (not just a set of parts).
11. Community and communication is integral to teaching.
12. The teacher teaches and lives with honesty and kindness.

In editing this manuscript and bringing up to date some of the references I quoted in my doctoral dissertation, I have discovered that the Alexander world has progressed in just a few years. Group teaching is certainly more accepted and seen as a viable option, as is application work. Whether or not Barstow's interpretation of inhibition and the primary control have been equally accepted remains to be seen.

One of the reasons I compiled the biographical notes, even of people I quoted just once in the book, was because, when listed in close succession, the roll call of Barstow's students tells a story in itself – two stories, in fact. First, her most dedicated students were a group of extremely well educated, sophisticated and sensitive people. Second, the overwhelming majority of her long-term students were performing artists and/or teachers of the performing arts. This bears out my underlying rationale for writing this book, which is, to make the point that the Barstow style of teaching the Alexander Technique is particularly useful for performers because, amongst other things, it is educative rather than therapeutic and it is active rather than passive.

I want to leave the reader with the voice of Marjorie Barstow, helping Judith Leibowitz to walk during a class at the Stony Brook Congress. Leibowitz suffered from polio as a child and still had difficulty walking despite her years of Alexander work. As Leibowitz takes a turn with Barstow in this class, she observes a great change in her ability to walk. This class took place towards the end of the first workshop. It follows the class of which a small section is transcribed in the early pages of this book, also featuring Leibowitz. This excerpt begins at the end of a conversation in which Barstow has just asked, "Does anybody have a

question about why I'm taking the time this morning just to do that little tiny bit for everybody?":

Participant: I'm willing to ask it if you're willing to tell it.... Why are you doing it?

Barstow: Why am I doing it? Because this is the very first thing that Alexander discovered about himself through the nine years he was experimenting and developing this. See? He kept seeing that he was doing this [she lifts her head and draws in breath noisily, as a gasp] every time he talked, and so what I'm going to ask you people to do is, part of the time during this lovely meeting we're all having, is to watch yourself as you talk to other people [gasps] and see how much of the time [gasps] you all do this [gasps]. Because if you begin to watch this in your daily activities, you will learn a lot about yourself [gasps]. And as soon as you see [gasps] you're doing this all the time [gasps], I can talk to you this way to you [gasps], I don't know how long my voice would last [gasps]. But we do this [gasps]. And I do it too. And when I do it to myself, what do you think I say to myself? 'You dummy!' [audience laughter] You know better. Why don't you quit doing it?'[1] I have to be real severe with myself [gasps]. I can just go on [gasps] and do this [gasps]. You see that? [Gasps].

And watch... friends... watch television. You see a lot of it on television [gasps]. And Alexander found out he did that, and then he said, "I wonder if doing that, this thing [gasps], has any effect upon the fact that I'm losing my voice. So I'm giving you the very, very beginnings of what he did. And this is all very well said in that first chapter. I don't know how many of you have that little book, *The Use of the Self*, and how long you keep it on the shelf without looking at it or let it get covered with dust, but you all would learn a lot as you

[1] This appears somewhat contradictory to Barstow's relentless constructive attitude, but it is important to hear Barstow's bantering tone and recognize that at this point she is entertaining her audience with her sense of humour and poking fun at herself.

238 CONCLUSION

are either teaching or helping students if you just peruse that one chapter [long pause] and, I think, as I do, find something always in that chapter that I had just forgotten a little bit about and I would use it just every once in a while, but it's a fabulous chapter... [To Judith Leibowitz]: I haven't helped you for quite a while.

All right. Now, you're going to do *exactly* what we've been talking about: just that little ease up there, and then turn your head and look around [Barstow has her hand on Leibowitz's chin] and decide where you want to walk to. Now you want to walk forward. [Leibowitz takes a step.] There you are. Now stop, just a minute. Now, as you take that step, just follow my hands here [shows Leibowitz where to move her head, then immediately lets her start walking on her own]. There you are, now off you go. Start walking because you'll do real nicely.... How are we doing?

Leibowitz: I mostly lose my limp now, don't I?.

Barstow: Yes, you lose a lot of your limp. So, this, there [Barstow touches Leibowitz bilaterally in front of the ears] did you sense that? Now, wait a minute! Wait before you take off. [Leibowitz loses her balance and falls backwards; Barstow catches her] I've got you. I'm not going to let you fall. You do this, and I'm going to come right here [places hands just under Leibowitz's armpits on her ribs]. Now, what this is going to do... My hands are about where your respiratory mechanism is... My hands here are just going to steady you a little bit. And see what happens as you go. And I won't take my hands away...[audience responds with surprise and enthusiasm while Leibowitz takes confident steps]. All right, now, let's [Leibowitz stumbles] it's all right... I've got you.... I'm not going to let you fall. What did that feel like?

Leibowitz: That was really supported through the middle, where I need the support.

Barstow: That's right. That's right, so it's a little here [left hand on Leibowitz's chin, right behind her head], and this might change the stride of your legs. I don't know. But I will help you, and just take it easy. Don't be in too

CONCLUSION **239**

	much of a rush. I'll help you. [Leibowitz walks, Barstow follows her]. There. All right, now let's stop a minute. See, after two or three steps, those first two or three steps are real nice, aren't they. And I think if I can help you a little bit...
Leibowitz:	If we could open up a little bit [Leibowitz motions to people to make space for her].
Barstow:	Yes... now take your time and just decide you're going to watch that... and this will move up a little bit. Take your time with it, there's no rush, and I'll come down here [under the armpits] and help you a little bit, because you started so well. That's right. [Leibowitz walks again and then stumbles]. Now I've got you... (laugh) That's right. Now wait a minute, maybe I helped you a little bit too much. Did I? See...
Leibowitz:	Yes...
Barstow:	Just a very little now... take a couple of steps and then stop. Now stop. There. Now take a couple more and then stop.[2] We're not in a rush to get any place. [Leibowitz takes two more steps]. Now, let's stop a minute. Because right here you're not going any place.... Does that bother you too much?
Leibowitz:	No.
Barstow:	Do you want to sit down?
Leibowitz:	No, I'm fine.
Barstow:	Ok, that's great. So just a little [pauses, puts hands back at the base of Leibowitz's head] now, just a little delicately with this [indicates head-spine joint with her hands]. That's right. Now just turn your head from one side to the other [follows Leibowitz's head with hands]. How does that *feel*?

[2] Note that Barstow here does not mean "stop" in the sense of "do nothing," but rather stop taking steps and stand to regain balance, recalibrate and allow the student time for her thinking to catch up with what is changing. Leibowitz could also be said to be a special case, as she loses her balance twice in the course of this short "turn," and does need reminding to slow things down so she can learn, adjust and recalibrate.

240 CONCLUSION

Leibowitz: I'm comfortable standing now. Now I'm centred standing, so I can stand here, which I wasn't able to do earlier.

Barstow: Oh, great. All right.

Leibowitz: Yes, and now because I'm centred, I could also walk more easily.

Barstow: I think you will be able to too, and that's why, when you're here, if I help you take a couple of steps and then you stop just a minute to get that centred, and then you take a couple more, gradually it's going to help you. Because the first two steps you take are *very nice*. [Barstow continues using her hands to teach Leibowitz]. Now you just decide that you're going to let me help a little bit, and I'm going to follow you. I'm not going to tell you where to go; I'm just following your body. There you go. All right, now stop. Now let's sit down there a minute. Turn around and just sit down. Now, look how nice you look. Don't you feel good?

Leibowitz: Oh, yes! Thank you.

Barstow: Yes, that's great. You're welcome. It was my pleasure, we'll do some more. All right.

NOTES

Frontmatter

1. Jane Heirich, "The Speaking and Singing Voice: Breathing Issues," *NASTAT News* Autumn (1994): 19–21; and Matthew Hemley, "Fury as Rada Cuts Alexander Technique." *The Stage News*. (11 August 2010). Accessed July 2012. http://www.thestage.co.uk/news/newsstory.php/29232/fury-as-rada-cuts-alexander-technique.
2. Patsy Rodenburg, "Foreword," in McEvenue, Kelly, *The Actor and the Alexander Technique* (New York: St Martin's Griffin, 2002), x.
3. Kelly McEvenue, *The Actor and the Alexander Technique*, 5.
4. John Dewey, "Introduction to *The Use of the Self* by Professor John Dewey, Reprinted from the 1939 Edition," in F.M. Alexander, *The Use of the Self*, (London: Orion, 2004), xix.
5. Gert Biesta and Nicholas Burbules, *Pragmatism and Educational Research*, (Lanham, MD: Rowman & Littlefield, 2003).
6. Franis Engel, "STATnews Roundup," *In All Directions* 2, no. 10 (June 2002), 4–5.
7. For example: Dianna Kenny, *The Psychology of Music Performance Anxiety*, (Oxford University Press, 2011).
8. For example: Shao-Chin Chien, "Application of the Principles of the Alexander Technique to Viola Playing and Performance," (Chien, Shao-Chin: U Miami, FL, 2007).

© The Editor(s) (if applicable) and The Author(s) 2022
A. Cole, *Marjorie Barstow and the Alexander Technique*,
https://doi.org/10.1007/978-981-16-5256-1

242 NOTES

9. See, for example: Elizabeth Valentine, "Alexander Technique for Musicians: Research to Date," in *Psychology and Performing Arts*, ed. by Glenn Wilson (Lisse, NL: Swets & Zeitlinger, 1992); Valentine, Fitzgerald, Gorton, Hudson, and Symonds, "The Effect of Lessons in the Alexander Technique on Music Performance in High and Low Stress Situations," *Psychology of Music* 23, no. 2 (1995); Frank Pierce Jones, "Voice Production as a Function of Head Balance in Singers," *J Pyschol* 82 (1972); and Wilfred Barlow, "Research at the Royal College of Music," in *More Talk of Alexander: Aspects of the Alexander Technique*, ed. Wilfred Barlow (London: Mouritz, 2005).
10. Heirich, "Speaking and Singing," 21.
11. Hemley, "Fury."
12. Naming different approaches of course opens up a new set of problems. Barstow's approach has been called the Application Approach, while the other teachers' approaches have been called Traditional. Any renaming would have to avoid value judgements and hierarchies, and can then lead – as it has done – to fierce debate. Barbara Conable, who runs the Body Mapping franchise, is one such teacher who has renounced her title as an Alexander teacher and calls herself an Andover Educator. This appears to have been a smart business move but does it impoverish both education and the Alexander Technique, focussing, as Body Mapping does so relentlessly on parts rather than the whole? This is discussed further in Chapter 3 (Making Ideas Clear).
13. Richard Gummere. "Three Lessons from Dewey," *The Alexander Review* 3, no. 2 (1988), 47.
14. Frank Pierce Jones, Letter to John Dewey, March 1947, in Barstow, Correspondence with Frank Pierce Jones, The F. M. Alexander-Frank Pierce Jones Archive, Dimon Institute. New York.
15. See, for example, Wilson and Roland, "Performance Anxiety," in *The Science and Psychology of Music Performance*, ed. Richard Parncutt and G. E. McPherson, (New York: Oxford University Press, 2002); Valentine, "Alexander Technique"; and Valentine et al., "The Effect of Lessons."
16. Williamson, "Learning to Learn," in *Marjorie Barstow: Her Teaching and Training. A 90th Birthday Offering (Festschrift)*, ed. Barbara Conable (Columbus: Andover Road Press, 1989), 54.

NOTES 243

17. Her siblings were Helen Jacques, Adrian Foote and Frances Isabel, who were born in 1887, 1890 and 1895.
18. Nebraska is a state both of the Great Plains and of the Midwest. Lincoln has been the capital and the home of the University of Nebraska since 1869.
19. History Nebraska, s.v. "Marjorie L. Barstow," http://history.neb raska.gov. accessed 19 April 2021.
20. For example, the Barstow's Golden Wedding Anniversary was reported as "one of the outstanding events of the fall social season" with more than 200 guests. "People You Know," *Lincoln Evening Journal,* Tuesday, 1 Dec 1936.
21. Kay Retzlaff, Susan Erickson, Marjorie Barstow, Helen Barstow DePutron, and Janette L. Forgy (transcriber), "Lincoln, Nebraska: Helen Barstow Deputron and Marjorie L. Barstow," Neighborhood Oral History Project, Office of Neighborhood Assistance, 1980, 8. Barstow's mother was originally from New Berlin, in upstate New York.
22. Walnut Hill School for the Arts, *Behind Stowe, Celebrating 125 years!* School Year 2018–19, 9. The name Stowe was the name of one of the early buildings at the school (Stowe Hall), not to be confused with Stow, Massachusetts, (15 miles away) where the Alexanders set up a school during World War II.
23. Ibid., 2.
24. Retzlaff et al., "Lincoln, Nebraska," 8.
25. Ibid., 9.
26. Ibid.
27. University of Nebraska (UON), *Cornhusker,* 1920, 382.
28. Probably a mis-spelling of the *Danse Bacchanale* from Saint-Saëns's opera, *Samson et Dalila.*
29. UON, *Cornhusker,* 1920, 388.
30. Ibid., 1919; 1920, 236.
31. American Association of University Women. "Early College Women: Determined to be educated" http://stlawrence.aauw-nys.org/college.htm. Sources are vague as to whether this means percentage of girls aged 18–21 or some other category.
32. Helen was also singled out in 1907 as part of a comic diary, "Nubbins," because her "buggy broke down" (UON, *Cornhusker,* 1910, 385). She also said that she only completed two years of

244 NOTES

university because after a trip to Europe 1910 she needed a year to recover from typhoid fever.

33. UON, *Cornhusker* 1919, 393.
34. Ibid., 1920, 313.
35. Ibid., 1921, 419.
36. Ibid., 1920, 31.
37. Ibid., 1921, 419.
38. Ibid., 1920, 64.
39. Ibid., 1921, 42.
40. Ibid., 119.
41. Ibid., 397.
42. Ibid., 396.
43. This was reported in several newspapers at the time and is described by the Nebraska State Historical Society (quoting Maupin) as "one of Lincoln's unsolved murders," in *Omaha World-Herald* ed. Maupin, Will M., 31 December 1931.
44. UON, *Cornhusker*, 1924, 218.
45. History Nebraska, s.v. "Lincoln's Lindell Hotel," https://history.nebraska.gov/publications/lincolns-lindell-hotel. Accessed 20 April 2021. This page includes two photos of the hotel ca. 1889 and 1909.
46. UON, *Cornhusker*, 1924, 467.
47. Retzlaff et al., "Lincoln, Nebraska," 25–26.
48. Retzlaff et al., 26. In my dissertation, I wrote that Barstow also attended the Vestof-Serova Dancing School in New York and the Rock Mt. Dancing Camp in Colorado. This information is no longer publicly available. It was retrieved from Owen, K. "Walker Family Tree." Provo, UT: Ancestry.com Operations Inc, 2005, on 15 February 2013. I leave it here in the interests of future research.
49. Anna Kisselgoff, "Dance View; The Isadorables: Cherishing the Duncan Legacy," *New York Times*, 11 September 1988, Sect. 2, 24.
50. Janet O'Brien Stillwell, "Marjorie Barstow: An Interview," *Somatics* 3, no. 3 (Autumn/Winter 1981), 15.
51 Note the similarity of Marjory Barlow's name to that of Marjorie Barstow. See Biographical Notes.
52. Frances Oxford, "Marjory Barlow Interviewed," Interview, *Direction Journal* 2, no. 2 (June 1994): 15.
53. Stillwell, "Marjorie Barstow".

54. Ibid., 15.
55. Ibid., 17.
56. Ibid.
57. In Media an affiliation with a Quaker school was established, where the trainees and graduates would teach. There are many references to this school in Barstow's letters. Alexander ended up calling the teachers there "vandals" and Alexander may, in his old age, have tarred Barstow and Jones (and all American teaches) with the same brush. Barstow herself was scathing of the quality of teaching that took place there, and Jones too tried to distance himself from it. The main problem appears to be that when the Alexanders left, only one of the teachers (Richard Gummere) had been given permission to teach, and none had been given permission to train teachers. This did not stop them from proceeding to do both, thus earning Alexander's disdain.
58. Walter Carrington, *A Time to Remember: A Personal Diary of Teaching the F.M. Alexander Technique in 1946* (London: Sheildrake Press, 1996), 26.
59. Ibid., 26.
60. Ibid., 26.
61. Marjorie Barstow in Marjorie Barstow, Correspondence with Frank Pierce Jones (The F.M. Alexander-Frank Pierce Jones Archive, Dimon Institute, New York), Letter 29 April 1948.
62. Frank Pierce Jones in Marjorie Barstow, Correspondence with Jones, Letter to John Dewey, March, 1947.
63. Barstow, Correspondence with Jones, Letter 16 April, 1962.
64. Tommy Thompson, for example, describes Barstow's career as beginning in 1972 ("that's when she started her career with all those workshops" he said, in Robert Rickover, "The Teaching of Frank Pierce Jones: Robert Rickover Talks to Tommy Thompson," in *Body Learning* (2014), https://bodylearning.buzzsprout.com/382/230326, accessed 16 Feb 2015.
65. Conable, Interview with the author, 2013.
66. William Conable, "Marjorie Barstow," in *Festschrift*, 22.
67. Barstow, Correspondence with Jones, Letter to Helen Jones, 7 Nov 1975.
68. Ibid., Letter to Helen Jones, 23 Feb 76.
69. Rickover, Interview with the author, 2015.
70. Barbara Conable, "Introduction," in *Festschrift*, xiii.

246 NOTES

71. Barbara Conable, ed., *Festschrift* (Columbus: Andover Road Press, 1989).

Chapter 1

1. F. Matthias Alexander, *The Use of the Self: Its Conscious Direction in Relation to Diagnosis, Functioning and the Control of Reaction* (London: Orion, 1932/1985).
2. In *Body Awareness in Action, A Study of the Alexander Technique* (New York, NY: Schocken Books, 1979), Jones gives some hints only. The procedures F.M. Alexander passed on to teachers are discussed in Chapter 2.
3. Barstow, in Barstow, Correspondence with Jones, Letter 27 May 1947.
4. Barstow also stresses the importance of the long, slow, individual process of learning to apply the Alexander Technique oneself before beginning to teach, something that seemed to be increasingly overlooked by some of her compatriots. She was careful to make sure she and Jones could not be accused of this.
5. Lulie Westfeldt, *F. Matthias Alexander: The Man and His Work. Memoirs of Training in the Alexander Technique 1931–34*, 2nd ed. (London: Mouritz, 1998), 51.
6. Marjory Barlow, in Marjory Barlow and Trevor Allan Davies, *An Examined Life: Marjory Barlow and the Alexander Technique* (Berkeley, CA: Mornum Time Press, 2002), 143.
7. Jeremy Chance, "A Teacher's Perspective of Feelings," in *Festschrift*, 69–73, 71. To use an expression coined by Jeremy Chance to describe his own early training in the AT.
8. Barlow, in Barlow and Davies, *An Examined Life*, 143.
9. Carrington writes of three special points that Alexander had raised in the students' class, the third point being "the controlling of breathing whilst being worked upon." Carrington, "12th March 1946," *A Time to Remember*, 5.
10. Alexander, *The Use of the Self*, 45.
11. Westfeldt, *F. Matthias Alexander*, 48.
12. Ibid., 96.
13. Anthony Ludovici, *Religion for Infidels* (London: Holborn Pub. Co, 1961), 105.

14. Erica Whittaker, "England: The First Training Course," *The Alexander Review* 2, no. 3 (1987): 26.
15. In Jones, *Body Awareness*, 76.
16. Judith Leibowitz, and Kathryn Miranda, *Dare to Be Wrong: The Teaching of Judith Leibowitz* (New York: American Center for the Alexander Technique, 2007), 24.
17. Barstow, Correspondence with Jones, Letter 3 February 1948.
18. Ibid.
19. Barlow and Davies, *An Examined Life*, 25.
20. Jones, *Body Awareness*, 104.
21. Barstow, Correspondence with Jones, Letter 11 July 1947.
22. Barlow, in Barlow and Davies, *An Examined Life*, 26.
23. Chance, in *Festschrift*, 71.
24. Ibid., 71.
25. Ibid., 73.
26. Mark Lacey, "The Skeleton Key" 2012, accessed 26 March 2012, 2012, http://theskeletonkey.co.uk.
27. Robert Rickover and Mike Cross, "Marjorie Barstow and Marjory Barlow," Body Learning: The Alexander Technique (Podcast), 2012. https://bodylearning.buzzsprout.com/382/44972. Accessed January 2022.
28. Barstow, Correspondence with Jones, Letter 27 July 1948.
29. Ibid., Letter 29 April 1948.
30. Armstrong, Joe, "A Crucial Distinction: Manner and Conditions of Use in Teaching the Alexander Technique and Alexander Teacher Training." https://joearmstrong.info/MannerAndCon ditions.html March 2015. joearmstrong.info/MannerAndCondit ions.html. Accessed 19 Jan 2022.
31. 16 Ashley Place, London, was where Alexander's residence, teaching rooms and training course were, before the house was destroyed in WWII.
32. Barstow, Correspondence with Jones, Letter 3 February 1948.
33. Raymond D. Boisvert, "John Dewey's Reconstruction of Philosophy (A Review of the Middle Works Volumes 11–15, Ed. Boydston, Carbondale, Southern Illinois University Press)," *Educational Studies: A Journal of the American Education? Studies Association* 16, no. 4 (1985): 345.

248 NOTES

34. Jane Addams, "A Function of the Social Settlement," in *Pragmatism: A Reader*, ed. Louis Menand (New York: Vintage, 1997), 282.
35. Paulo Freire, *Pedagogy of the Oppressed* (London, England: Penguin, 1970), 46.
36. For example: Frances Oxford, "Marjory Barlow"; and Walter Carrington, *A Time to Remember*.
37. William Conable, in *Festschrift*, 26.
38. Barstow, Correspondence with Jones, Letter 11 July 1947.
39. Ibid.
40. 16 Ashley Place, London.
41. Barstow, Correspondence with Jones, Letter 29 April 1948. Not wanting to dismiss Alexander out of hand, Barstow continued: "I admire him for his good characteristics and his discovery but now I cannot accept his technique as suitable for me to use, because in my experience I have found it has too many loopholes."
42. Barstow, Correspondence with Jones, Letter 28 December 1966.

Chapter 2

1. Dieter Freundlieb, *Dieter Henrich and Contemporary Philosophy: The Return to Subjectivity* (Aldershot: Ashgate, 2003), 16.
2. Ibid., 16.
3. Ibid., 16.
4. Ibid., inside front cover, [translation mine].
5. Jacques Barzun, and Henry Franklin Graff, *The Modern Researcher*, 5th ed. (Boston, MA: Houghton Mifflin, 1992), 180.
6. Boisvert, "John Dewey's Reconstruction," 345.
7. Richard Rorty, *Consequences of Pragmatism: Essays 1972–1980* (Minneapolis: University of Minnesota Press, 1982), xviii.
8. Nicholas Rescher, "Pragmatism," in *The Oxford Companion to Philosophy*, ed. Ted Honderich (Oxford: OUP, 1995).
9. Ibid.
10. Boisvert, "John Dewey's," 343.
11. John Dewey, *Problems of Men* (New York: Philosophical Library, 1946).

NOTES **249**

12. In the words of Israel Scheffler, *Four Pragmatists: A Critical Introduction to Peirce, James, Mead, and Dewey*, (London: Routledge & Kegan Paul, 1974), 243.
13. Conable, Interview with the author.
14. Jones, *Body Awareness*, 99.
15. Ibid.
16. Ibid.
17. These reservations are expressed in letters from Dewey to Jones, a copy of which is stored with Barstow's Correspondence with Jones.
18. Carrington, *A Time to Remember*, 12.
19. Edward Maisel (ed.), *The Resurrection of the Body: The Essential Writings of F. Matthias Alexander* (New York: University Books, 1969), xxxvi.
20. Jones, *Body Awareness*, 44.
21. For example: Marian Goldberg, "John Dewey and the Alexander Technique." The Alexander Center. 27 March 2020: https://alexandercenter.com/jd/; Rickover, Robert. The John Dewey and F. Matthias Alexander Homepage. The Complete Guide to the Alexander Technique. 27 March 2020. https://www.alexandertechnique.com/articles/dewey/; Barlow and Davies. *An Examined Life*.
22. Eric David McCormack, "Frederick Matthias Alexander and John Dewey: A Neglected Influence," PhD, University of Toronto, 1958.
23. Frank Pierce Jones, Letter 18 May 1957 to Eric McCormack. Eric McCormack's Papers, Special Collections, Latimer Family Libraries, St Vincent's College, Pennsylvania.
24. F. Matthias Alexander, *Constructive Conscious Control of the Individual. Introduction by John Dewey. Foreword by Walter H.M. Carrington. Edited by Jean M.O. Fischer*, (CCC) 8th ed. (London: Mouritz, 1923/2004), xxiv.
25. Terry Fitzgerald, "The Future of Alexander Technique Teacher Education: Principles, Practices and Professionalism," PhD, University of Technology, 2007, 71.
26. Alexander, *CCC*, 28.
27. Ibid.
28. Ibid., 201.

250 NOTES

29. In Corliss Lamont, *Dialogue on John Dewey, by James T. Farrell and Others* (New York: Horizon Press, 1959), 27.
30. Maisel, *Resurrection, xli.*
31. Jones, *Body Awareness.*
32. Dewey, Introduction, in Alexander, *CCC, xxxi.*
33. Ibid., *xxv.*
34. Dewey, Introduction, in Alexander, *UOS,* 8.
35. Jones, *Body Awareness,* 45.
36. Barstow, Correspondence with Jones, Letter 20 June 1950.
37. Maisel, *Resurrection,* xxvii.
38. Barlow and Davies, *An Examined Life,* 65.
39. Jones, *Body Awareness,* 31.
40. In C Gounaris, C Tarnowski, and C Taylor, *Taking Time: Six Interviews with First Generation Teachers of the Alexander Technique on Alexander Teacher Training* (Aarhus, Denmark: Novis Publications, 2000), 131.
41. "See what happens" could be described as a hallmark of Marjorie Barstow's teaching. Cathy Madden has adopted it also. I learned it from Madden as a particularly useful way of asking a student to do something without giving an order and without imposing my own wishes on the student.
42. In Gounaris et al., *Taking Time,* 131.
43. Donald Weed, "For a Darn Good Reason," in *Festschrift,* 159.
44. Oxford, "Marjory Barlow," 15.
45. Fitzgerald, "The Future," 69.
46. Rescher, "Pragmatism."
47. Alexander, *Man's Supreme Inheritance: Conscious Guidance and Control in Relation to Human Evolution in Civilization (MSI),* (London: Mouritz, 1910/1996), 114.
48. Carrington, "11th March 1946," *A Time to Remember,* 5.
49. Maisel, *Resurrection,* xli.
50. Carrington, *A Time to Remember,* 3.
51. Alexander, *CCC,* 124.
52. Alex Murray, "John Dewey and F.M. Alexander: 36 Years of Friendship," F.M. Alexander Memorial Lecture, Society of Teachers of the Alexander Technique, 1982.
53. Alexander, *CCC,* 124.
54. Goddard Binkley, *The Expanding Self: How the Alexander Technique Changed My Life* (London: STAT Books, 1993), 48.

55. Cited in Bloch, *F.M.: The Life of Frederick Matthias Alexander: Founder of the Alexander Technique* (London: Little, Brown Book Group, 2004), 142. Alexander's private correspondence was made available to Bloch for his book on Alexander. It is not publicly available.
56. Carrington, "21ˢᵗ March 1946," *A Time to Remember,* 11.
57. Barstow, Correspondence with Jones, Letter 20 September 1947.
58. Barstow, Correspondence with Jones, Letter 20 June 1950.
59. Barstow, Correspondence with Jones, Letter 8 May 1947.
60. Jones, Letter to Dewey, March, 1947.
61. Barstow Correspondence with Jones, Letter 15 April 1947.
62. Jones, *Body Awareness*, 68.
63. Jackie Evans, *Frederick Matthias Alexander: A Family History* (Chichester: Phillimore, 2001), 93.
64. Jones, *Body Awareness*, 68.
65. According to Evans, *Frederick Matthias*, 100.
66. Ibid., 123.
67. Ibid.,124.
68. Ibid., 124; Stillwell, "Marjorie Barstow," 17.
69. Evans, *Frederick Matthias*, 135, 144.
70. According to shipping records, Albert Alexander (occupation: "none") left Melbourne for London, travelling alone and arriving 21 November 1910. This more or less tallies with other records and reports by Bloch, Evans and Fischer (in Binkley) and the Albert here is probably A.R.. He married on 20 April 1912 in London (Public Records).
71. Jean Fischer, in Binkley, *Expanding Self*, 158.
72. Michael Bloch, *F.M.: The Life*, 118.
73. Stillwell, "Marjorie Barstow," 17.
74. Barlow and Davies, *An Examined Life*, 153.
75. Weed, "Our Debt to A.R. Alexander," Interactive Teaching Method: A revolutionary approach to the Alexander Technique. 2012, https://www.itmalexandertechnique.org, Accessed 19 July 2012 (page no longer active).
76. Stillwell, "Marjorie Barstow," 17.
77. Jones, *Body Awareness*, 68.
78. Ibid.
79. Ibid., 104.
80. Ibid., 71.

252 NOTES

81. Oxford, "Marjory Barlow," 14.
82. Of course, in the letter Barstow quotes from F.M. (in 1950) informing her that he has not given anyone permission or authority to train teachers, he must have meant nobody other than his brother, who was no longer alive at that point.
83. Weed, "Our Debt".
84. Jane Dewey. Letter 13 March 1920 to Alice Chipman Dewey and John Dewey. *The Correspondence of John Dewey, 1871–1952 (Vol. II)*. Electronic Edition, ed. Larry Hickman (Charlottesville: Intelex Corp., 1999).
85. Stillwell, "Marjorie Barstow," 18.
86. Barstow, Correspondence with Jones, Letter 29 July 1953.
87. Whittaker, "The FM Alexander Memorial Lecture," delivered before the Society of Teachers of the Alexander Technique (STAT) on October 26, 1985, 14.
88. Oxford, "Marjory Barlow," 15.
89. Stillwell, "Marjorie Barstow," 18.
90. Nebraska University *Cornhusker*; Census, 1920.
91. Boisvert, "John Dewey's Reconstruction," 343.
92. When I asked Cathy Madden whether she knew what Barstow used to read, she laughed and said, "Well, her library was a wonder to behold. I mean, she had this giant coffee table that spun, that was made from an old wagon wheel with a glass top on it, and, it was mostly magazines, but what we would marvel at was that every year a whole new topic would appear." While Madden does not "remember particular philosophy," she knows that Barstow "read a lot" (Private Lesson, 1 February 2012). Richard Gummere reports that Barstow's reading "reflects her concern for growth." He observed that she was hungry "for assurance that the world is capable of growth." The list of books and journals she tells Jones about in their letters reflects this. In 1989 she subscribed to a scientific periodical and asked Gummere especially to read an issue devoted to the great discoverers of this century. This was the year in which she turned 90. Gummere adds that, at the same time, "she was re-reading *The Use of the Self* as though it were holy scripture" (in *Festschrift*, 166–67).
93. Retzlaff et al. "Lincoln, Nebraska."
94. Westfeldt, *F.M. Alexander*.

95. In fact, A.R.'s alliance with Barstow may have been a contributing factor in Lulie Westfeldt's bitterness towards the Alexanders. Although Westfeldt lived in New York (much closer than Nebraska), she was not invited to assist A.R. either in Boston or New York.
96. Jones, *Body Awareness*, 104.
97. Stillwell, "Marjorie Barstow," 18.
98. Barstow, Correspondence with Jones, Letter 20 June 1948.
99. Ibid., Letter 19 August 1946.
100. In fact, Jones did eventually travel to England with his wife in 1969 (in Barstow, Correspondence with Jones, Letter 30 June 1969), but by then both Alexander brothers had been buried for over a decade.
101. Barstow, Correspondence with Jones, Letter 20 June 1950.
102. Ibid.
103. Frank Pierce Jones, "The Work of F.M. Alexander as an Introduction to Dewey's Philosophy of Education," *School and Society*, no. 57 (1943): 1–4.
104. Jones, *Body Awareness*, 78–79.
105. Bloch confirms this, suggesting that Alexander did his best to ensure that the practice of the Alexander Technique would not long survive him (*The Life*, 241).
106. Amanda Cole, "Constellation Mentorship," in *Mentoring through the Centuries: On the Dynamics of Personal and Professional Growth*, ed. Manzin & Duche (Classiques Garnier: Paris, 2022, in press).
107. Barstow, Correspondence with Jones, Letter 29 June 1947.
108. In 1971 Barstow mentions the trip in a letter, referring to "some of the things we saw in Denmark." (Letter 1 February 1971). Alexander training schools in England may have records of where else they visited and taught on this trip.
109. Barstow, Correspondence with Jones, Letter 7 November, 1975.
110. John Dewey, *Experience and Education*, in *The Collected Works of John Dewey, The Later Works, Volume 13 1938–39*, ed. Jo Ann Boydston, 6.
111. Ibid., 21.
112. Ibid., 35.
113. Maisel, *Resurrection*, xli.

254 NOTES

Chapter 3

1. Charles Sanders Peirce, "How to make our ideas clear," in *Pragmatism: A Reader,* ed. Menand (New York: Vintage, 1878/1997), 27.
2. Alexander, *CCC*, 113.
3. Barstow, Correspondence with Jones, Letter 26 November 1947.
4. Barry Green and Timothy Gallwey, *The Inner Game of Music* (London: Pan Books, 1986), 118.
5. Marjorie Barstow, Interview (Interviewer unnamed). *The Alexander Technique: A Worldwide Perspective. The First International Congress, Stony Brook, New York,* 1986 (David Reed Media, UK, 2011). DVD.
6. Shirlee Dodge, "UP," in *Festschrift*, 135.
7. Frank Ottiwell, "Let Us Now Praise Marjorie Barstow," in *Festschrift*, 2.
8. Sarah Barker, "Excerpts from Journal, Annotated," in *Festschrift*, 86.
9. William Conable, "Marjorie Barstow," in *Festschrift*, 24.
10. Ibid.
11. Diana Bradley, "The Joy of Learning," in *Festschrift*, 113.
12. Stacy Gehman, "Working with Marjorie Barstow," in *Festschrift*, 119.
13. Bradley, in *Festschrift*, 115.
14. Peirce, "How to Make Our Ideas Clear."
15. Cleo Cherryholmes, *Reading Pragmatism. Advances in Contemporary Educational Thought* (New York: Teachers College Press, 1999), 3.
16. Louis Menand, *The Metaphysical Club* (New York: Farrar, Straus and Giroux, 2001), 12.
17. John Dewey, "The Development of American Pragmatism," in *Pragmatic Philosophy*, ed. Rorty (1925/1966), 210.
18. Stillwell, "Marjorie Barstow."
19. Marsha Paludan, "Dancing," *Direction Journal* 1, no. 10 (1993): 383.
20. Barker, in *Festschrift*, 93.
21. Barstow, Correspondence with Jones, Letter (Author's reference #26), n.d.
22. Stillwell, "Marjorie Barstow," 17.

23. Dewey, "Introduction," in Alexander, *UOS, 19.*
24. Dewey, *"Experience and Education,"* 46.
25. Richard Gummere, "Marjorie Barstow," in *Festschrift,* 165. Marjory Barlow describes the younger Marjorie Barstow in a similar way: "It was funny because she was very prim and proper, but she and A.R. got on like a house on fire!" (in Barlow and Davies, *An Examined Life,* 197).
26. Amanda Cole, PhD Research data, Lesson #14, DCE3, 2011. Unpublished.
27. Barstow, Correspondence with Jones, Letter 8 September 1946.
28. Ibid., Letter 7 February, 1970.
29. Conable, Interview with the author.
30. Conable, in *Festschrift,* 24.
31. Barstow, Correspondence with Jones, Letter 6 May 1947.
32. Robert Rickover, "Some Reflections of Marj's Teaching," *Festschrift,* 27.
33. Cathy Madden, *Teaching the Alexander Technique: Active Pathways to Integrative Practice* (Singing Dragon, London, 2018) Chap. 1, Kindle.
34. Barstow, Correspondence with Jones, Letter 7 July 1952.
35. Ibid., Letter 17 November 1947.
36. Ibid.
37. Ibid., Letter 17 February 1970.
38. Ibid.
39. Ibid.
40. Barstow, Correspondence with Jones, Letter 19 March 1970.
41. Ibid.
42. Ibid.
43. Ibid.
44. Ibid.
45. Rickover, in *Festschrift,* 28.
46. Bradley, in *Festschrift,*114.
47. Arro Beaulieu, "The Great Cauliflower" in *Festschrift,* 18.
48. Ibid., 12.
49. Madden, *Teaching the AT*, Chap. 1.
50. Ibid.
51. Ibid.
52. Barstow, Correspondence with Jones, Letter 2 February, 1965.

256 NOTES

53. Parker Palmer, *The Courage to Teach*, (San Francisco: Jossey-Bass, 1998), 10.
54. Barstow, Correspondence with Jones, Letter 8 October 1968.

Chapter 4

1. Jones, *Body Awareness*, 68.
2. Andrews, "Working with Marj," in *Festschrift*, 111.
3. "Principles," in the Mouritz Companion to the Alexander Technique, https://www.mouritz.org/companion/article/principles. Accessed 5 May 2021.
4. Ibid.
5. Patrick Macdonald, *The Alexander Technique As I See It* (London: Mouritz, 2015), 75. Cited in "Principles," Mouritz Companion.
6. Pedro de Alcantara, *Indirect Procedures* (Oxford: Oxford University Press, 1997), xiii.
7. Jones, *Body Awareness*, 68.
8. Jones, Letter to Dewey, March 1947. In Barstow, Correspondence with Jones.
9. Ibid.
10. Barstow, Correspondence with Jones, Letter 3 April 1954.
11. Barstow, Correspondence with Jones, Letter #26, n.d.
12. Madden, *Teaching the AT*. Chap. 1.
13. Bradley, in *Festschrift*, 114.
14. Ibid.
15. James Kandik, "The Contributions of Marjorie L. Barstow to the Study of Human Reaction and the Act of Constructive Change," in *Festschrift*, 145.
16. Michael Holt, "Making FM Reader-Friendly," *Direction Journal* 2, no. 6 Spirituality (September 1998): 29.
17. Alexander, *CCC*, *xiv*.
18. Westfeldt, *F. Matthias*, 68.
19. Ibid., 49.
20. Ibid.
21. Barlow in Oxford, "Marjory Barlow," 16.
22. Alexander, *CCC*, 112.
23. Ibid.
24. Ibid.

25. Ibid., 116.
26. Whittaker, "England," 27.
27. Barstow, Correspondence with Jones, Letter 11 March 1947.
28. Andrews, in *Festschrift*, 111.
29. Scheffler, *Four Pragmatists*, 195.
30. Alice Pryor, "My Experiences with the Alexander Technique and Marj Barstow," in *Festschrift*, 130.
31. Holt, "Making FM," 31.
32. William Conable, in *Festschrift*, 24.
33. Ibid.
34. Ibid., 25.
35. Aase Beaulieu, "Contribution to a Book by Marjorie's Students," in *Festschrift*, 109.
36. Cathy Madden, "A Process that Continues," in *Festschrift*, 32.
37. Barker, in *Festschrift*, 88.
38. Williamson, in *Festschrift*, 56.
39. Alexander, *UOS*, 59–60.
40. Jones, *Body Awareness*, 46.
41. Ibid., 47.
42. Ibid.
43. According to Fischer, in *F. Matthias Alexander: Articles and Lectures*, ed. Fischer (London: Mouritz, 1995), 282. Alexander gave this description on page 65 of *UOS*.
44. Alexander, Letter to Mungo Douglas, 18 September 1951. Cited in *Articles and Lectures*, ed. Fischer, 282. Alexander's letters are held by Fischer and are not publicly available.
45. Jones, Letter to John Dewey, March, 1947. In Barstow, Correspondence.
46. Ibid.
47. Barstow, Correspondence with Jones, Letter 3 April 1954.
48. Barstow, Correspondence with Jones, Letter #26, n.d.
49. Westfeldt, *F. Matthias*, xiii.
50. Fischer, in *Articles and Lectures*, 282.
51. Barstow, Correspondence with Jones, Letter 11 July 1947. "Alison" had written to Jones from Ashley Place, where she was training with Alexander, and Jones had forwarded the letter on to Barstow.
52. Ibid.
53. Ibid., Letter 11 November 1946.

258 NOTES

54. Ibid., Letter 4 November 1947.
55. Ibid., Letter 26 November 1947, Thanksgiving.
56. Ibid., Letter 24 February 1949.
57. Barker, in *Festschrift*, 83.
58. Cathy Madden, *Integrative Alexander Technique Practice for Performing Artists: Onstage Synergy*, Bristol: Intellect, 2014, 26–27.
59. Note that Barstow tended to use the word "technique" to describe Alexander's teaching, from which she had begun to deviate. She used the word "discovery" to describe the principle that she believed was at the heart of his work—what he called the "primary control," which she still taught, but again increasingly leaving his words behind. This seems also to have been a significant point of difference between Barstow and Jones, as Jones continued to use Alexander's terminology even in the book that was he was working on in the final weeks of his life, despite his reservations about the terms.
60. Barstow, Correspondence with Jones, Letter 29 April 1948. Barstow here refers to chapter XII of *The Universal Constant in Living (UCL)*, which Alexander called "Knowing How to Stop."
61. Alexander, *MSI*, 157–58.
62. Alexander, *CCC*, 123.
63. Alexander, *UOS*, 38.
64. Ibid., 42.
65. Alexander, *The Universal Constant in Living (UCL), 3rd ed. London: Chaterson, 1986.* 3rd ed. (London: Chaterson, 1986), 31.
66. Ibid., 133.
67. Ibid., 228.
68. Ibid., 233.
69. Ibid., 146.
70. Ibid., 106.
71. Ibid., 106.
72. Jones in Barstow, Correspondence with Jones, Letter from Frank Jones to John Dewey, 1948, 16 July.
73. Barstow, Correspondence with Jones, Letter 17 November 1947.
74. Barstow, Correspondence with Jones, Letter 16 July 1948.
75. Rickover in Rickover and Cross, "Marjorie and Marjory" n.p.

76. Kroll, "What are you Thinking? What do you Notice?" in *Festschrift*, 123.
77. Venable, "Learning with Marjorie Barstow," in *Festschrift*, 76.
78. Beaulieu, in *Festschrift*, 17.
79. Ibid., 17.
80. Biesta and Burbules, *Pragmatism*, 12.
81. Lena Frederick, "Some Observations on Studying with Marj," in *Festschrift*, 104.
82. Alexander, "Bedford Physical Training College Lecture," in *Articles and Lectures*, ed. Jean Fischer, 168.
83. Ibid.
84. Wynhausen, "From Portland to Lincoln: From Chiropractic College to the World of the Alexander Technique," in *Festschrift*, 133.
85. Alexander, *MSI*, 157.
86. Alexander, *CCC*, 123.
87. Jones, *Body Awareness*, 97.
88. Barstow, Correspondence with Jones, Letter 17 November 1947.
89. Alexander, "Bedford", 168.
90. Barstow, Correspondence with Jones, Letter 11 March 1947.
91. Barstow, Correspondence with Jones, Letter 4 November 1947.
92. Carrington, *A Time to Remember*, 12; Maisel, *Resurrection*, xxxvi.
93. Barstow, Correspondence with Jones, Letter 26 November 1947.
94. Ibid.
95. Ibid.
96. Ibid.
97. Rickover, in Rickover and Cross, "Marjorie Barstow" n.p.
98. Michael Frederick, "Interview with Michael Frederick by Barbara and Bill Conable," in *Festschrift*, 47.
99. Michael Frederick in Robert Rickover, "Marjorie Barstow's Teaching 1" ("MBT1"), with guest Michael Frederick, 2012, https://marjoriebarstow.com/marjoriefrederick.docx, n.p.
100. Rickover, "MBT1," n.p.
101. Jones, *Body Awareness*, 157.
102. Ibid.
103. Madden, *Teaching the AT*, Chap 1.
104. Jean-Louis Rodrigue, "Constructive Thinking in the Individual: The Teaching of Marjorie Barstow," in *Festschrift*, 101 [emphasis in the original].

105. Madden, *Integrative*, 15.
106. Madden, *Teaching the AT*, Chap 1.
107. Ibid.
108. F.M. Alexander, "Notes of Instruction (addressed to a variety of students during actual teaching sessions)," in *The Resurrection*, 4.
109. Alexander, *UOS*, 20.
110. Alexander, *CCC*, 112.
111. Ibid., 115.
112. Ibid.
113. Ibid.
114. Ibid., 113.
115. Ibid.
116. Ibid., 112.
117. Ibid., 113.
118. Barstow, Correspondence with Jones, Letter 3 February 1948.
119. Maisel, *Resurrection*, xxxvii.
120. William Conable, in *Festschrift*, 25.
121. Barstow, Correspondence with Jones, Letter 24 February 1949. Charlie and Eric are Charles Neil and Eric de Pleyer. See Charles Neil in Biographical Notes.
122. Madden, *Teaching the AT*, Chap 1.
123. Jones, *Body Awareness*, 72.
124. Barstow, Correspondence with Jones, Letter 3 February 1948.
125. Barstow, Correspondence with Jones, Letter 26 November 1947.
126. Jones, *Body Awareness*, 72.
127. Barstow, Correspondence with Jones, Letter 20 June 1948.
128. Alexander, *CCC*, 113.
129. William Conable, in *Festschrift* 24.
130. Private Lesson, 2006.
131. Barbara Doscher, *The Functional Unity of the Singing Voice* (Metuchen, New Jersey: The Scarecrow Press, 1988), 67.
132. Ibid.
133. Barstow, Correspondence with Jones, Letter 11 July 1947.
134. Private correspondence, 27 July 2012.
135. Alexander, *CCC*, 113.
136. Alexander, *CCC*, 116.
137. Donald L. Weed, *What You Think Is What You Get*, 3rd ed. (Bristol: ITM Publications, 2004), 55.
138. Lena Frederick, in *Festschrift*, 104.

NOTES 261

139. Conable, Personal correspondence, 6 January 2021.
140. William Conable, "Origins and Theory of Mapping," in Barbara Conable and William Conable, *How to Learn the Alexander Technique: A Manual for Students*, 3rd ed. (Portland, OR: Andover Press, 1992). Although frequently cited as a book by Barbara Conable alone, William Conable is co-author of *How to Learn the Alexander Technique* and contributed to every part of it, including being responsible for all the illustrations.
141. Conable, Personal correspondence, 6 January 2021.
142. Conable, "Origins and Theory," 129.
143. Ibid.
144. Conable, in *Festschrift*, 24.
145. Conable, Private Correspondence, 6 January 2021. For a more in-depth discussion of why Barstow objected to the idea of Body Mapping, see also Amanda Cole, "The Body Mapping Revolution: Origins, Consequences and Limitations," *Australian Voice* 22 (2021).
146. Alexander, *MSI*, 169.
147. The reference to Macdonald's "lunge" is from Don Weed, in *Festschrift*, 161. Jean Fischer (in the Mouritz Companion) cites the "spiral" as an invention of Raymond Dart. Judith Stern describes Judith Leibowitz's "arabesque" at ACAT: Well-being in work; Well-being in life,. https://www.acatnyc.org/blog-posts/tag/Judith+Leibowitz. Accessed 17 March 2021.
148. Williamson, in *Festschrift*, 58. As described later in the chapter, Feldenkrais observed that after Alexander's death, the AT had become a set of manipulations of the body rather than a functional approach to human learning based on a way of thinking.
149. Barstow, Correspondence with Jones, Letter 27 May 1947.
150. Barstow, Correspondence with Jones, Letter 3 February 1948.
151. Barstow, Correspondence with Jones, Letter 20 April 1948.
152. Barstow, Correspondence, Letter to Jones, 27 July 1948.
153. David Mills, "Dimensions of Embodiment: Towards a Conversational Science of Human Action," PhD, Brunel University, 1996, 79.
154. Weed, in *Festschrift*, 151.
155. Williamson, in *Festschrift*, 57.
156. John Dewey, *Interest and Effort in Education*, in *The Collected Works of John Dewey, The Middle Works, Volume 7: 1912–1914*, ed.

262 NOTES

Boydston, Carbondale: Southern Illinois University Press, 2008. 74.
157. John Wynhausen, in *Festschrift*, 132.
158. Private correspondence with music graduate, 2011.
159. An academic at the same university, who had encountered the AT in his undergraduate music degree in the UK.
160. Cathy Madden: A definition given in Alexander Teacher Training Online Class, Seattle, WA, 2020.
161. Alexander, "Teaching Aphorisms, 1930s," in *Articles and Lectures*, ed. Fischer, 203.
162. Michael Frederick, in *Festschrift*, 48.
163. Ibid., 52.
164. Bruce Fertman, "Earn It A new," in *Festschrift*, 66.
165. Martha Fertman, "The Intending Mind," in *Festschrift*, 9.
166. Alexander, *MSI*, 17.
167. Ibid., 118.
168. Ibid., 119.
169. Ibid.
170. Ibid., 118.
171. Ibid., 119.
172. Ibid., 114.
173. Alexander, "The Theory and Practice of a New Method of Respiratory Education," March 1907, in *Articles and Lectures*, ed. Fischer, 59–60.
174. Ibid., 60.
175. Ibid., 64.
176. Alexander, "Why We Breathe Incorrectly," 1909, in *Articles and Lectures*, ed. Fischer, 91–102.
177. Ibid., 93. Emphasis in original.
178. Fischer in Alexander, *Articles and Lectures*, ed. Fischer, 282.
179. Alexander, *MSI*, 118.
180. "Monkey," in the Mouritz Companion to the Alexander Technique, https://www.mouritz.org/companion/article/monkey. Accessed 10 May 2021.
181. Ibid.
182. Erika Whittaker, "Alexander's Way," *The Alexander Journal*, 13 (STAT, 1993), 7.
183. Ibid.
184. Ibid.

185. Ibid.
186. Alexander, "Supplement to Re-education of the Kinaesthetic Systems," in *Articles and Lectures*, ed. Fischer, 104.
187. "Monkey," in Mouritz Companion. Deborah Frank is Alma Frank's daughter and later became Deborah Caplan. More in Biographical Notes.
188. Jones, *Body Awareness*, 69.
189. Barlow in Barlow and Davies, *An Examined Life*, 67.
190. Macdonald, *The Alexander*, 75.
191. Barker, in *Festschrift*, 83.
192. Alexander used the term, "position of mechanical advantage," less discriminately, however, and it is not always clear exactly what he means by the term (*MSI*, 170, for example). In *MSI* he describes in detail a procedure of sitting in a chair and gradually leaning back into the back of the chair (118) and ends by saying: the position thus secured "is one of a number which I employ and which for want of a better name I refer to as a position of '"mechanical advantage'." On page 170 of *MSI* he seems to use it to describe the "monkey" procedure, while in *CCC* the example given is "hands on the back of the chair" (112–20).
193. Madden, Private Correspondence, 22 April 2015.
194. Alexander, "Supplement," 103.
195. Ibid., 103–104.
196. Barstow, Correspondence with Jones, Letter 11 July 1947. This is the trainee Barstow quotes, referred to simply as "Alison." See Biographical Notes.
197. Alexander, *UCL*, 80.
198. Alexander, "Teaching Aphorisms," 203.
199. Ibid.
200. Alexander, *CCC*, 197.
201. Ibid.
202. Ibid.
203. Ibid., 198.
204. Alexander, *UOS*, 34.
205. Carrington, *A Time to Remember*, 24.
206. Barker, in *Festschrift*, 83.
207. Michael Frederick in Rickover, "MBT1," n.p.
208. Ibid.
209. Madden, Personal Correspondence, 22 April 2015.

264 NOTES

210. Weed, in *Festschrift*, 156.
211. Ibid.
212. Eva Webb, "Diary of My Lessons in the Alexander Technique," 1947, in *The Philosopher's Stone: Diaries of Lessons with F. Matthias Alexander*, ed. Jean Fischer (London: Mouritz, 1998), 18.
213. Ibid.
214. Marjory Barlow, "A Masterclass with Marjory Barlow," *6th International Congress of the F.M. Alexander Technique.* (1999). http://www.youtube.com/watch?=cxxtj06OHUs.
215. Ibid., [author's transcription].
216. Barstow in Stillwell, "Marjorie Barstow," 18.
217. Ibid.
218. Eva Webb, "The Diary," 18.
219. Marjory Barlow, "A Masterclass.".
220. Whittaker, "England," 25.
221. Irene Tasker, "Connecting Links" (London: The Sheildrake Press, 1978), 14; and Whittaker, "England," 25.
222. Jones, *Body Awareness*, 76.
223. Whittaker, "England," 25.
224. Madden, Group Class, Madden's Seattle Studio, 2006.
225. Marjorie Barstow, "Aphorisms of Marjorie Barstow," ed. Marion Miller and Jeremy Chance, MarjorieBarstow.com/aphorisms.
226. Barstow, Correspondence with Jones, Letter 24 February 1948.
227. Jones, *Body Awareness*, 6.
228. Wynhausen, in *Festschrift*, 132.
229. Stillwell, "Marjorie Barstow," 18.
230. Barstow, Correspondence with Jones, Letter 24 February 1948.
231. Ibid. There is a repetition of the word "kind" here which I have removed so as not to distract from the main point. Barstow wrote: "I would say Alma is carrying on some kind of glorified kind of gymnastics". She is referring to Alma Frank.
232. Barstow, Correspondence with Jones, Letter 24 February 1948.
233. Letter 28 December 1968. Barstow is referring here to Walter Carrington.
234. Domenico Crivelli, *Instructions and Progressive Exercises in the Art of Singing* (Boston: Oliver Ditson, 1859), 7. Cited in "Whispered 'ah'," in the Mouritz Companion to the Alexander Technique, https://www.mouritz.org/companion/article/whispered-'ah'#_ftn1 Accessed June, 2020.

235. William Aiken, *The Voice: Its Physiology and Cultivation* (Kessinger Legacy Reprints, 2018); first published by Macmillan & Co., 1900. Cited in Fischer, "Whispered Ah." I was unable to find any trace of this book on WorldCat, US Library of Congress, or a Google search.
236. *Voice Training in Speech and Song* by H. H. Hulbert (University Tutorial Press, 1912). Cited in Fischer, "Whispered Ah.".
237. Alexander, "Introduction to a New Method of Respiratory Vocal Re-education," 1906, in *Articles and Lectures*, ed. Fischer, 46.
238. Michael Frederick describes Barstow at "about 85," looking "refreshed and glowing" after a lunchbreak of a teacher refresher course she was teaching, while he (much younger) was feeling tired. When he asked her what she had been doing, she said, "Well, I went for a little walk, and then I sat under under a tree and did some whispered '*Ahs*'," in *Festschrift*, 51.
239. Barstow, Correspondence with Jones, Letter 8 October 1968.
240. Ibid., Letter 17 July 1948.
241. Weed, in *Festschrift*, 150–64.
242. Barstow, Correspondence with Jones, Letter 10 September 1947.
243. Steven Cahn, "Introduction," in *The Collected Works of John Dewey, Later Works, Volume 13* (Carbondale: SIUP, 2008), xiv.
244. William Conable, Interview with the author.
245. William Conable, in *Festschrift*, 23.
246. Barstow, Correspondence with Jones, Letter 16 May 1973. "Walter" is Walter Carrington.
247. Barstow in Jeremy Chance and Barbara Flynn, "Marjorie Barstow in Australia," (Sydney: Fyncot Pty Ltd. 1986). http://www.youtube.com/watch?v=6xUxvZnL2x4.
248. Barstow in Retzlaff et al., "Lincoln, Nebraska," 25.
249. It is unclear where this Institute was, what its name was or what kind of students they were. They may have been phys-ed students, as she mentions teaching these in several later letters.
250. Barstow, Correspondence with Jones, Letter 8 July 1969.
251. Ibid., Letter #26 (author's reference), n.d.
252. William Conable, in *Festschrift*, 23.
253. Paludan, "Dancing," 384.
254. Martha Fertman, in *Festschrift*, 8.
255. Ibid., 9.

266 NOTES

256. Saura Bartner, "Reflections on Lessons with Marj, in *Festschrift*, edited by Barbara Conable (Columbus: Andover Road Press, 1989), 74.
257. Barker, in *Festschrift*, 84 and 88.
258. This was in an article I was asked to proofread for *Direction Journal* in ca. 2015. I have not seen the published journal article or journal. Paul Cook, who was an AT teacher in Queensland at the time and ran the *Direction Journal* archive, has retired from the Alexander community and the archive is no longer available.
259. Lena Frederick, in *Festschrift*, 104.
260. Jane Heirich, "Speaking."
261. Alexander Murray, "The Alexander Technique for Relaxed Playing," *Flute Talk*, April 1998. Murray assumes here that "relaxed playing" is an ultimate goal for players.
262. Cathy Madden, *Integrative*, 371. And yet, the word "relax" is hardly new to performers and athletes (as Murray suggests, in the previous note), the most successful of whom are often described as "relaxed." Better words would be "coordinated" and "efficient." That is, wet noodle performers cannot be blamed solely on poor interpretations or teaching of the Alexander Technique.
263. In fact, one of my AT teachers used to describe and prescribe the Vipassana practice as a response to the urge to move. I remember her telling me that the key was, when you felt you wanted to move, to overcome the urge. It never occurred to question the relevance of Vipassana to singing or performing (the primary reason for my AT study), or to the AT.
264. Madden, *Integrative AT*, 341.
265. Madden, Online Teacher Training Class, Seattle, WA, 2020.
266. One Alexander teacher I worked with for many years referred to this idea constantly, using the phrase, "Less effort" as an instruction. Similarly, a pianist colleague of mine, who observed Madden teaching a drama/AT class at the University of Washington, said to Madden as we left the class together, "I get it: it's mainly about doing less." Madden corrected this impression.
267. Fischer, in Alexander, *Articles and Lectures*, ed. Fischer, 181.
268. Barstow, Correspondence with Jones, Letter 16 July 1948.
269. It was only with Madden's teaching, however, in which she integrates AT with practical performance training, that I really began to master the art of performance.

NOTES **267**

270. The traditionally accepted five senses as described by Aristotle (sight, taste, hearing, smell and touch) give us information that is predominantly external to ourselves. Many of the more recently acknowledged senses are more attuned to ourselves and important internal information. Proprioception is the static position recognition sense which registers the part-to-part relationships of bones to one another at the joints. Balance, while self-explanatory, is important to recognize as its own sensing mechanism. And kinaesthesia, while frequently confused with proprioception and position, informs us about the *rate* at which any given body movement is performed (Hall and Hall, *Guyton*, 1981 and Durie, "Senses Special," 2005). But there are more than just the traditional five senses of touch, taste, smell, sight and hearing. In 2005, *New Scientist* described *ten* senses that were conservatively accepted, as well as an additional twenty-one that were that were "accepted" and another thirty-three that were considered "radical" (Durie, 2005).

271. Maisel, *Resurrection*, xxix. Emphasis added.

272. Kevan A.C. Martin, "Marjory Barlow and Elisabeth Walker, 5 Day Masterclass Workshop," (1997). Cited in Donald Weed, *What You Think*, 21. No further details supplied.

273. Barstow, in "Marjorie Barstow," Chance and Flynn, n.p.

274. Barstow, Correspondence with Jones, Letter n.d.

275. Ibid., Letter 6 May 1963.

276. Barker, in *Festschrift*, 84.

277. Michael Frederick, in *Festschrift*, 47.

278. Arro Beaulieu, in *Festschrift*, 18.

279. Ibid.

280. Stillwell, "Marjorie Barstow," 19.

281. Jones, *Body Awareness*, 68 and 71; Barlow, in Oxford, "Marjory Barlow," 14.

282. Barstow, Correspondence with Jones, Letter 11 March 1947.

283. Barstow, Correspondence with Jones, Letter 19 March 1970. As Conable described, giving the example of the smoking incident (see Chapter 6), she was careful not to say anything that could be construed as negative. Obviously, she was also more guarded when speaking for publication than when writing in personal communication to a colleague who shared her view of the Alexanders. She would also have felt a sense of responsibility

268 NOTES

not to denigrate the AT publicly, as she wanted people who didn't already know about it to think well of it.

284. Jones, *Body Awareness*, 67–68.
285. Troberman, "My Two Trainings," in *Festschrift*, ed. Conable (Columbus, Andover Rd Press, 1989), 138.
286. Ibid.
287. Ibid.
288. Martha Fertman, in *Festschrift*, 9.
289. Rickover, "MBT6," n.p.
290. Franis Engel, *Discovery*, 5.
291. Dewey, *Psychology*, in *The Early Works of John Dewey Volume 2: 1887*, ed. Boydston (Carbondale: SIUP, 2008) 86.
292 Note that Barstow, in removing what I call the "nothing step" in the change process, was often thought to be providing shortcuts for her students. I have justified her decision to bypass this step based on the logic of the necessity to move and the problems she saw emerging from focussing on this "nothing step." By contrast, Alexander's shortcut – that of trying to re-educate his students' senses through sensory experience – flies in the face of all his other arguments.
293. Barstow, "Aphorisms," MarjorieBarstow.com.
294. Scheffler, *Four Pragmatists*, 10.
295. Ibid., 9.
296. Ibid., 259.
297. Barstow, Correspondence with Jones, Letter 1 June 1947.

Chapter 5

1. Dewey, *Interest and Effort*, 74.
2. Dewey, *Experience and Education*, 43.
3. Carrington, "16th May 1946," *A Time to Remember*, 24.
4. Martha Fertman, in *Festschrift*, 8.
5. John Dewey, *Interest and Effort*, 96.
6. Ibid.
7. Ibid., 15.
8. Carrington, "8th April, 1946," *A Time to Remember*, 18.
9. Jones, *Body Awareness*, 68.

NOTES 269

10. Although Barstow taught with this understanding and insistence, I have only heard it articulated this way by Cathy Madden.

11. Dewey, "Interest in Relation to Training of the Will," 1895, in *Early Works Volume 5:1895–1898*, ed. Boydston, 130.

12. Dewey, *The School and Society*, in *Middle Works Volume 1: 1899–1901*, ed. Boydston.

13. Barstow did not select or exclude students and claims (in the Stony Brook Interview, 1986) to have had no particular preference for performing artists, but performing artists did seem to flock to her.

14. Tasker, *Connecting Links*, 6.

15. Ibid., 13.

16. Ibid., 13–14.

17. Ibid., 14.

18. Ibid., italics added.

19. Ibid., 14.

20. Stillwell, "Marjorie Barstow," 18.

21. Whittaker, "England," 14.

22. Walton White, "An Appellation Approach: On Naming a Trade or Trading on a Name," *The Alexander Review* 3, no. 3 (Winter 1988); Eckhart Richter, "The Application Approach: Innovation or Heresy?" *The Alexander Review* 3, no. 3 (Winter 1988).

23. Dewey, *Experience and Education*, 45.

24. Barlow, in Barlow and Davies, *An Examined Life*, 3. Emphasis in original.

25. Ibid., 19.

26. Carrington, "6 March, 1946," *A Time to Remember*, 3. Emphasis added.

27. Dewey, *Experience and Education*, 37; Dewey, *How We Think*, in *Later Works Volume 5, 1929–30*, ed. Boydston, 140.

28. Barstow, Correspondence with Jones, Letter 8 January 1949.

29. Madden, *Teaching the AT*, Chap. 1.

30. Dewey, *Experience and Education*, 44.

31. Ibid., 46. Italics added.

32. Kevin Ruddell, "Some Lessons and Their Lessons," in *Festschrift*, 136.

33. Maisel, *Resurrection*, xxix.

34. Dewey, *Education and Experience*, 45.

35. Carrington, "16th July 1946," *A Time to Remember*, 39.

270 NOTES

36. Alexander, "An Unrecognized Principle in Human Behaviour, Child-Study Society Lecture," in *Articles and Lectures*, ed. Fischer, 153.
37. Westfeldt, *F.Matthias*, 79.
38. Barstow in Retzlaff et al., "Lincoln, Nebraska," 24.
39. Alexander, "Autobiographical Sketch [c. 1950]," in *Articles and Lectures*, ed. Fischer, 246.
40. Alexander, "An Unrecognized Principle," 152.
41. Westfeldt, *F.Matthias*.
42. Ibid., 75.
43. Ibid., 71, 72.
44. Ibid., 73–74.
45. Ibid., 79. She *thinks* it was the *Daily Telegraph*, but this was unverifiable.
46. Ibid. She says: "I remember reading a review the next day in a paper: I think it was the *Daily Telegraph* – which went something like this: F. Matthias Alexander and a group of his students had put on *The Merchant of Venice* at the Old Vic. They did not, however, expect to be judged on their acting ability, and this being the case, the reviewer had no comment to make".
47. Ibid. 77–78.
48. Richter, "The Application Approach."
49. Research Participant Data Collection Episode (DCE) 3 (2011), see Cole, "Marjorie Barstow, John Dewey and the Alexander Technique: A philosophical constellation, or 'Variations of the Teacher's Art,' (PhD diss., Griffith University, 2016), 289–291.
50. Louis Menand, "Introduction," in *Pragmatism: A Reader*," ed. Louis Menand. New York: Vintage, 1997, *xxvi*.
51. Ibid.
52. Ibid.
53. Sarah Barker, Interview with the author, 2013.
54. Jones, *Body Awareness*, 80.
55. Biesta and Burbules, *Pragmatism*, 12.
56. Dewey, "*Context and Thought*," 1931, in *Later Works Volume 6: 1931–32*, ed. Boydston, 11.
57. Jones and Dewey were discussing the concept of inhibition in the light of Dewey's essay on qualitative thought. In this essay Dewey is practising the critically pragmatic ideal of making ideas clear.

He describes a logical problem that exists between qualitative and quantitative descriptions and evaluations.

58. Jones wrote: "I was glad that you referred me to your paper on 'Qualitative Thought'." In Barstow, Correspondence with Jones, "From a letter to Dewey, 7 June 1948."

59. Ibid.

60. Dewey, "Qualitative Thought," in *Later Works Volume 5: 1929–1930*, ed. Boydston, 246. Emphasis added.

61. Dewey, "*The Dewey School*: Statements – General History, Chapter 1," in *Later Works Volume 11: 1935–1937*, 194.

62. Bruce Fertman, in *Festschrift*, 66.

63. Walton White, "An Appellation Approach".

64. Dawn Bennett, *Understanding the Classical Music Profession: The Past, the Present and Strategies for the Future*. Aldershot: Ashgate, 2008; Dawn Bennett, "Utopia for Music Performance Graduates. Is It Achievable, and How Should It Be Defined?" *British Journal of Music Education* 24, no. 02 (2007); Amanda Cole, "What Is Performance and Why Should We Teach It?" *Australian Journal of Music Education* 5, no. 2 (2019).

65. Barstow, Correspondence with Jones, passim.

66. Madden, in *Festschrift*, 29.

67. William Conable, Interview with the author, 2013.

68. Ibid.

69. Whittaker, in Gounaris et al., *Taking Time*, 127.

70. Ibid., 144.

71. Michael Frederick, in *Festschrift*, 49.

72. Paludan, "Dancing.".

73. Barstow, in Stillwell, "Marjorie Barstow," 19.

74. Richard Gummere, in *Festschrift*, 166. The detail about helping with her sister's family is only in Gummere's article. She does not write about this to Jones, while about the other activities she does.

75. Ibid. Gummere says: "When asked by a stranger about her occupation, I heard her reply, 'Oh, I'm just a farmer: diggin' in the dirt'."

76. Paludan, "Dancing," 384.

77. Barker, in *Festschrift*, 82.

78. Ibid.

79. Lena Frederick, *Festschrift*, 104.

272 NOTES

80. Barbara Conable, "Explorations of Time in the Spirit of Marj," *in Festschrift*, ed. Conable, 149.
81. This resonates strongly with Dewey's idea that the teacher is a guide or co-worker.
82. Venable, in *Festschrift*, 77.
83. Alexander, "Introduction to a New Method," 46. Alexander also discusses the cultivated habits of breathing in "The theory and practice of a new method."
84. Alexander, *UOS*, 34.
85. Upon re-reading Walter Carrington's 1946 diary, I was struck by how few interests he appeared to have had in his life apart from refreshing his training and teaching. He appeared to have left the bulk of the work of raising his three children to his wife, Dilys, and, apart from Alexander's daily training class and a small amount of teaching, Carrington appears to have spent 1946 flitting from one social engagement or light entertainment to another and getting extremely tired. Perhaps he needed this respite after what he had suffered during the war. But I was surprised by the apparent emptiness of, and lack of consequential activity in, his days compared with those Marjorie Barstow describes in her letters of the same period to Jones. Was this perhaps the cause of the excessive tiredness of which Alexander trainees often complain? (eg: Walter Carrington; Alison Grant-Morris, in Barstow, Correspondence with Jones, Letter 11 July 1947; and informal discussions with trainees and teachers of the AT).
86. White, "An Appellation."
87. Spencer Kagan and Miguel Kagan, *Kagan Cooperative Learning* (San Clemente, CA: Kagan Publishing, 2015).

Chapter 6

1. Baty, "Marj as Inspiration," in *Festschrift*, ed. Conable (Columbus, Andover Road Press, 1989), 117.
2. Barstow, Correspondence with Jones, Letter 20 June 1948.
3. Dewey, *Experience and Education*, 47.
4. Barstow, Correspondence with Jones, Letter 6 May, 1947. "A. brothers" here refers to the Alexander brothers.
5. Ibid., Letter 12 June 1956.

6. Ibid., Letter 8 July 1969.
7. Tommy Thompson, who trained with Jones from 1972, claims that Barstow's career began when she went to Southern Methodist to teach in place of Frank Jones, who was beginning to show the signs of his brain tumour. "It was Frank who sent Marj to Southern Methodist." He had been asked to "come out to Southern Methodist and give the workshop, but that's when he was stumbling so he called Marj and said, 'Why don't you go instead?' And that's when she started her career with all those workshops" (in Rickover, "The Teaching"). While it is true that Barstow's reputation grew significantly in the 1970s, it is inaccurate to suggest that she fell into group teaching thanks to Jones. Their correspondence shows that they had both been teaching groups since the 1940s and discussing methods of doing so for many years before Jones became ill.
8. Macdonald, "In the 80s: Alexander Technique Lesson by Patrick Macdonald—Part 1 of 2," http://youtube.com/watch?v=QPP xyHCWPu8, 23m37s.
9. Ibid. [Emphasis added].
10. John Dewey, *Democracy and Education,* in *Middle Works Volume 9: 1916,* ed. Boydston, 11.
11. Ibid.
12. Dewey, "My Pedagogic Creed," in *Early Works Volume 5: 1895–98,* ed. Boydston, 88.
13. Dewey, *The School and Society,* 19.
14. Dewey, *Experience and Education,* 25.
15. Ibid., 37.
16. Ibid., 47 [Emphasis added].
17. Ibid.
18. Dewey, *Democracy and Education,* 7.
19. Ibid.
20. Ibid., 20.
21. Dewey, "My Pedagogic," 90.
22. Dewey, *Democracy and Education,* 20.
23. Scheffler, *Four,* 10.
24. Madden, *Teaching the AT,* Chap. 1, Kindle.
25. See Conable, Barbara, *Marjorie Barstow: Her Teaching and Training (Festschrift).* ed. Barbara Conable, (Columbus: Andover Road Press, 1989). *(Festschrift).*

274 NOTES

26. Whittaker, "England," 27.
27. Barlow, in Barlow and Davies, *An Examined,* 197. Barlow explains that the training course split into two opposing camps, Patrick Macdonald's and George Trevellyan's and that "Marjorie Barstow, she was older and never a part of any group." Erika Whittaker is also quoted as saying that Barstow was "in the middle somewhere. She was older and a more experienced woman," in Barlow and Davies, *An Examined,* 197.
28. Cherryholmes, *Power,* 166.
29. Barlow, quoted in Madden, *Integrative,* 25.
30. Biesta and Burbules, *Pragmatism,* 12. Emphasis in original.
31. Ibid., 12.
32. Biesta, 1994, "Education as Practical Intersubjectivity," *Educational Theory,* 301. Biesta cites from Hans Joas's study on the works of George Herbert Mead (a pragmatist contemporary of Dewey) and explains that while the term stems from this work, it is not found in Mead's own works. Hans Joas, *G.H.—A Contemporary Re-examination of His Thought* (Cambridge: Polity Press, 1985), 15.
33. Williamson, in *Festschrift,* 56 [Emphasis added].
34. Westfeldt, *F. Matthias.*
35. Edward Bouchard, "To Group or Not to Group," *The Alexander Review* 3, no. 2 (1988): 32.
36. Madden, *Integrative Alexander Technique.*
37. Ibid., 245.
38. Jeremy Chance and Cathy Madden, "Communication: A Transcript from the 6th International Congress, Freiburg." *Direction,* 1999, accessed 5 July, 2006, http://www.directionjournal.com/congress/fc/maddenchance.html (no longer available).
39. Weed, "Let's get rid". Donald Weed, "Let's Get Rid of 'Group Teaching'." Electronic. 3rd International Congress for Teachers of the Alexander Technique, Engleberg, Switzerland, *Direction Journal,* 1991.
40. PAAT, http://paat.org.uk, accessed 2015 [Emphasis added]. The homepage has since been edited and no longer states this so emphatically. This shows how quickly things are changing and that Barstow's methods are becoming more widely accepted in the Alexander world. On another page, it now states: "Courses provide a different pathway to lessons, and

bring the benefits of making discoveries as part of a group." Paat.org.uk/faqs. Accessed 2021.

41. Diana Johnston, "Letter from Diana Johnston," The *Alexander Review* 3, no. 2 (1988) [Emphasis and capitals in the original].
42. Ibid.
43. Private Correspondence, 2 May 2013.
44. Ibid.
45. Ibid.
46. Michael Frederick, in *Festschrift*, 49.
47. Whittaker, "England," 27.
48. Gounaris, et al. *Taking Time*.
49. Jones, *Body*, 76.
50. Ottiwell, in *Festschrift*, 3.
51. Rickover, in *Festschrift*, 28.
52. Pryor, in *Festschrift*, 131.
53. Wynhausen, in *Festschrift*, 133.
54. Ibid. (Wynhausen is referring to the First International AT Congress in Stony Brook in 1986).
55. Barstow, Correspondence with Jones, Letter 28 September 1975.
56. After Frank's death, Helen Jones corresponded with Barstow to ask whether she was happy for her letters to Frank to be included in the donation of his papers to Tufts University. Barstow replied that in her discussion about this with Frank before he died, she had said she wanted to see her letters first. After reading the copies Helen had sent her, and wanting to protect some of the people they had freely exchanged frank opinions, Barstow suggested a less public home for their correspondence.
57. Renée Fleming, *The Inner Voice*, 51.
58. Wynhausen, in *Festschrift*, 133.
59. Stillwell, "Marjorie Barstow," 20.
60. William Conable, in *Festschrift*, 22.
61. Ibid., 24.
62. Ibid.
63. Wynhausen, in *Festschrift*, 133.
64. Troberman, in *Festschrift*, 138.
65. Fishman, in *Festschrift*, 5.
66. Ibid.
67. Barker, in *Festschrift*, 88.
68. Arro Beaulieu, in *Festschrift*, 13.

276 NOTES

69. Barstow, Correspondence with Jones, Letter 18 February 1975.
70. Bick, in *Festschrift*, 60.
71. Madden, *Teaching the AT*, Chap. 1.
72. Kaisa Tiippana, "What Is the McGurk Effect?" *Frontiers in Psychology* 5 (2014).
73. Bresciani et al., for example. "Vision and Touch Are Automatically Integrated for the Perception of Sequences of Events," *Journal of Vision* 6 (2006).
74. Timothy Wilson, *Strangers to Ourselves*, Belknap, 2002.
75. Barstow, Correspondence with Jones, Letter 17 July 1947.
76. Ibid., Letter 4 October 1951.
77. Kroll, in *Festschrift*, 123.
78. Dylan Wiliam, *Embedded Formative Assessment* (Bloomington: Solution Tree Press, 2018), 77.
79. Michael Frederick, in *Festschrift*, 46–47.
80. Ibid., 46.
81. Ibid.
82. Trimmer, in *Festschrift*, 140.
83. Research participant, DCE 4, 2012, see Cole, "Marjorie Barstow," 292.
84. See, for example: Barlow, in Barlow and Davies, *An Examined*, 143; Barstow in Miller and Chance, "Aphorisms"; Bradley, in Festschrift, 113.
85. Bradley, in *Festschrift*, 114.
86. Lena Frederick, in *Festschrift*, 104.
87. Bradley, in *Festschrift*, 114.
88. Gehman, in *Festschrift*, 119.
89. Kroll, in *Festschrift*, 124.
90. Kroll, in *Festschrift*, 124.
91. William Conable, in *Festschrift*, 23.
92. Barker, in *Festschrift*, 95.
93. Whittaker, "England," 23.
94. Ibid., 27.
95. Barstow, Correspondence with Jones, Letter 17 November 1947.
96. Barlow, in Davies and Barlow, *An Examined*, 86.
97. Westfeldt, *F. Matthias*, 57.
98. Stillwell, "Marjorie Barstow," 17.
99. Ibid.
100. Jones, Body, 68.

NOTES 277

101. Ibid.
102. Ibid., 80.
103. Mills, in *Festschrift*, 40.
104. Stillwell, "Marjorie Barstow," 17.
105. Barstow, Correspondence with Jones, Letter 17 November 1947.
106. Venable, in *Festschrift*, 77.
107. Gummere, in *Festschrift*, 165.
108. Ottiwell, in *Festschrift*, 2.
109. Madden, in *Festschrift*, 32.
110. Kroll, in *Festschrift*, 122.
111. Ibid.
112. Troberman, in *Festschrift*, 138.
113. Barstow, "Aphorisms,"
114. Barstow in "Marjorie Barstow in Australia," ed. Jeremy Chance, *Direction Journal: Marjorie Barstow Issue, 1(2)*, 41e.
115. Barstow, Correspondence with Jones, Letter 8 July 1969.
116. Stillwell, "Marjorie Barstow," 19.
117. Rickover, in *Festschrift*, 28.
118. Lena Frederick, in *Festschrift*, 105.
119. Barstow, "Aphorisms."
120. Rodrigue, in *Festschrift*, 102.
121. Ottiwell, in *Festschrift*, 3.
122. Bradley, in *Festschrift*, 116.
123. Conable, Interview with the author, 2013.
124. Bartner, in *Festschrift*, 74.
125. Stillwell, "Marjorie Barstow."
126. Venable, in *Festschrift*, 77–78.
127. Baty, in *Festschrift*, 118.
128. Carol Dweck, *Mindset: The New Psychology of Success*, (New York: Ballantine Books, 2007).
129. Bradley, in *Festschrift*, 114.
130. Madden, in *Festschrift*, 31.
131. Ibid.
132. Madden, "Viewpoint: Spirituality" *Direction Journal* 2, no. 9 (January 2001).
133. Madden, Interview with the author, 2011.
134. Vincent Kenny, "Life, the Multiverse and Everything, an introduction to the ideas of Humberto Maturana," (Rome: Oikos, 1985).

278 NOTES

135. Martha Fertman, *Festschrift*, 9.
136. Barstow, Correspondence with Jones, Letter 24 February 1948.
137. Barstow, Correspondence with Jones, Letter 24 February 1948.
138. Arro Beaulieu, in *Festschrift*, 18.
139. Bruce Fertman, in *Festschrift*, 67.
140. Wiliam, *Embedded Formative Assessment*, 77.
141. Patricia Carrington, "Solving the Mystery of Borrowing Benefits in EFT," https://patcarrington.com/solving-the-mystery-of-borrowing-benefits-in-eft-article/.
142. Ibid.
143. Peta Stapleton, Gabrielle Crighton, Debbie Sabot, Hayley Maree O'Neill, "Reexamining the Effect of Emotional Freedom Techniques on Stress Biochemistry: A Randomized Controlled Trial." *Psychological Trauma: Theory, Research, Practice, and Policy* 12, no. 8 (2020): 869–77.
144. Barker, in *Festschrift*, 85.
145. Ibid., 92.
146. William Conable, in *Festschrift*, 24.
147. Ibid.
148. Barker, in *Festschrift*, 98.
149. Scheffler, *Four Pragmatists*, 216.
150. Research Participant in DCE 1, 2010, see Cole, "Marjorie Barstow," 284–6.
151. Williamson, in *Festschrift*, 57.
152. Fishman, in *Festschrift*, 6.
153. Ibid.
154. Ibid., 9.

Chapter 7

1. Barstow, Correspondence with Jones, Letter 19 June 1945.
2. Dewey, *Experience and Education*, 26.
3. Dewey, *How We Think*, [emphasis in original], 157.
4. Dewey, *Democracy and Education*, 22.
5. Ibid.
6. Ibid.
7. Ibid.
8. Dewey, *The School and Society*, 11.

NOTES 279

9. Dewey, "Freedom in Workers' Education," in *The Later Works of John Dewey, Volume 5*, 332.

10. Jim Garrison, *Dewey and Eros*, 22.

11. Baty, in *Festschrift*, 117.

12. Madden, "Viewpoint," 34.

13. Ibid., 34.

14. Axel Cleeremans and Zoltan Dienes, "Computational Models of Implicit Learning," in *The Cambridge Handbook of Computational Psychology*, ed. Ron Sun (Cambridge: Cambridge University Press, 2008), 396.

15. Peter Frensch and Dennis Rünger, "Implicit Learning," *Current Directions in Psychological Science* 12 (2003): 13–18.

16. Madden describes Barstow's exacting process in "The Living Room Étude" in *Teaching the Alexander Technique*, Chap. 1.

17. Rickover, *MBT1*. It seems important to note that Barstow would not have been talking about lightness (or any other feeling for that matter) as a desired effect of her work, so insistent was she on the thinking. So it would be unlikely that the aide would have been picking up linguistic information about what Barstow was teaching in order to ask this.

18. The *Festschrift* is shorthand for Barbara Conable's collection of essays by Barstow's students to celebrate Barstow's 90th birthday (Columbus: Andover Road Press, 1989).

19. Conable, in *Festschrift*, 25.

20. Kroll, in *Festschrift*, 124.

21. Weed, *What You Think*, 108–9.

22. Paludan, "Dancing," 384.

23. Stillwell, "Marjorie Barstow," 17.

24. Paludan, "Dancing," 383.

25. Retzlaff et al., "Lincoln, Nebraska."

26. Ottiwell, in *Festschrift*, 2.

27. Ibid.

28. Frederick, in Rickover, "MBT1."

29. The only other male members who were in the first training course at the same time as Barstow were George Trevelyan, Gurney MacInnes and Charles Neil* (who died in 1958, long before this story) (from Carrington, *Time to Remember*, 71).

30. Barlow in Oxford, "Marjory Barlow," 15.

31. In Rickover and Cross, "Marjorie Barstow and Marjory Barlow."

280 NOTES

32. Conable, Interview with the author, 2013. A quarter horse, says Conable, is bigger than a pony, but smaller than a full-sized horse. It is trained to "cut" a herd of cattle. That is, you tell the horse which cow you want, and the horse will separate it. After being named world champion, the horse died the following winter (1971), when he might have been siring. This great disappointment coincides roughly with the beginning of the resurgence of Barstow's teaching career. Barstow is pictured with her horses at the end of Chapter 3.
33. Rickover, in *Festschrift*, 28.
34. Weed, in *Festschrift*, 156.
35. Rodrigue, in *Festschrift*, 101.
36. Baty, in *Festschrift*, 117.
37. Mernaugh, in *Festschrift*, 127.
38. Conable, Interview with the author, 2013.
39. Barlow, in Oxford, "Marjory Barlow," 15.
40. Horace Kallen in Corliss Lamont, *Dialogue on John Dewey*, 99.
41. Carrington, *A Time to Remember*.
42. Mernaugh, "My Lessons with Marj," in *Festschrift*, ed. Conable (Columbus, Andover Road Press, 1989), 129.
43. Gehman, in *Festschrift*, 121.
44. Bradley, in *Festschrift*, 115.
45. Frederick and Rickover, in Rickover, "MBT1."
46. Research Participant, DCE3 (2011), see Cole, "Marjorie Barstow," 289–290.
47. Research Participant, DCE1 (2010), see Cole, "Marjorie Barstow," 284–5.
48. Madden, Interview with the author, 2011.
49. Arro Beaulieu, in *Festschrift*, 77.
50. Aase Beaulieu. *Festschrift*, 109.
51. Madden, *Teaching the AT*.
52. Lesson #3, DCE 3, 2011. See Cole, "Marjorie Barstow."
53. Kandik, in *Festschrift*, 146.
54. Madden, *Teaching the Alexander Technique*, Chap. 1. While this was published in 2018, the lesson I quote from was in 2011.
55. Ibid.
56. Research Participant, DCE1, 2010. See Cole, "Marjorie Barstow."
57. Ibid.

58. Research Participant, DCE2, 2011, see Cole, "Marjorie Barstow," 286–9.
59. Ibid.
60. Ibid.
61. In Madden, *Teaching the Alexander Technique*, Chap. 1. Madden describes her experiences teaching at a residential workshop shortly after Barstow's death. Most of the participants were Alexander Technique teachers, and many questions were about Barstow and Madden's training with her. This question in particular provoked Madden's attention. The most important difference, she reflects, is the "I want."
62. See, for example, her letters to Jones about her own training, Alexander's methods, teacher standards, certificates and a training course she and Jones were planning together.
63. Dewey, *Democracy and Education*, 14.
64. Venable, in *Festschrift*, 76.
65. Jones, *Body Awareness*, 77.
66. Ottiwell, in *Festschrift*, 3.
67. Conable, Interview with the author, 2013.
68. Bruce Fertman, "Memory: A Tradition of Originality," (2012), accessed 11 March 2013. http://peacefulbodyschool.com/2012/05/28/memory/#comments.
69. Bradley, in *Festschrift*, 113.
70. William Conable, in *Festschrift*, 26 [emphasis in original].
71. Ibid. [emphasis in original].
72. AmSAT* (American Society for the Alexander Technique), https://www.amsatonline.org/aws/AMSAT/pt/sp/training_programs; Alexander Technique Teacher Training, https://thealexandertechnique.net/alexander-technique-training-courses/; School for F. M. Alexander Studies, https://www.alexanderschool.edu.au/course-prospectus. All Accessed 24 March 2021.
73. This information was accurate in 2015. As was the case for the information on groups versus individual lessons on this website, this information is now no longer accessible and the website appears to have been updated. In 2021, it no longer states how long training courses are.
74. Madden, Melbourne Alexander Training School Workshop, Palotti College, 2005.
75. Bruce Fertman, in *Festschrift*, 68.

282 NOTES

76. Barlow, in Barlow and Davies, *An Examined Life*, 232.
77. Barstow, Letter to the Board of Directors, American Center for the Alexander Technique, 22 October 1986, Courtesy of William Conable.
78. Bruce Fertman, in *Festschrift*, 68.
79. William Conable, in *Festschrift*, 26 [emphasis in original].
80. Arro Beaulieu, in *Festschrift*, 19.
81. William Conable, in *Festschrift*, 25.
82. Ibid.
83. Barlow, in Barlow and Davies, *An Examined Life*, 153.
84. Barlow, "Review of Lulie Westfeldt's *F. Matthias Alexander*," in Westfeldt, *F. Mathias*, 169.
85. Barlow, in Barlow and Davies, *An Examined Life*, 153.
86. This phrase is a title by John Dewey: *The Quest for Certainty: A Study of the Relation of Knowledge and Action.*
87. Michael Frederick, in *Festschrift*, 53.
88. Martha Fertman, in *Festschrift*, 10.
89. William Conable, in *Festschrift*, 26.
90. Ibid., 23.
91. Barstow addressed this in her letter to ACAT (1986), when she mentioned having two misunderstandings with respect to her teaching: first, that she had been encouraging students who had studied with her for only one month to go away and teach the AT; and second that she had never trained teachers.
92. Bruce Fertman, in *Festschrift*, 68.
93. Alexander Technique International, https://www.alexandertec hniqueinternational.org/history.
94. Troberman, in *Festschrift*, 139.
95. Andrews, in *Festschrift*, 112.
96. Troberman, in *Festschrift*, 139.
97. Ibid.
98. Madden, *Teaching the AT*, Chap. 1.
99. Ibid.
100. Ibid.
101. Chance and Madden, "Communication."
102. Ibid.
103. Ibid.
104. Ibid.
105. Kroll, in *Festschrift*, 123.

NOTES 283

106. Gehman, in *Festschrift*, 121.
107. Bradley, in *Festschrift*, 115.
108. Jones, *Body Awareness*, 18.
109. Madden, Personal Correspondence, 4 April 2015.
110. Alexander Technique International, "History," accessed 24 March 2021, https://www.alexandertechniqueinternational. org/index.php?option=com_content&view=article&id=53:his tory&catid=20:site-content&Itemid=144.
111. Marjorie Barstow, Letter to ACAT, 1986.
112. Ibid.
113. Madden, Personal Correspondence, 4 April 2015.
114. Ibid.
115. Should be Gehman.
116. Ibid.
117. Later Martha Fertman.
118. Heather Kroll (married to Kevin Ruddell but retained her name).
119. Fitzgerald, "The Future," x.
120. Ibid., 22.
121. Ibid., 23.

Backmatter

1. This is the phrase as I learned it from Cathy Madden.

Biographical Notes

ACAT: American Center for the Alexander Technique. Now AmSAT, ACAT was formed by Judith Leibowitz and her students, Lee Firestone, Joyce Ringdahl, Deborah Caplan, Barbara Callen and Frank Ottiwell. Leibowitz trained with Lulie Westfeldt, completing a training course in two years, finishing in 1949. She then worked with Alma Frank and travelled to have lessons with F.M. Alexander. A striking video of Barstow working with Leibowitz was made at the 1986 Stony Brook Conference in which Barstow helped Leibowitz (by changing her thinking) to overcome the limp she had had since suffering from polio as a teenager (*The Alexander Technique: A Worldwide Perspective. The First International Congress, Stony Brook, New York, 1986.* David Reed Media, 2001).

Addams, Jane (1860–1935). A pioneer settlement worker, sociologist and public philosopher, Addams founded one of the first social settlement houses in the US, an educational and community service centre for the disadvantaged of Chicago. It attempted "to apply knowledge to life, to express life in terms of life." This was a concrete example of applying theory to praxis, and she referred to the philosophy of Dewey and James to support her experiment. It was the experiment of her settlement that inspired Dewey to open his Lab School. She won the Nobel Peace Prize in 1931. Her pacifistic ideas, holistic approach to social welfare, philosophy of education

© The Editor(s) (if applicable) and The Author(s) 2022
A. Cole, *Marjorie Barstow and the Alexander Technique,*
https://doi.org/10.1007/978-981-16-5256-1

286 BIOGRAPHICAL NOTES

and belief in democracy meant that she and Dewey exerted mutual influence on each other, but not without significant debate and disagreement.

AmSAT. American Society for the Alexander Technique. See ATAS for more context.

Alexander, Amy (1879–1951). The sixth of ten children of John and Betsy Alexander, and the sister of F.M. Alexander. F.M. trained her to teach his method, which she continued to do in Melbourne after his departure for London. She and her mother eventually followed him to England, where they remained. Amy married George Mechin and had two daughters, Marjory (later Barlow) and Joan (later Evans). See also Marjory Barlow.

Alexander, A.R. (Albert Redden) (1873–1947). The fourth of ten children of John and Betsy Alexander, of which F.M. Alexander was the first. A.R. was one of the first teachers trained by his brother, F.M. He followed F.M. to London and beyond, and eventually took over the American arm of the Alexander mission during the 1930s after his wife, Grace, died in 1933. He had intended to stay in the US but died in England, when he was denied re-entry to the US due to his health.

Alexander, F.M. (Frederick Matthias) (1869–1955). The founder of the Alexander Technique. The first of ten children of John and Betsy Alexander, F.M. was born in Wynyard, Tasmania. See Appendix, The Alexanders and the AT. F.M. Alexander published four books and many articles on the Alexander Technique. The books and their dates can be found in the References section.

Andrews, Meade. Ph.D. in Theater and Dance (University of California/University of Georgia). AT teacher (AmSAT and ATI). Graduate of Teacher Training Program at F.M. Alexander School of Philadelphia. Student of Marjorie Barstow from 1982. Currently Associate Professor of Theatre and Dance at Rider University.

ATAS: Alexander Technique Affiliated Societies. These comprise eighteen national societies, and approximately 3000 member-teachers. The Affiliated Societies "maintain and assure training standards," which include training courses of a minimum of three years, an average of 36 weeks per year, 5 days a week and 3 hours per day. All training course directors and assistants are certified to have the necessary skills and experience to train other Alexander teachers. Affiliated societies include those in Australia (AUSTAT),

BIOGRAPHICAL NOTES **287**

Austria, Belgium, Brazil, Canada (CanSTAT), Denmark, Finnland, France, Germany, Israel, Netherlands, New Zealand, Norway, South Africa, Spain, Switzerland, UK and Ireland (STAT) and the United States (AmSAT).

ATI: Alexander Technique International. A society formed to recognize teachers who had trained in legitimate ways that did not necessarily accord with STAT's quantitative prescriptions involving numbers of hours, days, years and frequency of training. ATI's members, rather, satisfy qualitative standards. ATI was formed in 1992 with 28 teachers as an open organization. By 2004 it had twelve regional offices around the world serving over 300 teachers in nineteen countries. It accepts members of the Affiliated Societies and other AT societies.

Barker, Sarah. AT teacher and actor. Began studying with Marjorie Barstow in 1971. In 1978 she published *The Alexander Technique*, to which many in the Alexander world took exception because of her implication that one could learn the technique without a teacher. She is currently Associate Professor of Acting and Movement at the University of South Carolina and a nationally recognized leader in movement training for actors.

Barlow, Marjory (née Mechin) (1915–2006). AT teacher. Daughter of Amy Alexander and niece of F.M. and A. R. Alexander. She joined the first training course in 1933 and qualified as a teacher in 1936. She taught at Ashley Place while Alexander was in the US (1940–1943). Married Wilfred Barlow in 1940 and together they were the first graduates of the Ashley Place training program to start their own teacher-training program. Note the similarity of her name with that of Marjorie Barstow.

Barlow, Wilfred (1915–1991). AT teacher who trained with F.M. Alexander from 1938 to 1945 while studying medicine simultaneously. As a principal witness in 1948 he helped Alexander win the defamation case in South Africa. With his wife, Marjory (née Mechin, Alexander's niece), he ran an Alexander teacher-training course (1952–1982) while practising as a rheumatologist. In 1958 he founded The Society of Teachers of the Alexander Technique (STAT), with Joyce Wodeman and Marjory Barlow. He was editor of STAT's *Alexander Journal* and a number of books on the technique.

288 BIOGRAPHICAL NOTES

Bartner, Saura (?1948–2003). AT teacher, dancer and English major. Began lessons in 1971. Trained at ACAT-NY and graduated in 1977. Taught at several universities and arts departments. In 1999, she gave the AmSAT Memorial Lecture, "Feathers of Consciousness," in which she talked of her experiences of spiritual traditions and the triumph of the peaceful, creative and open mind over totalitarian viewpoints.

Baty, Jan. AT teacher and violinist. Studied at Eastman School of Music, Yale School of Music, and Julliard, with Dorothy DeLay and Robert Mann. Began Alexander studies with Bruce Fertman and Marjorie Barstow in 1975 while a violinist for the Delos String Quartet. Certified as a teacher by the Alexander Alliance in Philadelphia.

Beaulieu, Aase. AT teacher. B.A. in comparative literature (UC Berkeley); MBA (University of Nebraska, Lincoln). Came to the US from Denmark in 1961 as an exchange student. Began AT lessons in 1971 with Frank Ottiwell and Linda Avak and graduated as a teacher from ACAT-West in San Francisco (Ottiwell and Giora Pinkas). Moved to Lincoln in 1979 with Arro Beaulieu (her husband) to study with Barstow.

Beaulieu, Arro (Anthony) (1942–2010). Pianist, piano teacher and AT teacher. He began studying the Alexander Technique in 1973 with Marjorie Barstow and Frank Pierce Jones. In 1978 he moved to Lincoln, Nebraska, to study more intensively with Barstow. He and his wife Aase spent six years in Lincoln. They were married at Barstow's house when rain threatened to ruin their wedding plans.

Bick, Jane. AT teacher and actor. Studied with Marjorie Barstow from 1976. Moved to Nebraska in 1984 to further her studies and stayed for many years. She began teaching in 1987.

Binkley, Goddard (1920–1987). AT teacher. Trained first with Dolly Dailey in the United States. He then spent almost two years studying with F.M. Alexander in London towards the end of the latter's life. His lessons began in 1951. He then entered the training course in the summer of 1953. *The Expanding Self* is based on Binkley's diary from this time, telling the story of his introduction to the AT, his own process of discovery and healing, and his lessons with the founder of the technique.

Bradley, Diana. AT teacher and dancer and martial artist (Aikido). Currently at The Studio Theatre, Washington, DC. Certified as an

AT teacher in 1979. Began studying with Marjorie Barstow in 1978, when she attended the summer workshop.

Caplan, Deborah (née Frank) (1931–2000). AT teacher. Attended Alexander's Little School for children in the US around 1940, when Alexander had relocated to avoid the war. Her mother was Alma Frank, with whom she trained from 1950 to 1953. Her father was the writer, Waldo Frank. Caplan was a dancer, with an MA from Hunter College and a master's degree in physical therapy from NYU. She ran a private practice specializing in back problems and teaching body use and movement to many performers. She was a co-founder of ACAT.

Carrington, Walter (1915–2005). AT teacher. Trained with Alexander in London from 1936 to 1939. During the war he was a pilot in the RAF, and returned to Ashley Place to re-train and recover his "use" after significant injuries and trauma before returning to teaching full time. He was one of four teachers who took over Alexander's London training course in 1955 when Alexander died (the others being Peggy Williams, Margaret Goldie and Irene Stewart). In 1960 the school moved to Lansdowne Rd and was renamed the Constructive Teaching Centre. The centre claims to be "the uninterrupted continuation of the training school for teachers of the Alexander Technique that was started by FM Alexander in 1931 at Ashley Place in London." Carrington trained several hundred teachers during his lifetime and published several works on the Alexander Technique, including his diary, *A Time to Remember* (1996).

Chance, Jeremy. AT teacher & actor. Began studying the Alexander Technique in 1969. He began training in London in 1976 at the Carrington-style School of Alexander Studies with Paul and Betty Collins and then studied with Barstow from 1986. He organised Barstow's three teaching visits to Europe in 1988–1990 and continued studying with her until one of her last winter workshops in 1992. He currently runs the Professional Teacher Education School for Alexander Technique Teachers in Japan, BodyChance, which continues Barstow's approach to teaching and training. His book *Principles of the Alexander Technique* was published in 1999.

Conable, Barbara. AT teacher. Studied with Marjorie Barstow from 1963. During her years as an Alexander Technique teacher she belonged, consecutively, to ACAT, NASTAT, AmSAT, and ATI.

She then founded Andover Educators, and has since focussed her attention on Body Mapping for musicians in preference to the Alexander Technique. In 1989 she published what I have referred to in this thesis as *The Festschrift: Marjorie Barstow, Her Teaching and Training, A 90th Birthday Offering.* She is the co-author of *How to Learn the Alexander Technique.*

Conable, William. DMA. AT teacher, cellist, and originator of Body Mapping, the idea for which, he says, came from Barstow's teaching. He is Professor Emeritus of Music at Ohio State University, where he taught from 1972 to 2008. He studied with Marjorie Barstow from 1962 and also underwent some teacher training with Frank Pierce Jones and Walter Carrington. He still teaches the Alexander Technique and runs workshops in Columbus, Ohio, and Spokane. He is the co-author of *How to Learn the Alexander Technique.*

Cook, Paul. Former AT teacher and archivist of *Direction Journal.* Based in the Gold Coast, Queensland (Australia), he appears to have left the AT community. The *Direction Journal* archive is no longer accessible.

Dailey, Dolly (Philomene Barr, Mrs Norris Barr) (1904–1994), trained with A.R. Alexander in Massachusetts in the early 1940s, but is not known to have been certified to teach. In 1944 she started a class based on Alexander's principles at the Media Friends School in Philadelphia, Pennsylvania.

Dart, Raymond (1893–1988). Australian-born South African anatomist and anthropologist. He graduated in medicine at Sydney University in 1917 and was Professor of Anatomy at Witwatersrand University in Johannesburg from 1923. He is best known for his involvement in the discovery of the first fossil of *Australopithicus africanus* (in 1924). He is responsible for the Dart Procedures (having collaborated with Alex and Joan Murray). According to Marjory Barlow, Dart's contributions did not add anything valuable to the Alexander Technique and were simply a way of making the AT seem more scientific and complicated (in Barlow and Davies, *An Examined Life*). They are a series of exploratory poses and movements relating to the sequence of human developmental movement from infant to adult and are to be done while applying the Technique. Barstow writes (to Jones) that Alex Murray "had a copy of the paper Dart is giving in London in April at the Alexander Society meeting. There are some very good things in it, but Dart has missed

BIOGRAPHICAL NOTES **291**

the point of awareness as Alexander knew it. ... [He] leaves the reader with the impression that it is simple and can be a do-it-yourself performance. He does not give the technique directly any credit for bringing the idea of awareness to his attention although he does speak very highly of Irene Tasker and the fact that he met F.M. only once for very few minutes" (Barstow, Correspondence with Jones, Letter 7 February 1970). She describes Dart's exercises as "silly things" that "don't make much sense" but are "not harmful" (ibid.).

Dewey, John (1859–1952). John Dewey was one of America's most important public thinkers from the turn of the twentieth century to World War II and was perhaps the last American philosopher to have had a major impact on society (Boisvert, "John Dewey's," 343). Dewey met Alexander in 1916 and had lessons in the Alexander Technique. There were many congruencies in their work. Dewey supported Alexander in numerous ways, most notably by writing introductions and recommendations for his books, but also by organising scientific research projects into the exact mechanism of what Alexander called the "primary control." Alexander rejected the projects, and their relationship was strained thereafter. Dewey maintained that Alexander's influence had prolonged his life.

Dodge, Shirlee (1916–2008). Dancer and choreographer with an international teaching and performing career and degrees from the Mary Wigman School in Dresden, Germany (1939). She founded the dance program at The University of Texas at Austin in 1943 and became a full professor (the first in dance) in 1965. She began studying with Barstow while she was in the Department of Theatre at the University of Iowa, "driving west across the plains to Lincoln whenever possible" (*Festschrift*, 134).

Feldenkrais, Moshé (1904–1984). An Israeli physicist who developed a method to improve human functioning by increasing self-awareness through movement. Similarities have been drawn between the Feldenkrais Method and the Alexander Technique.

Fertman, Martha. AT teacher and dancer. Began her professional dance training in 1965 at the School of Pennsylvania Ballet. She studied and trained for one year with Kitty Wielopolska and then began studying with Barstow in 1976. She attended every summer workshop for nine years. Her doctoral dissertation is a somatic study of the art and pedagogy of Isadora Duncan (Temple University).

After a 10-year apprenticeship with Barstow, she began teaching dancers and other performers. She directs the Philadelphia School for the Alexander Technique, at which Barstow taught twice a year for many years.

Fertman, Bruce. AT teacher, former gymnast and professional modern dancer, with a Master's in movement re-education and extensive training in Aikido. He apprenticed with Marjorie Barstow for 16 years. He is the Co-Founder, Director and Senior Teacher for the Alexander Alliance International, and also teaches at the Alexander Alliance Germany and The Peaceful Body School, New Mexico.

Fischer, Jean M.O. AT teacher who trained with Karen Wentworth in Denmark from 1984 to 1987. He did further study and also taught at the Constructive Teaching Centre in London (founded by Walter Carrington). He has trained teachers, founded STAT Books, and edited and typeset a number of AT books, including Carrington's diary of 1946 (*A Time to Remember*) and several of Alexander's works (e.g. *CCC*, *MSI* and *Articles and Lectures*). Fischer co-directed the 7th International AT Congress in Oxford, 2004. He lives and teaches in Graz, Austria, and runs the Mouritz website, including "Companion to the Alexander Technique."

Fishman, Marguerite. AT teacher, dancer, choreographer and dance teacher. Began AT studies with William Conable at Ohio State University during her undergraduate degree in dance. Moved to Lincoln, Nebraska in 1977 specifically to study with Marjorie Barstow.

Fitzgerald, Terry. PhD. Sydney AT teacher, wrote the first doctoral dissertation on AT teacher education.

Frank, Alma (1898–1953). AT teacher who trained 1937–1940 and taught until her death in New York City. In 1946 she returned to Ashley Place and appears frequently in Carrington's diary of that year. Barstow mentions Alma Frank in several letters to Frank Pierce Jones. It seems that in 1947 Alma Frank had been writing to Frank Jones about the possibility of her training teachers. Barstow was less than enthusiastic about the idea. After 1948, it seems that neither Barstow nor Jones had much more to do with her. Jones does not mention her in his book. See also Deborah Caplan (née Frank).

Frederick, Lena. AT teacher and actor/director. BA (Harvard); MFA (Yale School of Drama). Trained with Walter Carrington in England (qualifying as a teacher in 1978) and Marjorie Barstow in America (from 1980). Acted on the board of directors for ACAT-Western Region.

Frederick, Michael. AT teacher and actor. Founding director of the first three International Congresses on the Alexander Technique, he played an active part in attempting to have Barstow's trainees recognized by the American professional associations. With his wife, Lena, he trained first with Walter and Dilys Carrington and then studied for many years with Marjorie Barstow. He also studied in the U.S. and Israel as a Feldenkrais Practitioner with Moshe Feldenkrais.

Gehman, Stacy. AT teacher, physicist and engineer. Began AT lessons in 1977. Then studied with Marjorie Barstow from 1978 and moved to Lincoln in 1980 for six years to intensify this study. Began teaching the AT in 1983. Helped form the Performance School in Seattle in 1986. He currently researches new computer techniques for analyzing the electrocardiogram and teaches integration of *Tai Chi* (which he has studied since 1973) with the Alexander Technique.

Goldie, Margaret (1904–1997). A part-time member of the first training course, although it appears that she was already teaching with Tasker in the Little School when the training course began. She travelled to the US with F.M. Alexander on several of his teaching visits and in later years they became very close, cohabiting when he was in London. The nature of their relationship is unknown. After his death and the fall-out over who should teach at Ashley Place, Goldie shared premises with Irene Stewart, John Skinner and Walter Carrington.

Grant-Morris, Alison. According to Walter Carrington's list of trainees at Ashley Place, Alison Grant-Morris (Macdonald) trained there from 1942 and then "joined the course again in 1947 to do some extra training" (*A Time to Remember*, 72). Jean Fischer connects Grant-Morris with Dolly Dailey,* saying that together they ran the training course in Media when A.R. Alexander was unable to return in 1944 (Mouritz Companion, "Alexander Foundation School"). This would explain how she came to be a mutual acquaintance of Jones and Barstow. Fischer also indicates that she

294 BIOGRAPHICAL NOTES

married Patrick Macdonald in 1952. This was his second marriage (Companion: Patrick Macdonald).

Gummere, Richard M. "Buzz", Jr. (1912–2007). American educator and AT teacher who trained in the first American training course, receiving his certificate from F.M. Alexander in 1944. Served as Director of Admissions at Bard College and taught at Columbia University Teachers College. He taught for a short time at the Media School with Dolly Dailey and wrote to Barstow about the possibility of her taking over if Dailey resigned. His father was a colleague of John Dewey's. In his book, *How to Survive Education*, Gummere devotes a chapter to Dewey. He took lessons from Barstow, attended her workshops and contributed to the *Festschrift*.

Heirich, Jane. Emeritus Lecturer at the University of Michigan and AT teacher in Ann Arbor. Musician, AT teacher and author.

James, William (1842–1910) was Professor of Philosophy and Psychology at Harvard from 1885 to 1907. He is known as the father of modern psychology. His psychology represented the scientific study of the mind. He was strongly influenced by Darwin. One of the hallmarks of his pragmatism was his strong belief in the power of individual agency. James was the first prominent philosopher to recognize Dewey as an important philosopher in the pragmatist tradition.

Jones, Frank Pierce (1905–1976). AT teacher and classics professor. The first of only a handful of people who graduated from the U.S. training course, 1944. His certificate was signed by A.R. Alexander, as F.M. had already returned to England before the end of the war. He remained in contact with F.M. A professor of classics at Brown University (his dissertation was on Greek participles), he was an unlikely candidate for the role of scientific researcher, which he ultimately became at Dewey's urging. It had also been with Dewey's encouragement that Jones had decided to train with the Alexanders in the 1940s.

Kandik, James. A student of Marjorie Barstow's who began AT lessons in 1976 (It is not clear from his entry in the *Festschrift* whether this was with Barstow).

Kettrick, Catherine. Student of Marjorie Barstow's from 1973. She was one of Barstow's assistant teachers, taught at a number of International Congresses, and on teacher training programs in Europe, Japan and Australia. In 1986 she co-founded The Performance

School, and in 1992, co-founded Alexander Technique International. She has worked on several ATI Committees for many years including Professional Development Committee. She has a Ph.D. in linguistics, works as an ASL/English interpreter and is an actor and burlesque performer.

Kroll, Heather. When she began studying with Marjorie Barstow 1980, Kroll was a physical therapist (PT) and dancer. She lived in Lincoln for three years to study with Barstow. She continued to work as a PT (and as part of the faculty of the Performance School in Seattle) for several years before retraining as a physiatrist, a medical doctor specialising in physical medicine and rehabilitation, graduating in 1994.

Leibowitz, Judith (1920–1990). AT teacher and chemist. Studied first with Alma Frank, trained with Lulie Westfeldt, returned to lessons with Alma Frank, then studied with F.M. Alexander in two 6-week stints in London. Despite suffering the severe long-term symptoms of polio from the age of 15, she became a practising chemist before encountering the Alexander Technique. She was a founding member of ACAT in 1964 and taught the technique at the Juilliard School for twenty years. She is the author of *Dare to be Wrong*.

Ludovici, Anthony M. (1882–1971). A prolific author who started out as an illustrator, worked as secretary to Auguste Rodin and later as translator of and lecturer on Nietzsche's philosophy. In 1927 he began Alexander lessons and in 1933 wrote the first introduction to the Alexander Technique (apart from those in Alexander's own books), *Health and Education through Self-Mastery* (London: Watts and Co., 1933).

McCormack, Eric David (1911–1963). A Father of the Catholic Order of St Benedict. His doctoral thesis was completed in 1958 and was the first thesis to link the work of Alexander and Dewey. It was published by Alex Murray in 1992 and by Mouritz in 2014.

Macdonald, Patrick (1910–1991). AT teacher trained by Alexander. He joined the first training course in its second year, 1932, having had lessons in the AT since the age of ten, at the behest of his father, a physician strongly in support of Alexander's work. After qualifying in 1935, Patrick became the first paid assistant teacher at Ashley Place (according to Kaminitz). Having also taught in Birmingham and Cardiff, he began to train teachers at

Ashley Place in the late 1950s. He continued training teachers for much of his life, among them Shmuel Nelken through whom many Israelis learned of the technique and several of them went on to train with Macdonald. Nelken started the first Alexander training school in Israel and Macdonald visited Israel many times. In 1989 Macdonald published *The Alexander Technique As I See It*.

Mackie, Vivien. AT teacher and cellist, who studied with Walter Carrington and Pablo Casals. She observed great similarities between Casals's teaching and the Alexander Technique, and her book, *Just Play Naturally*, describes these in detail.

Madden, Cathy. AT teacher, actor, director and performance coach. Studied with Barstow from 1975 after completing a B.A. in theatre arts and a Master's degree in drama and literature. She moved to Lincoln, Nebraska, for seven years and began teaching the Alexander Technique in 1980. She worked for many years as Barstow's teaching assistant. She is currently Principal Lecturer for the University of Washington's School of Drama, Director of the Alexander Technique Training and Performance Studio in Seattle, a former chair of Alexander Technique International, and an Associate Director for BodyChance. She teaches workshops for performers and Alexander Technique teachers in Australia, England, Germany, Japan and Switzerland. She is the author of *Integrative Alexander Technique Practice for Performing Artists: Onstage Synergy* (2014) and *Teaching the Alexander Technique* (2018).

Media School. The pre-history behind the enterprises at Media began when Alexander evacuated to America with the children from his Little School in England. They settled at the Whitney Homestead in Stow, Massachusetts. Here the first U.S. training school was established (in 1941, with one student, Frank Pierce Jones). When the homestead was sold in September 1942, F.M. moved to New York (and, not long after, back to England). It is unclear where the children went. A.R. moved the training course to Boston and then in September 1943 to Swarthmore and Media (twin towns in Pennsylvania) at the invitation of Esther Duke. In 1945, when A.R. was prevented from returning from his annual summer break in England in 1945, the trainees began to run the school themselves. Dolly Dailey took over the teacher training, while Alison Grant-Morris assisted. Both had begun their own training in September 1942 (according to Jones, *Body Awareness*, 79), which means they were

BIOGRAPHICAL NOTES **297**

training teachers with less than three years' experience of their own in either training *or* teaching. The training course was discontinued in 1949. But the Alexander Foundation and Alexander Foundation School, formed in 1946 and 1947 respectively, grew out of the related activities of teaching at the Media Friends School and training teachers. The school was to be a "memorial to A.R." (Rootberg, "The Alexander Foundation"). In 1949, the community disintegrated, but Rootberg thinks the school continued into the 1950s and possibly later.

There are nine references to this school in Barstow's letters, from 1946 to 1950. In 1949 Gummere wrote to her to ask if she would be interested in taking over from Dailey. Alexander called the teachers there "vandals" and may, in his old age, have tarred Barstow and Jones (and all American teachers) with the same brush. Barstow herself was scathing of the quality of teaching that took place there, and Jones too tried to distance himself from it. When A.R. left, it seems that only one of the teachers there (Gummere) had been given permission to teach at all, and none had been given permission to train teachers. This did not stop them from proceeding to do both, thus earning Alexander's disdain.

Mernaugh, Kelly. Computer programmer and analyst and AT teacher certified by Barstow. Began studying the AT with Barstow in 1979. Lived in Lincoln until 1984.

Mills, David. Studied with Barstow from 1975, having recently been a graduate student in Biophysics. He saw Barstow's approach to the AT as a personal biophysics. His doctoral work was a synthesis of Alexander's work and that of George Kelly's Personal Construct Theory. He is currently Artistic Director of Infinity Box Theatre Project, using theatre to explore science and its relations with the rest of society.

Murray, Alexander. AT teacher and flautist. Began Alexander studies with Charles Neil in 1955 and continued after Neil's death in 1958 with Walter Carrington. The Murrays (Alex and his wife Joan) spent nine years working with Carrington. In 1967 they met Raymond Dart and with him developed the Dart Procedures. In 1977 they opened a training course, the Alexander Technique Center, Urbana, Illinois.

Naumburg, Margaret (1890–1983). Pioneer in art therapy and founder of the Walden School. As a student at Barnard, New York,

298 BIOGRAPHICAL NOTES

Naumburg shared a room with Evelyn Dewey. At Columbia she did graduate work with John Dewey. In Europe, she studied economics at the London School of Economics, the Dalcroze method of music with Alys Bently and child education with Maria Montessori in Rome. Here she met Irene Tasker and Ethel Webb and she then went to London to study the Alexander Technique with F.M. Alexander in London. She returned to New York in 1914 and opened the first Montessori school in the US. A year later she founded a school based on her own educational philosophy, the Walden School. The school used Freudian psychoanalysis as a foundation and used music and art extensively to stimulate children's originality and passion. She married Waldo Frank in 1916 (they divorced ten years later and he married Alma Magoon—see also Alma Frank). In the 1930s, Naumburg pioneered the field of art therapy, and greatly enlarged it through her books and lectures during the next three decades. She is the author of many articles as well as the book, *The Child and the World* (New York: Harcourt Brace, 1928).

Neil, Charles (1917–1958). AT teacher and teacher trainer. Began training in 1933 at the age of 16. Bloch describes him as "an asthmatic teenager in whom F.M. took a fatherly interest" (*F.M.: The Life*, 148). After his training and a short spell of teaching at Ashley Place, he set up on his own in London, eventually teaching "what Alexander regarded as a bastardised version of his Technique" (ibid., 153). He called himself a "kinaestheticist" and combined elements of the AT with physiotherapy. When Alexander failed to establish a professional society in 1948, the wealthy Cripps family (Sir Stafford and Dame Isobel) decided to give their financial support instead to Neil (ibid., 235). According to Fischer, Eric De Peyer worked with Charles Neil for some time and some of de Peyer's pamphlets may indirectly describe the work at the Isobel Cripps Centre.

Ottiwell, Frank. AT teacher who trained with Judith Leibowitz in the late 1950s. Shortly after completing his training he co-founded ACAT in New York (with Leibowitz, Caplan and two others). In the 1960s he moved to San Francisco as the resident Alexander teacher with the American Conservatory Theatre. He co-founded ACAT-West in the late 1960s. He ran a training course in San Francisco and, as an enthusiastic and enterprising supporter of Marjorie

Barstow, was responsible for much of the early publicity surrounding her teaching.

PAAT. The Professional Association of Alexander Technique Teachers is based in Birmingham, UK. Its training course claimed, in 2012, to be the only four-year training course in the world and that it "has been successfully training teachers to the highest standards for 25 years." Qualification is strictly by examination only.

Peirce, Charles Sanders (1839–1914). Natural scientist and philosopher. While James acknowledged Peirce as the originator of pragmatism, in fact it was a movement that had input from many sources. Peirce's greatest philosophical influence was Kant. Peirce described himself as a logician and saw himself "as constructing the philosophical system that Kant might have developed had he not been so ignorant of logic." (*Oxford Companion of Philosophy*, Honderich, ed., 648).

Pryor, Alice (1929–2018). AT teacher certified by Barstow. Began studies with Barstow in 1976, when she attended the summer workshop. Pryor had a master's degree in art education and taught in Minnesota, Mexico, Ontario and Texas, but had to leave the world of art due to a sensitivity to art chemicals. She taught the AT for 30 years and described herself as being in Barstow's debt for having become healthy and flexible, where she was previously "very ill, depressed," and "negative" (*Festschrift*, 131). She died in Austin, Texas, her adopted home.

Rickover, Robert. AT teacher with degrees in physics, engineering and economics (Yale and MIT). He was halfway through his AT-training course with Paul and Betsy Collins and Vivien Mackie in London when he met Barstow in 1978 at her winter workshop. He completed his Carrington-style training course (to which Carrington made a visit once per semester) in 1981 and moved back to his home town, Toronto. After commuting for about ten years to Barstow's workshops, he moved to Nebraska in 1990. He has written extensively on the Alexander Technique for the general public and has been a regular contributor to *Direction Journal* and *The Alexander Review*. He is also the author of *Fitness without Stress: A Guide to the Alexander Technique* (Portland, OR: Metamorphous Press, 1988).

Rodrigue, Jean-Louis. AT teacher, actor, acting coach and movement director. Graduated from ACAT teacher training program in San Francisco. After becoming a teacher he continued his AT studies,

300 BIOGRAPHICAL NOTES

with Marjorie Barstow, the Carringtons and Patrick Macdonald. He is a faculty member of UCLA School of Theater, Film and Television and UCLA School of Music.

Ruddell, Kevin. AT teacher, apprenticed with Marjorie Barstow. He began studying with her in 1980, lived for three years in Lincoln, assisted with teaching at her workshops for seven years, and served on the faculty of the Performance School. A physicist and software engineer, he also studied modern dance and karate, finding new meaning and connections in those disciplines through the Alexander Technique. In 2013, at age 60, Ruddell began studying circus aerial arts, specializing in corde lisse. He has given several performances, including in a professional setting. This performance medium would not have been available without his studies in the Alexander Technique. Ruddell supplied the photos for this book of Barstow teaching in Seattle in 1989 and 1990.

STAT: Society of Teachers of the Alexander Technique was the first society of teachers of the Alexander Technique, founded by Wilfred Barlow in 1958. Barlow worked closely with Alexander to set up a professional body in the 1950s and had even paid lawyers to help work out a constitution. F.M. did not ultimately go ahead with it. Marjory Barlow believes that F.M. was worried about what would happen to the technique with the advent of a society. After F.M.'s death the need grew, however, and the society was formed. STAT now claims to be "the oldest and largest professional society of teachers of the Alexander Technique" and offers "*the* definitive guide to the Alexander Technique" [emphasis added]. Their website claims that "all STAT registered teachers have completed an approved three-year training course or have reached a standard approved by STAT... STAT training courses are regulated through a system of external moderation." Their publications include *STATnews* and *The Alexander Journal*. See also ATAS.

Stewart, Irene (1906–1990). AT teacher who was a member of the first training course. Fischer refers to her as having trained from 1931 to 1934 (Carrington, *A Time to Remember*, 102), that is, contemporaneously with Marjorie Barstow but staying for the extra year (1934). She does not appear in the list of students of the first training course, however, in the same book (ibid., 71). In Westfeldt's book Irene Stewart is pictured with the other trainees on the front stairs of 16 Ashley Place and is included amongst them (ibid., 33). Stewart

BIOGRAPHICAL NOTES **301**

accompanied Alexander to America during WWII (with Webb and Goldie), returning to England with him in 1943. She remained as a teaching member of staff at Ashley Place at least until the late 1950s. After F.M.'s death, alongside Carrington and Peggy Williams she fought Alexander's brother Beaumont for the right of all Alexander teachers to use the name "Alexander Technique."

Tasker, Irene (1887–1977) completed studies at Cambridge before training with Montessori in Rome, where she met Ethel Webb. Webb recommended Alexander's work to Tasker, who began lessons in 1913 and became his assistant in 1917. She met the Deweys at about this time and travelled with them from Chicago to California, discussing in detail with John Dewey the Alexander work and the book he was writing at the time, *Human Nature and Conduct*. In 1924 her tutelage of a young boy in her guardianship evolved into her running of Alexander's "Little School," where Barstow frequently assisted during her own training. Tasker and Webb gave Alexander a great deal of assistance with his own publications. Tasker emigrated to South Africa in 1935 and was the teacher whom Ernst Jokl encountered and to whom he took exception before writing his inflammatory criticism of the Alexander Technique that resulted in a major court case. She returned to England permanently in 1949.

Thompson, Tommy. AT teacher who began teaching in 1975. He is the only AT teacher known to have trained exclusively with Frank Pierce Jones. He is the founder and Director of the AT Center at Cambridge, Massachusetts, and has been training teachers since 1983. He is on the faculty at Harvard University, at the Institute for Advanced Theater Training. Thompson was a co-founder, charter member, and first Chair of the Executive Board of Directors of ATI.

Trevelyan, Sir George, 4th Baronet (1906–1996). One of the first three members of Alexander's first training course, which he began after his studies in history at Cambridge. He attempted to set up a teaching practice after qualifying but without success. He worked as a school teacher, college principal and in adult education before forming the Wrekin Trust, an educational foundation concerned with the spiritual nature of humanity and the universe. He re-established contact with the AT community in the 1980s. In addition to writing (and publishing) a wide variety of his own works, his diary of lessons in the technique is published in *The Philosopher's Stone* (Fischer, ed.).

302 BIOGRAPHICAL NOTES

Trimmer, Peter. Aikido Sensei and AT teacher certified by Marjorie Barstow. Started teaching in 1974. Studied with Barstow for over fifteen years.

Troberman, Eileen. AT teacher certified by ACAT-West in 1982. Lecturer in the Alexander Technique at the University of California San Diego's Department of Theatre and Dance. Began studying with Barstow in 1979 but didn't move to Lincoln to study with Barstow until several years later, when she saw friends and colleagues, who *had* moved there, rapidly accelerating in their ability to carry Alexander's ideas into practice. She lived there for three years, and her total apprenticeship with Barstow lasted for 15 years.

Twycross, Lilian (1874–1943) was a contralto and voice teacher. She was an early student of F.M. Alexander's who taught the technique in Melbourne from 1898. She was one of the first generation teachers of the AT outside the Alexander family.

Venable, Lucy (1926–1919). AT teacher (certified by Marjorie Barstow) and Professor of Dance. Began studying with Marjorie Barstow in 1974, when Barstow gave classes at the School of Music at the Ohio State University. Venable was a member of the Department of Dance there from 1968 and was an Emerita there when she died. Venable studied with Barstow for more than fifteen years.

Webb, Ethel (Pip) (1866–1952). The first person in England not related to the Alexanders to work closely with F.M. Alexander and teach. While studying piano in Berlin she befriended the New Yorker, Alice Fowler. This connection was later to help Alexander during his wartime stays in America. Webb began Alexander lessons in 1913 after reading *CCC*. She then became his secretary and assistant, subsequently devoting her life to the Alexander Technique and giving up the piano. In Rome, while studying with Montessori, she met Irene Tasker and Margaret Naumburg and introduced them to the Alexander Technique.

Weed, Don. Weed began his study of the Alexander Technique in 1971 with Marjorie Barstow. He has degrees in music and drama as well as biology and chiropractic. He worked closely with Barstow from the time of her early experiments in 1971 until 1993. He also studied with Frank Pierce Jones and Margaret Goldie. He is the creator of the Interactive Teaching Method for the Teaching of the F.M. Alexander Technique (ITM).

BIOGRAPHICAL NOTES 303

Westfeldt, Lulie (1895–1965). A member of the first training course. Originally from New Orleans, she majored in English at college and worked as a social worker in a settlement house. She was drawn to the AT having suffered from poliomyelitis as a child. A series of orthopaedic operations had aggravated her difficulties in walking. She studied with Alexander for four years and taught the AT for 26 years. She is the only teacher from that initial course to write extensively about her experiences both as a student and a teacher, which she published as *F. Matthias Alexander: The Man and His Work*. Barstow commented to Jones that Westfeldt had put the wrong title on the book if she had wanted to put down on paper her trials and tribulations for posterity. Westfeldt began training teachers in the 1940s, it seems, and in a letter to Jones in 1947 Barstow expressed her lack of confidence in Lulie's methods and displeasure at "the way she talked" in front of her student (Correspondence with Jones, Letter 17 November 1947).

Whittaker, Erika (née Schümann) (1911–2004). Born in Germany to a German father (musician and author, Hans) and English mother (Elsie Webb, Ethel's sister). When her mother died in 1927, her father went to America and Erika moved to England to be with her aunt (Ethel Webb). Having had lessons from her aunt since the age of eight, she began studies with Alexander himself in 1929. She was one of the first three members of the first training course, remembering the first day with just Marjorie Barstow and George Trevelyan. In the late 1950s she moved to Australia, where her older brother resided. In 1985 she was invited to give the STAT Annual Memorial Lecture in London. The following years saw her assisting Marjorie Barstow in Australia and supporting the International Congresses in New York (1986) and Brighton (1988). According to John Hunter, Barstow had a hand in influencing Michael Frederick to invite Whittaker to give the Keynote Address at the Brighton Congress.

Wielopolska, Catharine "Kitty" (Countess Wielopolska), née Merrick (1900–1988), attended Alexander's first teacher training course and then later retrained with Patrick MacDonald from 1969 to 1972. She suffered from schizophrenia and is believed to have made an extremely rare recovery. She credited the Alexander Technique in great part for this recovery. Her book, written "in

304 BIOGRAPHICAL NOTES

conversation with" Joe Armstrong is called *Never Ask Why: The Life-Adventure of Kitty Wielopolska (1900–1988): Her Experience with the Alexander Work, Schizophrenia and the Psychic State* (Novis, 2014).

Williamson, Nancy Forst. AT teacher certified by her fellow Nebraskan Marjorie Barstow. B.A in Communications and Women's Studies (University of Nebraska), and Feldenkrais Practitioner. She is the Director of the Barstow Alexander Technique Institute, Doane College, which is an endowed summer program in Lincoln, Nebraska, featuring senior Alexander teachers trained by Marjorie Barstow. She also manages the Marjorie Barstow Archive and provided photographs for this book.

Wynhausen, John. AT teacher certified by Marjorie Barstow and Chiropractor. Began studies with Barstow in 1979, in his last year of chiropractic college. Wynhausen contrasts Barstow's teaching with that of teachers trained by Patrick Macdonald, Judith Leibowitz and Goddard Binkley, whom he saw as skilled technicians. Barstow, by comparison was not just a technician, but also a teacher.

APPENDIX: THE ALEXANDERS AND THE ALEXANDER TECHNIQUE

In his early twenties, F.M. Alexander began to suffer vocal problems during dramatic recitations, which he gave regularly as part of his acting career. Dissatisfied with prescriptions of rest from medical practitioners and voice specialists, he set out to observe his "manner of doing." So successful was he in his analysis and modification of his "use of self," as evidenced by the changes in his voice, that by the mid-1890s Alexander had a flourishing teaching practice in Melbourne and had trained both his sister Amy, his brother A.R. Alexander and Lilian Twycross, a Melbourne contralto and singing teacher, to teach the work.

He moved to Sydney in 1900 and then to London in 1904, where his teaching practice developed rapidly. During the First World War, Alexander introduced his work to the United States and soon F.M. and A.R. were dividing their time between the two continents. In London, F.M. established a school for children based on his principles and introduced a training course for those wishing to teach the technique. He published four books (in 1910, 1923, 1932, 1941) and many articles on his work, which eventually became known as "the Alexander Technique." He died in 1955, leaving a significant number of "first generation teachers" to carry on his work throughout the world. In Alexander parlance a "first generation teacher" is generally held to mean someone who trained with one or both the Alexander brothers, although the term is open

© The Editor(s) (if applicable) and The Author(s) 2022
A. Cole, *Marjorie Barstow and the Alexander Technique*,
https://doi.org/10.1007/978-981-16-5256-1

305

to hair-splitting debate and interpretation[3]. In this book I have adopted the generally held definition of "first generation teacher" as anyone who received their teacher training directly from the Alexanders. The last surviving member of that generation who went on to teach died in 2013. This was Elisabeth Walker, who was 98 years old, "still living by herself, and still giving Alexander lessons."[4].

Even F.M. Alexander found it difficult to describe his technique without demonstration or lengthy discussion. He was frequently criticised for his wordy prose. And yet he also came up with the occasional aphorism, such as, "We are giving Nature her opportunity."[5]. This description is not only pithy and comprehensive, but also, as Trevelyan describes, allows "for change and growth".[6]

In *Music and the Mind* Anthony Storr describes everyday activity in a way that shows how we function *without* the Alexander Technique:

> We are not usually *conscious* of our inner sense of striving as manifested in bodily movements (a phenomenon described by Schopenhauer) except under special circumstances when we plan some action which is not habitual, as when we are learning to ride a bicycle or play a musical instrument. In the ordinary way, we just move in accordance with some prior intention which may or may not be consciously perceived, and then evaluate the move we have executed according to its results.[7]

The Alexander Technique is a way of becoming consciously aware of our underlying coordination in *any* activity, habitual or new. Alexander's principal observation was that this coordination is governed by the quality of the relationship between our head and spine, and that it underpins everything we do. Marjorie Barstow describes the technique as "a unique approach to movement."[8] It is not just about how we move. It starts

[3] See Weed, "For a darn," in *Festschrift.*

[4] Jeremy Chance, "Goodbye Elisabeth Walker," Jeremy's Alexander Technique Career Success. Body Chance, 2013, http://www.alexandertechniquecareersuccess.com/2013/09/goodbye-elisabeth-walker.html. Accessed August 2014.

[5] George Trevelyan, "The Diary of Sir George Trevelyan, Part 2: 1936-1938." In Fischer, ed., *The Philosopher's Stone, 73.*

[6] Ibid.

[7] Anthony Storr, *Music and the Mind,* (London: Harper Collins, 1992).

[8] Barstow in Chance, "Marjorie Barstow."

with *how we think* about how we move and is therefore a method of psychophysical re-education. It is a technique that has utility not just for performers, although performers have been particularly drawn to it. This is because they need to operate psychophysically at a heightened level in order to do what they do. Elite performance requires a highly developed awareness of functioning, and so performers are often quicker to recognize and value the small changes in functioning effected by the Alexander Technique. In her teaching Madden frequently describes the AT as "conscious cooperation with human design."

REFERENCES

Addams, Jane. "A Function of the Social Settlement." In *Pragmatism: A Reader*, edited by Louis Menand, 323–45. New York: Vintage, 1997.

Alcantara, Pedro de. *Indirect Procedures*. Oxford: Oxford University Press, 1997.

Alexander, F. M. "An Unrecognized Principle in Human Behaviour, Child-Study Society Lecture, 1925." In *Articles and Lectures*, edited by Fischer, 141–162.

———. "Autobiographical Sketch, c. 1950." In *F. Matthias Alexander: Articles and Lectures: Articles, Published Letters and Lectures on the F.M. Alexander Technique*, edited by Jean Fischer, 221–50. London: Mouritz, 1995.

———. "Bedford Physical Training College Lecture, 1934." In *Articles and Lectures*, edited by Jean Fischer, 163–84. London: Mouritz, 1995.

———. *Constructive Conscious Control of the Individual*. Introduction by John Dewey. Foreword by Walter H. M. Carrington. Edited by Jean M. O. Fischer (CCC). 8th ed. London: Mouritz, 1923/2004.

———. *F. Matthias Alexander: Articles and Lectures: Articles, Published Letters and Lectures on the F.M. Alexander Technique*, edited by Jean Fischer. London: Mouritz, 1995.

———. "Introduction to a New Method of Respiratory Vocal Re-education, 1906." In *Articles and Lectures*, edited by Jean Fischer, 39–50. London: Mouritz, 1998.

———. *Man's Supreme Inheritance: Conscious Guidance and Control in Relation to Human Evolution in Civilization*. London: Mouritz, 1910/1996.

———. "Re-education of the Kinaesthetic Systems, 1908." In *Articles and Lectures*, edited by Jean Fischer, 79–86. London: Mouritz, 1995.

———. "Supplement to Re-education of the Kinaesthetic Systems, 1910." In *Articles and Lectures*, edited by Jean Fischer, 103–6. London: Mouritz, 1995.

310 REFERENCES

———. "Teaching Aphorisms, 1930s," compiled by Ethel Webb. In *Articles and Lectures*, edited by Jean Fischer, 193–208. London: Mouritz, 1995.

———. "The Theory and Practice of a New Method of Respiratory Education 1907." In *Articles and Lectures*, edited by Jean Fischer, 59–60. London: Mouritz, 1995.

———. *The Universal Constant in Living.* 3rd ed. London: Chaterson, 1941/1986.

———. *The Use of the Self: Its Conscious Direction in Relation to Diagnosis, Functioning and the Control of Reaction (UOS).* London: Orion, 1932/1985.

———. "Why We Breathe Incorrectly 1909." In *Articles and Lectures*, edited by Jean Fischer, 91–102. London: Mouritz, 1995.

American Association of University Women. "Early College Women: Determined to be Educated." Accessed May 2021. http://stlawrence.aauw-nys.org/col lege.htm.

Andrews, Meade. "Working with Marj." In *Festschrift*, edited by Barbara Conable, 111–12. Columbus: Andover Road Press, 1989.

Armstrong, Joe. "A Crucial Distinction: Manner and Conditions of Use in Teaching the Alexander Technique and Alexander Teacher Training." Accessed 19 January 2022. http://joearmstrong.info/MannerAndCondit ions.html.

Barker, Sarah. "Excerpts from Journal, Annotated." In *Festschrift*, edited by Barbara Conable, 79–100. Columbus: Andover Road Press, 1989.

———. *The Alexander Technique: The Revolutionary Way to Use Your Body for Total Energy.* Toronto: Bantam, 1978.

Barlow, Marjory. "A Masterclass with Marjory Barlow." *6th International Congress of the F.M. Alexander Technique.* (1999). Accessed 20 May 2013. http://www.youtube.com/watch?=cxxtj06OHUs.

———. "Review by Marjory Barlow of Lulie Westfeldt's *F. Matthias Alexander*." Originally published in *The Alexander Journal* 5 (1966): 30–31. In Westfeldt, *F. Matthias Alexander*, 168–170. London: Mouritz, 1998.

Barlow, Marjory, and Trevor Allan Davies. *An Examined Life: Marjory Barlow and the Alexander Technique.* Berkeley, CA: Mornum Time Press, 2002.

Barlow, Wilfred. "Research at the Royal College of Music." In *More Talk of Alexander: Aspects of the Alexander Technique*, edited by Wilfred Barlow, 204–10. London: Mouritz, 2005.

Barstow, Marjorie. "Aphorisms of Marjorie Barstow," collected and edited by Marion Miller and Jeremy Chance, originally published in *Direction Journal*. MarjorieBarstow.com/aphorisms.

———. Correspondence with Frank Pierce Jones. The F.M. Alexander-Frank Pierce Jones Archive, Dimon Institute. New York.

REFERENCES 311

———. Interview. Interviewer unnamed. *The Alexander Technique: A Worldwide Perspective. The First International Congress, Stony Brook, New York, 1986.* David Reed Media, 2011. DVD.

———. Letter to the Board of Directors, the American Center for the Alexander Technique (ACAT), Western Region. 22 October 1986. Courtesy of William Conable.

Bartner, Saura. "Reflections on Lessons with Marj." In *Festschrift*, edited by Barbara Conable, 74–75. Columbus: Andover Road Press, 1989.

Barzun, Jacques, and Henry Franklin Graff. *The Modern Researcher.* 5th ed. Boston, MA: Houghton Mifflin, 1992.

Baty, Jan. "Marj as Inspiration." In *Festschrift*, edited by Barbara Conable, 117–18. Columbus: Andover Road Press, 1989.

Beaulieu, Aase. "Contribution to a Book by Marjorie's Students." In *Festschrift*, edited by Barbara Conable, 108–9. Columbus: Andover Road Press, 1989.

Beaulieu, Arro. "The Great Cauliflower." In *Festschrift*, edited by Barbara Conable, 11–20. Columbus: Andover Road Press, 1989.

Bennett, Dawn. *Understanding the Classical Music Profession: The Past, the Present and Strategies for the Future.* Aldershot: Ashgate, 2008.

———. "Utopia for Music Performance Graduates. Is It Achievable, and How Should It Be Defined?" *British Journal of Music Education* 24, no. 02 (2007): 179–89.

Bick, Jane Clanton. "Freeing My Voice." In *Festschrift*, edited by Barbara Conable, 60–61. Columbus: Andover Road Press, 1989.

Biesta, Gert J. J. "Education as Practical Intersubjectivity: Towards a Critical-Pragmatic Understanding of Education." *Educational Theory* 44 (3) (1994): 299–317.

Biesta, Gert J. J., and Nicholas C. Burbules. *Pragmatism and Educational Research.* Lanham, MD: Rowman & Littlefield, 2003.

Binkley, Goddard. *The Expanding Self: How the Alexander Technique Changed My Life.* London: STAT Books, 1993.

Bloch, Michael. *F.M.: The Life of Frederick Matthias Alexander: Founder of the Alexander Technique.* London: Little, Brown Book Group, 2004.

Boisvert, Raymond D. "John Dewey's Reconstruction of Philosophy (A Review of the Middle Works Volumes 11–15, Ed. Boydston, Carbondale, Southern Illinois University Press)." *Educational Studies: A Journal of the American Education? Studies Association* 16 (4) (1985): 343–53.

Bradley, Diana. "The Joy of Learning." In *Festschrift*, edited by Barbara Conable, 113–16. Columbus: Andover Road Press, 1989.

Bresciani, J-P., F. Dammeier, and M. O. Ernst. "Vision and Touch Are Automatically Integrated for the Perception of Sequences of Events." *Journal of Vision* 6 (2006): 554–64.

312 REFERENCES

Bouchard, Edward. "To Group or Not to Group." *The Alexander Review* 3, no. 2 (May 1988): 27–36.

Cahn, Steven. "Introduction by Steven Cahn." In *John Dewey The Later Works, 1925–1953, Volume 13, 1938–1939*, edited by Jo Ann Boydston. Carbondale: Southern Illinois University Press, 2008.

Carrington, Patricia. "Solving the Mystery of Borrowing Benefits in EFT." 2014. Accessed 8 February 2015. http://masteringeft.com/masteringblog/solving-the-mystery-of-borrowing-benefits-in-eft-article/.

Carrington, Walter. *A Time to Remember: A Personal Diary of Teaching the F.M. Alexander Technique in 1946*. London: Sheildrake Press, 1996.

———. "Centre News," No. 9 (September 1966). The Constructive Teaching Centre Ltd, 18 Lansdowne Road, Holland Park, London, W11. In Barstow, Correspondence with Jones.

Chance, Jeremy. "A Teacher's Perspective of Feelings." In *Festschrift*, edited by Barbara Conable, 69–73. Columbus: Andover Road Press, 1989.

———. "Goodbye Elisabeth Walker." Jeremy's Alexander Technique Career Success. Body Chance, 2013, http://www.alexandertechniquecareersuccess.com/2013/09/goodbye-elisabeth-walker.html. Accessed August 2014.

Chance, Jeremy, and Bernadette Flynn. "Marjorie Barstow in Australia." Sydney: Fyncot Pty Ltd, 1986. http://www.youtube.com/watch?v=6xUxvZnL2x4.

Chance, Jeremy, and Catherine Madden. "Communication: A Transcript from the 6th International Congress, Freiburg." *Direction Journal*, 1999. Accessed 5 July 2006. http://www.directionjournal.com/congress/fc/maddenchance.html-.

Cherryholmes, Cleo. *Reading Pragmatism. Advances in Contemporary Educational Thought*. New York: Teachers College Press, 1999.

Chien, Shao-Chin. "Application of the Principles of the Alexander Technique to Viola Playing and Performance." DMA diss., University of Miami, 2007.

Cleeremans, Axel, and Zoltan Dienes. "Computational Models of Implicit Learning." In *The Cambridge Handbook of Computational Psychology*, edited by Ron Sun, 396–421. Cambridge: Cambridge University Press, 2008.

Cole, Amanda. "Marjorie Barstow, John Dewey and the Alexander Technique: A philosophical constellation, or 'Variations of the Teacher's Art'." PhD diss., Griffith University, 2016.

———. "Constellation Mentorship." In *Mentoring in History, Literature, and Performing Arts: On the Dynamics of Personal and Professional Growth*, edited by Gregoria Manzin and Véronique Duche. Paris: Garnier Classique (in press, 2022).

———. "The Body Mapping Revolution: Origins, Consequences and Limitations." *Australian Voice* 22 (2022): 38–48.

Conable, Barbara. "Explorations of Time in the Spirit of Marj." In *Festschrift*, edited by Barbara Conable, 147–149. Columbus: Andover Road Press, 1989.

REFERENCES **313**

————, ed. (*Festschrift*). *Marjorie Barstow: Her Teaching and Training. A 90th Birthday Offering*. Columbus: Andover Road Press, 1989.

Conable, Barbara, and William Conable. *How to Learn the Alexander Technique: A Manual for Students*. Portland: Andover Press, 1992.

Conable, William. "Marjorie Barstow." In *Festschrift*, edited by Barbara Conable, 21–26. Columbus: Andover Road Press, 1989.

————. "Origins and Theory of Mapping." In *How to Learn the Alexander Technique: A Manual for Students*, by Barbara Conable and William Conable, 3rd ed. Portland: Andover Press, 1992.

Cook, Paul. "Pilates and Alexander: Mind-Body Movement." Unpublished *Article for Direction Journal*.

Dewey, Jane. Letter 13 March 1920 to Alice Chipman Dewey and John Dewey. *The Correspondence of John Dewey, 1871–1952 (Vol.II)*, edited by Larry Hickman, Electronic edition. Charlottesville: Intelex Corp., 1999. Accessed 30 March 2015.

Dewey, John. "Art as Experience." In *The Collected Works of John Dewey, The Later Works, Volume 10: 1934*, edited by Jo Ann Boydston (entire volume). Carbondale: Southern Illinois University Press, 2008.

————. "Context and Thought." In *The Collected Works of John Dewey, The Later Works, Volume 6: 1931–2*, edited by Jo Ann Boydston, 3–21. Carbondale: Southern Illinois University Press, 2008.

————. *Democracy and Education*. Radford, VA: Wilder Publications, 1916/2008.

————. "Ethical Principles Underlying Education." In *The Collected Works of John Dewey. The Early Works, Volume 5: 1895–1898, Essays*, edited by Jo Ann Boydston, 54–83. Carbondale: Southern Illinois University Press, 2008.

————. *Experience and Education*. In *The Collected Works of John Dewey, The Later Works, Volume 13: 1938–39*, edited by Jo Ann Boydston, 1–62. Carbondale: Southern Illinois University Press, 2008.

————. "Freedom in Workers' Education." In *The Collected Works of John Dewey, The Later Works, Volume 5: 1929–30*, edited by Jo Ann Boydston, 331–37. Carbondale: Southern Illinois University Press, 2008.

————. "How We Think". In *The Collected Works of John Dewey, The Later Works, Volume 8: 1933*, edited by Jo Ann Boydston, 105–354. Carbondale: Southern Illinois University Press, 2008.

————. "Human Nature and Conduct". In *The Collected Works of John Dewey, The Middle Works, Volume 14: 1922*, edited by Jo Ann Boydston, entire volume. Carbondale: Southern Illinois University Press, 2008.

————. "Interest and Effort in Education". In *The Collected Works of John Dewey, The Middle Works, Volume 7: 1912–1914*, edited by Jo Ann Boydston, 151–200. Carbondale: Southern Illinois University Press, 2008.

314 REFERENCES

———. "Interest in Relation to Training of the Will." National Herbart Society: Supplement to the Yearbook 1895. *The collected works of John Dewey, The Early Works, Volume 5: 1895–1898*, edited by Boydston, 111–50. Carbondale: SILP, 2008.

———. "Introduction." In *Alexander, F. M. Constructive Conscious Control of the Individual*, edited by Jean Fischer, xxv–xxxii. London: Mouritz, 2004.

———. "Introduction to the Use of the Self by Professor John Dewey, Reprinted from the 1939 Edition." In *The Use of the Self* by F. M. Alexander, xix. London: Orion, 2004.

———. "My Pedagogic Creed." In *The Collected Works of John Dewey, Early Works Volume 5: 1895–98*, edited by Jo Ann Boydston, 84–95. Carbondale: SILP, 1897.

———. *Problems of Men*. New York: Philosophical Library, 1946.

———. *Psychology*. In *The Collected Works of John Dewey, The Early Works, Volume 2: 1887*, edited by Jo Ann Boydston (entire volume). Carbondale: Southern Illinois University Press, 2008.

———. "Qualitative Thought." In *The Collected Works of John Dewey, The Later Works, Volume 5: 1929–30*, edited by Jo Ann Boydston, 243–62. Carbondale: Southern Illinois University Press, 2008.

———. "The Development of American Pragmatism." In *Pragmatic Philosophy: An Anthology*, edited and with an introduction by Amelie Rorty, 203–16. New York: Anchor Books, 1925/1966.

———. "*The Dewey School*: Statements—General History, Chapter 1." In *The Collected Works of John Dewey, The Later Works, Volume 11: 1935–1937*, edited by Jo Ann Boydston, 193–201. Carbondale: Southern Illinois University Press, 2008.

———. "The Quest for Certainty: A Study of the Relation of Knowledge and Action." In *The Collected Works of John Dewey, The Later Works, Volume 4: 1929*, edited by Jo Ann Boydston, 3–250. Carbondale: Southern Illinois University Press, 2008.

———. *The School and Society*. New York: University of Chicago Press, 1899/1964.

Dodge, Shirlee. "UP." In *Festschrift*, edited by Barbara Conable, 134–35. Columbus: Andover Road Press, 1989.

Doscher, Barbara. *The Functional Unity of the Singing Voice*. Metuchen, NJ: The Scarecrow Press, 1988.

Durie, Bruce. "Senses Special: Doors of Perception." *New Scientist*, no. 2484 (29 January 2005). Accessed 5 May 2021. https://www.newscientist.com/article/mg18524841-600-senses-special-doors-of-perception/.

Dweck, Carol. *Mindset: The New Psychology of Success*. New York: Ballantine Books, 2007.

Engel, Franis. "Discovery in Motion". 1999 (unpublished).

REFERENCES 315

Evans, Jackie A. *Frederick Matthias Alexander*. Chichester: Phillimore, 2001.

Fertman, Bruce. "Earn It Anew." In *Festschrift*, edited by Barbara Conable, 66–68. Columbus: Andover Road Press, 1989.

———. "Memory: A Tradition of Originality." 2012. Accessed 11 March 2013. http://peacefulbodyschool.com/2012/05/28/memory/#comments.

Fertman, Martha Hansen. "The Intending Mind." In *Festschrift*, edited by Barbara Conable, 8–10. Columbus: Andover Road Press, 1989.

Fischer, Jean, ed. *Mouritz Companion to the Alexander Technique*. https://mouritz.org/companion.

———. *The Philosopher's Stone: Diaries of Lessons with F. Matthias Alexander*. London: Mouritz, 1998.

Fishman, Marguerite. "In the Process of Moving." In *Festschrift*, edited by Barbara Conable, 5–7. Columbus: Andover Road Press, 1989.

Fitzgerald, Terry. "The Future of Alexander Technique Teacher Education: Principles, Practices and Professionalism." PhD, University of Technology Sydney, 2007.

Fleming, Renée. *The Inner Voice: The Making of a Singer*. New York: Viking, 2004.

Frederick, Lena. "Some Observations on Studying with Marj." In *Festschrift*, edited by Barbara Conable, 103–5. Columbus: Andover Road Press, 1989.

Frederick, Michael. "Interview with Michael Frederick." In *Festschrift*, edited by Barbara Conable, 46–53. Columbus: Andover Road Press, 1989.

Freire, Paulo. *Pedagogy of the Oppressed*. London, UK: Penguin, 1970.

Frensch, Peter A., and Dennis Rünger. "Implicit Learning." *Current Directions in Psychological Science* 12 (2003): 13–18.

Freundlieb, Dieter. *Dieter Henrich and Contemporary Philosophy: The Return to Subjectivity*. Aldershot: Ashgate, 2003.

Garrison, Jim. *Dewey and Eros: Wisdom and Desire in the Art of Teaching*. New York: Teachers College Press, 2010.

Gehman, Stacy. "Working with Marjorie Barstow." In *Festschrift*, edited by Barbara Conable, 119–21. Columbus: Andover Road Press, 1989.

Goldberg, Marion. John Dewey and the Alexander Technique. The Alexander Center, 27 March 2020. https://alexandercenter.com/jd/.

Gounaris, C., C. Tarnowski, and C. Taylor. *Taking Time: Six Interviews with First Generation Teachers of the Alexander Technique on Alexander Teacher Training*. Aarhus, Denmark: Novis Publications, 2000.

Green, Barry, and W. Timothy Gallwey. *The Inner Game of Music*. London: Pan Books, 1986.

Gummere, Richard M. "Marjorie Barstow." In *Festschrift*, edited by Barbara Conable, 165–66. Columbus: Andover Road Press, 1989.

———. "Three Lessons from Dewey." *The Alexander Review* 3, no. 2 (1988): 45–49.

316 REFERENCES

Hall, John, and Michael Hall. "Somatic Sensations: I. General Organization, Tactile and Position Senses." In *Guyton and Hall Textbook of Medical Physiology*, 14th ed. Elsevier, 2021. Accessed January 2022.

Heirich, Jane. "The Speaking and Singing Voice: Breathing Issues." *NASTAT News* (Autumn 1994): 19–21.

Hemley, Matthew. "Fury as RADA Cuts Alexander Technique." *The Stage News* (Wednesday 11 August 2010). Accessed 17 July 2012. http://www.thestage.co.uk/news/newsstory.php/29232/fury-as-rada-cuts-alexander-technique.

History Nebraska. https://history.nebraska.gov.

Holt, Michael. "Making FM Reader Friendly." *Direction Journal* 2, no. 6 Spirituality (September 1998): 29–31.

Johnston, Diana. "Letter from Diana Johnston." *The Alexander Review* 3, no. 2 (1988): 23–24.

Jones, Frank Pierce. *Body Awareness in Action: A Study of the Alexander Technique*. Introduction by J. McVicker Hunt. New York, NY: Schocken Books, 1979.

———. Letter 18 May 1957 to Eric McCormack. Eric McCormack's Papers, Special Collections, Latimer Family Libraries, St Vincent's College, Pennsylvania.

———. "The Work of F.M. Alexander as an Introduction to Dewey's Philosophy of Education." *School and* Society, no. 57 (1943): 1–4.

———. "Voice Production as a Function of Head Balance in Singers." *Journal of Psychology* 82 (1972): 209–15.

Kagan, Spencer, and Miguel Kagan. *Kagan Cooperative Learning*. San Clemente, CA: Kagan Publishing, 2015.

Kandik, James. "The Contributions of Marjorie L. Barstow to the Study of Human Reaction and the Act of Constructive Change." In *Festschrift*, edited by Barbara Conable, 145–46. Columbus: Andover Road Press, 1989.

Kenny, Dianna. *The Psychology of Music Performance Anxiety*. Oxford University Press, 2011.

Kenny, Vincent. "Life, the Multiverse and Everything: An Introduction to the Ideas of Humberto Maturana, Revised Version of an Invited Paper Presented at the Istituto Di Psicologia, Università Cattolica Del Sacro Cuore, 2 October 1985." http://www.oikos.org/vinclife.htm.

Kisselgoff, Anna. "Dance View; The Isadorables: Cherishing the Duncan Legacy." *New York Times* (11 Septemper 1988), Sect. 2, 24.

Kroll, Heather. "What are you Thinking? What do you Notice?" In *Festschrift*, edited by Conable, 122–26. Columbus, Andover Road Press, 1989.

Lacey, Mark. "The Skeleton Key." 2012. Accessed 26 March 2012. http://the skeletonkey.co.uk.

Lamont, Corliss. *Dialogue on John Dewey, by James T. Farrell and Others*. New York: Horizon Press, 1959.

REFERENCES 317

Leibowitz, Judith, and Kathryn Miranda. *Dare to Be Wrong: The Teaching of Judith Leibowitz*. New York: American Center for the Alexander Technique, 2007.

Ludovici, Anthony. *Religion for Infidels*. London: Holborn Pub. Co, 1961.

McCormack, Eric David. "Frederick Matthias Alexander and John Dewey: A Neglected Influence." PhD, University of Toronto, 1958.

Macdonald, Patrick. "In the 80's: Alexander Technique Lesson by Patrick Macdonald—Part 1 of 2." YouTube: Edo Svorai and Noam Renen (Hadassim2), 1980s. https://www.youtube.com/watch?v=QPPxyHCWPu8.

———. *The Alexander Technique as I See It*. Brighton: Rahula Books, 1989.

McEvenue, Kelly. *The Actor and the Alexander Technique*. New York: St Martin's Griffin, 2002.

Madden, Cathy. "A Process that Continues." In *Festschrift*, edited by Barbara Conable, 29–38. Columbus: Andover Road Press, 1989.

———. *Integrative Alexander Technique Practice for Performing Artists: Onstage Synergy*. Bristol: Intellect, 2014.

———. "Keynote Address, Alexander Technique and Performing Arts Conference." Victorian College of the Arts, Melbourne, Australia, 2012. In *Integrative AT*, by Madden, Appendix 4, 369–74.

———. *Teaching the Alexander Technique: Active Pathways to Integrative Practice*. Singing Dragon, 2018. Kindle.

———. "Viewpoint: Spirituality." *Direction Journal* 2, no. 9 (2001): 34.

Maisel, Edward, ed. *The Resurrection of the Body: The Essential Writings of F. Matthias Alexander*. Introduction by Edward Maisel. 1st Shambala ed. Boston: Shambala, 1986.

Menand, Louis, ed. *Pragmatism: A Reader*, edited and with an Introduction by Louis Menand. New York: Vintage, 1997.

———. *The Metaphysical Club*. New York: Farrar, Straus and Giroux, 2001.

Mernaugh, Kelly. "My Lessons with Marj." In *Festschrift*, edited by Barbara Conable, 127–129. Columbus: Andover Road Press, 1989.

Mills, David. "Dimensions of Embodiment: Towards a Conversational Science of Human Action." PhD, Brunel University, 1996.

———. "F.M. and the Scientific Method." In *Festschrift*, edited by Barbara Conable, 39–43. Columbus: Andover Road Press, 1989.

Murray, Alexander. "John Dewey and F.M. Alexander: 36 Years of Friendship." F.M. Alexander Memorial Lecture, Society of Teachers of the Alexander Technique, 1982.

———. "The Alexander Technique for Relaxed Playing." *Flute Talk* (April 1998): 13–14.

Mulsow, Martin, and Marcelo Stamm, eds. *Konstellationsforschung*. Frankfurt: Suhrkamp, 2005.

318 REFERENCES

Ottiwell, Frank. "Let Us Now Praise Marjorie Barstow." In *Festschrift*, edited by Barbara Conable, 1–4. Columbus: Andover Road Press, 1989.

Oxford, Frances. "Marjory Barlow Interviewed." Interview. *Direction Journal* 2, no. 2 (June 1994): 12–22.

Palmer, Parker. *The Courage to Teach*. San Francisco: Jossey-Bass, 1998.

Paludan, Marsha. "Dancing." *Direction Journal* 1, no. 10 (1993): 383–84.

Peirce, Charles Sanders. "How to Make Our Ideas Clear," (1878). In *Pragmatism: A Reader*, edited and with an Introduction by Louis Menand. New York: Vintage, 1997.

Pryor, Alice. "My Experiences with the Alexander Technique and Marj Barstow." In *Festschrift*, edited by Barbara Conable, 130–31. Columbus: Andover Road Press, 1989.

Rescher, Nicholas. "Pragmatism." In *The Oxford Companion to Philosophy*, edited by Ted Honderich, 710–13. Oxford: Oxford University Press, 1995.

Retzlaff, Kay, Susan Erickson, Marjorie Barstow, Helen Barstow DePutron, and Janette L. Forgy (transcriptionist). "Lincoln, Nebraska: Helen Barstow Deputron and Marjorie L. Barstow." *Neighborhood Oral History Project*, Office of Neighborhood Assistance, 1980.

Richter, Eckhart H. "The Application Approach: Innovation or Heresy?" *The Alexander Review* 3, no. 3 (Winter 1988): 21–38.

Rickover, Robert. "Marjorie Barstow's Teaching 1," ("MBT1"). *Guest Michael Frederick*. Marjoriebarstow.com, 2012.

———. "Marjorie Barstow's Teaching 6" ("MBT6"). *Guest Franis Engel*. Marjoriebarstow.com, 2012. Accessed 30 April 2015.

———. "Some Reflections of Marj's Teaching." In *Festschrift*, edited by Barbara Conable, 27–29. Columbus: Andover Road Press, 1989.

———. The John Dewey and F. Matthias Alexander Homepage. The Complete Guide to the Alexander Technique, 27 March 2020. https://www.alexander technique.com/articles/dewey/.

———. "The Teaching of Frank Pierce Jones: Robert Rickover Talks to Tommy Thompson." In *Body Learning (Podcast)*. Accessed 16 February 2015. https://bodylearning.buzzsprout.com/382/230326.

Rickover, Robert and Mike Cross. "Marjorie Barstow and Marjory Barlow: An Interview with Mike Cross." Body Learning: The Alexander Technique (Podcast), 2012. https://bodylearning.buzzsprout.com/382/44972.

Rodenburg, Patsy. "Foreword." In *The Actor and the Alexander Technique*, by Kelly McEvenue. New York: St Martin's Griffin, 2002.

Rodrigue, Jean-Louis. "Constructive Thinking in the Individual: The Teaching of Marjorie Barstow." In *Festschrift*, edited by Barbara Conable, 101–2. Columbus: Andover Road Press, 1989.

REFERENCES 319

Rootberg, Ruth. "The Alexander Foundation School: An Experiment in Education." *AmSAT Journal* Spring, no. 1 (2012). http://www.alexandertechni que.com/amherst/alexander-foundation-school.pdf.

Rorty, Richard. *Consequences of Pragmatism: Essays 1972–1980*. Minneapolis: University of Minnesota Press, 1982.

Ruddell, Kevin. "Some Lessons and Their Lessons." In *Festschrift*, edited by Barbara Conable, 136–38. Columbus: Andover Road Press, 1989.

Scheffler, Israel. *Four Pragmatists: A Critical Introduction to Peirce, James, Mead, and Dewey*. London: Routledge & Kegan Paul, 1974.

Stapleton, Peta; Gabrielle Crighton, Debbie Sabot, and Hayley Maree O'Neill. "Reexamining the Effect of Emotional Freedom Techniques on Stress Biochemistry: A Randomized Controlled Trial." *Psychological Trauma: Theory, Research, Practice, and Policy* 12, no. 8 (2020): 869–77.

Stillwell, Janet O'Brien. "Marjorie Barstow: An Interview." Interview. *Somatics* 3, no. 3 (Autumn/Winter 1981): 15–21.

Storr, Anthony. *Music and the Mind*. London: Harper Collins, 1992.

Tasker, Irene. *Connecting Links*. London: The Sheildrake Press, 1978.

Tiippana, Kaisa. "What Is the McGurk Effect?" *Frontiers in Psychology* 5 (2014): 725–27.

The University of Nebraska, Lincoln. *The Cornhusker Yearbook 1919, 1920, 1921, 1922, 1924*.

Trimmer, Peter. "The Alexander Technique and Aikido." In *Festschrift*, edited by Barbara Conable, 140–41. Columbus: Andover Road Press, 1989.

Troberman, Eileen. "My Two Trainings." In *Festschrift*, edited by Barbara Conable, 138–139. Columbus, Andover Road Press, 1989.

Valentine, Elizabeth R. "Alexander Technique for Musicians: Research to Date." In *Psychology and Performing Arts*, edited by Glenn Wilson, 239–47. Lisse, The Netherlands: Swets & Zeitlinger Publishers, 1991.

Valentine, Elizabeth R., David F. Fitzgerald, Tessa L. Gorton, Jennifer A. Hudson, and E. R Symonds. "The Effect of Lessons in the Alexander Technique on Music Performance in High and Low Stress Situations." *Psychology of Music* 23, no. 2 (1995): 129–41.

Venable, Lucy. "Learning with Marjorie Barstow." In *Festschrift*, edited by Barbara Conable, 78–79. Columbus: Andover Road Press, 1989.

Walnut Hill School for the Arts. "Behind Stowe, Celebrating 125 Years! School Year 2018–19." Accessed February 2022. https://issuu.com/behindstowe/ docs/bds_wh_behstowe_summer2019

Weed, Donald L. "For a Darn Good Reason." In *Festschrift*, edited by Barbara Conable, 150–64. Columbus: Andover Road Press, 1989.

———. "Let's Get Rid of 'Group Teaching'." 3rd International Congress for Teachers of the Alexander Technique, Engleberg, Switzerland, Direction Journal, 1991.

320 REFERENCES

——. "Our Debt to A.R. Alexander." *Interactive Teaching Method: A Revolutionary Approach to the Alexander Technique*. Web. 19 July 2012.

——. *What You Think Is What You Get*. 3rd ed. Bristol: ITM Publications, 2004.

Webb, Eva. "Diary of My Lessons in the Alexander Technique," 1947. In *The Philosopher's Stone: Diaries of Lessons with F. Matthias Alexander*, ed. Jean Fischer, 15–35. London: Mouritz, 1998.

Westfeldt, Lulie. *F. Matthias Alexander: The Man and His Work. Memoirs of Training in the Alexander Technique 1931–34*. 2nd ed. London: Mouritz, 1998.

White, Walton L. "An Appellation Approach: On Naming a Trade or Trading on a Name." *The Alexander Review* 3, no. 3 (Winter 1988): 41–43.

Whittaker, Erika. "Alexander's Way." *The Alexander Journal* 13 (STAT, 1993): 7.

——. "England: The First Training Course." *The Alexander Review* 2, no. 3 (1987): 21–29.

——. "The FM Alexander Memorial Lecture." *Delivered Before the Society of Teachers of the Alexander Technique (STAT)*, 26 October 1985. Published as a pamphlet.

Wiliam, Dylan. *Embedded Formative Assessment*. Bloomington: Solution Tree Press, 2018.

Williamson, Nancy Forst. "Learning to Learn." In *Festschrift*, edited by Barbara Conable, 54–59. Columbus: Andover Road Press, 1989.

Wilson, Glenn D., and D. Roland. "Performance Anxiety." In *The Science and Psychology of Music Performance*, edited by Richard Parncutt and G. E. McPherson, 47–61. New York: Oxford University Press, 2002.

Wilson, Timothy, *Strangers to Ourselves: Discovering the Adaptive Unconscious*. Cambridge: Belknap, 2002.

Wynhausen, John. "From Portland to Lincoln: From Chiropractic College to the World of the Alexander Technique." In *Festschrift*, edited by Barbara Conable, 132–33. Columbus: Andover Road Press, 1989.

INDEX

A
ACAT, 105, 136, 223, 229, 230, 282, 285, 289, 293, 295, 298, 299
Activity, xxv, 11, 32, 38, 42, 50, 52–54, 57, 86, 87, 90, 91, 93–98, 101, 102, 104, 110, 111, 113, 119, 123, 125–127, 131, 135, 138, 147, 150, 155, 159–163, 166, 172, 177, 181, 187, 193, 222, 223, 225, 272, 306
Addams, Jane, 11, 285
Alexander, Albert Redden (A.R.)
 and Dewey, 31
 biographical details, 33, 286
 compared with FM, 36
 discussions with, 110
 early days, 38
 his teaching, xxiii, 35
 media, 293
 move to the USA, 296
Alexander brothers (A.R. and F.M)
 abandonment by, 156
 differences in teaching, xiv
 (early lessons), 8

independence from, 199
strokes/falls, 34
Alexander Frederick Matthias (F.M.)
 Alexander's disapproval, 89
 and Ashley Place teachers, 149
 and Dewey, 19, 31
 and Jones, 19, 31
 and original thinking, 89, 141
 and scientific method, 26
 and stiffness, 31
 biographical details, 286
 direction and directions, 107
 emphasizing the back, 92
 first training course, xxiii, 41, 287
 his discovery and original process, xii
 his procedures (table work; etc...), xi
 his teaching, or technique, xii
 inconsistency, 121
 language and terms, 91
 limitations, 28
 the principles of his technique, xii, 86, 159, 167, 168, 180, 305
 or technique, xiii

© The Editor(s) (if applicable) and The Author(s) 2022
A. Cole, *Marjorie Barstow and the Alexander Technique*,
https://doi.org/10.1007/978-981-16-5256-1

322 INDEX

stroke, 34
teaching and training in the USA, 27
Use of Self, 20
Alexander Technique (AT)
and education, xiii, xiv, 12, 19, 147
as cult, 32
AT lessons, xiv, 59, 115, 137, 288, 293, 294
defining the AT, 107
essence and essential process, 53
First/Early lessons, 106, 119, 162, 173, 213
formal AT method, 133
in performing arts institutions, 156
Integrative, 162
problem with, xxvi, 99
progress, 202
relationship between head and spine, 54
See also Teaching and training
Anatomy, 34, 52, 94, 114
Anxiety, xi, xiv
Application
and "Application Approach", 85, 147, 149, 152, 161
criticism, 161, 167
rationale, 85
Art
and desire, wishes and interest, 118, 151
Arts, and performing artists, 236
Ashley Place, 9, 11, 27, 92, 109, 128, 130, 149, 178, 196, 200, 287, 289, 292, 293, 295, 298, 300
regime, 11
Audience
group teaching and preparation for, 178
performers and, 105, 162, 178, 187
Awareness, xxvi, 3, 7, 12, 14, 36, 50, 54–57, 85, 99, 100, 125, 126,

131, 135, 178, 187, 190, 218, 236, 291, 307

B

Back
emphasis, 96
flattening, 131
Balance, 95, 101, 123, 129, 131, 135, 139, 219, 239
Barlow
Marjory, xxii, 6, 9, 27, 35, 37, 41, 88, 103, 128, 130, 134, 140, 154, 190, 213, 214, 223, 224, 287, 290
Wilfred, 24, 41, 287, 300
Barr, Philomene, 290
Barstow, Marjorie
and application, 15, 23
and body mapping, 52, 113, 114
and communication, 171, 174, 176, 177, 189, 190, 226
and dancing, xxii, 167
and democracy, xxvi, 171, 199
and education, 12, 51, 167, 197
and farming, 165
and horses, 135, 213
and inhibition, 60, 86, 93, 98, 104, 196, 229, 236
and musicians, xii, 118, 127, 163
and pragmatism, 19, 144
and procedures, 124, 132, 133, 147
and research, xxi, xxviii, 18, 38
and social context, xxvi, 23, 171, 199, 226
and the teaching-training continuum, 228
and travel/visits/moves (NY/ACAT), xxii, 42
and wholeness, 50, 106
as A.R. Alexander's assistant, xxiii, 34

INDEX 323

Barstow's principles of the AT, 59, 84
biographical details, 286
clarity, xxvii, 49
criticism of, 134, 135, 158, 167, 179
departures from Alexander's teaching, 58
early lessons, 116
early lessons with Alexanders, 8
family, xx, xxiv
freedom of motion, 51
generosity, xxvii
in Boston and New York, xxiii
in London, xxiii
nurses, 163
older people, 131
PhD student, xxviii
physical education students, xx, 37
playwright, 163
praise, 8
sense of humour, xvi, 195
thinking, xxvii, 3, 18
(to Frank), xxiii, 34
Wales (w Tasker), 36
Western breezes, 14
voice teachers, 163
younger people, 11, 117, 173
Binkley, Goddard, 288, 304
Body mapping, 85, 92, 113, 114

C
Carrington, Walter, 30, 56, 58, 94, 103, 126, 133, 149, 151, 154, 156, 214, 221, 289, 290, 292, 293, 296, 297
criticism of Barstow, xxiv
teaching, 41, 52
Change, xxv, xxvi, 5–7, 9, 27, 50, 56, 59, 60, 85, 87–89, 93, 98, 100, 101, 103, 104, 107, 110, 111,
116, 117, 123, 125, 126, 133, 134, 138, 139, 141, 142, 155, 158, 162, 163, 176, 178, 184, 186, 188, 189, 191, 193, 198, 200–202, 224, 305, 307
Communication, xiii, xxvi, 15, 35, 51, 58, 86, 98, 112, 174–180, 186, 194, 197, 199, 203, 222, 226, 233, 267. *See also* Community
Community, xi, xv, xxvi, 15, 25, 31, 146, 152, 171, 174–176, 184, 185, 199, 208, 229, 233, 285, 297, 301
and Barstow, 174, 183
and communication, 175, 199, 203, 236
and Dewey, 174
Conable, Barbara, xxviii, 167, 242, 246, 261, 272
Conable, William, xxv, xxviii, 35, 48, 52, 113, 114, 127, 134, 141, 184, 193, 195, 196, 211, 213, 221, 257, 260, 261, 265, 271, 275, 276, 278, 281, 282, 292
Conditions for learning, creating, 48, 90, 207–209, 226
Conscious control, 125
and reason and thinking, 5
Constellation, 19, 33, 36, 37, 43
Barstow's, xxvi, 20
philosophical, xxix, 17, 47
research, 17
Constructive, 11, 107, 115, 130, 162, 197
Coordination, xi, xii, xiv, xvii, xxiii, 3, 8, 9, 29, 37, 50, 54, 55, 57, 86, 93, 95, 98, 104, 108, 109, 112, 120–123, 126, 135, 136, 153, 155, 158, 162, 177, 179, 187, 194, 198, 199, 202, 209, 210, 212, 213, 217–219, 226, 227, 306

324 INDEX

Creative, creatives, creativity, xiv, 4, 43, 51, 57, 118, 141, 209, 213, 288

D
Dailey, Dolly, 288, 290, 293, 294, 296. *See also* Barr, Philomene
Dart, Raymond, 55, 290
& Tasker, 291
Procedures, 290, 297
Decide, deciding, as a step in the Alexander process, 3, 53
Desire, 13, 53, 54, 96, 98, 103, 113, 116, 126, 133, 149–151, 153–158, 161, 162, 165, 168, 172, 207, 210, 220, 221, 225, 226, 233
in Alexander Studies, 152
wishes, 4
Dewey, John
Alexander lessons, 37
and Marjorie Barstow
qualitative thought, 270
teacher as guide, 42
part of constellation, life, health, 19
Direction and directions, 26, 35, 41, 51, 57, 87, 89, 91, 97, 98, 100, 102, 104–111, 113, 124, 152
Duke, Esther, 296

E
Eastman School of Music, 288
Education
as expanding freedom, 208, 209
billiard-ball style, 12
creating conditions for learning, 208
Dewey's philosophy of, xiii, 19, 42, 161, 171, 199
objective conditions for, 210
reinstating in AT, 12

teacher as guide, 42, 154
End-gaining, 4
Ends in view
versus end-gaining, 158, 168
Exercises, xi, 51, 52, 55, 94, 102, 111, 115–117, 119, 121–125, 131, 132, 134, 151, 154, 209, 291
Experience. *See* Feelings
Experimental approach
and pragmatism, 192

F
Feelings, 5, 7, 14, 101, 116, 127, 134, 140–143, 147, 175, 202, 227, 265
feeling good, 10, 142
feeling wrong, 143
lightness, 13, 139
the passive experience in AT lessons, 10
versus thinking and process, 143
Feldenkrais, Moshe, 10, 261
and Method, 291
Fitzgerald, Terry, 29, 232, 249, 250, 292
Fixed/set ideas, 89, 147
Fixtures, 85, 134, 135
Fowler, Alice, 302
Frank, Alma, 289, 295
Alma's teaching, 292
first lessons with FM, 285
FM and Jesus, 13
Jones's experience with her, 292
thoughts about training, 292
Frank, Deborah, 123

G
Goldie, Margaret, 41, 130, 149, 156, 221, 289, 293, 301, 302
Grant-Morris, Alison, 92, 293, 296

INDEX 325

Groups. *See* Teaching and training
Growth, 11, 13, 23, 42, 100, 197, 252, 306
Gummere, Richard (Buzz), xiv, xxviii, 36, 51, 165, 192, 252, 294, 297

H

Habits, 20, 25, 56, 93, 125, 126, 132, 146, 158, 167, 187, 188, 195, 202, 208, 272
Hands. *See* Teaching and training, use of hands in
Huxley, Aldous, 87

I

Ideas
 clarifying, 176
 making clear, 32, 47–49, 124, 144, 145, 159, 209, 220, 222, 233, 270
implicit learning
 Teaching and training, 207, 210
Independence, 23, 43, 126, 171, 199, 200, 202, 209, 214, 220
 of performers, 23
 of students, 28, 52, 134, 199, 203, 209, 226, 233, 236
Inhibition, 24, 26, 32, 48, 86, 87, 90, 93, 96–107, 134, 136, 138, 144, 153, 158, 160, 161, 164, 165, 196, 236, 270
 and the impossibility of nothing, 101
 as change of direction, 104
Interest as motivation, 126, 150, 154
Inviting, invite, 50, 89, 98, 185, 198, 253

J

James, William, 21, 26, 29, 30, 159, 294

Jesus
 Alexander teacher as missionary, 13
Jones, Frank Pierce
 and A.R., xxiv
 and Barstow's mentorship, 41
 and Dewey, 99
 and F.M., xxiv
 as conduit between Barstow and Dewey, 41
 Barstow's guidance, 216
 Barstow's representation to Alexander, xxiv, 40, 41
 biographical details, 294
 early lessons and training, 160, 221
 encouragement, 294
 procedures, 115
 publications, 40
 US training course, 39
 writings, 31

K

Kinaesthesia, 139

L

Language, xxvi, 15, 21, 38, 87–91, 94, 116, 123, 147, 154, 175, 176, 194, 195, 198, 214, 215
Leibowitz, Judith, xix, 8, 115, 229, 230, 236, 285, 295, 298, 304
Lightness, 13, 139, 279
Ludovici, Anthony, 8, 9, 295

M

Macdonald, Patrick, 85, 88, 103, 123, 149, 173, 213, 294, 295, 300, 303, 304
 moving to NY, 213
Macy Foundation, 32
Madden, Cathy, xxviii, 51, 55, 58, 86, 90, 91, 94, 95, 98, 100, 106, 107, 109, 113, 118, 123, 127,

326 INDEX

130, 137–139, 154, 159, 160,
162–164, 177–179, 185, 186,
188, 189, 192, 193, 198, 199,
201, 202, 208, 215–218, 222,
226, 227, 230, 250, 252, 255,
257, 262, 266, 274, 283, 296
Maisel, Ed, 26, 27, 109, 161, 249
Manner of use, 9, 84, 85, 93, 98, 99,
104, 219
McCormack, Eric, 24, 249, 295
Means whereby, xv, 4, 5, 96, 97, 103,
133, 139, 155
Mechanical advantage, positions of,
91, 115, 119–121, 123, 132,
136, 138, 142, 143, 147, 152,
159
Mechanical model, 86, 91
Mechanism, xviii, 38, 39, 86, 90, 91,
93, 108, 109, 112, 114, 120,
125, 175, 211, 291
Media, 40, 196, 245, 293, 296
Michigan, National Music Camp, 56
Movement, moving, xvii, 5, 14, 48,
59, 90, 93, 95, 113, 117, 119,
124, 125, 132, 134–138, 141,
143, 147, 155, 157, 177, 178,
186, 187, 189, 190, 192, 200,
202, 212–214, 289, 290, 299,
306
and thinking, xiii, 20, 87, 97
as inhibition, 26, 85, 87, 91, 99,
105, 136
Murray, Alex, 137, 180, 183, 201,
250, 290, 295

N
NASTAT, 229, 289
Naumburg, Margaret, 24, 297, 302
Noticing. *See* Observation

O
Observation
in Alexander's training course, 190
observing others learning, 167
of others, 87
of self, 87
Orders, 32, 86, 102, 108, 109, 135.
See also Direction and directions

P
Parrot talk, 93, 104, 110
Peirce, Charles Sanders, 21, 159, 299
Performers, xi, xii, xiv, xxv, 3, 10, 11,
14, 23, 43, 52, 84, 98, 105, 114,
118, 130, 137, 139, 151, 159,
162–165, 167–169, 177, 178,
187, 189, 194, 198, 212, 228,
236, 289, 292, 295, 296, 307
and independence from teacher, 52
and thinking, 3
Physiology, 34
Positions and procedures, 107, 115.
See also Procedures
Practical, 4, 14, 21, 52, 57, 87, 98,
100, 116, 124, 132, 142, 145,
171, 177, 195, 266
Pragmatism, 27, 28, 31, 32, 49, 96,
145, 146, 156, 294, 299
and Barstow, 145
and Dewey, 21
philosophical, xiii, xxvi, 18–22, 26,
29, 43, 144, 159
Primary control, xxiv, 38, 39, 54, 86,
90–94, 97, 104, 110, 111, 135,
137, 138, 147, 177, 236, 291
primary movement, 91, 95, 235
Principles
Alexander's, 86, 89, 159, 163, 167,
177, 225, 235, 290
Barstow's, 168, 235
Procedures. *See also* Alexander
Frederick Matthias (F.M.)

INDEX 327

chair work, 119
hands on the back of the chair, xii,
60, 115, 118, 119, 122, 124
lunge, 119
monkey, xii, 60, 115, 118, 119,
122
semi-supine, xi, 60, 127, 151
whispered ah, 115, 119, 132
Process, xi, xii, 5–9, 12, 14, 25–28,
30, 32, 39, 48, 52, 53, 55, 57,
60, 87, 92, 105, 107, 113, 117,
120, 121, 124, 125, 132, 133,
138, 140, 141, 143, 147, 151,
153, 165, 174, 177, 189, 192,
197, 201, 209, 210, 214, 222,
226, 235
Alexander's steps of discovery, 169
Proprioception, 139
Psychology, 26, 143, 184, 294
and psychologists, 21, 42, 199
Psychophysical, xiv, 4, 7, 30, 84, 85,
157, 164, 188, 212, 214, 236,
307

R
Reconstruction
concerning scientific method, 144,
146
of AT teaching (Barstow's), 23, 61,
144
of philosophy (Dewey's), 23, 145
of terms, 92
uncertainty, 144, 145
unity, 144
Reflex, 217

S
Scientific method, 22, 24, 26, 28, 30,
146

Senses, xvi, 5, 7, 21, 22, 26, 29, 55,
56, 58, 120, 139, 140, 155, 176,
186, 268
role of, 139. *See also* Balance;
Feelings; Kinaesthesia;
Observation; Proprioception;
Unreliable sensory apprecia-
tion/awareness/sensations
Sensory re-education, 138
Shaw, George Bernard, 87
Social context, xxvi, 23, 171, 177,
178, 184, 199, 203, 220, 233
Society of teachers, 58, 300
Southern Methodist University, 273
Spine
and vertebrae, 92
relationship to head, 54, 59, 91,
94, 95, 103, 110, 306
Stage fright, 156, 178
Standards, 42, 55, 57, 107, 172, 194,
213, 230, 232, 281, 286, 287,
299
Society of Teachers of the Alexander
Technique (STAT), 58, 250, 287,
300
Stewart, Irene, 128, 130, 149, 289,
293, 300
Stiffness, xviii, 10, 31, 99, 102, 103,
111, 113, 135, 138
Stony Brook Congress, xvi, xxv, 218,
236
Stow
The American Alexander School,
130, 181
the U.S. Training Course, 39, 296
The Whitney Homestead, 39, 296

T
Table work. *See* Alexander Frederick
Matthias (F.M.)
Tangents, wild, 60, 196

328 INDEX

Tasker, Irene, 19, 23, 36, 153, 164,
221, 264, 269, 291, 298, 301,
302
and application, 36, 152
and Barstow, 37, 130, 153
and Dewey, 36
and Little School, 36
Teaching and training
Abracadabra, 177
Alexander's, xii, 8, 11, 13, 14, 18,
26, 27, 42, 50, 88, 112, 116,
117, 132, 142, 166, 201
antagonistic pulls, 92, 125
application, 24, 163, 167, 189, 220
Ashley Place model versus Barstow's
model, 27, 287, 298
beginnings of group teaching, 172
certification, 221
children, 152
coordinating movement and activity
movement, 94, 95, 111
delicacy of movement, 192
dependence on teacher, 126, 189
gradual improvement, 154, 202
groups and group teaching, 168,
176, 179, 181, 185, 195
head-neck-back relationship, 5, 92
independence and responsibility of
the student, 7, 53
individual work, 42, 172, 181, 182,
191
inhibition, 60, 87, 99, 100, 104,
153
integration of training and teaching,
207
meeting and accepting, 207, 214,
232
multi-level teaching, 179, 193, 207,
228
musicians, xxv
non-doing, 101, 136
perfected teaching, xxiv, 31

performers, xxv, 10, 11, 178, 189,
228, 292
phys-ed students, 163
private lessons, 185
relax, 188
respect, 163, 207
role of the teacher, 42
small changes, 202
stop, 85, 104, 133, 202
teaching by example, 207, 209,
210, 233
the neck and back, 88
thinking in, 9, 25, 47
tiredness from, 272
use and extension, 94, 111
use of hands in, 214, 216
working "on/with" students, xxv,
12, 211
See also Procedures
Tension, xiv, xviii, 50, 97, 101, 102,
109, 113, 119, 125, 135, 137,
179, 188, 212. See also Stiffness
Thinking, 3–10, 14, 19, 20, 22, 23,
25, 34, 35, 47, 49, 51, 52, 54,
60, 89, 97, 100, 103, 104, 116,
117, 128, 131, 137, 140–142,
145–147, 155, 158, 160, 166,
173, 183, 185–188, 190, 194,
195, 201, 216, 220, 261
and moving, xiii, 43, 58, 85, 97,
106, 126, 134, 140, 142, 143,
147
constructive, 11, 13, 38, 51, 58,
87, 115, 116, 135, 167, 171,
189, 194–199, 202, 203, 207,
214, 218, 219, 226, 227
in activity, 32, 38, 86, 91, 97, 132
Tufts University, 275

U
University of Nebraska, xx, 37, 243,
244, 288, 304

INDEX 329

Unreliable sensory apprecia-
tion/awareness/sensations, 5,
120, 138, 140
Use of the self, 85, 91

V
Vertebrae, 92

W
Walker, Elisabeth, 306
Webb, Ethel, 116, 130, 149, 164,
221, 298, 301–303
Westfeldt, Lulie, 5, 7–9, 13, 28, 88,
92, 156–158, 191, 253, 285,
295, 300, 303

Barstow and Westfeldt's book, 6
Whispered Ah, 115, 119, 132, 133
White, Walton, 161, 167, 269, 271,
272
Whittaker, Erika, 8, 28, 37, 88, 122,
129, 130, 153, 164, 166, 176,
177, 181, 190, 247, 252, 262,
264, 269, 271, 274–276, 303
Wholeness, 50, 52, 106
Workshops, xxvi, 54, 58, 127, 135,
184, 201, 213, 223, 225,
229–231, 236, 289–291, 294,
296, 299
Barstow's, 106, 136, 168, 299
Wrong impressions, 13, 92, 143

Printed in the United States
by Baker & Taylor Publisher Services